THE|ROSE

A FIREFLY BOOK

Published by Firefly Books Ltd. 2003

First published by Scriptum Editions
565 Fulham Road, London, SW6 1ES
in association with The Royal Horticultural Society.

Created by Co & Bear Productions (UK) Ltd.
Copyright © 2003 Co & Bear Productions (UK) Ltd.
Text copyright © Co & Bear Productions (UK) Ltd.
Co & Bear Productions (UK) Ltd. identify Peter Harkness as author of the work.
Preface copyright © Co & Bear Productions (UK) Ltd. Graham Stuart Thomas
asserts his moral rights.
Photographs and illustrations copyright © The Royal Horticultural Society,
Lindley Library, unless otherwise specified (see p.336).

First printing

Publisher Cataloguing-in-Publication Data (U.S.)
(Library of Congress Standards)

Harkness, Peter.
 The rose : an illustrated history / Peter Harkness. —1st ed.
 [344] p. : col. ill. ; cm.
Includes bibliographical references and index.
Summary: The history and cultivation of roses from wild roses to
cultivated roses with illustrations from the archives of the Royal
Horticultural Society.

ISBN 1-55297-787-0
1. Roses—History. 2. Rose culture—Encyclopedia. 3. Roses—Pictorial works. I. Title.
635.9/33734 21 SB411.45.H375 2003

National Library of Canada Cataloguing in Publication Data

Harkness, Peter
 The rose: an illustrated history / Peter Harkness.
Includes index.
ISBN 1-55297-787-0
 1. Roses—History. 2. Rose culture. I. Title.
SB411.45.H37 2003 635.9'33734 C2003-901607-2

Published in the United States in 2003 by
Firefly Books (U.S.) Inc.
P.O. Box 1338, Ellicott Station
Buffalo, New York 14205

Published in Canada in 2003 by
Firefly Books Ltd.
3680 Victoria Park Avenue
Toronto, Ontario, M2H 3K1

Printed and bound in Italy, at Officine Grafiche DeAgostini.
Color Separation by Bright Arts Graphics, Singapore.

THE ROSE

AN ILLUSTRATED HISTORY

WRITTEN BY **Peter Harkness**

PREFACE BY **Graham Stuart Thomas**, OBE

FIREFLY BOOKS

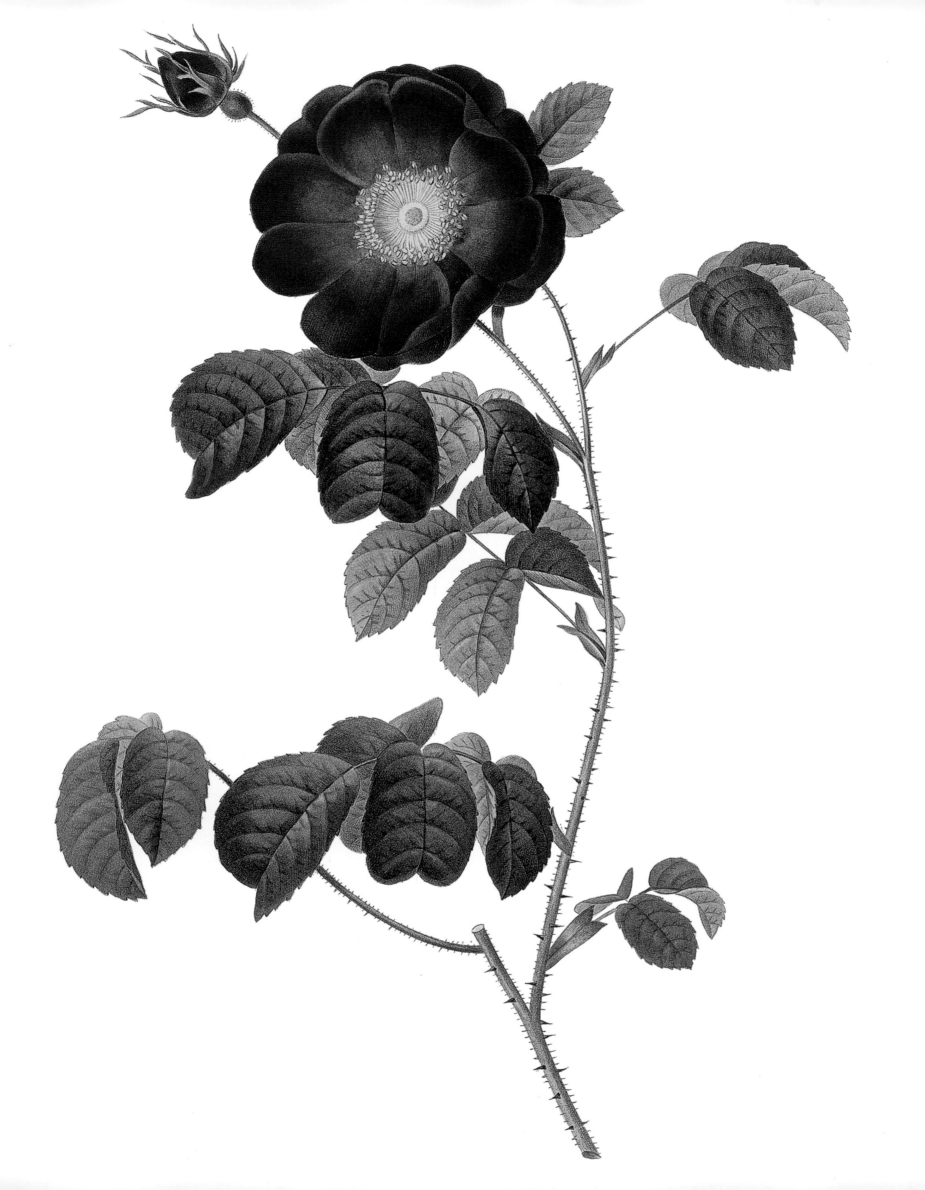

Contents

Foreword 6

Introduction 10

Roses *of* Nature 28
ORIGINS OF THE SPECIES

Roses *of* History 114
A GLOBAL EVOLUTION

Roses *by* Design 224
CREATIVE CULTIVATION

List of Illustrations 328

Index 332

Acknowledgements 336

Foreword

by Graham Stuart Thomas, OBE, VMH, DHM, VMM

GARDENS CONSULTANT TO THE NATIONAL TRUST

There is no doubt in my mind that this book will be of inestimable value to all rose lovers. It will act as a *vade mecum* for the hundreds of keen seekers after knowledge and facts concerning roses, both those who are able to make use of the unequalled resources of the Lindley Library of *The Royal Horticultural Society* – recently re-housed and rearranged – and also those who cannot. In it Peter Harkness has spread before us his great store of knowledge about roses, both in the wild and the ever-growing army of garden hybrids. It is not only a reference book, but through his erudition and application to the subject he provides us with a firm historical base, which we all need.

The book is crammed with interesting historical asides, gardening and botanical lore, and the rare asset of translations into English of the Latin names of wild roses – some have little significance to us gardeners; others may trigger off an understanding of the needs and character of the species.

My shelves devoted to books concerned with roses extend to nearly three yards. It will not be with any reluctance that I may need to cast aside a wordy and chatty book or two to make room for this priceless newcomer. The author will have earned deep gratitude from us all for his comprehensive work and very readable account of the endeavours of many artists who have done their best to record the beauty of roses.

Thinking of roses as we all do, mainly of the almost incredible number of man-made hybrids amounting to more than 20,000 raised in the last 150 years or so, it may come as a shock to many to realise that only a very few species occur in their parentage. The species, all from countries in the Northern Hemisphere, range from tiny bushlings of a few inches to immense plants which, with the aid of tree branches to support them, may achieve as much as 40–50ft. From these bare facts we may conjecture what the breeders may achieve in the future. The firm of Harkness has long been in the forefront of rose breeding and will benefit from the new scientific discoveries.

In the early decades of the twentieth century, Dr. C. C. Hurst led the van by making use of the then recent discovery of the part played by the chromosomes in heredity. There is today another vital scientific discovery; deoxyribonucleic acid (DNA for easier convenience) which is going to bring greater knowledge of the origins of the prehistoric ancestral roses. It is this recent discovery, going hand in hand with Peter's devotion to the genus, which will help us along the rosy paths of the future.

ROSA BRUNONII 'LA MORTOLA'

Towards the end of the nineteenth century, Sir Thomas Hanbury created a celebrated garden at La Mortola on the Italian Riviera. This rose, a beautiful scented form of the Himalayan species R. brunonii, became established there, and was brought to England by the old rose specialist E. A. Bunyard. A magnificent plant at Kiftsgate in Gloucestershire, England, extending in a mound to 30ft by 40ft (10 by 14m), caught the eye of Graham Stuart Thomas, who in 1954 introduced it into commerce. The pencil drawing (opposite) is also by Graham Stuart Thomas.

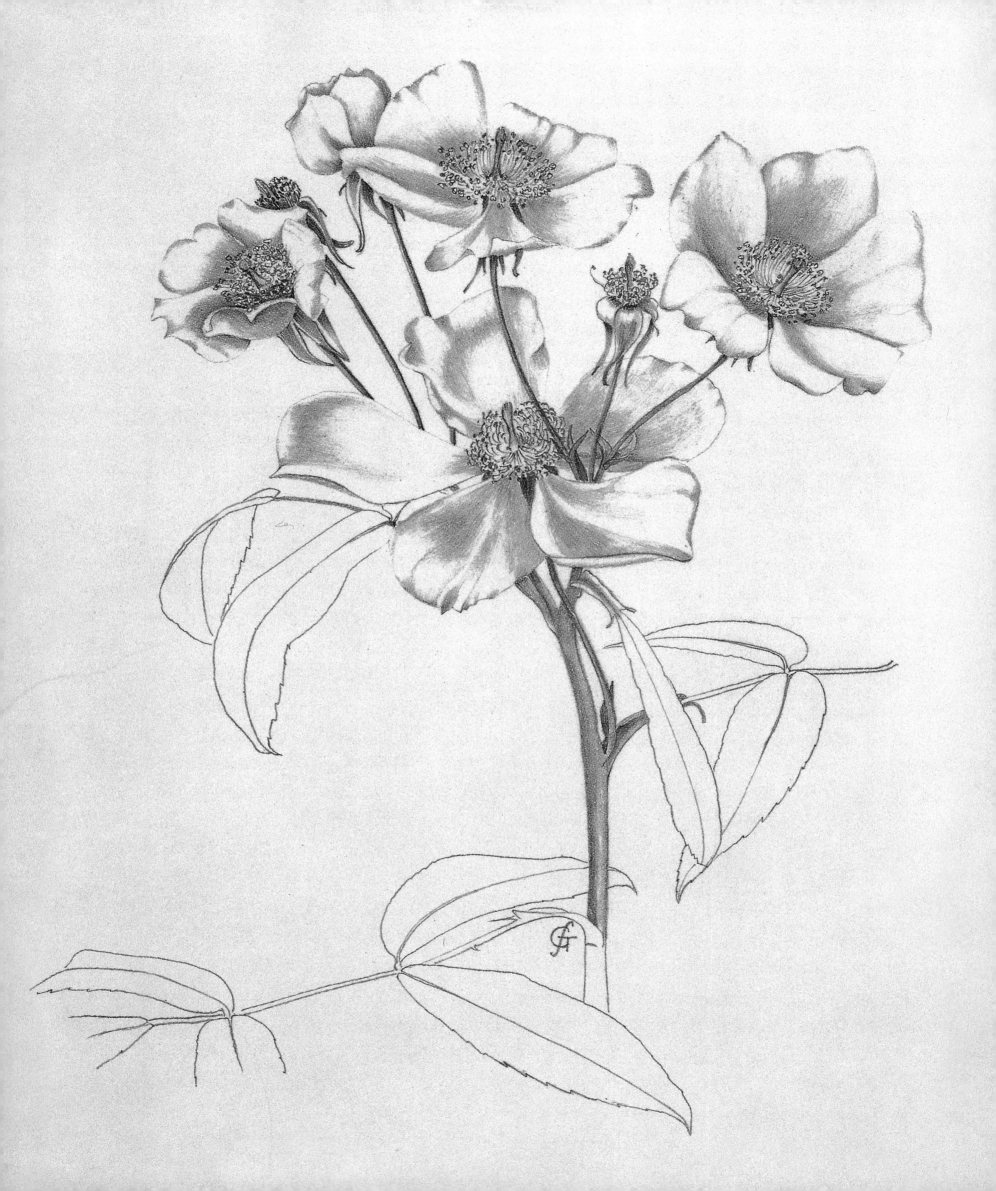

Introduction

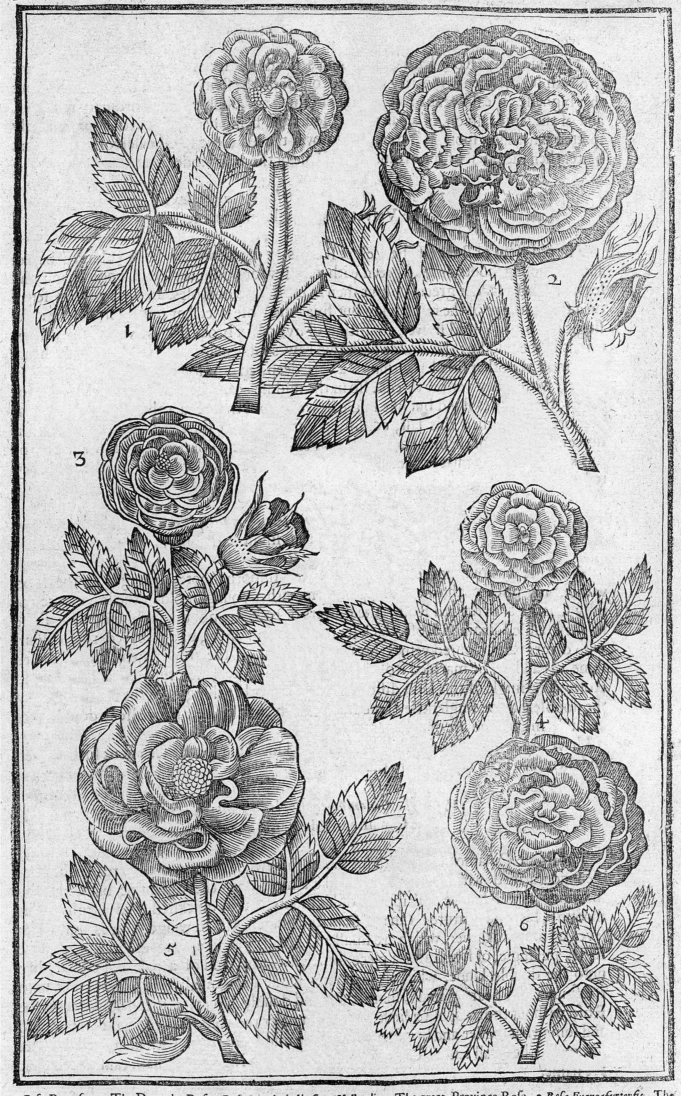

1 *Rosa Damascena.* The Damaske Rose. *Rosa Provinsialis sive Hollandica.* The great Province Rose. 3 *Rosa Francafurtensis.* The
Franckford Rose. 4 *Rosa rubra humilis.* The dwarfe red Rose. 5 *Rosa Hungarica.* The Hungarian Rose. 6 *Rosa lutea multi-
plex.* The great double yellow Rose.

Introduction

In the heart of London, The Royal Horticultural Society safeguards its archives, the accumulation of more than two centuries of research, exploration and discovery during which plant material from every corner of the world has been recorded for posterity. The collection includes more than 18,000 illustrations of flowering plants, depicted by botanical artists with painstaking care – rose artworks form a significant component, and many images in the pages that follow will be unfamiliar because for decades they have been lost to general view. Also lost in many instances are the very plants depicted, which means the artists' work may be the only visual guide to the roses enjoyed by garden lovers of the past. Some regard this as a tragedy, but it is inevitable that old varieties will be displaced as fashions alter, or when disease takes hold, and better forms are introduced. The best of the new will prove to be harbingers of change, continuing the process by which the rose has evolved to be one of the most versatile of garden plants.

The earliest pictorial evidence of a rose dates to the sixteenth century BC and is found in the famous 'Blue Bird' fresco in the royal Minoan palace at Knossos, Crete. Although flowers and leaves appear, too little of the original remains for the rose's identity to be clearly established.

At the temple of the Greek goddess Artemis (known to the Romans as Diana) at Ephesus, dating perhaps to the fourth century BC, is a statue of the goddess with a rose at the hem of her robe. Carved with five incurving petals, the rose resembles the pinky red *R. gallica*, and reflects the early use of the rose as a religious symbol.

Evidence of religious links is found in the earliest rose writings that survive, the poems of Sappho. She was born about 620 BC and lived on the Greek island of Lesvos. Surviving fragments of her verses certainly justify her reputation as the first poet of the rose:

> *'Come, goddess, to your holy shrine,*
> *Where your delightful apple grove awaits,*
> *And altars smoke with frankincense.*
> *A cool brook sounds through apple boughs,*
> *And all's with roses overhung...'*

In a poem to a departing friend she refers to garlanding with roses:

> *'... All the lovely and beautiful times we had,*
> *All the garlands of violets and of roses...'*

PARKINSON'S ROSES

In his Paradisus Terrestris *John Parkinson (1567–1650), apothecary to James I, listed twenty-four roses with descriptions, more than twice the number known to John Gerarde a few years earlier. Of the six illustrated here by Parkinson the nearest approximations to roses now available are 1) the Damask 'Kazanlik', 2) R. x centifolia, 3) R. x francofurtana, 4) R. gallica pumila, 5) R. 'Conditorum', and 6) R. hemisphaerica. During the next hundred years a few more were added to the list, but after that interest in novelties grew rapidly. Over thirteen thousand different roses are available today.*

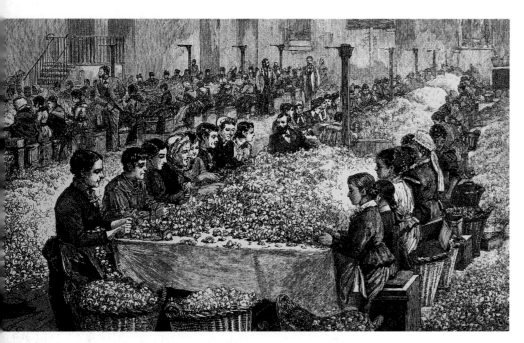

English versions of the Bible contain seven references to roses, but only one is thought to mean true roses. Scholars believe that in most cases the Hebrew words of the original manuscript have been misunderstood, and that other plants were intended. Narcissus, lily, crocus, anemone, tulip and iris are among the options they suggest. The single mention that scholars do accept is found in Wisdom, one of the books of the Apocrypha, written about 100 BC:

> 'Those who forsake the true path, reasoning not aright, say within themselves:
> "Let us fill ourselves with costly wine and perfumes, and let no flower of spring pass us by;
> Let us crown ourselves with rosebuds before they be withered;
> Let none of us go without his share in our proud revelry."'

This Judaic view of roses as tainted flowers, synonymous with hedonistic practices and loose living, was at odds with contemporary religious practice in other lands. The rose,

according to Greek and Roman legend, was the very creation of the gods Aphrodite, Dionysius, Chloris and others, who gave it its beauty, fragrance and form. In Persia the Avesta or Zoroastrian scriptures refer to a special rose entrusted to the care of an angel, and grown by magicians and fire-worshippers for ceremonial use.

In nature worship certain plants became linked to a specific divinity. The rose was identified with the living god Ahura-Mazdah in Persia, with the earth goddess Cybele in Phrygia (part of Turkey), and with the sun god Helios in Rhodes, where his emblem was displayed on the island's coins. A Hindu legend tells how Brahma the Creator argued with Vishnu the Protector over the merits of the lotus and the rose, but when Brahma saw Vishnu's fragrant arbour the matter was settled in the rose's favour. Vishnu thought so highly of his roses that he fashioned his bride Lakshmi out of rose petals. She must have been an intricate construction; he used 108 big petals and 1008 small ones.

This likening of a beautiful maiden to the rose recurs throughout the ages. In Roman times, a lover would call his sweetheart *mea rosa*. In Urdu, the word *gul* (actually borrowed from the Persian tongue) means both a rose and a beautiful damsel. The same principle applies in the little Devon town of Bideford, where the prettiest girl is chosen as the Rose of Torridge. 'She was lovely and fair as the rose of the summer' sang William Mulchinock in the west of Ireland, but he was over-optimistic in claiming 'I won the heart of the Rose of Tralee' because the girl who inspired him, Mary O'Sullivan, found love elsewhere. Emily Morgan was immortalised as the 'Yellow Rose of Texas' for her part in securing the independence of Texas from Mexico in 1836. She was captured by the Mexicans and brought to the general's tent, but proved both

ROSE PERFUME

In his painting, The Perfume Maker *(above), artist Rudolph Ernst depicts a romantic scene of Cabbage Roses (R. x centifolia) being brought to an Arab perfume maker. By contrast, the plate from the Illustrated London News of 4 April 1891 (opposite), shows the pressured business of perfume making as adults and children work together to sort through mounds of rose petals in the French town of Grasse. It is important to pick and process the roses as quickly as possible during their short flowering season to ensure the petals retain their fragrant oils.*

her bravery and guile by leaking word of the general's plans to her own side and then keeping him in dalliance to divert him. The Texans won the day and ever since have honoured Emily Morgan as 'the sweetest little rosebud that Texas ever knew'.

In Egypt the rose was adopted for worship of Isis, the goddess of fertility. In the century before Christ, the demand was such that growing roses for cut flowers became an important industry. The florists had a field day in 42 BC when Cleopatra set out to woo Mark Antony in one of the most blatant seductions in history. She came to meet him in a golden barge decorated with roses and powered by silver oars and purple sails. She presented herself as Aphrodite, wreathed and garlanded with roses, and if this was not enough to win him, roses were strewn around the palace chambers, on the furnishings, in the grounds and were even floating on the lakes.

The association of the rose with such decadent extravagance was reinforced by Nero (37–68 AD), who is said to have expended the equivalent of £100,000 strewing rose petals on a beach. On another occasion he enjoyed seeing supper guests half choked by the sheer bulk of petals poured down on them from above. A later exponent of this practice was emperor Heliogabulus who reigned 204–222 AD, and perfected the art by bolting all the exits.

A turning point in the story of the rose came when Christianity became the state religion of the Roman Empire, and the rose was restored as a symbol of honour. The return of the rose to favour in the Christian realm is demonstrated by the story of Queen Radegund. Having left her dissolute Frankish husband, she founded a nunnery at Poitiers in approximately 550 AD, and in due time achieved sainthood. She would welcome special visitors 'in the old Roman fashion', strewing roses on the dining table, placing wreaths of roses round the dishes and hanging rose garlands on the walls.

Earlier in the sixth century the bishop of Noyon in northern France had instituted an annual festival designed to find the most virtuous maiden in his diocese. The winner was honoured with a crown of roses, and also received twenty gold crowns to provide her with a dowry. The first recipient is said to have been the bishop's own sister, and perhaps that was a deliberate action to disarm any criticism that he was indulging in a pagan practice.

The growth of monastic life under the influence of Saint Benedict (c480–547) proved valuable for rose cultivation. Monasteries are by their nature permanent establishments, where gardens can develop undisturbed and where a workforce is available to maintain them. In this environment the rose became especially favoured. It was useful for medicinal, culinary and cosmetic purposes, and was considered a flower of contemplation. Alcuin, a scholar and monk of York, England, refers to it fondly in his Latin poem *Farewell to My Cell*: 'Thy cloisters smell of apple trees in the gardens, and white lilies mingle with little red roses.'

THE ROSE GARDEN AT ASHRIDGE

Humphry Repton (1752–1818) is thought to have invented the term 'landscape gardener', uniting an artist's eye for the location with a practical knowledge of gardening. His work at Ashridge in Hertfordshire was among the last of his commissions, and the rose garden can be seen to the left of the conduit.

Ashridge had been a religious foundation dating back to the thirteenth century, but Repton's creation is very different in appearance and spirit from a monastic garden, where different plants were grown in close proximity and for usefulness rather than decoration.

In the year 781 AD, the English deacon Alcuin of York, left the school where he was headmaster and travelled to Aachen to join the court of Europe's mightiest ruler, Charlemagne. There he rose to become Charlemagne's key adviser and a significant force behind the throne. His influence may well have been behind an initiative that would profoundly affect the development of the rose, not only as a garden flower but also as an emblem of faith and nationhood.

By force of arms Charlemagne created an empire in the heart of Europe, bringing most of Germany, France and Italy under his command. Around the year 794 he issued an official ordinance, an agricultural regulation for lands under the Crown's control, and in paragraph 70 he set out certain plants that were required of any farm or garden. Their names are known, because a copy of the ordinance has survived at the monastery of St. Gall in Switzerland. The plant list begins: *'Volumus quod in horto omnes herbas habeant id est I) Lilium II) Rosas'*. This translates as: 'We desire that you shall have all kinds of plants in the garden and, in particular, first lily, secondly roses.'

The list goes on to total eighty-nine plants, specifying herbs, vegetables and trees. Apart from the lily and roses, only one other item of an ornamental nature is mentioned, namely the flag iris, which comes in at seventeenth. It is interesting to note that in the Latin ordnance lily is in the singular and roses in the plural, which indicates that at least two kinds of roses were intended. These were probably forms of the white and

THE ROSARY AT ASHRIDGE
The theatrical effect of Repton's rose garden reflects the French taste for formal garden areas designed to impress. The low bedding roses may well be 'De Meaux', and the ramblers perhaps Ayrshire or Multiflora roses.

light pink Alba roses (all of which were usually termed 'white') and forms of the 'red' Gallica roses, which to modern eyes appear pinkish red to purplish red.

Among the other roses used in the gardens of Charlemagne's empire might have been some of the eleven known to Pliny the Elder centuries before, such as 'spineola'; the name suggests it is the prickly low shrub known to botanists as *Rosa pimpinellifolia*. This has the interesting capability of showing variation in its seedlings, admitting primrose, blush and purplish markings into its creamy petals.

The fragrant Damask rose, were it available, would certainly have interested the monks, but it is not known to have reached Europe at such an early stage. Charlemagne was well aware of its products; his court in Aachen was likened to a great scented rose garden, thanks to Arabian rose essences.

Following the emperor's decree, the standing of the rose was greatly advanced throughout the crown lands of Europe. Its high ranking may have been due to its role in religious festivals. Just as lilies were bought and displayed at Easter, roses were used for the Fourth Sunday in Lent, the feast days of John the Baptist and Corpus Christi, and those of several saints.

Links between the rose and religious practice persist, as the story of Charlemagne's successor, Louis the Pious, demonstrates. While out hunting he had lost a jewelled cross containing a precious relic. After much searching it was found caught on the branches of a rose bush, and in thanksgiving Louis

founded a church on the very spot. There today stands Hildesheim Cathedral, with a rose growing along its walls. Archaeologists date the foundations of the building to 818 AD, but it is hard to believe that the rose, a form of *R. canina*, has been climbing up the stonework ever since. Yet local records mention it as a well established feature in 1573, and no other rose can claim a documented history to compare with that. It is often referred to as 'The Hildesheim Rose' or 'The Thousand Year-Old Rose Tree'.

Another version of this tale says that long before the time of Louis, the rose was already growing beside a spring, and both the rose and the spring were dedicated in honour of Frigga, the Norse goddess of marriage. This explains why another local name for the rose is "Friggdorn" meaning Frigga's thorn.

In March 1945 this venerable plant suffered fire damage in an air raid, but recovered well, suckering freely from its roots. In the course of postwar excavations, the key to its ability to survive and flourish was discovered. Deep below the surface of the soil, archaeologists revealed the ancient spring from which the roots drew sustenance.

In medieval times, connections between roses and religious faith found fresh expression, furthered by advanced artistic skills. The gardening writer Sarah Coles provides a matchless description of an illumination painted by Renaissance artist Giovanni de Paolo (1400–1482):

'The white rose with rays of gold stamens is shown with the

ENGLISH ROSES

This circle of roses decorates the frontispiece of Mary Lawrance's book, subtitled The Various Kinds of Roses found in England *and dedicated to Queen Charlotte, consort of George III. It was produced between 1796 and 1799 and is important as the first monograph in Britain devoted to the rose. Lawrance, a teacher of botanical drawing, employed at times a heavy-handed stippling technique on her hand-coloured etchings which often causes her foliage to appear unnaturally dark. Near the bottom of the circlet is 'Sulphurea', now* R. hemisphaerica, *the only full-petalled bright yellow rose then known.*

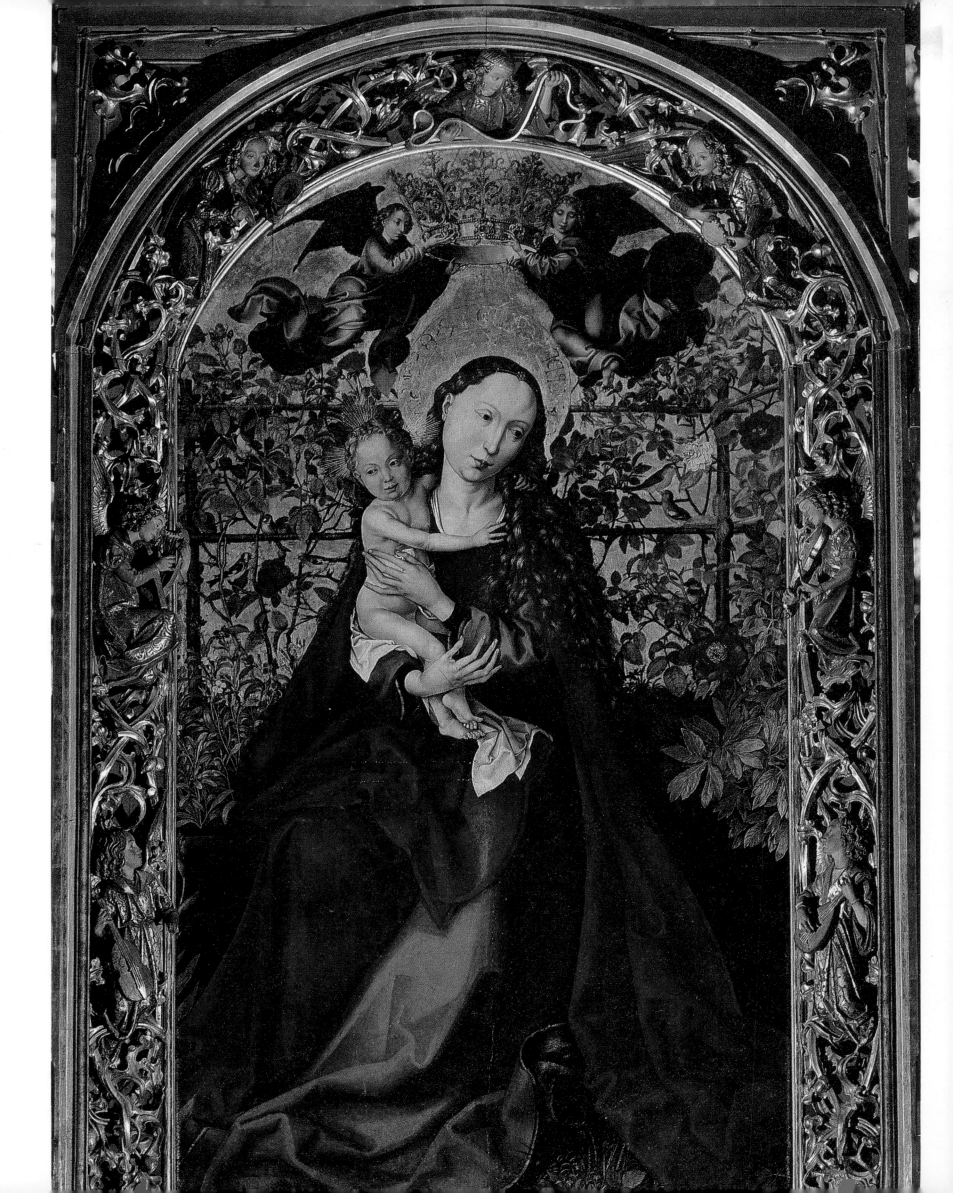

Saints, the Virgin, Child and a recumbent St Anne tightly tucked as bees in their brood chamber within the curved petals. The rose has become heaven, symbol of all we could want or conceive for this world or the next…The symmetry of the rose's circular pattern, enclosed yet expanding from the central boss through the ray of stamens to overlapping petals which reach outwards in waves which could embrace infinity, is a microcosm of the universe.'

White roses are associated with purity and innocence, and also with concealment, perhaps because of the incurving nature of the petals of *R.* x 'Alba Semiplena'. According to Dante, in the after life the white rose is itself the Celestial City within Paradise, 'unfolding its petals layer by layer'. Botticelli chose white or blushing roses to cover Aphrodite's nakedness as she rose from the sea, and they served him equally well for 'The Coronation of the Virgin'.

In death white roses have long been the traditional mark of purity and innocence, used for planting on virgins' graves, and borne in garlands at their funerals. A memento of this widespread medieval custom can be seen inside the English village church at Abbotts Ann in Hampshire, which preserves the largest collection of 'maiden's crowns'. The traditions were last observed in 1918 for fifteen-year-old William Annetts, and in 1973 for Lily Annetts, who died aged seventy-three.

The red rose, by contrast, implies pain and suffering, along with courage, passion and desire. A Greek myth tells how Aphrodite ran to her dying lover's side, heedless of the prickly white roses beneath her feet. Her blood turned the roses red. To this day red roses are the archetypal tokens of true love.

Ideas of suffering, courage and devotion come together in stories of many Christian saints, including Britain's Saint Alban, martyred in 209 AD. After his death, a red rose sprang up at the place of execution. His feast day falls on 22 June and a Rose Service is still held in Saint Alban's Abbey on the Sunday nearest to that date. At Carthage Saint Felicitas and Saint Perpetua died in the same period of persecution, and in 1827 the rose 'Félicité-Perpétue' was named for them. Appropriately it is white, to mark the purity of the victims, but it also has flecks of pinkish red, a symbolic reminder of the blood they shed.

Devotion to the Virgin Mary reached new heights in the medieval period, and many paintings portray her with the rose. The Wilton Diptych of about 1394 shows a kneeling King Richard II facing Mary, with white roses liberally strewn over the grass at the Virgin's feet, and chaplets of blush roses adorning the host of angels that surrounds her. In popular legend she was the Blessed Rose, the Mystic Rose, the Rose Without a Thorn and the rose-crowned Queen of Heaven. The five petals of the rose proclaimed her Five Joys and the letters of her name MARIA. This association has continued into modern times, through the visions at Guadeloupe in 1531, Lourdes in 1858 and Fatima in 1917, when Our Lady was observed with a

MADONNA OF THE ROSE BOWER

A favoured subject for European painters in the fifteenth century was to show Mary and Jesus associated with roses, reflecting the flower's acceptance as a symbol of sanctity. This painting by the German artist Schongauer was executed in 1473 and belongs to the cathedral of St. Martin at Colmar in Alsace. It shows in the background a trellis made with poles on which red R. *gallica 'Officinalis' roses and a blush-white Alba rose are trained. Below the roses are wallflowers on the left and paeonies on the right. The goldfinch symbolises eternal life.*

Fig. LXIV.

The Lover gathers the Rose. (From the *Romance of the Rose*, Vérard's Series, A.D. 1494-5).

romantic allegory of the thirteenth century, *The Romance of the Rose*. It tells of a lover seeking to win his beloved, the Rose, who is embowered in the heart of a garden. After being driven away by Danger, Shame and Jealousy, he struggles harder to overcome his beloved's prickly defences, and at last succeeds. This story highlights the contrast between the captivating beauty of the rose and the cruelty of its spiky armour, a paradox that has intrigued and inspired writers and painters through the ages.

From Persia comes the story of the Nightingale and the Rose. The lotus had been the Queen of Flowers, but because it slept by night it was dethroned, and the white rose took its crown. A nightingale was enraptured by the beauty of the rose and flew close to sing its praises, but a thorn pierced its breast and the bird's blood stained the petals crimson. In this way the red rose came to Persia.

The theme of the nightingale and the rose became a favourite with Persian poets and painters, and is echoed in these inspired lines by Lord Byron (1788–1824):

wreath of roses. In a second vision at Lourdes, the site of the healing spring was revealed behind a screen of species roses.

A number of paintings survive from the fifteenth century showing Mary embowered among roses, notable examples being by Bernardino Luini, Stefan Lochner and Martin Schongauer. Their works may have been inspired by a popular

'For there, the Rose, Sultana of the Nightingale,
the maid for whom his melody, his thousand songs,
are heard on high,
blooms blushing to her lover's tale;
his queen, the garden queen, his rose,
unbent by winds, unchilled by snows,

ROMANTIC ROSES

A popular medieval allegory, The Romance of the Rose, *tells of a day-dreaming lover searching the garden for his perfect rose, likened to a maiden embowered within a prickly palisade. Scenes from the tale are pictured in Sir Frank Crisp's* Medieval Gardens. *The Flemish illustration (c1470–1485) (opposite), shows him entering a garden door unlocked by Idleness, and approaching the 'Garden of Love'. He must fend off Danger, Shame and Jealousy to win the Rose.*

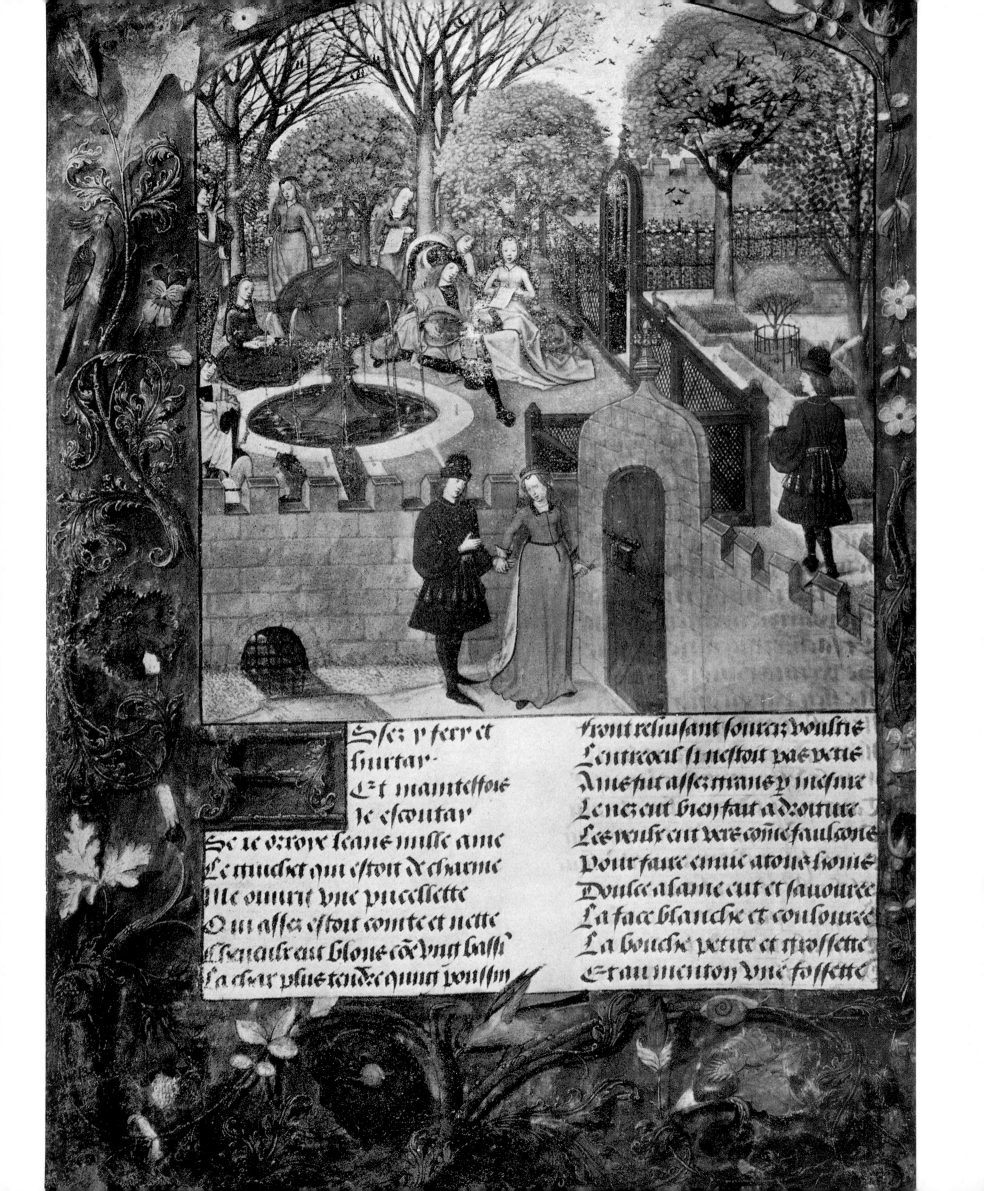

Ssez y ferir et
hurtar—
Et maintesfois
ie escoutay
Se ie o:roye seans nulle ame
Le truchet qui estoit de charme
Ille ouurit vne pucellette
Qui assez estoit coincte et nette
Cheueulx eut blons com vnd bassi
La chair plus tendre c vnni poussin

front reluisant sourcz voultie
L entreoeil si nestoit pas vetie
Ame fut assez mans y mesme
Le nez eut bien fait a droiture
Les yeulx eut vrc come faulcone
Pour faire enuie atoue sione
Doulce asaine eut et sauouree
La face blanche et coulouree
La bouche petite et esrossette
Et au menton vne fossette

far from the winters of the west, by every
breeze and season blest,
returns the sweets by nature given in
softest incense back to heaven.'

Apart from the tragic end they brought the nighingale in the Perisan tale, the prickles of the rose have also been considered a symbol of sin. Saint Ambrose (340–397) held that in Paradise the roses would be smooth stemmed, an idea echoed by John Milton (1608–1674) who described Eden before Adam and Eve committed sin:

'A happy rural seat of various view:
Groves of rich trees...Betwixt them Lawns, or level
Downs...Flowers of all hue, and without Thorn the Rose.'

This state of bliss was soon to end. The quotation comes near the beginning of *Paradise Lost*, but once Adam succumbs to temptation, the rose acquires its prickles. The Zoroastrians had precisely the same idea; thorns did not exist before Ahriman, the spirit of evil, came into the world. The English writer Edmund Spenser (d.1599) captured the dual personality of the rose when he wrote: 'Sweet is the rose, but grows upon a brier'. The poet perceives the rose as a powerful symbol of human life – because pleasure co-exists with pain, joy with sorrow, life with death.

In death, the rose is once again a symbol both of sorrow and of joy – roses planted on a grave give future hope of resurrection. Roses were placed on the grave of Sophocles in the fifth century BC, on that of Omar Khayyam in the twelfth century AD and of the Mogul emperor Jahangir in seventeenth-century India.

In parts of central Europe the link between death and roses was so strong that cemeteries in Switzerland and Bavaria were called rose gardens, and described as such on tombstones:

'Here, in this Rose garden, I await my father and mother
I was so young and small, and yet must die.'

The Indian poet Rabindranath Tagore (1861–1941) was more pragmatic. On 21 February 1941, while suffering from a serious illness, Tagore wrote the poem *Janmadine*, which translates into English as 'On [My] Birthday':

One by one from the vase drop the petals of the short-lived rose
In the world of flowers I do not see any ugliness in death.

While contemplating the winter roses in his garden in Buckinghamshire, the English poet and scholar William Cowper (1731–1800) saw in them a symbol of hope for life after death:

'These naked shoots, barren as lances, among which the
wind makes wintry music, sighing as it goes,
Shall put their graceful foliage on again, and more aspiring,
and with ampler spread,
Shall boast new charms, and more than they have lost.'

Occasionally a rose proves more than the mere symbol of death by being its cause, when spores of tetanus gain entry through a scratch. The bacteria that cause tetanus may be present in garden soil especially where horse manure is used. A case occurred in Britain in 1979, prompting reminders that everyone should be immunised.

A happier role for the rose is as an emblem of valour. The

tradition is as old as Hector and Achilles, and Roman generals displayed a design of roses on their shields. When going off to war, soldiers would wear roses on their uniforms and equipment, and the celebrations were repeated on their return if they were on the winning side.

Echoes of this tradition are found both in a German folk tale in which the king of the Ostrogoths defeats twelve knights and is crowned with a rose wreath, and in a battle honour known as the Minden Rose. The engagement at Miden on 1 August 1759 was between British and Hanoverian troops on one side opposing a large force of French cavalry. The French were taken by surprise and fled in disarray. At some point, either before or after the battle, some of the British soldiers picked roses and wore them in their caps. The details are vague, but to this day officers of the Lancashire Fusiliers and the Suffolk Regiment celebrate annually with roses and champagne.

As a symbol of nationhood, the rose has been claimed by England, Romania, Poland, Germany, USA, Iran and Honduras. The story of England's rose can be traced back to a gift made by the Pope to the Count of Provence, Raymond Bérenger IV, who died in 1245. This gift was the Golden Rose, awarded for exemplary religious devotion, and took the form of 'a single rose made of fine wrought gold'. Raymond adopted it as his personal badge.

Raymond's daughter Eleanor is known to English history as Eleanor of Provence, and when she established her household she followed her father's example in choosing a rose as her badge. Although differing opinions are expressed as to its colour, the College of Arms in London considers it was almost certainly golden. When she left Provence in 1236 to become England's queen she brought the rose with her.

Eleanor's marriage to Henry III in 1236 produced nine children. Six of them were sons, but only two outlived their childhood. The eldest son was Edward, and he too adopted the symbol of a golden rose, but with a green stalk to differentiate it from his mother's. A carving on an arch in Westminster Abbey shows him as a youth at about eighteeen years of age, and he is pictured together with a rose. The carving dates from around 1260 and is believed to be the earliest representation of a member of the English royal house with its newly adopted flower. When the prince came to the throne as King Edward I, he was the first of a long series of English kings to have the rose as his badge.

The younger surviving royal prince was Edmund. When only nine years old, he was proclaimed king of Sicily, and by the time he was twenty-two he was Earl of Lancaster. Like his grandfather, mother and brother, Edmund decided that his emblem should be a rose. It could not be a golden one, as that would cause confusion with his mother and brother, so he chose a red one, which became linked thereafter to the Lancastrian royal house.

There is a tale that Edmund was inspired to choose a red rose after visiting the French town of Provins, where the red *R. gallica* officinalis was grown extensively for commercial uses. The story was written down five centuries after the event, and is unlikely to be true. Edmund did visit Provins in order to secure his claim to an inheritance, but by then he was a battle-hardened warrior of 34, well past the stage when his royal status necessitated a badge.

When Edmund died in 1296, roses were carved over his tomb in Westminster Abbey and painted red. The five-petalled flowers resemble the species *R. gallica*, and they still bear traces of the medieval paint after 700 years.

The other significant rose in English history is the White

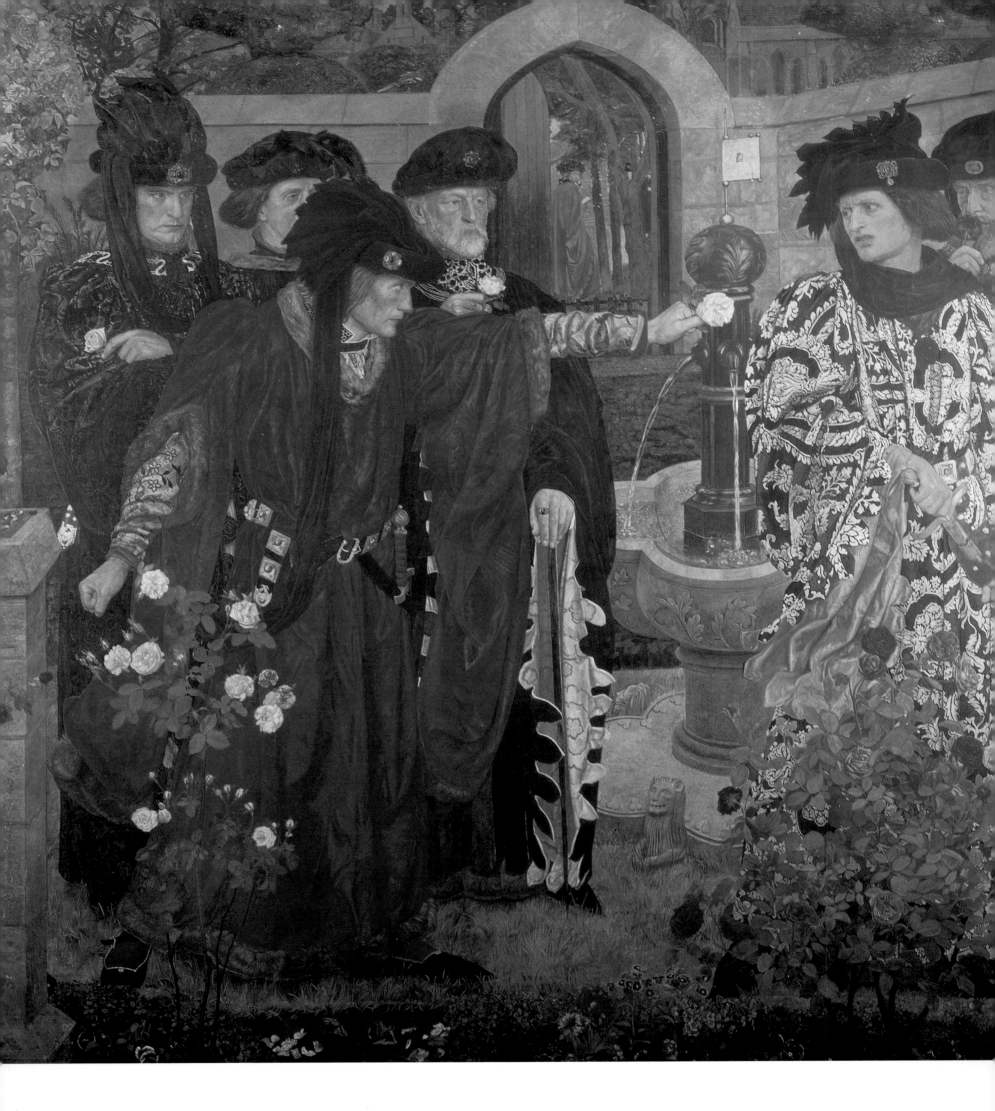

Rose of York, which came into being when Richard, son of the duke of York, married his cousin Anne Mortimer in 1406. The York badge was a mixture of blue and murray (mulberry), but it was a rather dull combination and so the couple adopted the white rose badge of the Mortimer family, perhaps because it was more distinctive. The marriage was short-lived. Anne Mortimer died aged twenty after the birth of her son, another Richard, in 1411. He grew up to become a claimant to the crown, and was immortalised as Shakespeare's Duke of York.

The Duke of York's son came to the throne as Edward IV. He adopted the *rose en soleil* design, featured it on his coinage, and in a window in Canterbury Cathedral, where it forms a magnificent background to his kneeling figure. Three years after Edward's death, a Lancastrian heir won back the throne as Henry VII. He played a key role in making the rose a national, rather than a factional flower. Through his marriage in 1486 to Elizabeth, the heiress of York, the rose became a unifying emblem and was promoted by the court as a powerful metaphor of peace. The union was symbolized in the device of the Tudor Rose, showing Henry's red rose embracing Elizabeth's white one.

The rose is also the national floral emblem of the United States. It was officially adopted in the 1980s, the culmination of many years' lobbying. At various times in the history of Congress, some seventy bills had been introduced to petition for a national flower, including the marigold, dogwood, corn tassel, columbine, carnation, sunflower, orchid, daffodil and daisy. The rosarians supported their case by extolling all the merits of the rose in a written treatise, which listed the reasons why roses are loved and grown, and why they have been embraced not just by Americans but by countless countries and cultures around the world:

They grow in every state, including Alaska and Hawaii.
Fossils show they have been native to America for millions of years.
The only flower recognised by virtually every American is the Rose.
The name is easy to say and recognisable in all western languages.
It is one of the few flowers in bloom from spring until frost.
It has exquisite colours, aesthetic form, and a delightful fragrance.
Growth is versatile, from miniatures a few inches high to extensive climbers.
Roses mature quickly and live long.
They add value to property at minimal expense.
The range of varieties is such that there are roses to suit everyone.
As no other flower, the rose carries its own message symbolising love, respect and courage.

WARS OF THE ROSES

This scene, immortalised by Shakespeare, purports to show the dukes of York and Somerset in May 1455 inaugurating the 'Wars of the Roses' with their respective emblems of the white rose and the red. The reality, however, was quite different. The Duke of York was two hundred miles away at the time of the supposed emeting, and neither Somerset nor the Lancastrian king Henry VI used a red rose as their badge. Entitled Choosing the Red and White Roses in the Temple Garden *(1910), the illustration is by Henry A. Payne (1868–1940).*

Roses of Nature

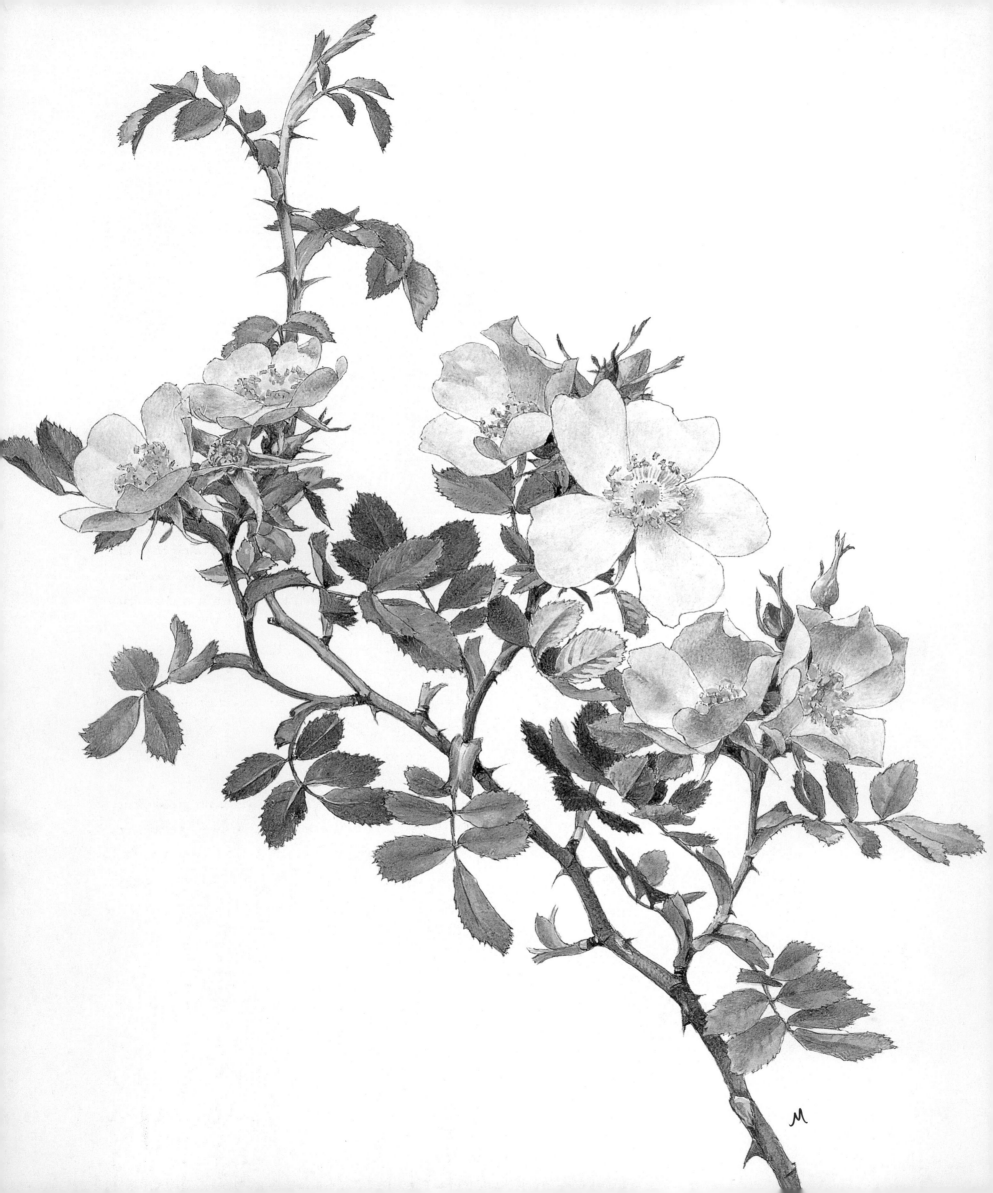

Roses *of* Nature

ORIGINS OF THE SPECIES

All the roses of the world in their glorious variety descend from wild roses. These naturally occurring species have been recorded in literature and folklore for centuries, but their origins stretch back further beyond written history. Indeed, the very earliest roses known to science are fossils.

Transforming the rose's delicate cell tissue from vegetable to mineral constitutes a rare miracle of nature, and fragmentary pieces of stem, leaflets and prickles have survived in this way for millions of years. The first recorded rose fossil was found in Austria in 1848, and over twenty sites have yielded further samples, though not all can be certainly identified as roses.

The fossils come from Bulgaria, the Czech Republic, France and Germany; from Alaska, California, Colorado and Oregon in the United States; and from China and Japan. This indicates a wide distribution and it is perhaps surprising that more have not been found. One explanation is that since roses thrive best in soil that is well drained, they would not have been present in wet or marshy areas where fossilisation is most likely to occur. The age of the fossils is estimated at between

Roses are a gift of price
Sent to us from Paradise
More divine our nature grows
In the Eden of the rose

KISAI OF MERVI
FROM AN INSCRIPTION AT OOTACAMUND
BOTANICAL GARDENS, INDIA.

three million and twenty million years. Some of the best preserved specimens have been linked to *Rosa acicularis*, *Rosa rugosa* and *Rosa roxburghii*. According to international botanical convention, these names appear in Latin, in italics, and there are two words that go to make up each name. Of the two names, the first, *Rosa*, is common to all roses, and indicates they are members of the genus *Rosa*. (For convenience *Rosa* is abbreviated to *R.* when it is clear that roses are the subject matter).

One of the pioneering rose classifiers was John Lindley (1799–1865). He looked for plants within the genus that 'differ in particular respects from the rest of the genus, but have more points of affinity among themselves than with others; their union being therefore natural'.

Among the features that distinguish roses, say from strawberries, which belong together with roses in the broad plant family called ROSACEAE, are the prickly stems, the manner in which the leaves grow, the form of the hips (the fruits of the rose), and the ability of the plants to interbreed. Plants deemed by Lindley and his successors to have elements in common to

ROSA AGRESTIS

This species is closely related to the Sweet Briar rose. Its Latin name means 'rustic' in the derogatory sense of uncouth. It makes an untidy prickly shrub up to 10 feet (3m) tall and is widely distributed through south-west Europe and parts of the British Isles, and from Tunisia to Morocco. Its blush or white flowers appear in summer and are followed by orange-red hips. It is officially recorded as having been in cultivation since 1878.

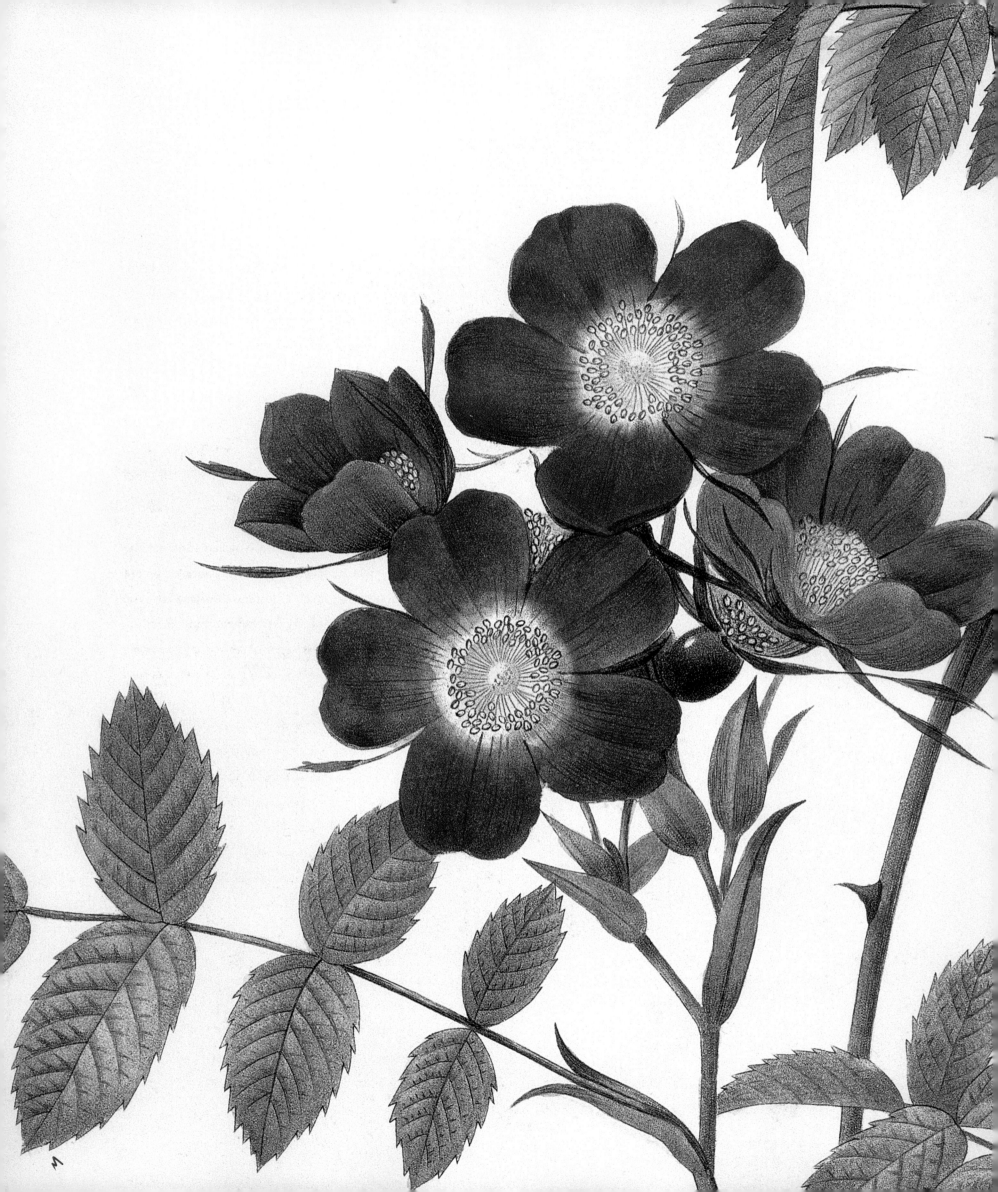

an acceptable degree are classed as members of the genus *Rosa*. Within the genus *Rosa* each distinct wild rose is called a species and receives a second name in order to distinguish it from other species. This second name is often that given by the botanist who first discovered or recorded it. Names are given for many reasons: To take the three examples above: *acicularis* relates to a feature of the prickles; *rugosa* to the leaves; and *roxburghii* to an early nineteenth century botanist.

Science cannot be certain that today's species descend directly from the fossils, but they do occur in the same regions of the world and all are in the northern hemisphere. No wild rose, fossilised or otherwise, has been discovered south of the equator, unless it has been taken there by humans in recent times. Logically then, all the species must have evolved after the separation of the northern land mass, Gondwanaland, from the southern land mass, Laurentia. It seems strange that migrating birds did not spread rose species to the south. The reason may be that rose seeds germinate most successfully after being chilled, and the combination of avian intestines and the warm equatorial belt may have been insurmountable.

In the northern hemisphere species roses occur in the polar regions, from Siberia westwards to Alaska. They occupy much of north and central Asia across to China, Korea and Japan, extend southwards to India, the Caucasus, Arabia, Ethiopia and northern Africa, touch Iceland and range over North America as far south as Mexico.

ROSA GLAUCA

The cerise pink star-shaped flowers, 1.5in (4cm) across make a fleeting appearance in summer and are followed by small, colourful, round red hips. The botanical name was changed from R. rubrifolia to R. glauca, but both names describe the foliage: respectively, 'reddish leaved' and 'covered with a powdery bloom'.

In such diverse environments, roses have adapted astonishingly well. Species are found in the chill of the Arctic tundra, in the arid mountains of New Mexico, in Indian marshlands and the highlands of Yemen, in steamy Burmese forests and on windswept Hebridean islands. Most prefer a supply of moisture on well drained sites, often in upland areas where competition from other plants does not block the sun's life-giving rays. Woodland fringes and lightly shaded sites suit many of them well. Roses are often found in hedgerows and are frequently among the plants present when species are counted to estimate the age of an ancient hedge.

Wild roses that have adapted to extreme conditions include the Swamp Rose, *R. palustris*, found in marshy places from Florida to Eastern Canada, and *R. clinophylla*, which grows in similar habitats in Burma and Bengal. Very different is the home of *R. minutifolia*, clinging on in a restricted area of Lower California. It is probably the rarest of rose species, and, as the name suggests, it has the smallest leaves, made up of three leaflets each measuring half an inch (1.25cm). The plant forms a wiry thicket fifteen inches (37cm) high and is covered with a fuzz of tiny hairs, presumably to give protection from extremes of heat and cold. By contrast, the rampant *R. sinowilsonii* can thrust its smooth red stems for 50 feet (1.25m) or more, blanketing neighbouring plants in the forests of south-west China with a canopy of enormous purplish leaves that are 12 inches in diamater by up to 12 inches (30cm) long.

Roses that clamber over neighbouring plants to obtain a share of light and moisture are often equipped with prickles. In common parlance they are thorns, but botanists prefer the term prickles – a thorn is a modified branchlet, as in hawthorns, whereas a prickle is a projection from the stem. Prickles may have developed to help roses rise above their neighbours, but other reasons could account for them, such as protection from being eaten. It is also possible that prickles function as reservoirs to protect the stems from dehydration: New shoots produced in periods of drought are noticeably pricklier than normal, and roses in arid regions are particularly bristly.

The exact number of rose species is still unknown and not for lack of study. Some wild roses are so similar that whether they are variations on the same species or plants of separate identity is endlessly debatable. Linnaeus himself declared that 'species of roses are distinguished with difficulty and are determined with even more difficulty'.

For example, the species *R. salictorum* is nearly spineless, while *R. woodsii* resembles it in every other respect except that it is prickly. When rose expert Jack Harkness wrote about *R. henryi*, in his book *Roses*, all he could find to say was that it is 'in complete confusion with *R. gentiliana*, whether identical or not, existent or not'.

When hips are gathered in the wild, the possibility that their seeds are the result of cross-pollination with another species cannot be dismissed. Who can say if the resulting

ROSA PALUSTRIS, SWAMP ROSE

The collaboration of the artist Pierre Joseph Redouté (1759–1840) and the botanist Claude Antoine Thory (1759–1827) led to the most influential rose books ever published, known under the title Les Roses. *The first three-volume edition appeared in instalments between 1817 and 1824. This rose bears the title* Rosa Hudsoniana Salicifolia, *meaning 'Hudson's rose with willow-like leaves' but its botanical name is* R. palustris, *from the Latin palus meaning 'marsh'. The common name is Swamp Rose. It is one of the few rose species that tolerates damp ground and has been in cultivation since 1726.*

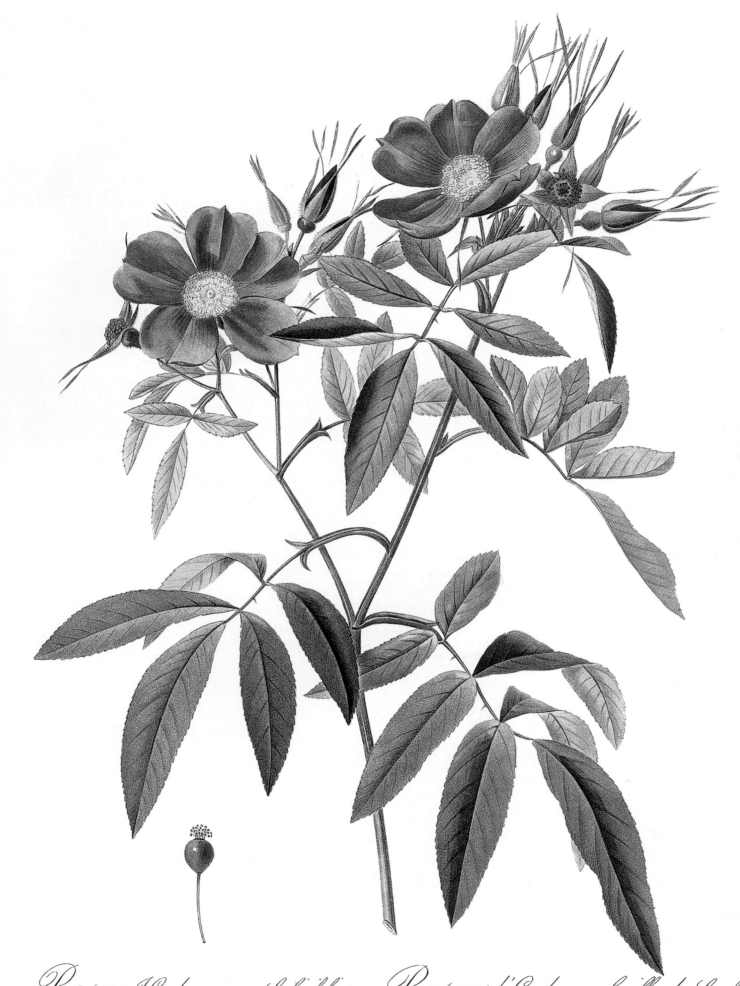

Rosa Hudsoniana Salicifolia. *Rosier d'Hudson à feuilles de Saule.*

P. J. Redouté pinx. Imprimerie de Rémond Langlois sculp.

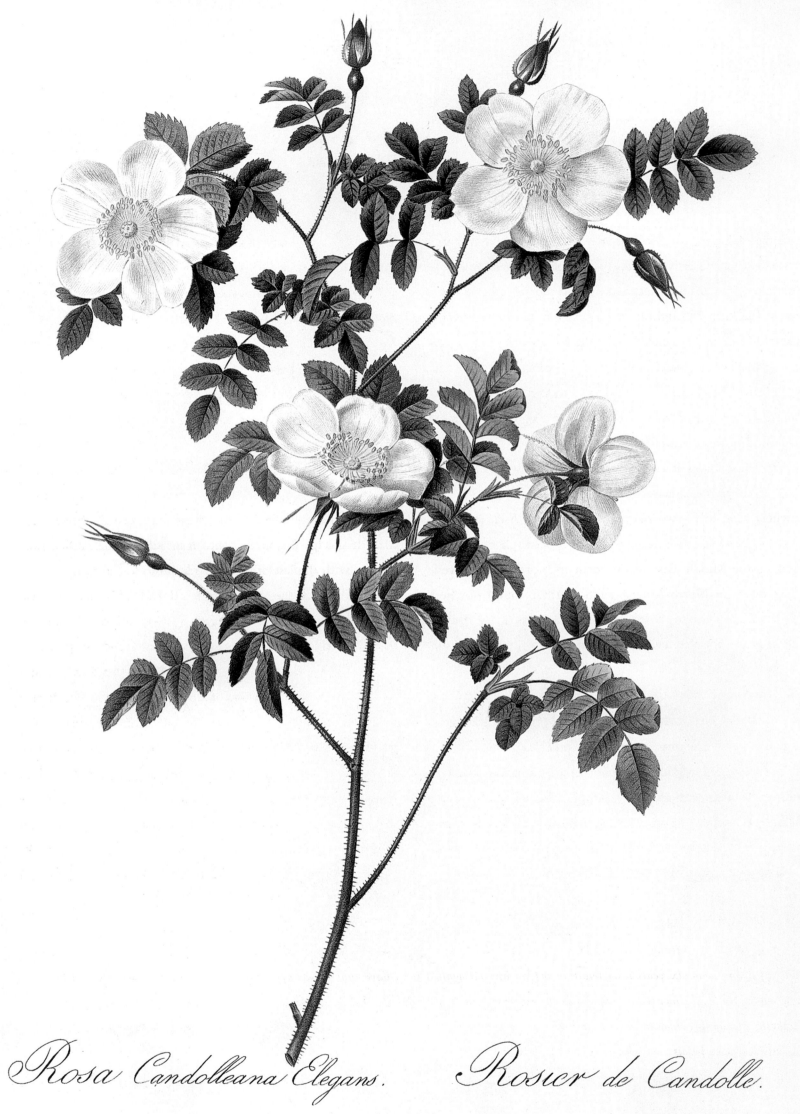

Rosa Candolleana Elegans. *Rosier de Candolle.*

P. J. Redouté pinx. Imprimerie de Rémond. Langlois sculp.

seedlings truly mirror the supposed parent in some remote location? One obsessive botanist found several species on the same plant, and another declared that no species appears completely identical throughout its habitat, either in its growth characteristics or its genetic make-up. All in all, it is not surprising that where one expert gives an estimate of some 150 species roses existing in the world, another is reluctant to admit more than a hundred. Most will settle for a figure towards the lower end of those extremes.

By comparison, it is much easier to clarify where species roses grow: forty-eight are native to China, and are found nowhere else; forty-two occur in the rest of Asia, including some of those also in China; thirty-two occur in Europe; six occur in the Middle East; seven occur in North Africa; twenty-six occur in North America, ten of these found nowhere else. That adds up to 161, but the total number of distinct species is less because several occur in more than one region.

At flower shows and in gardens, the brilliance and variety of colour seen among the roses is breathtaking. This makes it easy to overlook the fact that the flowers of most species come in gentle, pastel colours. Almost 70 per cent are white to light pink; 12 per cent are deeper pink; and crimsons, light yellows and purples share the remaining 18 per cent in roughly equal measure. Yet when it comes to sales of roses, rich reds, strong pinks, bright yellows and other flamboyant colours lead the field, turning nature's provision on its head.

In the wild, the brightest yellow species roses are limited to areas of central and south-west Asia, and the most richly coloured reds solely to parts of China. Throughout Europe, Africa, America and much of Asia, the muted colours prevail. Modern garden roses also generally repeat their flower, producing more than one flush of flowers in the same growing season, whereas nearly all the wild roses bloom freely for a short period, with only a handful prolonging their flowering over several weeks.

The accepted botanical order for rose species was devised in 1949 by Alfred Rehder, who worked for fifty years at the Arnold Arboretum in Boston, and it has been modified since then. It groups the species into four sub-families, called subgenera, with the last of these divided into ten sections:

The first of the subgenera is HULTHEMOSA, formerly SIMPLICIFOLIAE, containing a single plant, *R. persica*. Simplicifolia means 'having single leaves', and *R. persica* is unique among roses in producing one leaf rather than a group of leaflets. Secondly is HESPERRHODOS. In Greek this means 'western roses', and by this it means very far west, for the three members of the subgenus are all from the south-west of the United States: *R. minutifolia*, *R. stellata* and *R. stellata mirifica*. The third subgenera is PLATYRHODON – Greek for 'flaky roses' and so named because their bark peels away. This subgenus contains the remarkable *R. roxburghii* and *R. roxburghii normalis*. Lastly is EUROSA: *ura* is Latin for 'east' and

ROSA CANDOLLEANA ELEGANS, 'ROSE DECANDOLLE'

This rose proved a source of botanical controversy. It was dedicated to Augustin-Pyramus de Candolle (1778–1841) and described in 1819 by Thory, who six years later wrote to defend himself against the charge that it was synonymous with another rose. He had also been implicated in comments by Jean-Pierre Vibert, who criticised botanists for their over-readiness to admit new species and cited 'De Candolle' as one 'they would have done better to have forgotten'. The rose itself is a form of R. pimpinellifolia *with pink marking on the outside of the petals.*

perhaps the name stands for 'eastern roses', though species in this large group are found in wide-ranging areas of the northern hemisphere, from Japan to North America.

EUROSA is botanically divided into ten sections. Banksianae is a small group of white and yellow roses from China. Bracteatae contains two white species, one from China and one from India. Caninae has numerous pink and white species found in western Asia, Europe and North Africa, while Carolinae has a few white, pink and bright pink species found only in North America. Chinensis is a small section of white, pink, yellow, red and mixed-colour roses from China and Burma; Cinnamomeae comprises white, pink, lilac, mulberry and red roses found everywhere but Africa. Gallicanae contains pink-to-crimson and striped roses from western Asia & Europe, and Laevigatae boasts a single white species from China. Pimpinellifoliae has white, pink, bright yellow, mauvish and striped roses from Asia and Europe. Synstylae is a sizeable section of white, pink and crimson roses found in all areas.

Many species have several names, given to them by successive waves of botanists. For example, *R. virginiana* was so named by Johann Herrmann in 1762 and Philip Miller in 1768, but another botanist called it *R. carolinensis*, another *R. lucida*, and yet another *R. carolina*, this last inviting confusion with the true *R. carolina*. The work of Linnaeus made all names save one redundant, and superseded botanical names are shown in this volume only where they are of special interest.

Some *Rosa* species are of particular note – for their beauty, garden worth or general interest – and their stories are told here. Almost all of the flowers described are five-petalled. Evolution has determined that this is the optimum number for successful pollination, whether by visiting insects, the wind, or the flower itself.

The Arctic Rose, *R. acicularis* [Cinnamomeae], is also known as the Prickly Rose because of the dense bristles that protrude from the stems. The Latin name refers to the needle-like shape of the bristles. They offer protection from the cold, as this is the only species found throughout the Arctic regions, from Alaska through Asia to Finland and northern Japan. Its scented deep pink flowers, opening wide around golden stamens, brighten the brief Arctic summers in May and June. It is exceptional among roses in having up to fifty-six chromosomes, whereas most species have fourteen or twenty-eight.

Another rose that has developed strategies for coping effectively with extreme conditions is *R. arkansana* (*R. suffulta*) [Cinnamomeae]. The name gives a clue as to the origin of this species, which is native to North America and prefers the drier slopes and prairies of the Midwest. Here it extends itself by suckering (sending shoots from its roots or the base of its trunk) and can survive the loss of much of its top growth in hard winters. The stems are bristly, the bushes short, up to 2 feet (60cm) high, and the species is unusual because it flowers on strong shoots of the current growing season, giving it a longer

'AYRSHIRE SPLENDENS'

The Ayrshire Roses are vigorous growers with trailing habits and show affinity with R. arvensis, *which is known to hybridise with neighbouring species, and a natural cross with* R. sempervirens *may explain how the group originated in the 1760s. By 1811 an early form was in the garden of Sir Joseph Banks. 'Ayrshire Splendens', or the Myrrh-scented Rose, has been known since 1838 and was in the United States by 1846. As late as 1898 it was being commended for its 'rapid growth, most excellent for covering rough banks, running up old trees, forming archways, festoons etc.', but it is not often seen today.*

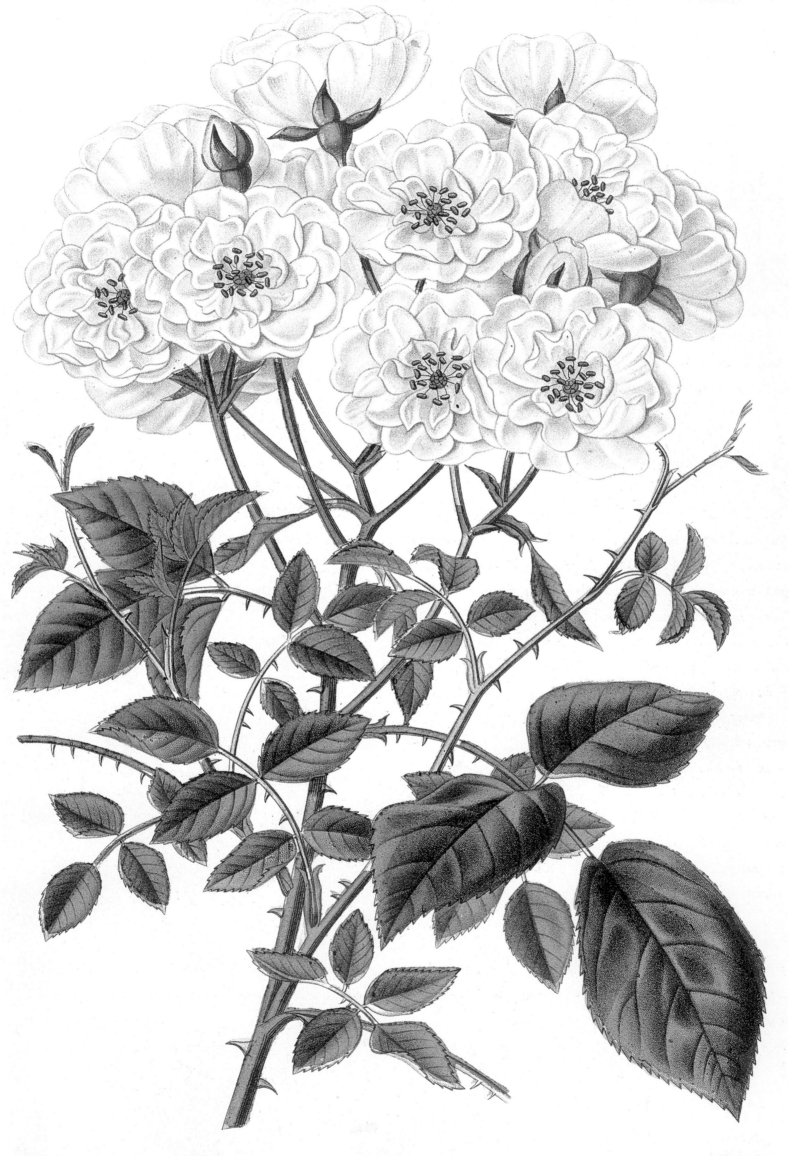

flowering span than most roses. The flowers are typically pink with lilac tones and make a brave show against bright green, deeply toothed leaves.

The Field Rose or Trailing Rose, *R. arvensis* [Synstylae], is found across much of Europe from Bulgaria to Ireland. Its attractive flowers feature veining on the petals and prominent gold stamens. They are sometimes mistaken for those of the Dog Rose, but the field rose is a paler colour, just a blush away from white, and a close look at the flower reveals that the pistils in the centre are fused into a column, whereas in the Dog Rose they are formed like a low cushion.

R. arvensis means 'of the cultivated fields', and in shady field margins it often scrambles into hedges, using large hooked thorns to reach into trees, or sending purplish green stems along the ground. This unassuming flower has been intensely scrutinised by some of Europe's foremost rosarians to determine if it is the rose of Shakespeare's *Midsummer Night's Dream*:

> *I know a bank whereon the wild thyme blows,*
> *Where oxlips and the nodding violet grows*
> *Quite over-canopied with luscious woodbine,*
> *With sweet musk-roses, and with eglantine.*

Arguments in favour of *R. arvensis* are the setting, the 'over-canopied' description, which is typical of the plant, and the fact that the rest of the flowers mentioned are native British

ROSA PALUSTRIS, SWAMP ROSE
Alfred Parsons RA (1847–1920) provided illustrations for The Genus Rosa *in 1910–1914. Parsons' drawings are less decorative but often more true to life than Redouté's. However, here he has not depicted* R. carolina *as he intended, but its close relative* R. palustris, *the Swamp Rose.*

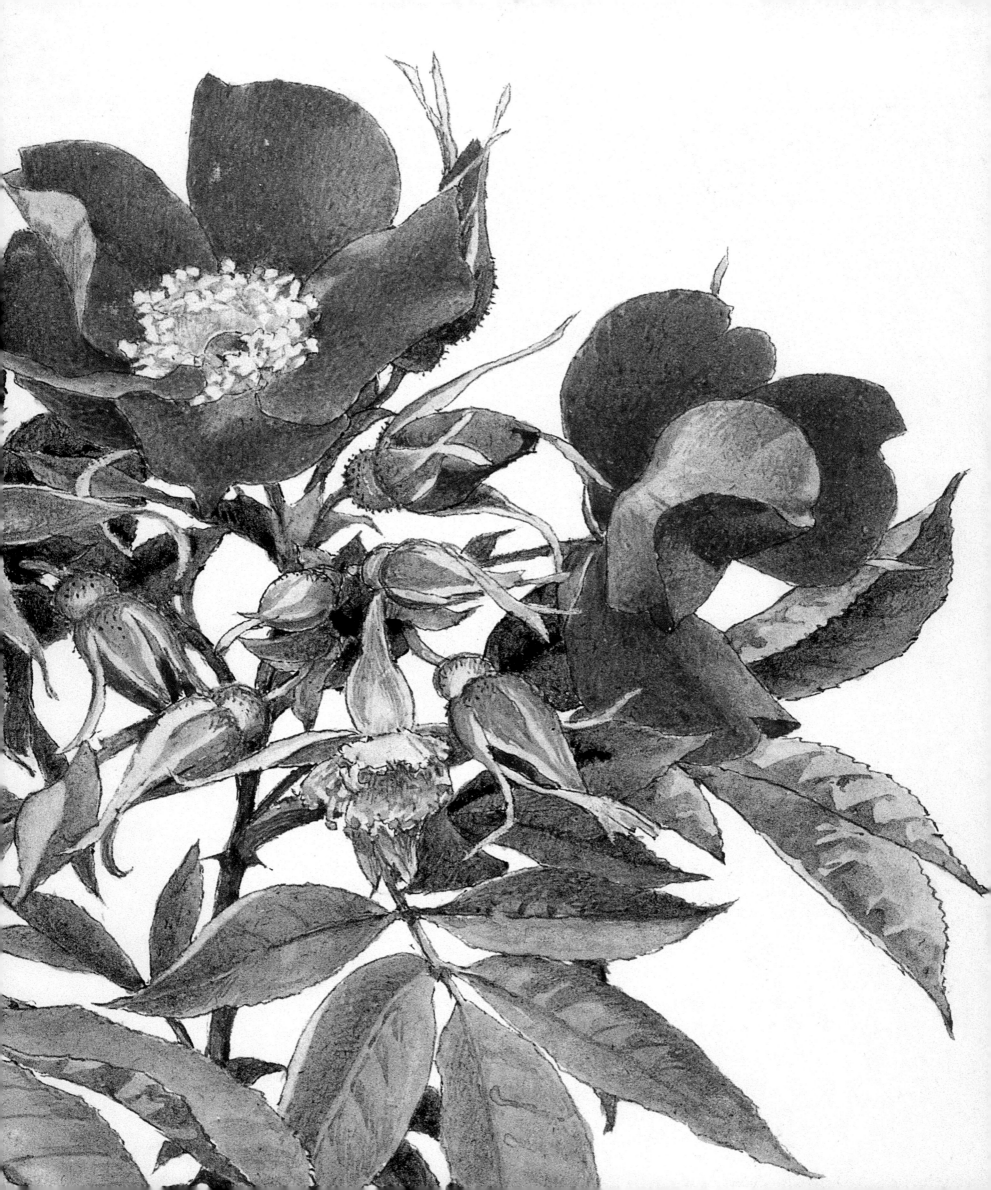

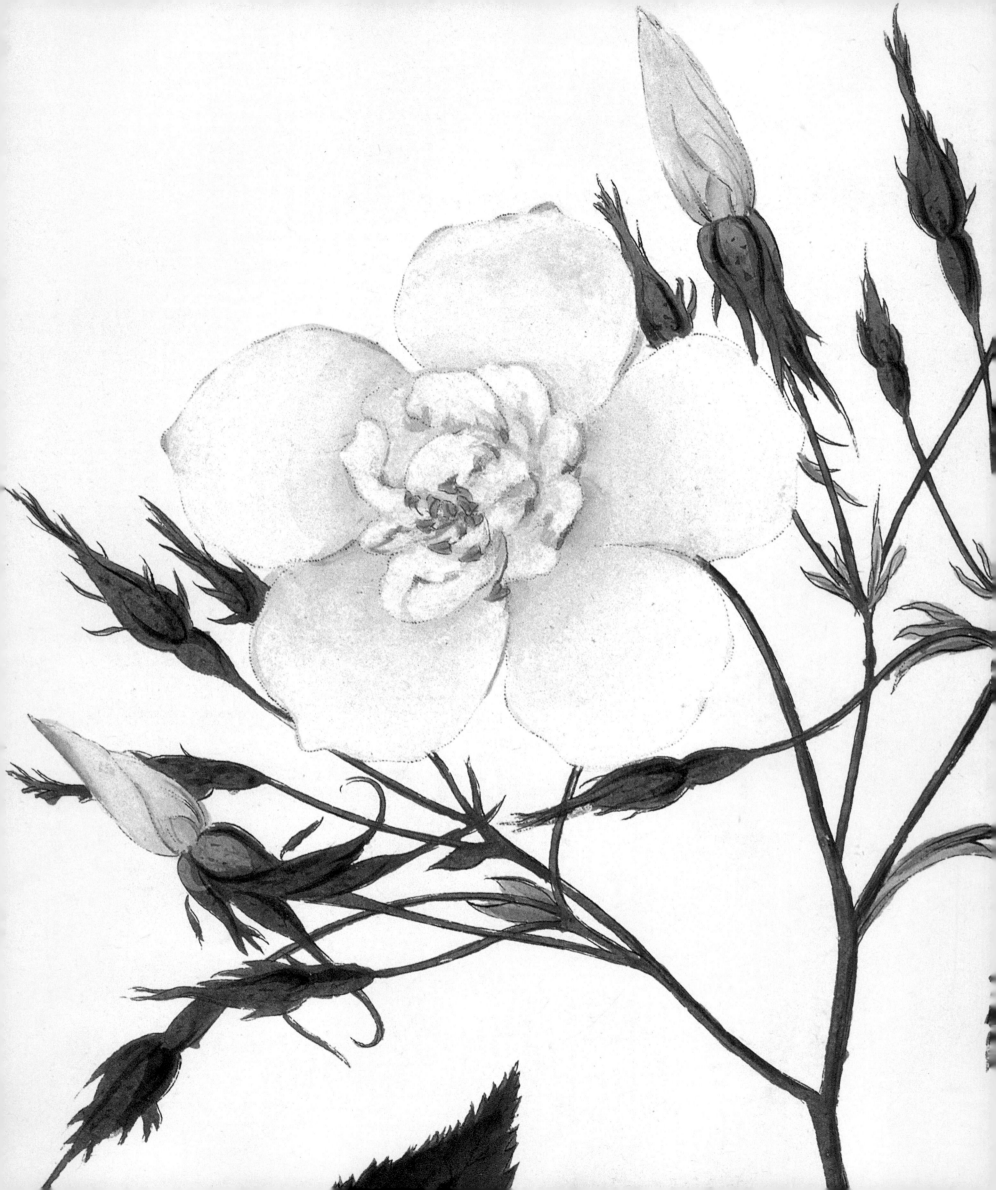

ones. Others press the claims of *R. moschata*, which was indeed called the Musk Rose, but blooms later than the rest and had only recently come to England. The argument against *R. arvensis* turned on the use of the word 'sweet', because opinion was divided on the question of its scent.

In an attempt to resolve the issue in 1988, E. F. Allen of Britain's Royal National Rose Society sought the advice of members, saying he had found the rose to be 'quite without scent, both by day and by night, in the wild and in cultivation', and cited half a dozen botanists in support. On the other hand, Graham Thomas, doyen of English rosarians, found *R. arvensis* 'very fragrant', nurseryman Peter Beales declared it 'slightly scented', and rose breeder Rev. Joseph Pemberton discerned 'a sweet scent peculiar to itself'. The writer of the French rose periodical *Les Roses Anciennes* sat firmly on the fence, describing the scent 'as being greatly appreciated by those who can perceive it, for some claim that it has none!' The story illustrates perfectly how different noses appreciate different kinds of scent, and the difficulty in presenting an objective assessment of this elusive quality.

Contention of a different kind has surrounded *R. banksiae normalis* [Banksiae], in both its naming and the story of its origin. In the usual course of events it should have been called just *R. banksiae* because it appears to be a true Chinese species. In fact, another rose derived from it, with more petals, had been discovered several years earlier and named *R. banksiae*.

ROSA CORYMBIFERA ALBA

R. corymbifera *can be light pink or white, and on account of its downy leaves is believed to be an ancestor of Alba roses. This illustration is from* Die Rosen, *produced between 1802 and 1820, with many of the pictures by Louise von Wangenheim. It shows a white Spanish form of the species.*

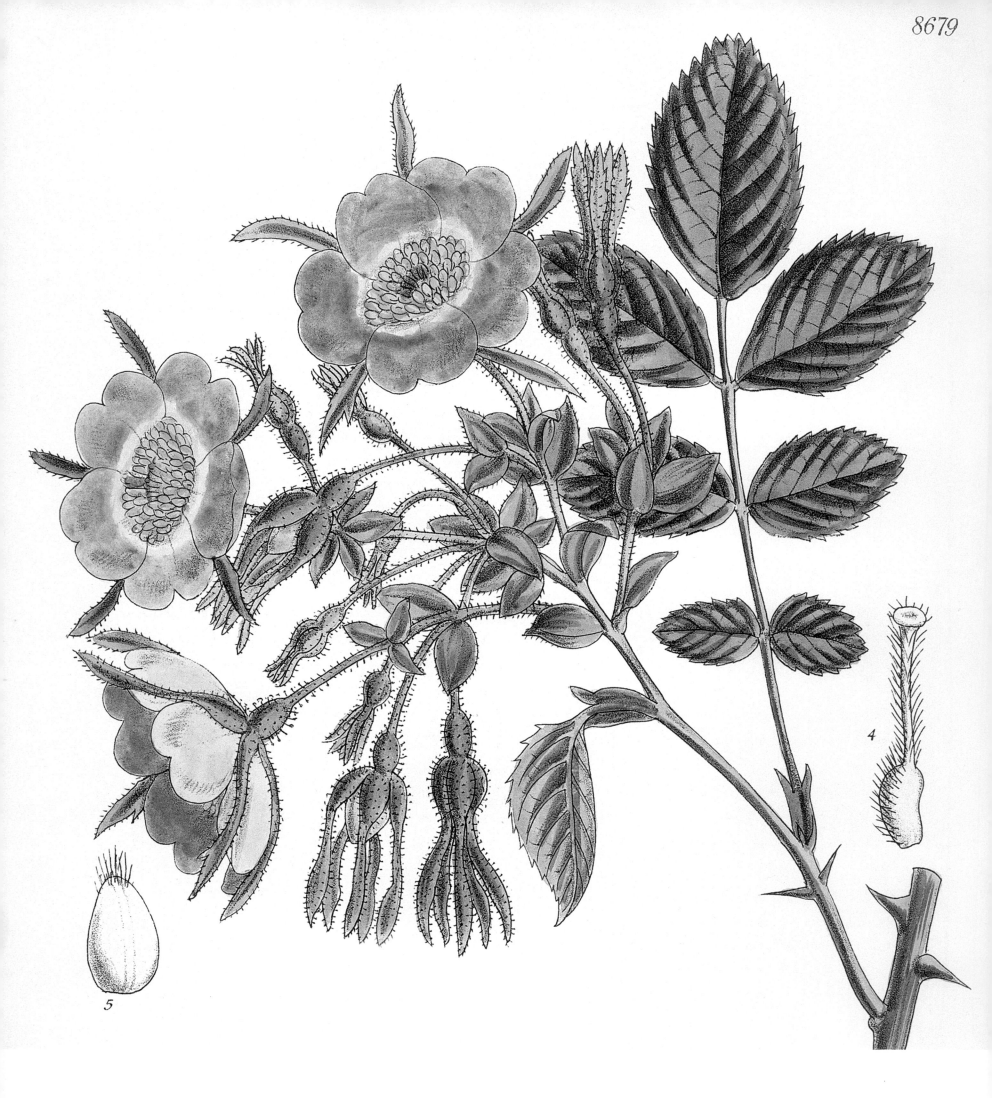

The name of that rose was then altered to *R. banksiae banksiae* (though it is generally known as *R. banksiae alba-plena*), and its ancestor became *R. banksiae normalis*, the word *normalis* indicating it is a prototype.

There are at least three different stories explaining how it came to Europe. One states that seed of *R. banksiae alba-plena* sown in Italy in 1869 germinated as *R. banksiae normalis* and was exhibited in Florence in 1874. Another story holds that the species was recorded in China in 1877 and came to Paris in 1884. There is also the tale that in 1796 a plant was taken from China to Megginch Castle in Scotland. It failed to flower due to a combination of unwise pruning and cold springs, but survived, and in 1905 cuttings were taken to the south of France where they proved to be *R. banksiae normalis*.

R. banksiae normalis bears sprays of simple white or yellowish white flowers, which appear in great profusion in early summer on stems that can extend 40 feet (13m) or more. The flowers carry the scent of violets, and the effect is such that in its native China it is known as the 'wood smoke' rose, or 'Mu-Hsiang'. Its preferred native habitats are valleys and rocky places near a source of water, and in Yunnan it is grown around paddy fields to help stabilise banks and keep livestock away.

Considered one of the most beautiful Chinese roses, *R. bracteata* [Bracteatae] is commonly called the Chickasaw Rose or Macartney Rose. In 1793 Lord Macartney led a British diplomatic mission to the court of the Emperor of China, with the object of securing trade concessions. Two gardeners accompanied the party, which was fortunate because the plants brought back were the mission's only fruitful outcome. Among them was *R. bracteata*, native to south-east China and Taiwan. Apart from its vicious prickles, it is one of the most elegant wild roses. It has distinctive shiny leaves and bears creamy white flowers, composed of large silky-textured petals with prominent orange yellow stamens, and it smells like ripe apricots. Tufts of small leaflets close to the blooms, known as bracts, give rise to its species name. The plant is vigorous, reaching or sprawling 10 feet (3m) or more, and bears its flowers sparingly over a long period in summer and autumn.

This 'aristocratic and altogether splendid rose' (to quote Graham Thomas) proved rather tender for the British climate, but in 1799 it was sent to the President of the United States, Thomas Jefferson, who was a keen rose fancier. It was so well suited to the dry south-east states that it became a serious environmental problem there. In Bermuda, where it also suckers freely, it is known as 'the fried egg', and the Bermuda Rose Society has issued a special warning to its members: 'Think twice before planting!!'

Another vigorous climber is *R. brunonii* (*R. brownii*) [Synstylae], or Brown's Musk, which can extend up to 40 feet (12m). During summer its prickly arching canes are covered with big clusters of small yellowish-white flowers, and their pleasing scent is diffused through the stamens rather than the

ROSA DAVIDII, FATHER DAVID'S ROSE

The large clusters of mallow pink flowers on this 15foot (5m) rose caught the eye of Père Armand David (1826–1900) in western China in 1869. They have the scent of paeonies and are followed by bottle-shaped scarlet hips. This illustration captures the unusually deep corrugations of the leaflets of this species. A related form, R. davidii elongata, *with fewer blooms and larger hips, has been used in breeding the healthy dwarf yellow shrub 'Baby Love' (1994).*

petals. Even when not in bloom, this species is easily recognisable by the long drooping greyish-green leaves, so plentiful that one observer wondered why it did not choke itself.

It was collected in Nepal in the 1820s by the Danish botanist Nathaniel Wallich, and named by John Lindley in honour of Robert Brown (1773-1858), who was in charge of new arrivals at London's Kew Gardens. For years there was complete botanical confusion between this rose, another distinct form called *R. moschata nepalensis*, and *R. moschata*.

The name of *R. californica* [Cinnamomeae] indicates its place of origin, in the west of the United States and north to Canada. It makes a fairly dense shrub, growing upright to 10 feet (3m) with dull green leaves and pink-to-lilac-pink flowers that appear over several weeks of summer.

Variant forms include the dwarf *R. californica nana*, and *R. californica plena*, which is dark pink with semi-double flowers. Since 1878 it has been grown as a garden plant. Its unusual colouring has proved useful in breeding, enabling Edward Le Grice to raise the brownish-red 'Tom Brown', and Jack Harkness the purplish 'Cardinal Hume' and 'International Herald Tribune'.

Not so eagerly fostered in gardens is the Common Brier or Dog Rose, *R. canina* [Caninae]. The arching, prickly stems and cheerful light-pink-to-whitish flowers of this species are a familiar sight through most of Europe and south-west Asia, often growing over hedge banks and beside woodland. It is a common sight in gardens, but usually unwelcome, for varieties of Canina have long been used as rootstocks, or understocks, on which cultivated roses are grown by means of budding or grafting. If a sucker appears and is allowed to grow unchecked, then the cultivated plant on which it is grafted will probably not survive for long.

The hips are valued as a rich source of vitamin C, though they need to be processed before they soften, or they lose their goodness. In ancient times an infusion of *R. canina* was believed to cure the bite of a rabid dog, hence the name Dog Rose, which is a direct translation from both Greek (*Kuno-rodon*) and Latin (*Canina*). Some rosarians maintain that the shape of the formidable prickles, like a canine tooth, inspired the name.

Roses in the Caninae section form seed in a curious way. Instead of both parents providing equal input, the female ovum contributes twenty-eight chromosomes and the male pollen only seven. This is thought to explain why breeders have had only limited success with them. The sepals are another oddity: two of them are whiskery, two smooth and one is a mix of both. Countryfolk of olden days observed such things, and an ancient rhyme goes:

> *On a summer's day in sultry weather*
> *Five brethren were born together*
> *Two had beards and two had none*
> *And the other had only half of one.*

ROSA ECAE

Startling in their brightness, the buttercup-like blooms of this species are among the earliest roses to appear in springtime. They are carried close to the slender, red-stemmed branches and have a musky scent. The plant grows upright to 5 feet (1.5m) with small dark ferny leaves, but does not always thrive in a damp climate, being native to open, rocky sloping sites in central Asia.

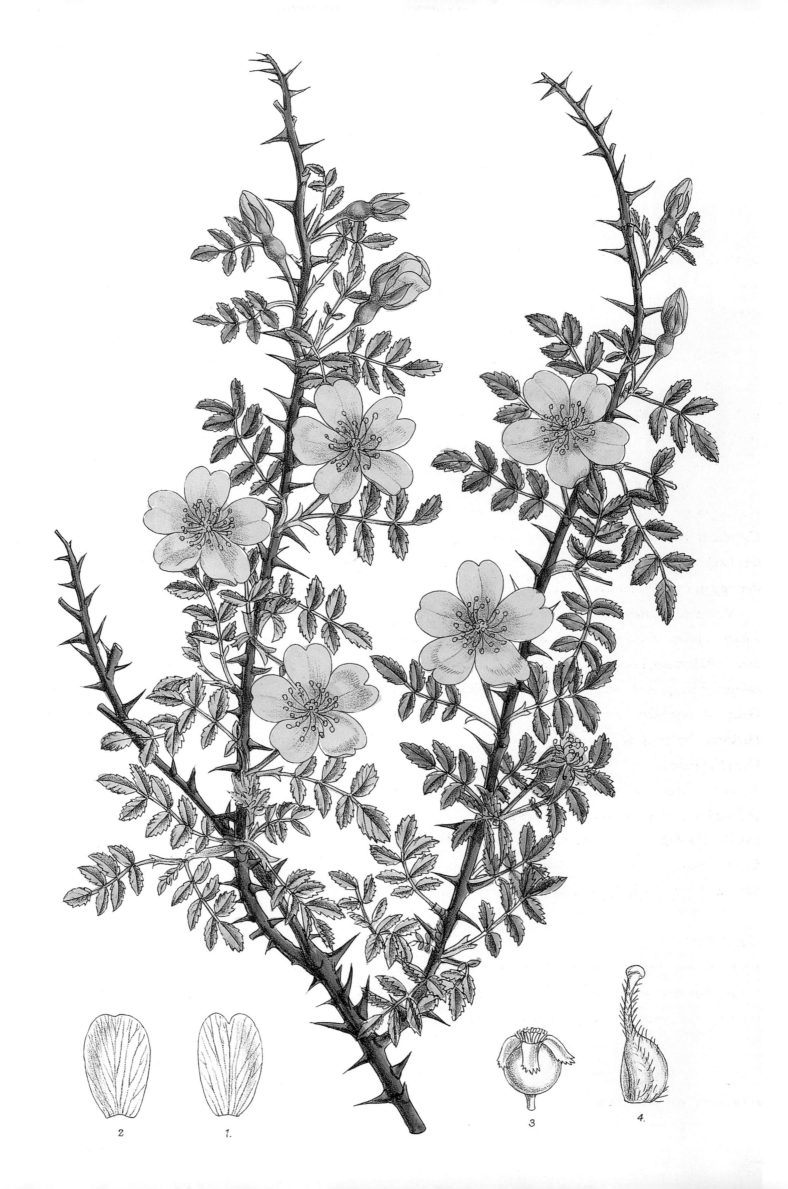

2 1. 3 4

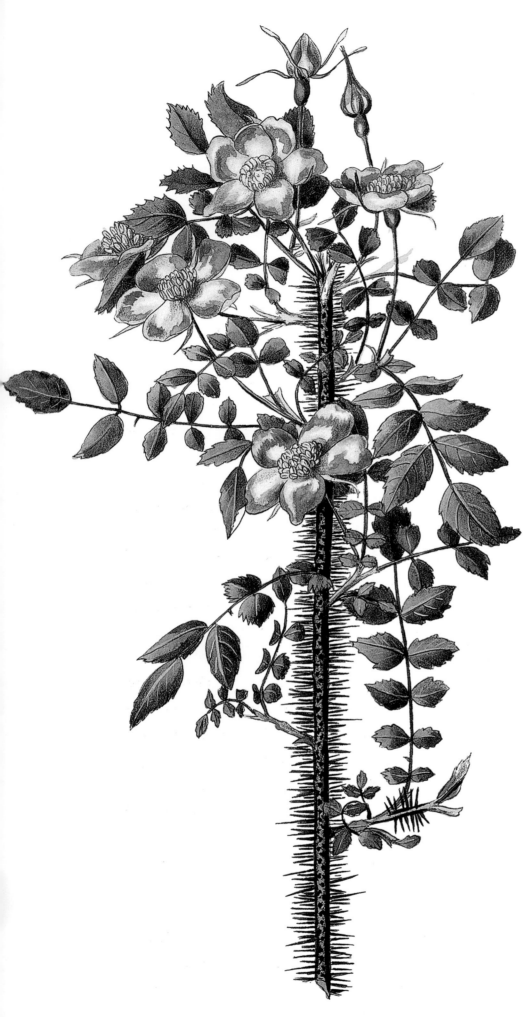

Native to America, *R. carolina* [Carolinae], the Pasture Rose, is a short prickly suckering shrub that takes its name from one of the states in its range, which extends south from Nova Scotia to Texas. Its scented pink-to-light-crimson flowers make a colourful show in summer against an attractive background of bright leaves. The leaves turn red and yellow in autumn and are accompanied by round red hips. This was one of the first native American roses sent to Europe, and was being grown in Kent as long ago as 1732.

Of all the world's wild roses, *R. chinensis* var. *spontanea* [Chinensis] is perhaps the most important. It is an ancestor of most roses in the world today and for many years it was the most elusive, at least for western botanists. In 1902 an observant Irish plantsman named Augustine Henry described in the *Gardeners' Chronicle* a wonderful wild rose he had seen eighteen years before, overlooking the Cave of the Three Pilgrims near Ichang on the Yangtze river. The region was little visited by botanists but, at the suggestion of Graham Thomas, Mikinori Ogisu instigated a search in 1983 and rediscovered it in a location several hundred miles to the west.

It is a summer-flowering climber, capable of reaching 10 feet (3m) into the trees. The flowers are reasonably large for a species rose, borne singly on a short stem, and they open wide from elegant pointed buds. Their colours can vary, with white, buff, red and pink forms all occurring. What makes this rose extraordinary is that the petals darken as they age: for example,

ROSA ELEGANTULA PERSETOSA, THREEPENNY BIT ROSE

This rose has wiry stems, tiny lilac-pink blooms and small leaflets. The flowers nestle close to the stems, which are finely coated with red-brown bristles. After the flowers fall, the foliage shows colourful autumn tints.

from light pink to crimson. The colour of the stamens and pistils also changes, from yellow to crimson. When seed is sown the resulting plants show great colour variation, the mark of a species still actively evolving.

Spontanea has several meanings, 'indigenous', 'unexpected' and 'without precedent' among them. All seem entirely appropriate for this remarkable rose. It is now commercially available, but requires the protection of an unheated greenhouse or a sheltering wall in cooler climates.

The name *R. cinnamomea* (*R. majalis*) [Cinnamomeae], the Cinnamon Rose, indicates an obvious link with cinnamon, but what can it be? John Gerarde, writing in 1597, said it was on account of the scent of the leaves, but a few years later the apothecary and herbalist John Parkinson disagreed, stating that the leaves had been sniffed in vain. Others suppose some cinnamon substitute was brewed from the leaves, or that it was named because of the red-brown colour of the stems, which seems the most likely explanation.

It grows wild in cooler parts of Europe and Siberia, often in wet habitats, and was known in cultivation before 1600. A form with fuller petals is grown in gardens. It makes a sturdy bush of 6 feet (2m), with arching stems, rather dull leaves and pinkish mauve flowers, sometimes verging towards purple. The older Latin name, *R. majalis*, means Rose of May, referring to its early summer flowering.

One of the few roses that grows well on wet ground, *R. clinophylla* (*R. involucrata*) [Bracteatae] is found from the Ganges plain to Bangladesh and Burma, and was described by Sir Joseph Hooker as India's only really tropical rose. It is a near relative of *R. bracteata*, with the pleasing scent and flower form of that species. The leaves are markedly different; they are long and narrow with a tendency to bend. This characteristic is so distinctive that both names refer to it: *clinophylla* from Greek means 'the leaves bend', and *involucra* from Latin implies concealment.

Although known to science since the early 1800s, and traditionally worn and offered in religious ceremonies in its homeland, little study was made of this interesting rose until the 1980s, when Shri M.S. Viraraghavan and Shri B.K. Banerjee began to explore its potential for rose breeding. Several seedlings have since been raised in India. Roses tolerant of wet ground could indeed be useful for many gardeners.

In rose history *R. corymbifera* [Caninae] is important as a likely ancestor of the Alba roses. It has also been used extensively as an understock for budded rose plants. The name means 'bearing flat-topped flower clusters', and its flowers can be pink or white. It is very similar to *R. canina* except for the leaflets, which are downy on both sides. This species is widely distributed across Europe to the east of the Black Sea, and along the African shoreline from Tunisia to Morocco.

The vigorous though rather tender Elderflower Rose, known as *R. cymosa* [Banksiae], warrants mention because of its natural grace and beauty. Native to China, it can grow to form a magnificent hedge, with smooth bowing stems bearing a multitude of small white flowers punctuated with prominent yellow stamens. The young leaves are a delightful shade of crimson. This rose was described in 1704 and its name, *cymosa*, is a botanical term indicating that the centre blooms open before the outer ones.

While the Elderflower Rose is noted for its beauty, Father David's Rose, *R. davidii* [Cinnamomeae], is valued for its hips, which are richly coloured and hang from unusually long necks. It was found in June of 1869 by Père Armand David, a French science teacher working in Peking, during a plant hunting

expedition in the mountains between Sichuan and Tibet. Because David saw it in summer there were no ripened hips, but it was covered in flower and he sent specimens to Paris, where the botanist Crépin named it after him.

Nearly forty years passed before a further expedition, under E. H. Wilson, succeeded in finding *R. davidii* in the wild again. Wilson undertook several expeditions to discover plants unknown to Western botanists, working successively for Kew Gardens and the Veitch nursery in England and Arnold Arboretum in Boston.

The many hundreds of new plants Wilson discovered fill three large volumes of the Arboretum's publication *Plantae Wilsoniae*. Among them are twenty-two rose species, a remarkable contribution and one achieved at the cost of much hardship and hazardous adventuring, to say nothing of the logistics required to transport live material from some of the remotest places in the world.

While many of the species roses where introduced to science by eminent botanists such as E. H. Wilson, other roses were introduced by amateur plant-spotters. The dainty *R. ecae* [Pimpinellifoliae] is a case in point. It was found in 1880 by a British army medical officer on government service in Afghanistan. He had an interest in plants and may have been attracted by the rose's eye-catching display of cupped, bright yellow blooms with their light musky fragrance, red stems and fresh, green fernlike leaflets. It is one of the odder examples of

botanical naming: *Ecae* is not derived from any language but is taken from the initials of Emily Carmichael Aitchison, the army officer's wife.

The name of *R. eglanteria* (*R. rubiginosa*) [Caninae], known as Eglantine or Sweet Briar, is more obvious. Eglantine comes from the Old French word for needle, *aiglent*, referring to the prickles. *R. eglanteria* has endured as a favourite garden rose thanks to the sweet, apple-like fragrance of its handsome deep green leaves. It carries light pink blooms on a vigorous, prickly and fairly dense plant, which grows up to 7 feet (2m), and is found across most of Europe and along the nearby fringes of Africa and Asia.

In the Antipodes *R. eglanteria* is considered a weed, especially in Otago on the south island of New Zealand, where settlers in the Gold Rush of the 1860s grew it for the nutritious value of the hips. The promise of gold riches was not fulfilled, but many thousands of *R. eglanteria* remain to perfume the air.

In England, Lord Penzance raised several shrub roses in the late nineteenth century by using *R. eglanteria*. It is also in the parentage of 'Manning's Blush', 'Goldbusch' and other shrubs.

One of the prettiest wild roses grown in the garden is *R. elegantula* 'Persetosa' (*R. farreri persetosa*) [Cinnamomeae], commonly called the Threepenny Bit Rose. In 1915 Reginald Farrer collected seeds from a plant of *R. elegantula* in western China and sent them to E. A. Bowles, one of England's foremost gardeners, who duly planted them and waited for them

ROSA FEDTSCHENKOANA

The flat pale flowers with their golden hearts show up beautifully against bristly stems and greyish foliage, especially in the half light of dusk. In gardens which can tolerate its suckering habit, the pretty display of this rose is well worth the 7 feet (2.2m) height and width it commands. Only recently, DNA research has revealed its important historic role as a parent of the Damask rose.

to emerge. When the seedlings grew and blossomed, Bowles singled out *R. elegantula* 'Persetosa' for praise as the most desirable rose for the garden.

The word *persetosa* means 'accidental' or 'by chance', and the discovery of the species was certainly a happy accident. It turned out to be 'an elegant little rose', as the first part of the name implies. The deeply cut leaves give a filigree effect, the petite lilac-blush flowers have golden centres and they are held erect on slim wiry stems coated with red bristles. For those engaged in pressed flower work, this is considered the only rose that can satisfactorily be pressed in its entirety.

The formidably named species *R. fedtschenkoana* [Cinnamomeae] is an important rose ancestor. It carries small, flat white flowers with attractive yellow stamens on vigorous arching stems, which are covered with small bristles. The leaves have a pronounced greyish tinge. Blooms appear sporadically until late autumn, making this one of the longest flowering species. Its prolonged blooming means *R. fedtschenkoana* is of great value as a garden plant, though allowance must be made for its tendency to sucker freely.

A native of central Asia to western China, and especially prevalent in Turkestan, it was named after a family of Russian botanists, Alexei, Olga and Boris Fedtschenko. Olga is said to have found it about 1875. Perhaps if it been given the simpler and more lyrical name of *R. olgae*, more gardeners would have been drawn to it.

The pungent floral scent of *R. foetida* [Pimpinellifolia] has been likened to that of the leaf maggot found in soft fruit and akin to that of bedbugs. The botanical name conveys an equally distasteful message, in contrast with the common names Austrian Briar and Austrian Yellow. The yellow petals of this rose are as bright as any in the world of roses, and they open wide on chocolate brown stems in early spring with an accompaniment of light green foliage.

Mentioned by Arabic writers in the twelfth century, this rose may have reached Moorish Spain via North Africa in the thirteenth century, but 300 years passed before its first mention in England. Why so remarkable a rose took such a long time to be disseminated can be explained by its low fertility. One theory holds that it was never truly wild in the first place, but originated as a natural hybrid between two other species.

In its Asian homelands *R. foetida* is said to be used for jam making. In Pakistan it is planted in apple orchards as an early warning sign of mildew, to which it is highly susceptible. If the roses show signs of trouble, it is time to spray the fruit.

A well-known close relative of *R. foetida* is *R. foetida bicolor* [Pimpinellifolia], commonly called Austrian Copper or Rose Capucine. This flamboyant rose appears to be a bud mutation of *R. foetida*, which it resembles except that the inside of each petal is a vivid shade of light orange-scarlet. This gives the 'bicolour' effect, which made it desirable to Arab gardeners in the twelfth century and has continued to ensure its popu-

ROSA GALLICA PUMILA, ROSIER D'AMOUR

This is the smallest form of the Gallica species, normally reaching only 12 inches (30cm) high and spreading freely by means of suckering. It is naturalised in Spain, Italy and central Europe, and the appeal of its pretty, scented flowers, large in proportion to the plant, led to its introduction in England by the plant nursery Lee and Kennedy in 1773. In France it became a nuisance because of its suckering habit, impeding the harvesting of crops and defying all attempts to remove it. The common names for Rosa gallica pumila *are Rosier d'Amour and Rose of Austria.*

larity. The mutating influence can be seen at work firsthand, for sometimes a flower contains both bicoloured and entirely yellow petals, and occasionally petals appear striped with both colours. The brilliant yellow and flame hues of modern roses derive from the Foetida strain.

R. gallica [Gallicanae] is of great importance in rose history, and is considered to have been the first rose cultivated in the western world. The petals retain their scent when dried, giving the rose a useful and valuable role as a cosmetic. It has also been used extensively for medicine, in food and as a symbol of religion and nationhood, and is admired for its intrinsic beauty.

R. gallica is hardy, withstands drought, and spreads by suckering freely, a good technique for survival in areas liable to be grazed. The plants are shrubby, bearing wide open flowers in shades of pink to light crimson. Although *gallica* means French – hence its common name of French Rose – the species may have originated in the Caucasus and then spread westwards across southern Europe. The name Rose of Provins is sometimes applied to it, but probably in error; the town of Provins near Paris was strongly associated with a cultivated form of *R. gallica* called 'Officinalis'.

It is used in vineyards across Europe (in much the same way as *R. foetida* in orchards) as an early warning system against mildew. Although the strain of fungus that attacks vines is different from the one that affects roses, the growers believe that if conditions favour mildew, the roses will show symptoms first.

R. gigantea [Chinensis] lives up to its name, extending as high as 90 feet (27m) in optimum conditions. It thrives in the humid climates of Burma, Laos and Assam, usually in remote forested valleys where it reaches for the light and dominates its neighbours by thrusting up long purplish canes armed with strong hooked prickles. It has big shiny leaves, deep red when young, opening to a rich glossy green.

More significantly, the flowers of *R. gigantea* are very large for a species rose, capable of reaching 6 inches (15cm) across. Opening from elegant long buds into beautiful wide, silky petalled blooms with a refreshing tarry scent, they flower intermittently over several months. In his book *The Plant Hunter*, Frank Kingdon Ward gave this description of *R. gigantea*, which he spotted in 1948 near Manipur in Assam: 'The chubby leaves, still soft and limp, were a deep red; the slim, pointed flower buds a pale daffodil yellow; but when the enormous flowers opened they were ivory white, borne singly all along the arching sprays, each petal faintly engraved with a network of veins like a watermark…The globose hips look like crab apples. They are yellow with rosy cheeks when ripe, thick and iron hard…' He found the fleshy hips on sale in the town's bazaars.

R. gigantea plants are also found in western China where they show more variety in their flowers, which can be yellow, white and sometimes pink. They combine four important characteristics in one plant, namely vigour, fragrance, colour variation and a long period of flower. This beautiful species is

ROSA GIGANTEA

This beautiful though tender rose has very large flowers, and the plants grow to such a size in remote Burmese valleys that an army officer, Sir Henry Collett, recalled looking through his field glasses and seeing a plant over a mile away. In ancient times shorter growing forms of Rosa gigantea *in western China hybridised with other local species and thus became important ancestors of today's repeat blooming roses.*

thought to have given rise to the Chinese garden forms through interbreeding with *R. chinensis* var. *spontanea*, or with hybrids of that rose. These two species, more than any others in the world, have influenced the development of roses. From them descend the Chinas and the Teas, the Bourbons and Noisettes, the hybrid teas and floribundas and thus the great majority of garden roses growing in the world today.

One of the rarer pleasures of horticulture is an opportunity to name a beautiful flower after a loved one. E. H. Wilson took his chance in 1900 when he found the climbing rose *R. helenae* [Synstylae], native to central and south-west China, and named it in honour of his wife. When it flowers during summer, this is one of the most spectacular of all wild roses, producing myriads of scented creamy white blossoms with noticeable yellow stamens in umbrella-like heads. Dark green leaves show up the flowers to advantage and help to make *R.helenae* a splendid garden plant.

R. hemisphaerica var. *rapinii* [Pimpinellifoliae] resembles *R. foetida*, except that its yellow flowers are not as bright, the prickles are hooked or curved rather than straight, and the scent is not unpleasant. It was discovered many years after the full-petalled *R. hemisphaerica*, which is derived from it, had become known in Europe. This is why it is botanically described as a variety of *R. hemisphaerica* rather than being accorded its true status as a species. It makes a bristly shrub up to 5 feet (1.5m) tall, and occurs in dry places, often by road-sides, from Turkey through Armenia and Iran. It is also found in cultivation within and beyond that range, but it is a difficult rose to establish in cool damp climates.

R. kokanica [Pimpinellifoliaeis] is rather a mystery and many books pass it by, but since it is one of the rare deep bright yellows, it merits some attention. It occurs on rocky slopes in remote regions of Afghanistan, Pakistan and across the frontiers of central Asia, bearing flowers of moderate size in early summer on 6ft (2m) plants with reddish stems and aromatic leaves. The flower petals show a tendency to curl back. It needs warmth to flower freely, sometimes failing to bloom at all following cool summers.

One theory is that *R. kokanica* is a parent of *R. foetida*, and if that were shown to be true, it would have an honoured place in the history of the rose as the precursor of all the deep yellow and flame roses of the present day. Another source believes it is related to *R. xanthina* – however unlike *R. kokanica*, which is a martyr to blackspot, *R. xanthina* is resistant to the disease. *R. kokanica* is said to have been introduced to Europe by Jelena de Belder, but there is no date given in any of the rose texts. The reason for the name is obscure; perhaps it is based on a local place in its native habitat.

By contrast, the history of *R. laevigata* [Laevigatae] is well documented. A Chinese herbal of 1406 AD depicts the rose, under the name 'Jin Ying Tzu', meaning 'Golden Cherry' with reference to the hips. It was brought to Europe about 1698 and

ROSA MOYESII

In a sizeable garden this healthy rose and several similar forms can be relied on to provide interest and colour, though in time they become bare at the base and need shorter screening plants in front. The rich wine-red flowers appear in midsummer, and superb pitcher-shaped hips follow. Among the best seedlings derived from it are 'Geranium' with larger hips, 'Sealing Wax' with very bright hips though its blooms are pink, and 'Wintonensis', outstanding for the quantity of hips it produces. R. moyesii *was used by Pedro Dot of Spain to produce 'Nevada', one of the finest shrub roses of modern times.*

subsequently introduced to the United States. In the southern states it became naturalized and spread out of control to the extent that it was called 'one of the unsolved problems of plant introduction'. A specimen in Florida grew to cover 10,000 square feet (910 sq m.). In spite of this it won the hearts of the people of Georgia, who chose it, as the Cherokee Rose, to be the emblem of their state. Its other common names include Camellia Rose and Mardan Rose.

Undoubtedly this vigorous climber is one of nature's loveliest roses. The large, scented white blooms have a waxy sheen on the petals, and golden stamens enhance their beauty. They appear in early summer, followed by bristly orange-red hips. Like many Chinese roses, *R. laevigata* finds a home in rocky places and by streams, and can clamber up to 15 feet (5m) or more. Its Latin name means 'polished smooth', with reference to the lustrous dark leaves, and often it bears three leaflets in the leaf, which is rare in species roses.

Also named for its foliage is the species *R. macrophylla* [Cinnamomeae], which means 'large leaves' (although they are not especially large). It was introduced in 1818 from the Himalayan region, where it grows in scrub and open forests. In cultivation it makes a substantial shrub up to 15 feet (5m) high, though in the Botanic Garden at Cambridge one specimen reached 18 feet across and 25 feet high (6 x 9m). The stems are smooth and purplish, and the flowers bloom rather late, in midsummer, in varying shades of pink . Its chief glories are the hips, described as 'little scarlet bottles' with star-shaped sepals standing out behind them. They are numerous and delicious enough to be harvested in its native haunts for jams and jellies.

Another rose that takes its name from the character of its foliage is *R. minutifolia* [Hesperrhodos], the smallest and rarest species rose. It is also called Tiny-leaf Rose. Pink or white flowers barely an inch (2cm) in diameter appear on bushes about 3 feet (1m) high, clothed with small greyish-green jagged leaflets. Its habitat is restricted to a limited area in San Diego County in the United States and Baja California in Mexico. Here it has adapted in an extraordinary way to a climate and soil unfavourable for roses, by remaining dormant during the summer and coming into bloom through the fogs and rains of winter. Although cultivated since 1910, it is not an easy rose to grow. It is tender, and in a climate other than its own it has very specialised needs that would be difficult for most gardeners to meet.

Unlike the fragile and fleeting *R. minutifolia*, the robust *R. moyesii* [Cinnamomeae] grows to dimensions of 12 feet x 10 feet (3.6 x 3m) on strong sweeping stems. The flowers appear in midsummer close to the stems and are remarkable for their colour, a rich wine red rarely seen in species roses, with prominent creamy stamens in their centres. A fine crop of large pitcher-shaped red hips follows in the autumn.

This splendid species rose from China was discovered by the botanist E. H. Wilson, and it was subsequently named by him as a compliment to the Rev. J. Moyes of the China Inland Mission, who acted as Wilson's host during one of his visits. The rose world owes a lot to Christian missionaries in China. Their discoveries have included *R. davidii*, *R. hugonis*, *R. sericea* and *R. soulieana*.

The name of *R. mulliganii* [Synstylae] commemorates Brian Mulligan, the assistant to the director of the RHS Gardens at Wisley, England. He had received the seed from the plant hunter George Forrest who collected it in Yunnan, China in about 1919. This is a fine rose, though there is much confusion between it and a similar species often sold as *R. longicuspis*, which some say is truly *R. mulliganii*.

It is a very vigorous climber, producing arching stems well covered with shiny dark leaves, which are ideal for covering a trellis. Viewed from within a pergola it makes a beautiful sight after midsummer, when hundreds of hanging clusters of saucer-shaped milk-white flowers with silky textured petals can be seen from below. This experience ranks as one of the magical moments in the rose world.

Another very attractive species is *R. multibracteata* [Cinnamomeae], bearing petite, star-shaped rose-lilac flowers with yellow stamens, both along the arching branches and in small clusters. They appear for several weeks in summer against a background of tiny, greyish serrated leaflets. Below each flower are even smaller modified leaves, which give the plant its Latin name, meaning 'many bracts.'

The Latin name of the pleasantly scented *R. multiflora* [Synstylae] means 'many flowers', and the Japanese name 'Noi-bara' means 'field rose'. The cone-shaped panicles of bloom are so abundant that on established plants their florets are uncountable, for some will fall and others open before the task is done. An old name for this rose is Bramble-flowered China, and at a casual glance it can be taken for a bramble. When the summer display is past, the plant looks coarse and uninspiring, becoming a thicket of interweaving prickly stems with dull foliage and unappealing hips.

It occurs naturally in Japan and Korea, in the hills, on the plains and in rocky areas near streams. It adapts well to other soils and in the United States has been widely used for hedging and as a wind and cattle break, being reputedly 'horse high, bull strong and goat tight'. *R. multiflora* was described and named by the Swedish botanist Thunberg, who studied the flora of Japan in the late eighteenth century, but the species did not reach Europe before 1860, a surprisingly late date since

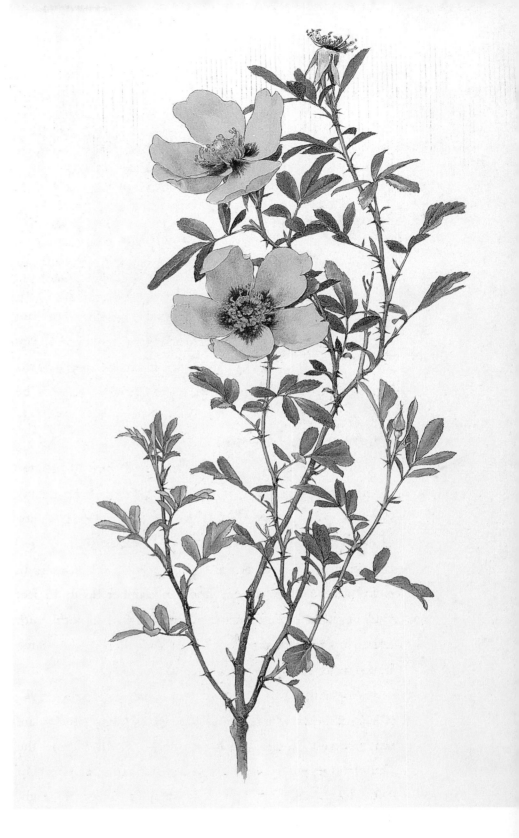

ROSA X HARDII

Julien-Alexandre Hardy raised this from seed of R. clinophylla, *and the 'red eye' seen at the petal bases means that the other parent had to be* R. persica, *because it was the only rose with this feature. The outcome sparked a debate among French raisers about the importance of cross-pollination in obtaining new varieties. When Hardy asked the Cels nursery to introduce it in 1835 they regarded it as such a wonder that they priced it at 25 francs instead of the normal 3 francs. It makes a rather lax plant with spindly stems, and needs warmth and well drained soil to thrive.*

cultivated forms of *multiflora* had been current in Europe long before. Another botanist then named it *R. polyantha*, which means the same as *multiflora* in Greek. The original Latin name was preferred but the Greek term survives as the class name of a group of roses derived from it.

R. nitida [Carolinae] is a native of eastern North America, able to survive in conditions not usually promising for roses, such as wet thickets, near ponds and on acid soil. The word *nitida* means 'shining', and describes the effect created by the ample covering of narrow, bright reddish-green leaflets on this low spreading plant. In autumn the leaf colour deepens to display brilliant red-brown tints. The flowers in summer are bright rose pink with a hint of mauve, and carry a light lily-of-the-valley scent. Small red hips shaped like currants follow in the autumn. It has been cultivated since 1807 and is excellent in the garden for the front of a border and near water features.

As its common name suggests, *R. palustris* [Carolinae], the Swamp Rose, also thrives in moist areas. It grows in damp and swampy ground, from Nova Scotia to Florida and further west. The flowers are pink, appear in early summer and are carried on smooth purplish-green stems. Introduced to gardens as long ago as 1726, it is no longer commonly cultivated.

Introduced even earlier was *R. pendulina* [Cinnamomeae]. Although it has been cultivated since 1683, and selected dwarf forms have been known since 1815, this is not often seen in gardens. The flowers vary in colour, from light pink to reddish purple. They appear in summer on slender, smooth purplish stems. The plants often spread by suckering, and inhabit mountainous regions of central and eastern Europe, where they are a common feature near wood margins, alpine scrubland and meadows. One of its common names, Alpine Rose, refers to its native habitat. The other common name, Drop Hip Rose, and its Latin species name refer to the way the bottle-shaped red hips hang down from the stem.

R. persica (*Hulthemia persica*, *R. simplicifolia*) [Simplicifoliae] grows in Iran, Afghanistan and adjacent lands, where it spreads itself by suckering over large areas of dry stony ground. In some areas it comes up in cornfields and is gathered for use as firing after the crop is harvested. Unlike all other roses, it has leaves that are 'simple', which means they are not divided into leaflets. Moreover they emerge directly from the stem that bears them, without the connection of a stipule or leafstalk. Their bluish green colour and the wiry, gooseberry-like stems are most unusual among roses. Its thin sharp prickles recall those of the berberis or barberry, hence its common name Barberry Rose. The most eye-catching features are the flowers, which are brilliant yellow, with a deep red patch at the base of each petal. It is the only wild rose with this colouring.

This horticultural treasure was introduced to Europe in 1788 but it has often proved elusive in cultivation because it does not respond to normal methods of propagation, such as budding, grafting, slipping or transplanting. Even growing it

ROSA RUGOSA, JAPANESE ROSE

This mauvish Rugosa is considered the 'type', or original form. It is pictured here as No. 42 in a series of ninety hand coloured etchings of roses which appeared between 1796 and 1799 as A Collection of Roses from Nature, *produced by Miss Mary Lawrance (fl. 1794–1830).* R. rugosa *was a novelty, having been introduced by Lee and Kennedy of Hammersmith, London, in 1796, and Mary Lawrance titled it 'Rosa ferox, Hedge-hog Rose' – Hedgehog Rose being one of its common names. The intense colours in this illustration are due to the artist's stippling technique.*

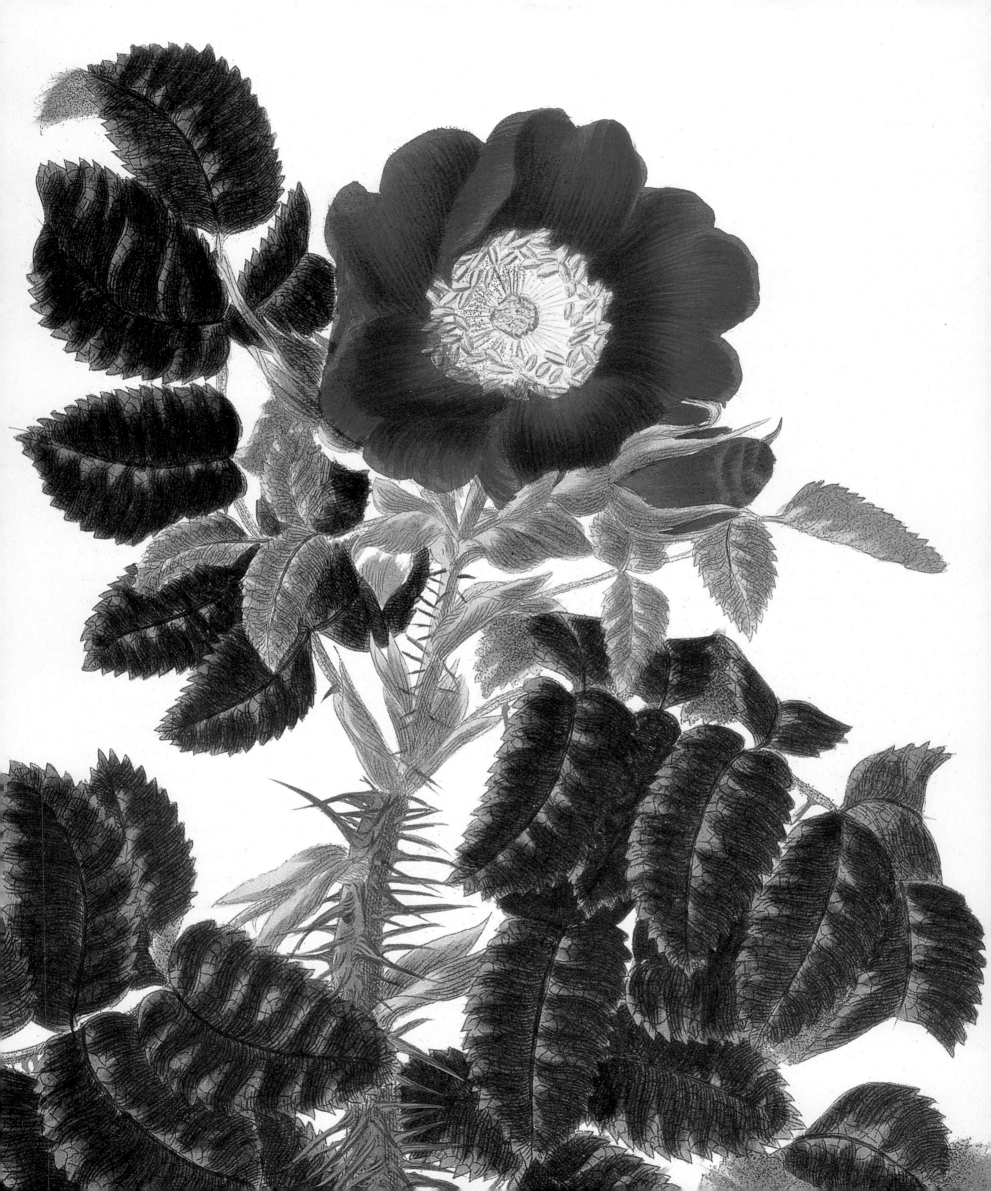

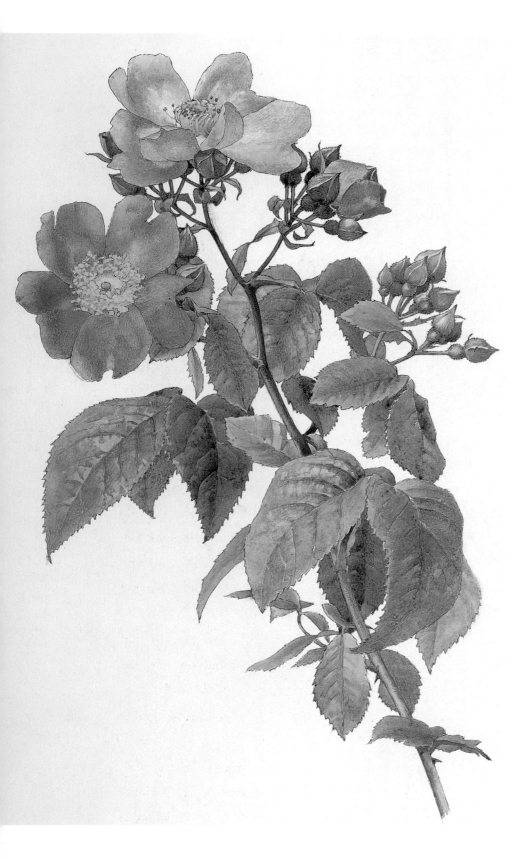

ROSA SETIGERA, PRAIRIE ROSE

This is the only climbing rose native to North America. Its beauty and vigor inspired Samuel and John Feast of Baltimore in the 1840s to raise varieties from it that could withstand severe winters. Dr. Van Fleet used it to produce 'American Pillar', still widely grown after a century in commerce.

from seed is difficult. It can be successful in an airy unheated greenhouse where there are opportunities for its roots to run. The hybrid *R.* x *hardii* was raised in the 1830s, and four hybrids by Jack Harkness in the 1980s. The potential of its unique colouring and other features are now well recognised, and several breeders have made use of it.

The hardy species *R. pimpinellifolia* (*R. spinosissima*) [Pimpinellifoliae], known as the Burnet Rose or Scots Rose, is found from Ireland through central and northern Europe to the Caucasus and central Asia. Sweetly scented flowers with prominent golden stamens appear in early summer, showing up against small dark leaves. These are followed in autumn by large round hips that are deep purple, almost black. This rose is especially noticeable in coastal areas, where a creeping, suckering pattern of growth enables it to survive the hazards of storms and poor soil. In normal growth conditions it can grow to 4 feet (1.2m)

The flowers are normally creamy white, but light yellow, pink and purplish tints are also known, and from them many selected forms were introduced during the years from 1790 to 1830. The leaves look like those of the salad burnet, the Latin for which is *pimpinella*. Its previous Latin name, *spinosissima*, refers to its prickliness. *R. pimpinellifolia* and its forms are important ancestors of some shrub and climbing roses, among them 'Golden Wings', 'Frühlingsgold' and 'Maigold'.

The botanist Georges Boulenger who described *R. primula* [Pimpinellifolia] is said not to have seen a flower of it, but named it *R. primula* because its colour was reported to him as 'pale primrose'. Its common name is Incense Rose because of the heavy scent, redolent of calfskin leather, that wafts from the leaves, each with up to fifteen polished narrow leaflets. Native plants are found in Turkestan and northern China, reaching up

to 6 feet (3m) on good soil, or as little as 2 feet (60cm) where survival is a struggle. Though known earlier, *R. primula* did not come into cultivation until 1910, when the American botanist F. N. Meyer collected seed from Samarkand and sent it home.

Few species come as close to satisfying the gardener's demands as *R. rugosa* [Cinnamomeae], which boasts no less than seven common names: Hama-nashi, Hama-nasu, Hedgehog Rose, Japanese Rose, Kiska Rose, Potato Rose and Ramanas Rose. Its ancient haunts are open coastal sites in China, Korea, Siberia and Japan, where it spreads by suckering and covers itself with handsome leaves. Unlike the leaves of other roses, they are deeply wrinkled, which is what the word *rugosa* means, and they are covered in fine hairs, making it hard for fungus spores to anchor.

There are mauve pink, white, and purplish forms, and in early summer the first clove-scented flowers open wide, showing creamy yellow stamens. Historically the petals were mixed with camphor and musk and used for perfume. A feature of Rugosa not matched by other species is that hips and flowers are seen on the plants together at the same time due to its long flowering period.

The hips are large, shaped like small tomatoes and said to be one of the richest sources of vitamin C, containing weight for weight sixty times as much as oranges or apples. The Japanese likened them to aubergines (*nasu*) and pears (*nashi*). The Swedish botanist Thunberg who visited Japan in 1784, called it 'Ramanas', which is probably a misunderstanding of the spoken Japanese term *Hama-nasu*.

It is a mystery why the Rugosas did not immediately find a market when first introduced to Europe in the 1790s. They were re-introduced in the mid nineteenth century with more success. The Rugosas are excellent in the garden, especially improved forms such as *R. rugosa* rubra and 'Scabrosa', and many of the hybrids retain the disease resistant foliage of the original species rose.

The rather tender species *R. sempervirens* [Synstylae], commonly called Evergreen Rose, is found in Mediterranean regions and bears lightly scented white flowers, either singly or in small clusters, for several weeks of summer. It hybridises fairly readily with other species in its range, such as *R. gallica* and *R. arvensis*, so that forms vary according to locality. The stems have few prickles and are well covered with long glossy leaflets. As the name indicates, they persist through the winter months. *R. sempervirens* has long been cultivated, and was described in 1623. In the 1820s Antoine Jacques used it to create several excellent climbers.

Also bearing white flowers is *R. sericea pteracantha* (*R. omeiensis pteracantha*) [Pimpinellifoliae], which means 'silky rose with winged thorns' – hence the common name Winged Thorn Rose. The silkiness refers not to the blooms but to fine hairs beneath the small fern-like leaflets. Most eye-catching though are the huge translucent reddish prickles, best seen on young stems with the sun shining through them. Another curious feature is that the flowers often have four petals, unlike other roses that typically have five petals.

This rose was one of over a thousand plants new to horticulture collected by the Jesuit father Jean-Marie Delavay (1834–95) during his many years of mission work. He found it in flower in the Mount Omei region of western China and returned there in 1887 to gather hips, which he sent to France. The resulting plants were introduced in Europe in 1890.

The handsome rambling species *R. setigera* [Synstylae] is found in Ontario and parts of the USA, and its deep rose-pink flowers provide an attractive and colourful display in mid to

late summer. They flourish in clusters against a background of trifoliate light green leaves, which turn attractive shades of yellow-orange in autumn and are accompanied by clusters of small round orange hips. It is a plant of fields and roadsides, and the long slender shoots can travel several yards, rooting themselves where they touch the ground and creating a tangle of growth. Commonly called Prairie Rose or Bramble Leaved Rose, its Latin name *setigera* (meaning 'bearing bristles') also refers to its prickly character. It was introduced into Europe about 1800 and Empress Josephine received it for planting at Malmaison in 1810.

Yet another French horticultural find was *R. soulieana* [Synstylae]. The name commemorates its discoverer, Père Jean Soulié, who collected seed from the plant's habitat in the rocky upland regions of Sichuan and Tibet. He sent the seed to France about 1895, but ten years later he suffered a cruel death at the hands of Chinese bandits in the troubles of 1905. The rose was described and named for him by the botanist Crépin. Its greyish green foliage forms a pleasing background to clusters of creamy yellow buds, which open around midsummer into scented, cupped white flowers. Understandably it is prized for its ornamental beauty.

The New Mexico native *R. stellata* [Hesperrhodos] is considered a primitive form of rose, with deeply cut foliage and springy wiry stems that give rise to its popular name of Gooseberry Rose. The flowers are a deep rose-purple with dusty yellow stamens in the centre. *Stellata*, meaning star shaped, refers to the coating of fine stellate hairs on the bark. A related form, the beautiful and unusual *R. stellata mirifica* [Hesperrhodos], grows near the Grand Canyon in Arizona, in Texas and in the Sacramento mountains of New Mexico, from where seed was sent to Kew Gardens in 1917. It is commonly called Sacramento Rose, while its Latin name *mirifica* means 'wonderful'. This name indicates that it is generally superior in growth and colour to the species *R. stellata*, which it resembles except that it does not have the stellate hairs. In 1997 Louis Lens of Belgium introduced the deep lilac shrub rose 'Pink Mystery' as a result of crossing *R. stellata mirifica* with a seedling of *R. bracteata* x *R. nutkana*.

Known as the Apple Rose on account of its prolific dark red hips, *R. villosa* (*R. pomifera*) [Caninae] grows wild through central Europe and west Asia, and has become naturalised elsewhere. The flowers are a clear shade of pink with crinkly petals, and they are carried against a background of greyish downy leaflets, which give the plant its name *villosa*, meaning 'soft-haired'. Parkinson wrote in 1629 that 'The whole beauty of this plant consisteth more in the gracefull aspect of the red apples hanging upon the bushes, than in the flowers, or any other thing'. Nevertheless it has been in cultivation since 1771.

Found in east and mid-west North America, *R. virginiana* (*R. lucida*) [Carolinae] is the prettiest of the American wild roses, and the first to be mentioned in European literature, in John

ROSA STELLATA, GOOSEBERRY ROSE

This beautiful species is native to mountain areas of New Mexico, and belongs to the primitive Hesperrhodos subgenus. It makes a low thicket with needle-like prickles and its common name of Gooseberry Rose arises from the appearance of the stems and leaves. It has been cultivated since 1902, and both it and its near relative R. stellata mirifica *deserve to be more widely known.*

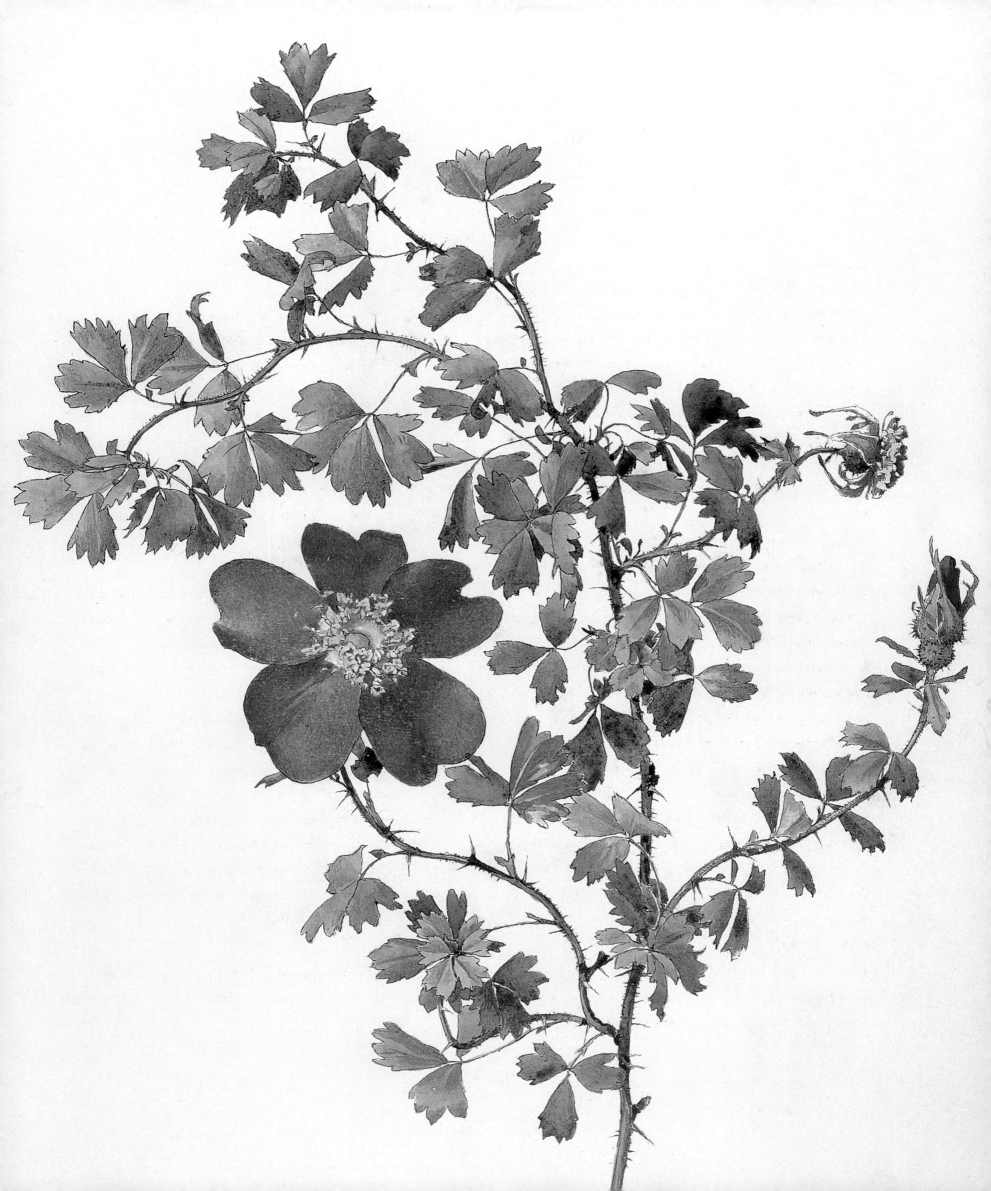

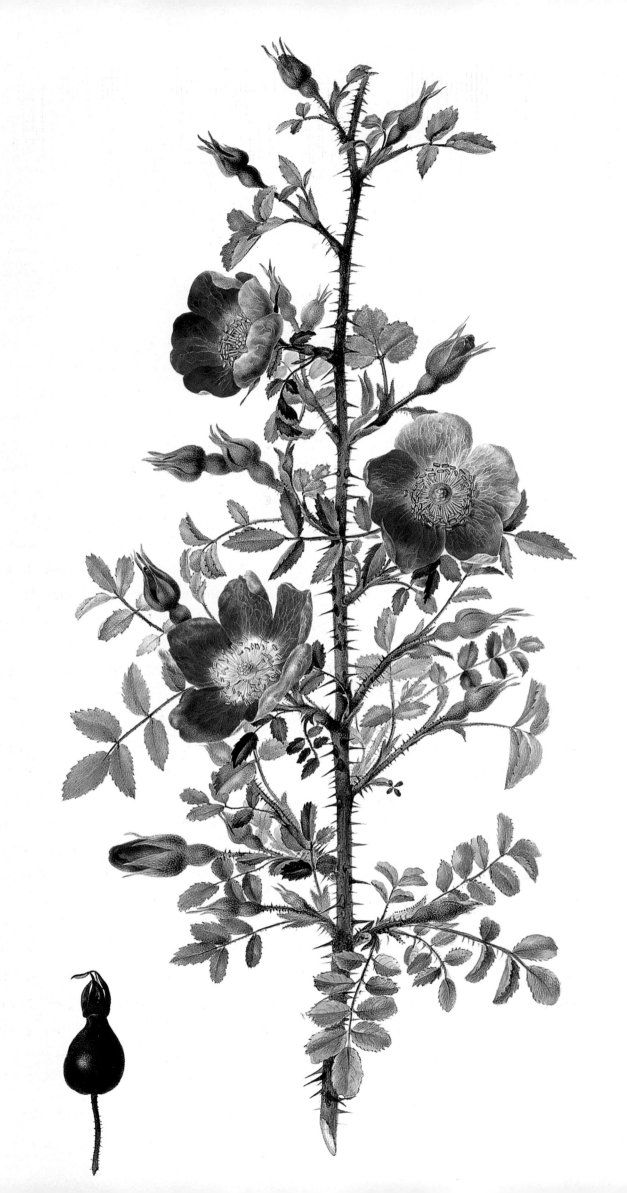

Parkinson's *Theatrum Bonicum* [Theatre of Plants] of 1640. It was sent from Virginia to Europe in 1724, hence its common name Virginia Rose, and soon won favour for its garden value. It makes a graceful plant with slender reddish stems bowing under the weight of foliage to create a dense, leafy effect. The leaves are shiny (which inspired the older name *lucida*) and display pretty red and yellow tints in autumn. Cerise-pink flowers appear in mid to late summer and continue for several weeks followed by bright ruby coloured hips.

As an ancestor of rambling roses, *R. wichurana* (*R. luciae*) [Synstylae] is important in the story of rose cultivation. It is native to Japan, Korea, China and Taiwan, and was named after Dr Max Wichura (1816–1866) who collected plant material in 1858 from an island off Hiroshima and sent it to the Botanical Garden in Berlin. The seeds were lost in transit, but a second attempt in 1880 was successful. In 1891 the rose reached the United States, where it was dubbed Memorial Rose because of its frequent planting in cemeteries.

The name *R. luciae* was originally given to a plant described by the botanist Père Franchet, who received it about 1870 from Dr. Savatier, a naval surgeon serving in Japan. Franchet named it after Savatier's wife, Lucie. Although considered distinct from *R. wichurana* at the time, *R. luciae* was eventually regarded as the same species. Both forms were used in the breeding of rambler roses, and gave rise to some of the rose world's most cherished ramblers, such as 'Albéric Barbier'

from *R. luciae* in 1900, and 'Dorothy Perkins' from *R. wichurana* in 1901. A century later, *R. wichurana* is being used with wonderful results for shrub and ground cover roses. Its creeping stems can extend as far as 20 feet (6m) and root readily. The stems are armed with stout hooked prickles and furnished with small polished leaflets, against which clusters of white clover-scented flowers bloom in late summer. The Japanese name 'Teri Ha-No-Ibara' means 'shiny-leaved field rose'.

The dainty *R. willmottiae* [Cinnamomeae], with its tracery of slender stems, ferny greyish foliage, and deep lilac-pink flowers was named after Ellen Willmott (1858–1934), author of *The Genus Rosa*. This labour of love set out to describe and illustrate all the species, with stories of their discovery and history. It was completed between 1910 and 1914.

Thanks to research by Willmott, and others before and since, we have been able to trace the journeys of some of the most important species roses, from the wild into cultivation. Together these species have provided the genetic bases of the modern rose. Their diversity of colour, form, habit and adaptability to environment have all had a part to play. Yet there are many whose genes have never been harnessed in the quest for better roses. Species collections are maintained in several countries and it is vital that they continue to be preserved, for in many regions of the world the roses of nature face an uncertain future. We can only guess what they might still contribute to the ongoing evolution of the garden rose.

ROSA X *REVERSA*

Thought to be a natural hybrid between R. pendulina *and* R. pimpinellifolia, *this was introduced from the Matras mountains in northern Hungary and cultivated from about 1820. It makes an upright twiggy shrub, with leaflets and prickles taking after* R. pimpinellifolia *and purplish wood and nodding flower stalks after* R. pendulina. *The flowers pictured are reddish pink but there are paler forms. The deep red oval hips are plump and handsome.*

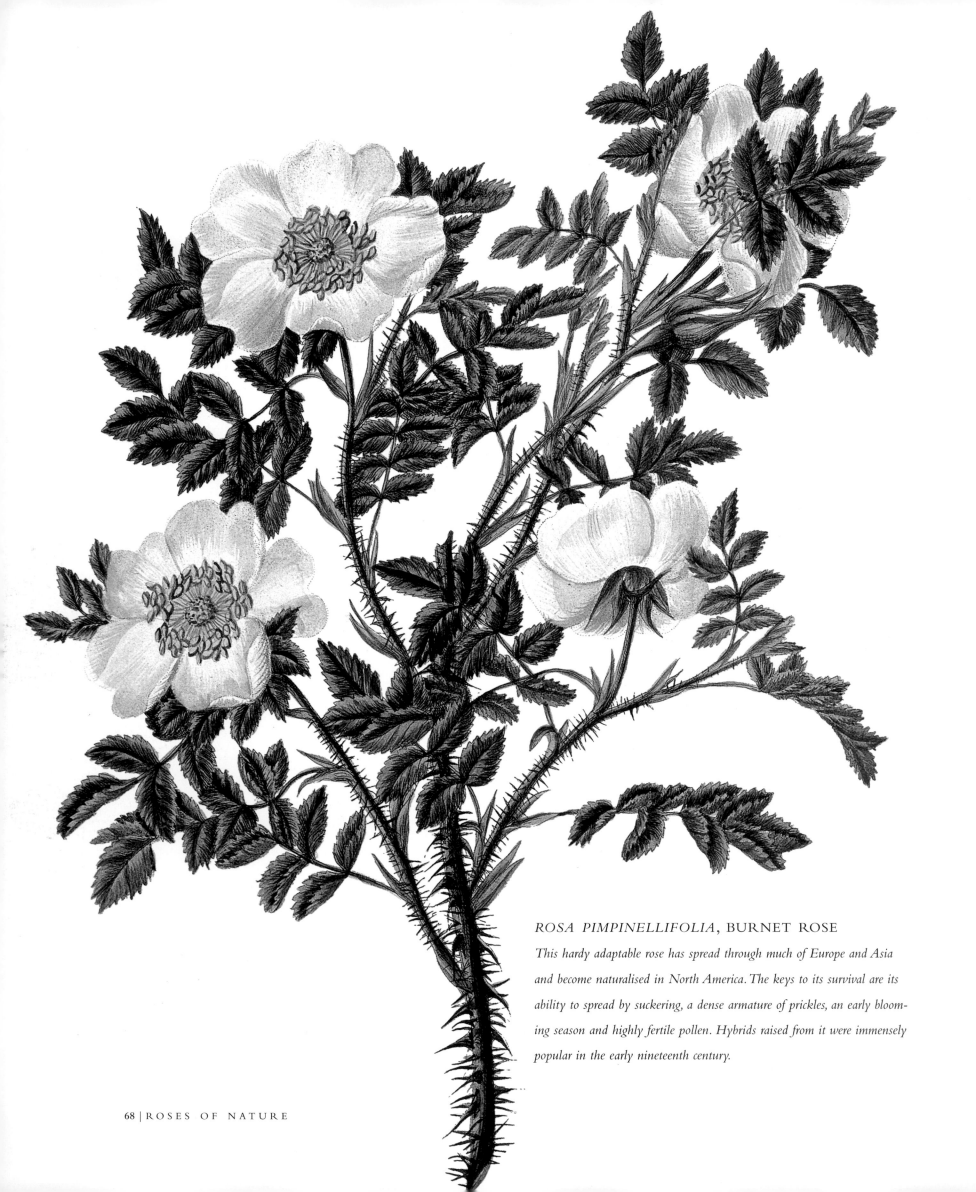

ROSA PIMPINELLIFOLIA, BURNET ROSE

This hardy adaptable rose has spread through much of Europe and Asia and become naturalised in North America. The keys to its survival are its ability to spread by suckering, a dense armature of prickles, an early blooming season and highly fertile pollen. Hybrids raised from it were immensely popular in the early nineteenth century.

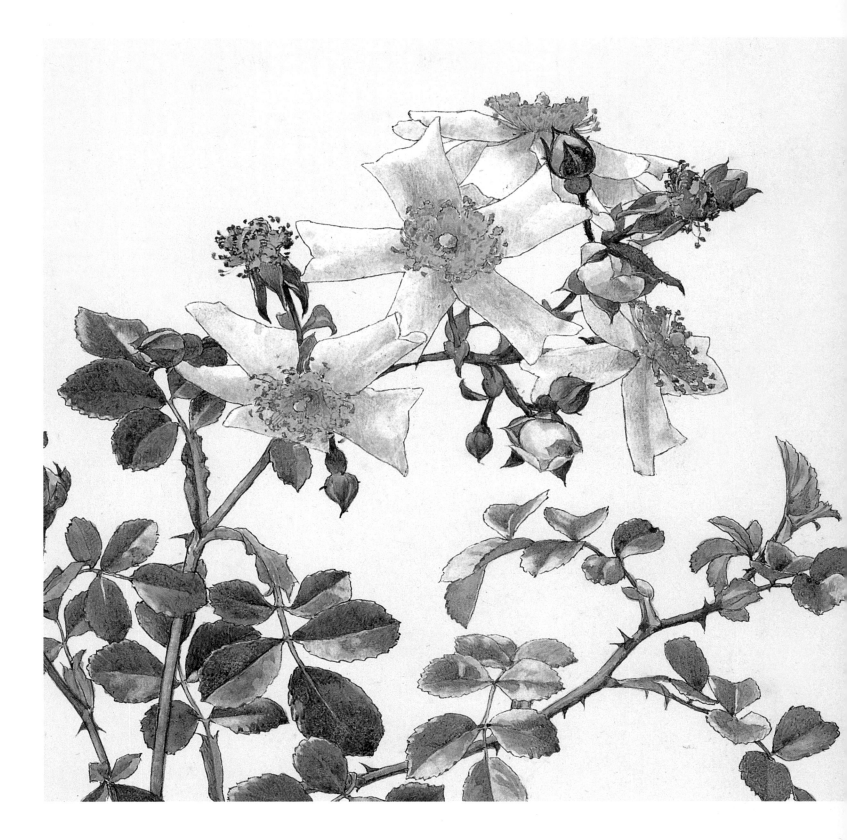

ROSA WICHURANA, MEMORIAL ROSE

This Far Eastern species is an important ancestor of ramblers and ground cover roses, many of which show its influence in their small, polished rich green leaflets. In mild climates it can be almost evergreen. Its small flowers appear after midsummer, and though individually lightly scented, collectively they create a wafting fragrance of clover. It is named after Dr Max Wichura, who was on a diplomatic mission to Japan when he found it and sent specimens to Berlin. He did not live to see it established in Europe, dying in 1866 at the age of 49.

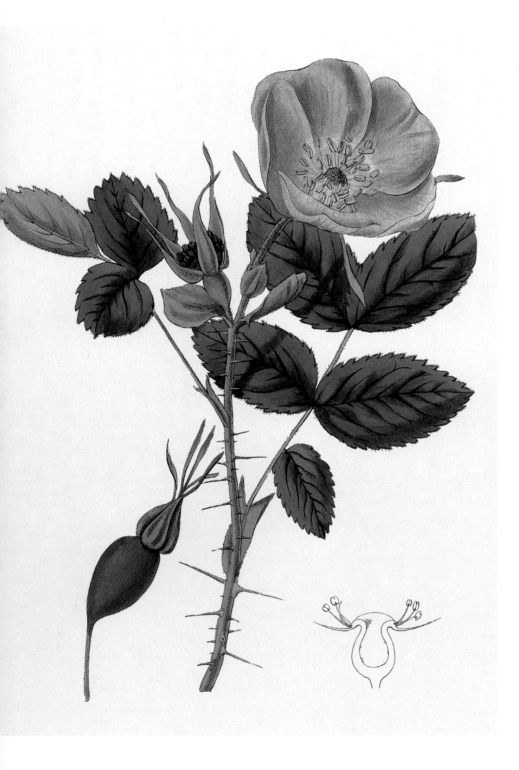

ROSA ACICULARIS, ALPINE ROSE

A drawing (left) by John Lindley shows one of four species named by him, in this instance with reference to the prickles, which are in the shape of needles. R. acicularis makes a lax shrub and the scented, deep pink flowers are succeeded by bright red pear-shaped hips. One of the hardiest roses of all, it is used in Siberia as a hedging plant.

ROSA ACICULARIS VAR. NIPPONENSIS

This form of R.acicularis (opposite) occurs in mountainous regions of Japan and was brought into cultivation in 1894. In garden conditions it makes a neat leafy shrub with purplish stems, growing to about 3 feet (1m). Because it has 14 chromosomes, breeders hoped it would prove an amenable parent in the creation of a race of hardy roses, but these expectations have so far been frustrated due to sterility in its seedlings.

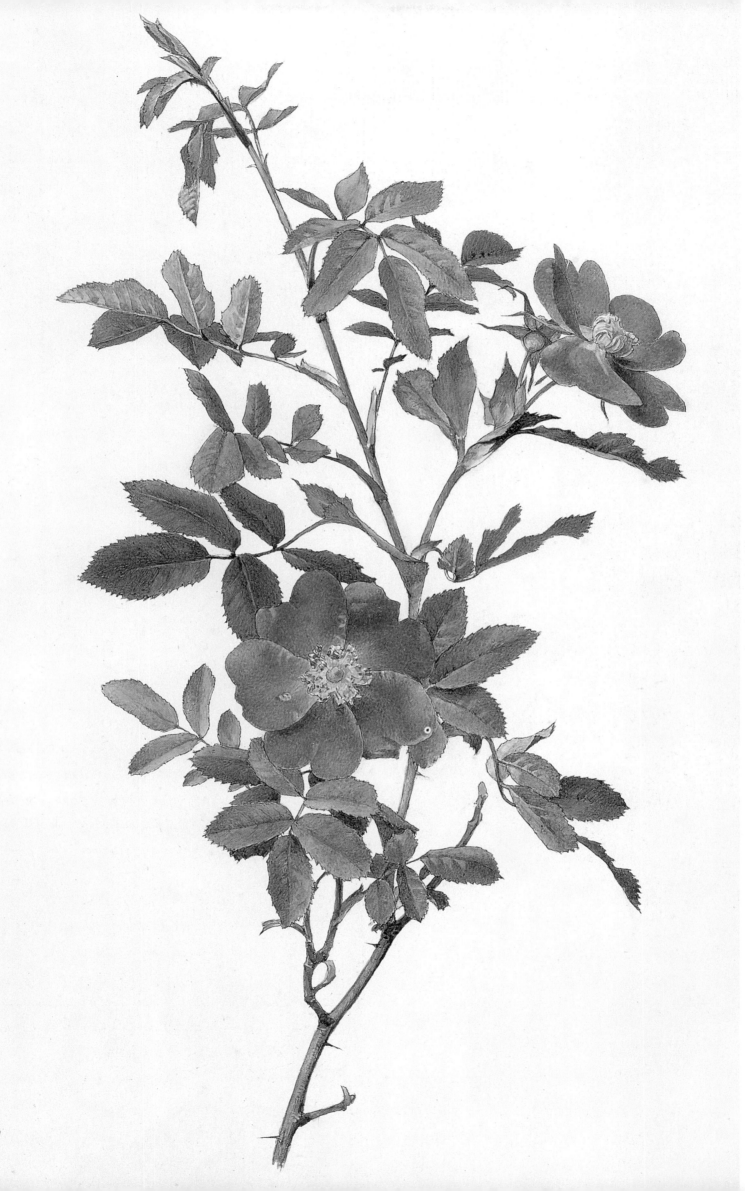

47

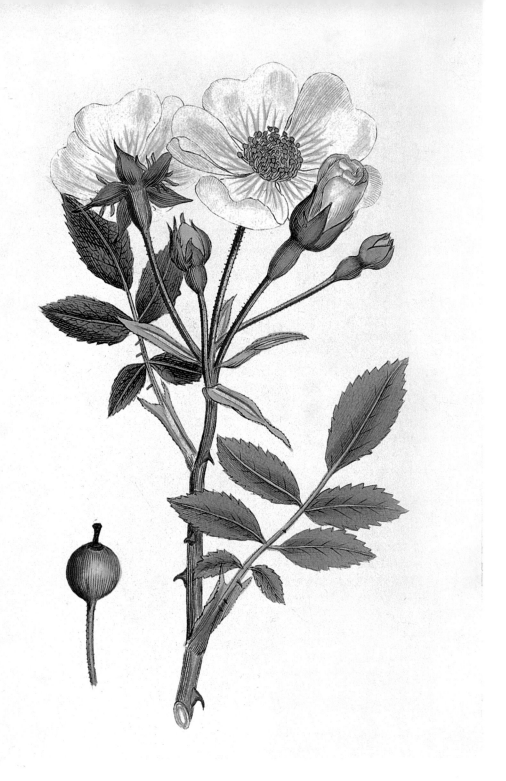

ROSA ARVENSIS, FIELD ROSE

It is interesting to compare how different artists depict the same rose. The illustration by James Sowerby (above)
exhibits careful botanical detail, whereas the plate (opposite) from Henry Andrews' Roses is presented with an eye
to overall display. Both artists show the fused column of pistils (or styles) in the centre of the flower, which define
R. arvensis *clearly as a member of the Synstylae section.* R. arvensis *is native to most of Europe.*

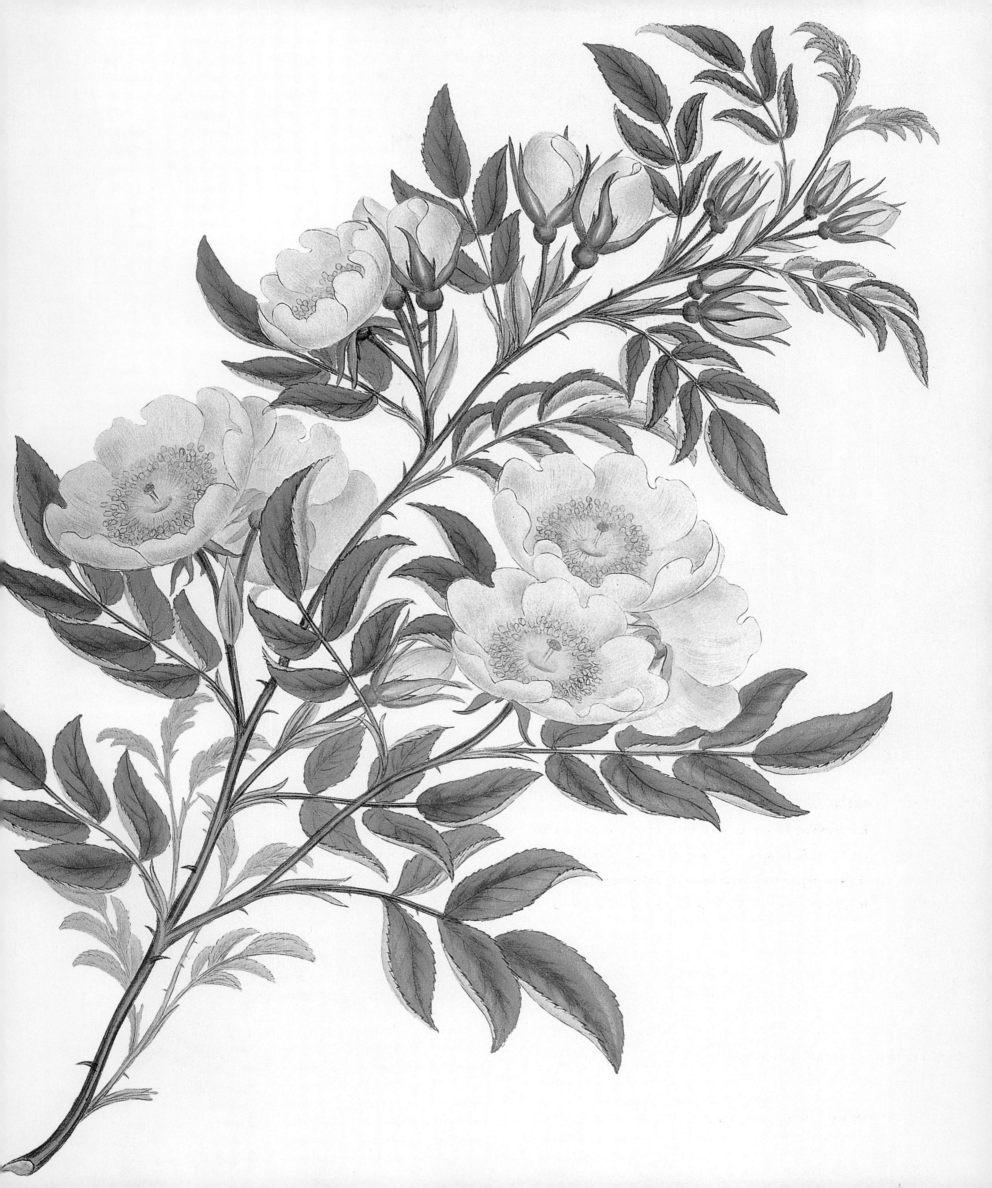

ROSA BANKSIAE NORMALIS, MU-HSIANG

This is the true prototype of the Banksian roses (above) as indicated by the use of the word normalis *in the botanical name. It is a spectacular sight in its native areas of central and western China where it can extend over 40 feet (13m). The visual and aromatic effects of its massed violet-scented blooms account for its local name 'Mu-Hsiang', which means 'wood smoke'.*

ROSA BANKSIAE ALBA-PLENA, DOUBLE-WHITE

This plate from Henry Andrews' book is titled Rosa Banksiae *(right), which was the correct name of this rose for much of the nineteenth century. It arrived in England in 1807 many years before the true species with five-petalled flowers was known there. Sir Joseph Banks sent William Kerr to China specifically to seek out new plants. This was an important find and was named in honour of Lady Banks. Its common names are Lady Banks Rose and Double White.*

Rosa, Banksiæ

ROSA BRACTEATA, MACARTNEY ROSE

This beautiful species (above & opposite) grows wild in dry sites in south-east China and Taiwan, and though rather tender it can be cultivated in cooler climates given a sheltered location. It has unusually large flowers for a species, some 4 inches (10cm) across, and bears them over a long period in summer and autumn. Its breeding potential has yet to be realized, the best effort so far being the yellow climber 'Mermaid' from William Paul's nursery in 1918.

Rosa Bracteata. *Rosier de Macartney.*

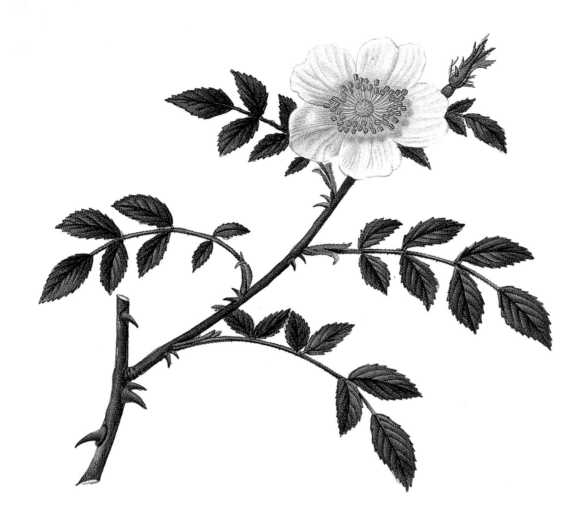

ROSA SEPIUM

R. sepium *(above) is related to* R. agrestis *and appears to be a natural hybrid between the Dog Rose and the Sweet Briar of which there were at least four forms current in France by 1824, and as many as nine subsequently identified. One had typically narrow leaves as seen here (hence the name Narrow Leaved Sweet Briar) and some had rose-tinted flowers rather than white ones. The French name 'Des Haies' is a translation of the Latin species name indicating its suitability as a hedge.*

ROSACEAE

Three wild roses commonly found in Britain (opposite) are the Dog Rose, which is especially noticeable in summer by country lanes and railway tracks, the Sweet Briar with its apple-scented leaves, most at home on chalk-based soil, and the Scots Rose, which prefers cliffs, heaths and sand dunes where its low cushiony shrubs run less risk of being overgrown.

Rosaceae

Sweet-briar.

Scotch rose
3.29

Dog rose
225.8

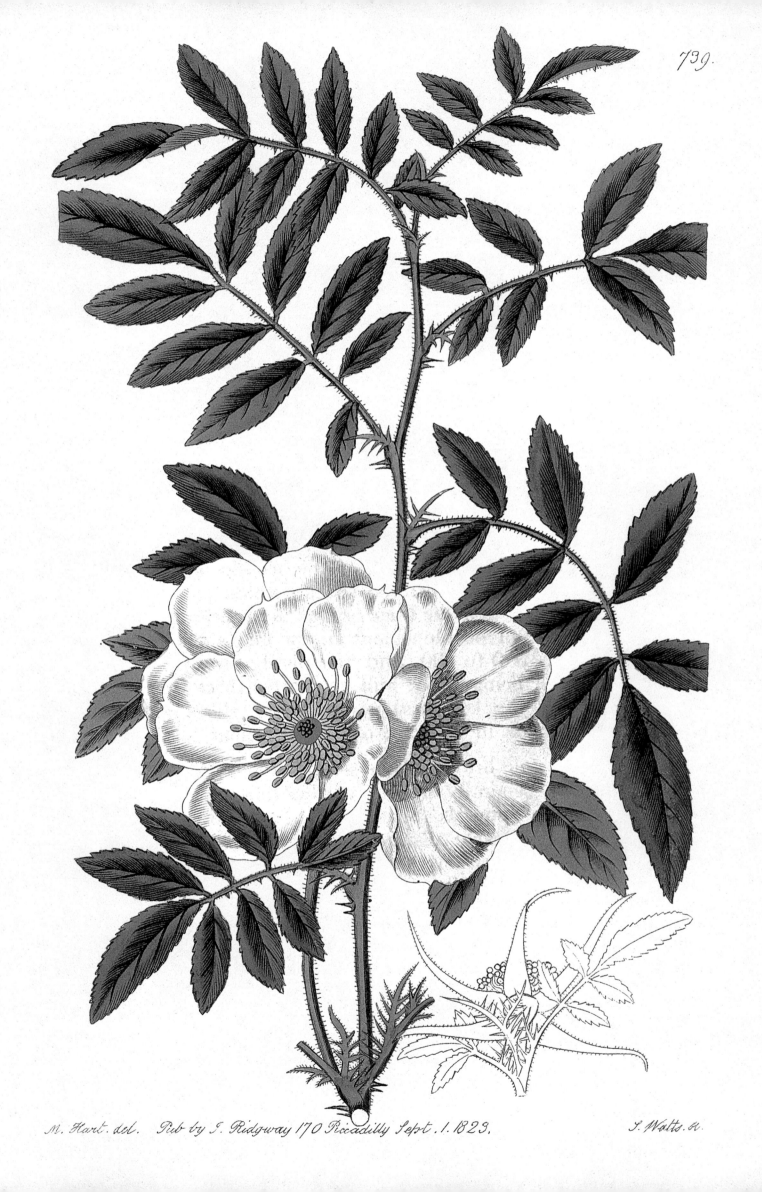

739.

M. Hart. del. Pub. by I. Ridgway 170 Piccadilly Sept. 1. 1823. S. Watts. sc.

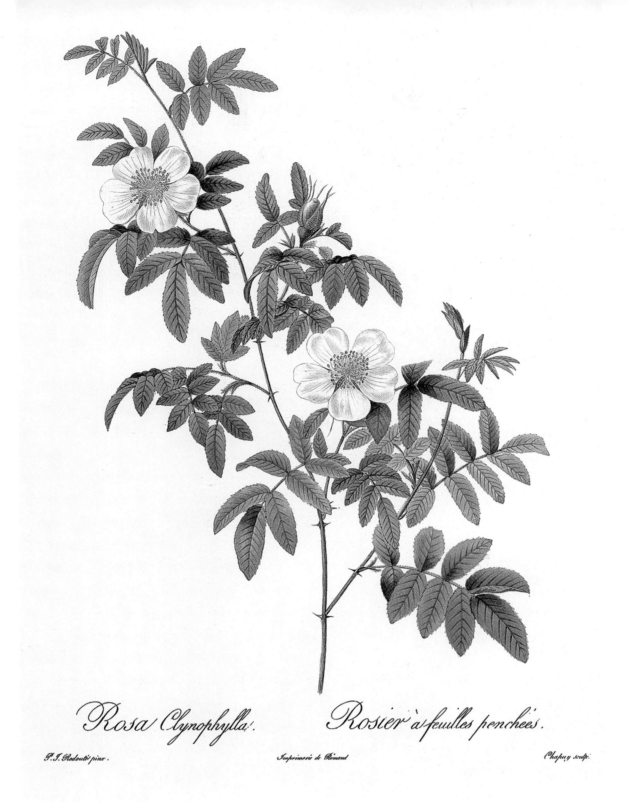

Rosa Clynophylla. *Rosier à feuilles penchées.*

P. J. Redouté pinx. Imprimerie de Rémond Chapuy sculp:

ROSA CLINOPHYLLA

The botanical name of this species means the 'leaves bend', and their bowing nature can be clearly seen in these illustrations, one from The Botanical Register *(opposite) and the other by the hand of Redouté (above). Mindful of the need for rose plants to be beautiful even when not in flower, Shri M.S. Viraraghavan of India has used* R. clinophylla *in hybridising, with the aim of bringing its lustrous evergreen foliage into modern roses.*

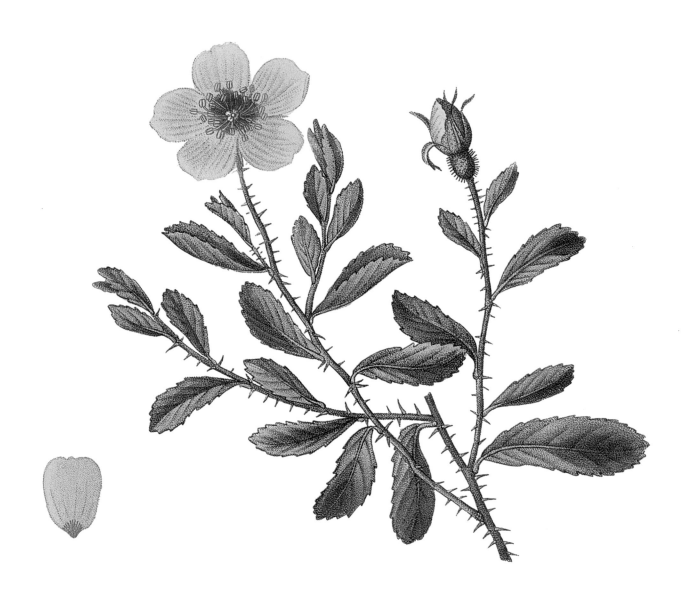

ROSA PERSICA, BARBERRY ROSE

This pretty species (above & opposite) is rare outside its native habitats, the steppe and desert regions of western Asia.

It is unlike any other rose in having a red eye at the petal base, simple leaves and no leaf stipules, factors which

caused botanists to put it in a Genus of its own as HULTHEMIA, named after the Dutch botanist

Van Hulthem. The standard reference book Modern Roses XI *still lists it as HULTHEMIA, but because it can*

hybridise with other roses there are strong grounds for regarding it as a rose.

ROSA EGLANTERIA & ROSA FOETIDA BICOLOR

The need for accuracy in naming becomes clear when viewing this pair of roses, both referred to as Eglantine roses. The vivid bicolour (opposite & overleaf) from western Asia, Rosa foetida bicolor, *has acquired more than half a dozen synonyms, including Eglantine, Austrian Copper and ' Rose Capucine.* Rosa Eglanteria *(above) commonly called Eglantine, is the native Sweet Briar of Europe and the near East. It is also known as* Rosa rubiginosa. *Since 'eglantine' refers to needle-sharp prickles both roses could qualify for the term on those grounds.*

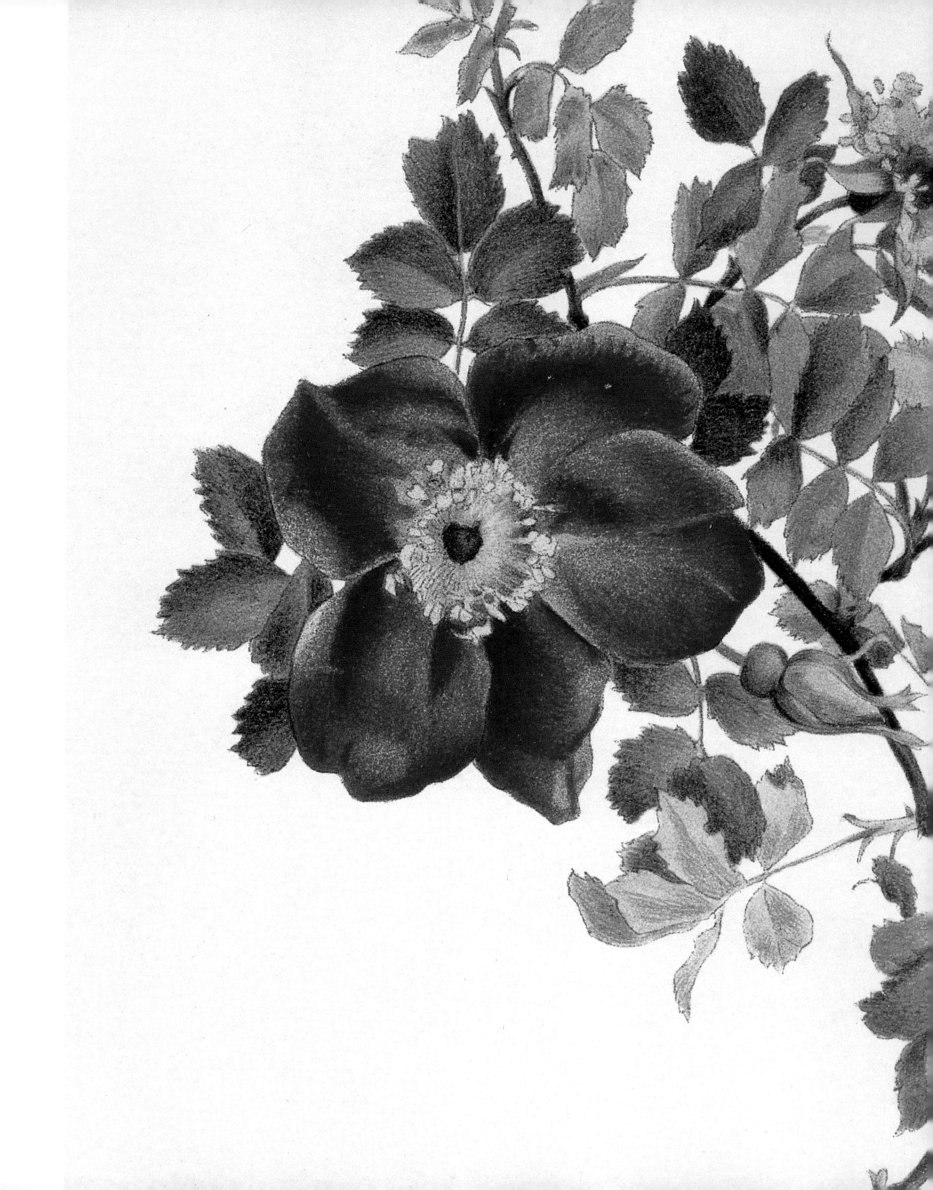

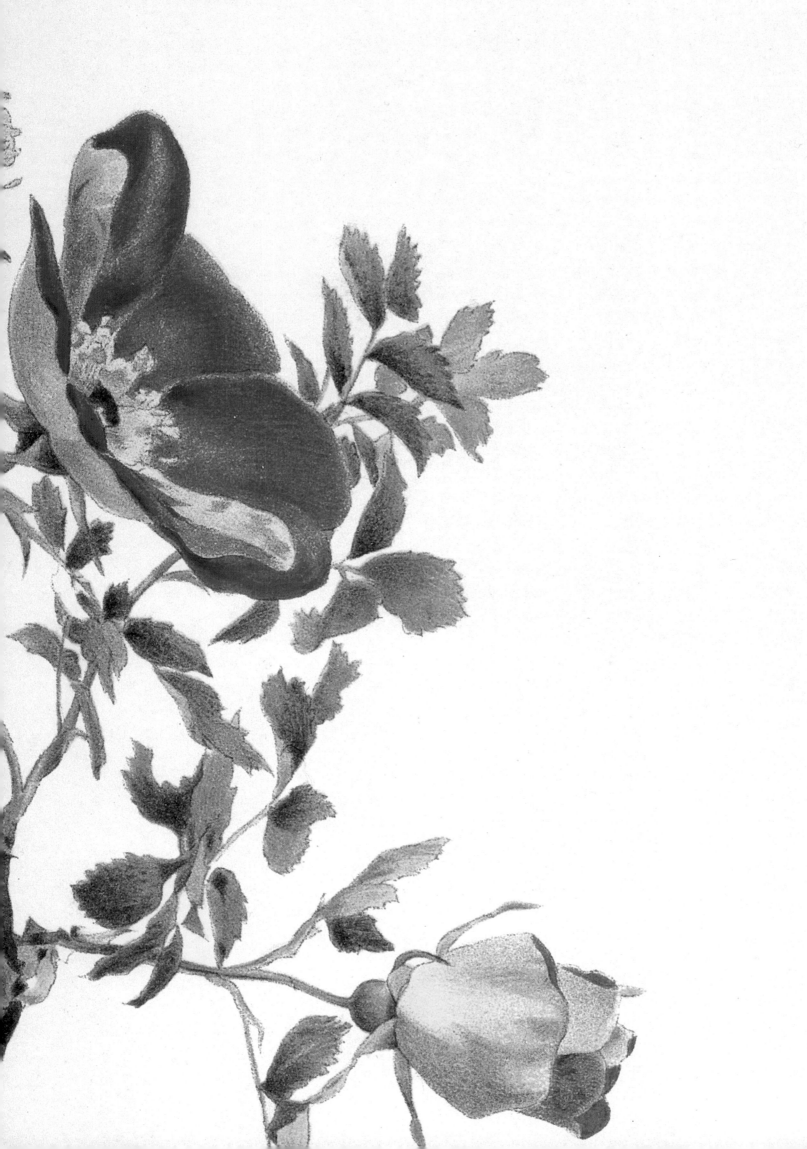

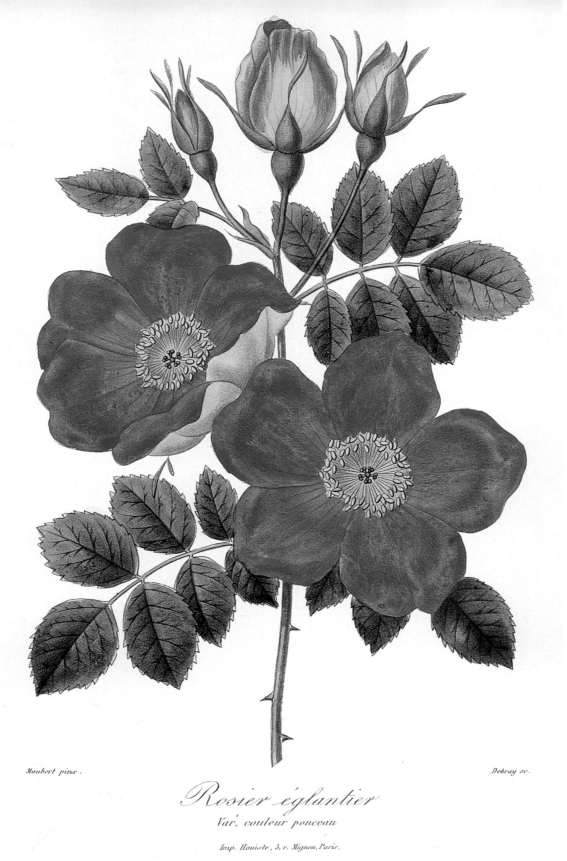

Maubert pinx.

Debray sc.

Rosier églantier

Var. couleur ponceau

Imp. Houiste, 5. r. Mignon, Paris.

ROSA FOETIDA BICOLOR

Philip Miller in 1768 named this R. punicea *(above & opposite), meaning reddish rose, which hardly does justice to its lively poppy hue. An admirer confronted in 1890 by a plant in flower described it in more glowing terms: 'as big as a small haystack, and ablaze like one of Turner's sunsets'. Its low fertility makes this rose difficult for breeding, but it did produce the Queen Alexandra Rose, the first good bicolour Hybrid Tea and a grandparent of 'Peace'.*

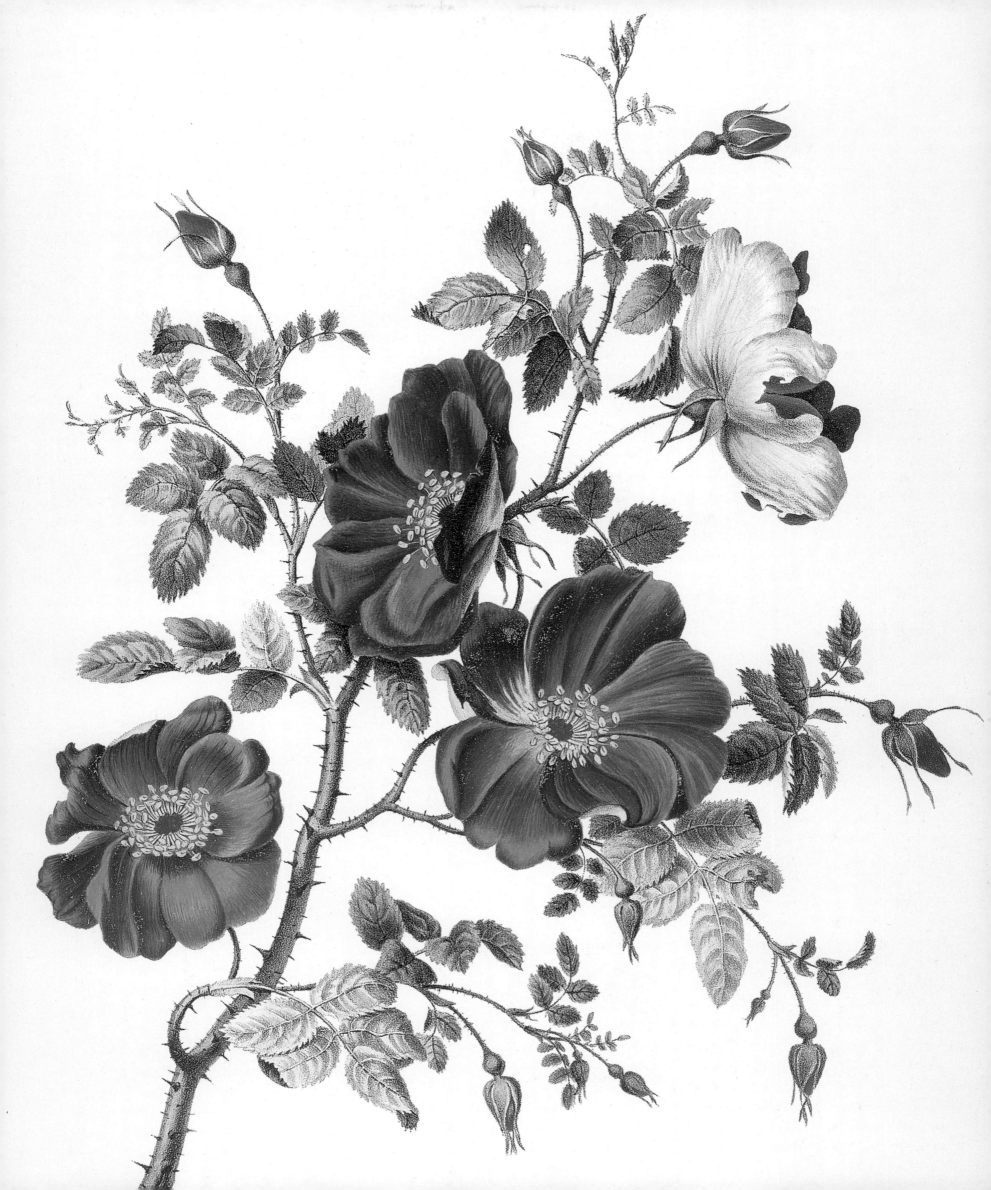

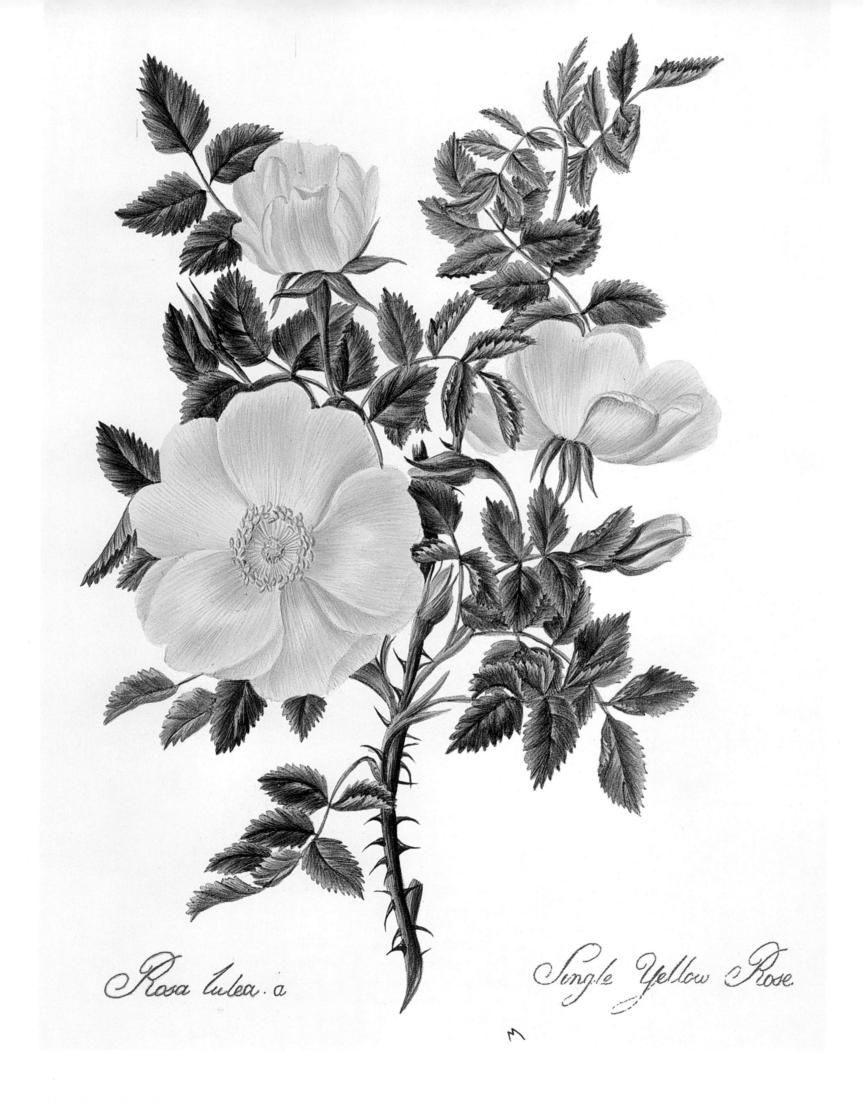

Rosa lutea . a

Single Yellow Rose.

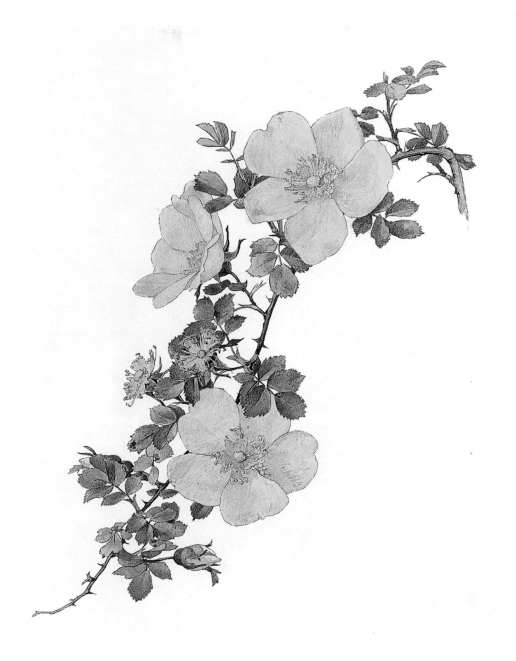

ROSA FOETIDA

R. foetida *(above & opposite) was anciently cultivated in western Asia and is probably the Yellow Rose of Asia mentioned by Arabic writers in the twelfth century. It acquired its common names Austrian Yellow and Austrian Briar in the sixteenth century when it came from Turkey into Europe, where roses of such brilliance were unknown. John Gerard was so amazed that he suggested it must have originated 'by grafting a wilde Rose upon a Broom-stalke'.*

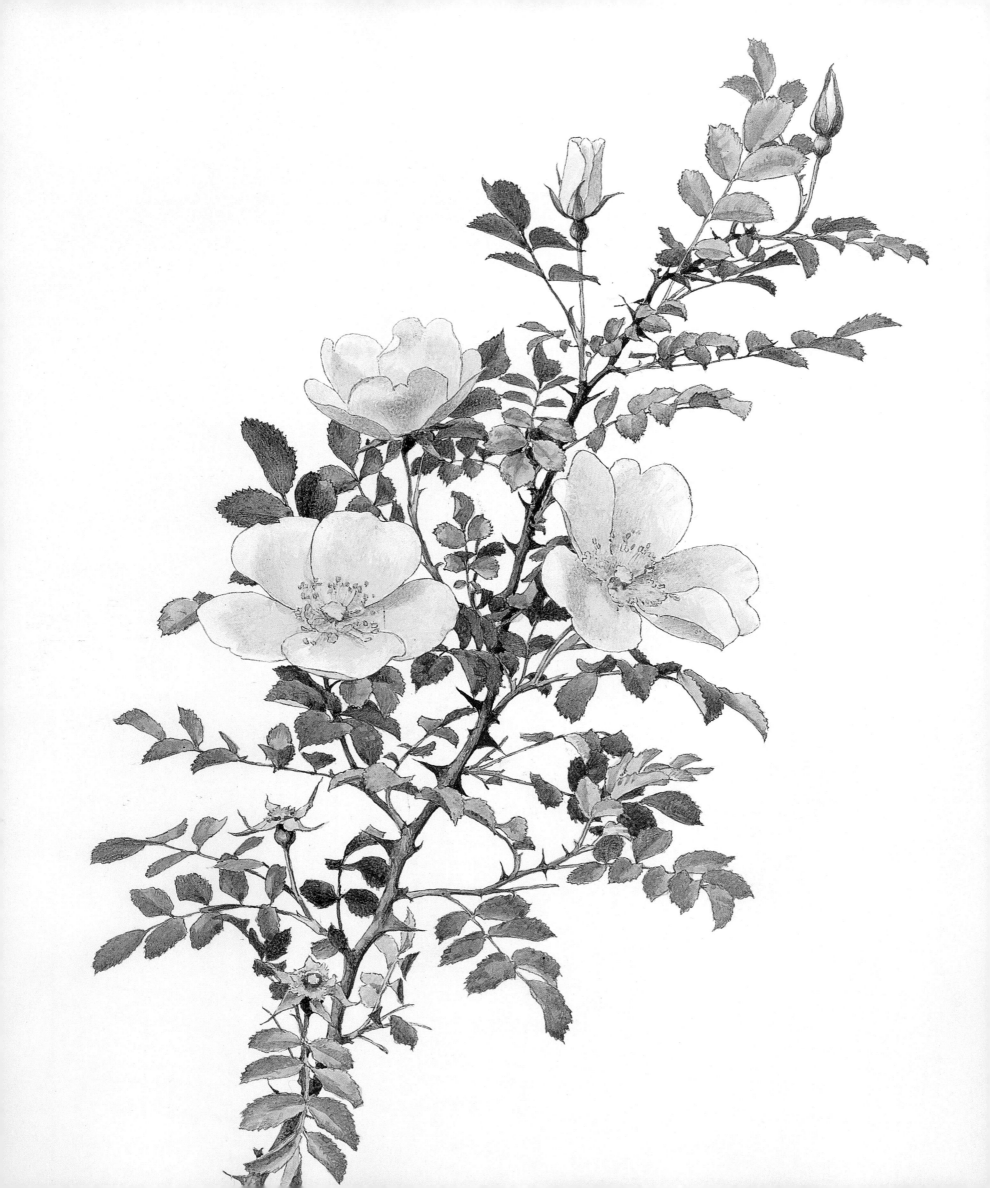

ROSA HUGONIS

About 1899 Father Hugo Scallan and Father Giraldi collected seed
from a plant in north central China and sent it to Europe. Seedlings
were raised and in 1908 R. hugonis *was introduced by James Veitch*
in London, trading from the Royal Exotic Nursery, King's Road,
Chelsea. The rose is covered with fern-like leaves and bears primrose-
coloured flowers with crinkled petals in late spring. In cool weather
the outer petals remain incurved, but in warmer conditions they
expand to make a generous show. In the United States the Conard-
Pyle nursery marketed it as the Golden Rose of China.

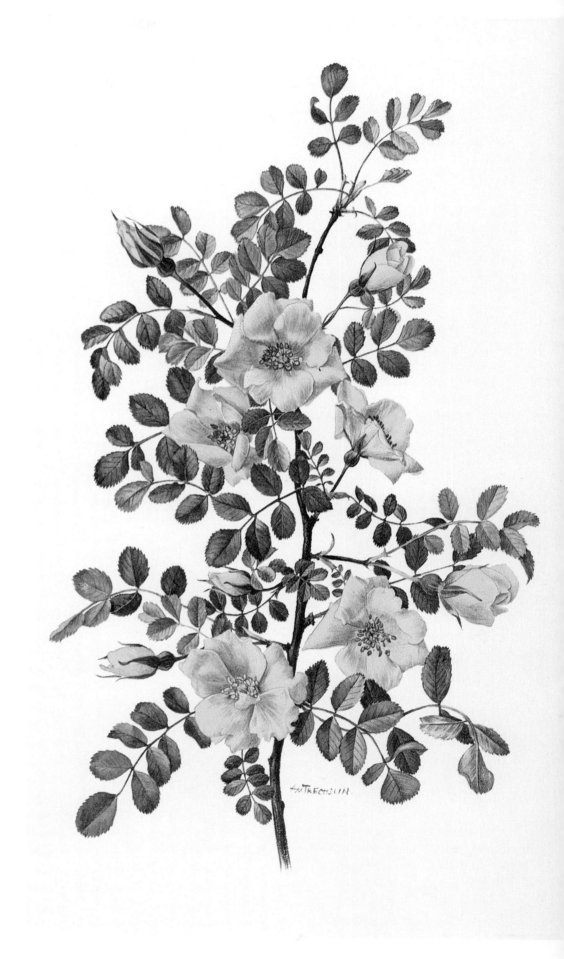

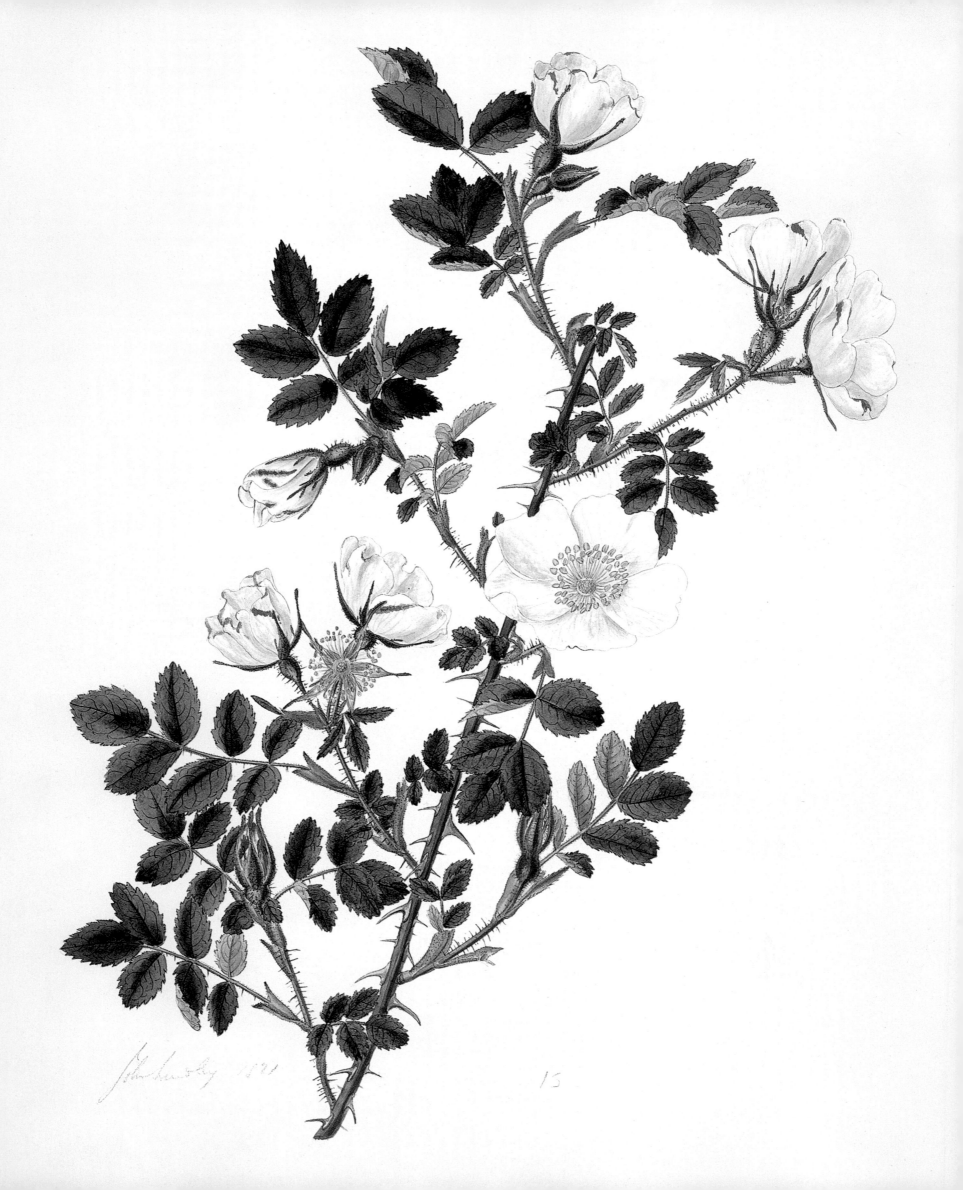

John Lindley 1821

15

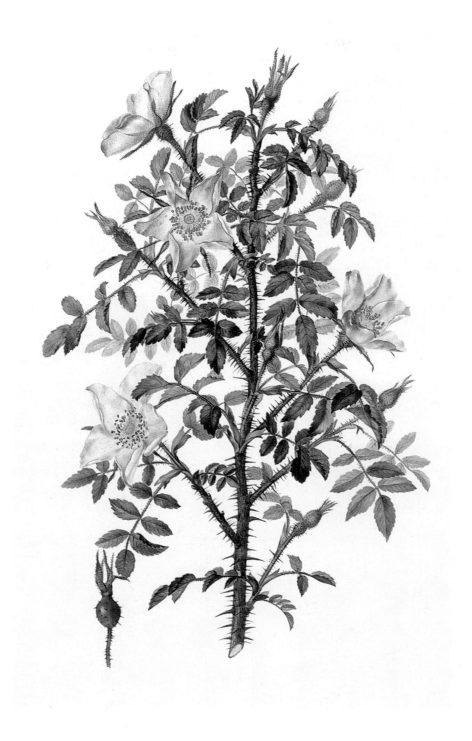

ROSA X INVOLUTA

This name is given to a number of chance hybrids involving R. pimpinellifolia *and probably* R. sherardii. R. x involuta *(above & opposite) was first recorded from the Hebrides in the early 1800s, at a time when interest in Scottish roses was at its height. Similar forms have been found in France and other parts of the British Isles. The influence of* R. sherardii *is apparent in the red rather than black appearance of the hips and in the pretty pink tints on the outside of the petals.* Pimpinellifolia *inheritance is seen in the general character of the foliage and a tendency to sucker.*

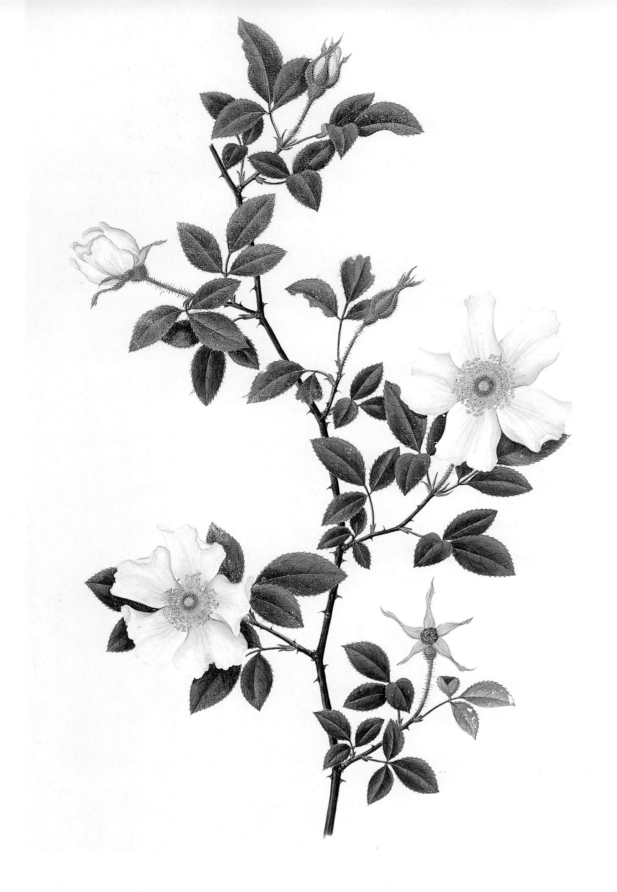

ROSA LAEVIGATA

Recorded under the name Golden Cherry in a Chinese herbal of 1406 AD, Rosa laevigata *is considered the most beautiful of all wild roses. Its charms were portrayed four centuries later (above) by an anonymous Chinese artist employed by John Reeves. The large flowers and trefoil leaves are also evident in an illustration (opposite) from the* Botanical Register. *It has given rise to some worthwhile hybrids, notably 'Cooper's Burmese', 'Ramona' and 'Silver Moon'. However, it is not the most obliging parent. American breeder Dr. Van Fleet complained that he had 'squandered whole seasons of work on the Cherokee, with little to show'. Cherokee is one of several common names for this rose.*

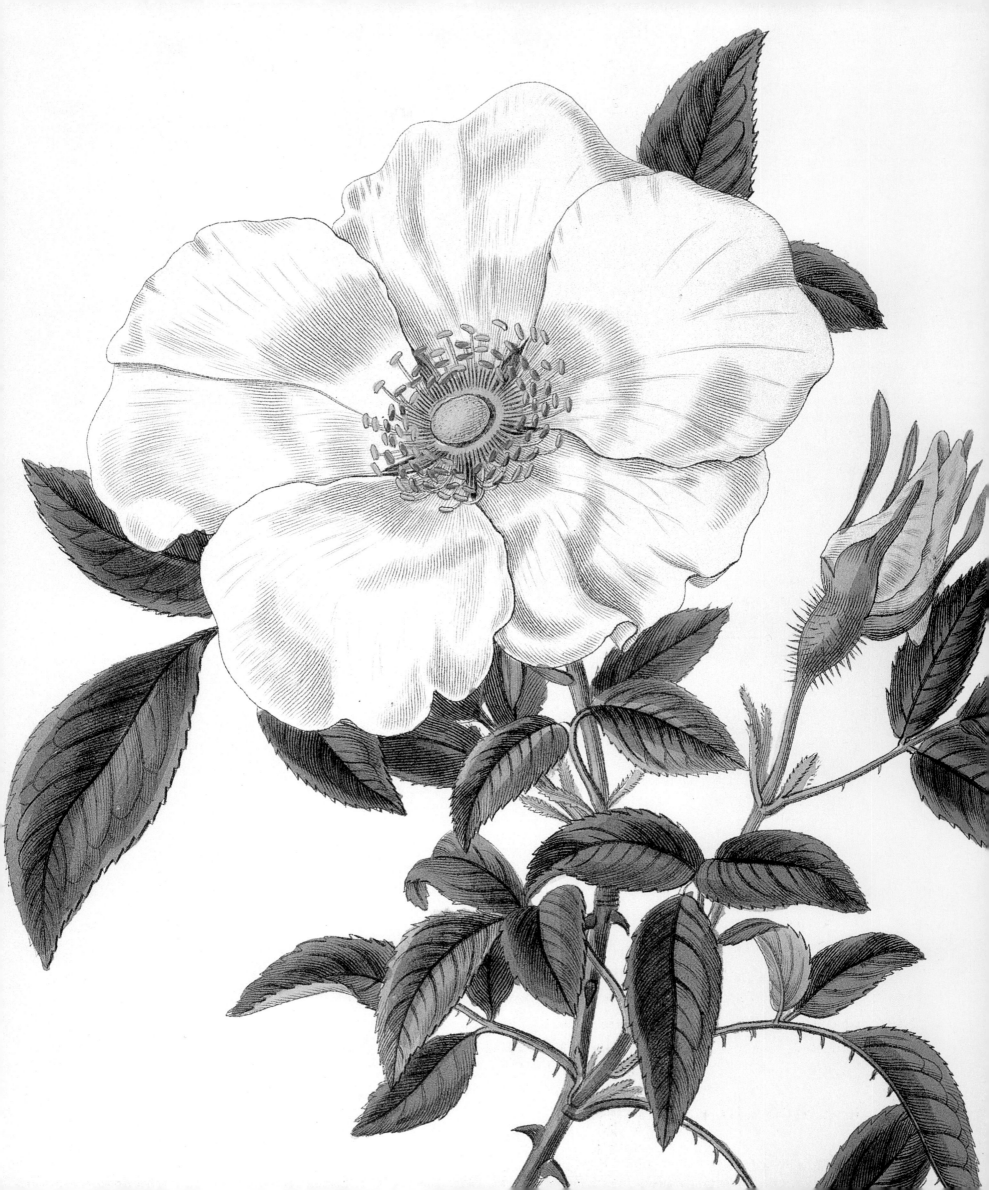

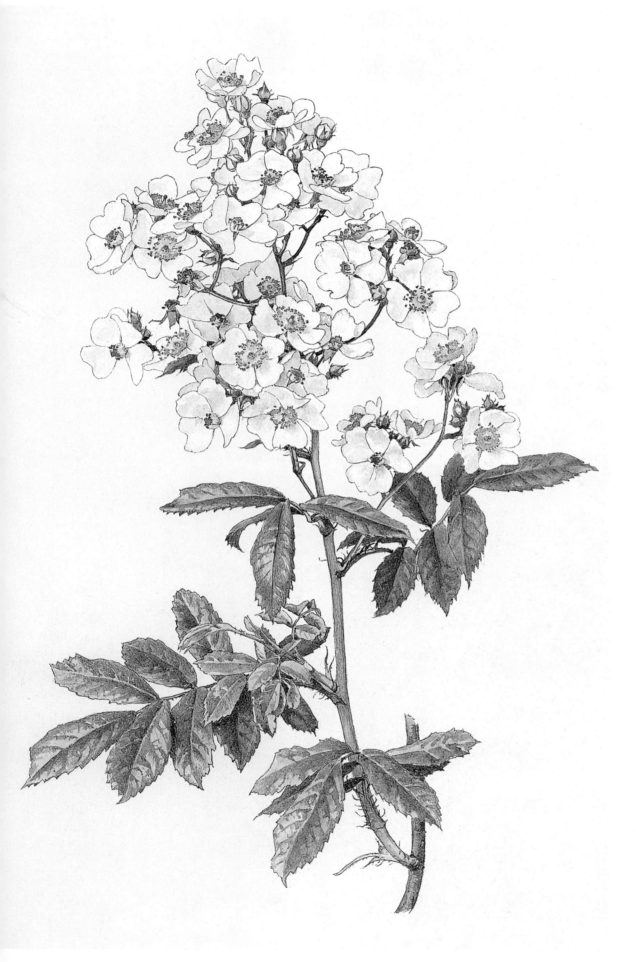

ROSA MULTIFLORA

Although recorded centuries ago in China and Japan, seeds of this species (left) were only sent to Europe in the 1860s. It is capable of reaching 20 feet (6m), given support, and is useful as an understock on which to graft other roses, but otherwise it has little garden merit. Here, Parsons' illustration from The Genus Rosa *captures very well the rough texture of the foliage and the conspicuous narrow lobes of the stipules, which are found in many of its descendants.*

ROSA NITIDA

This is a dwarf American species (opposite), not common in the wild, and has been in cultivation since 1807. The name nitida *means 'shining' and refers to the bright red-green leaflets. The autumn foliage effects are particularly lovely. In the wild it suckers readily; in the garden budded plants are easier to control.*

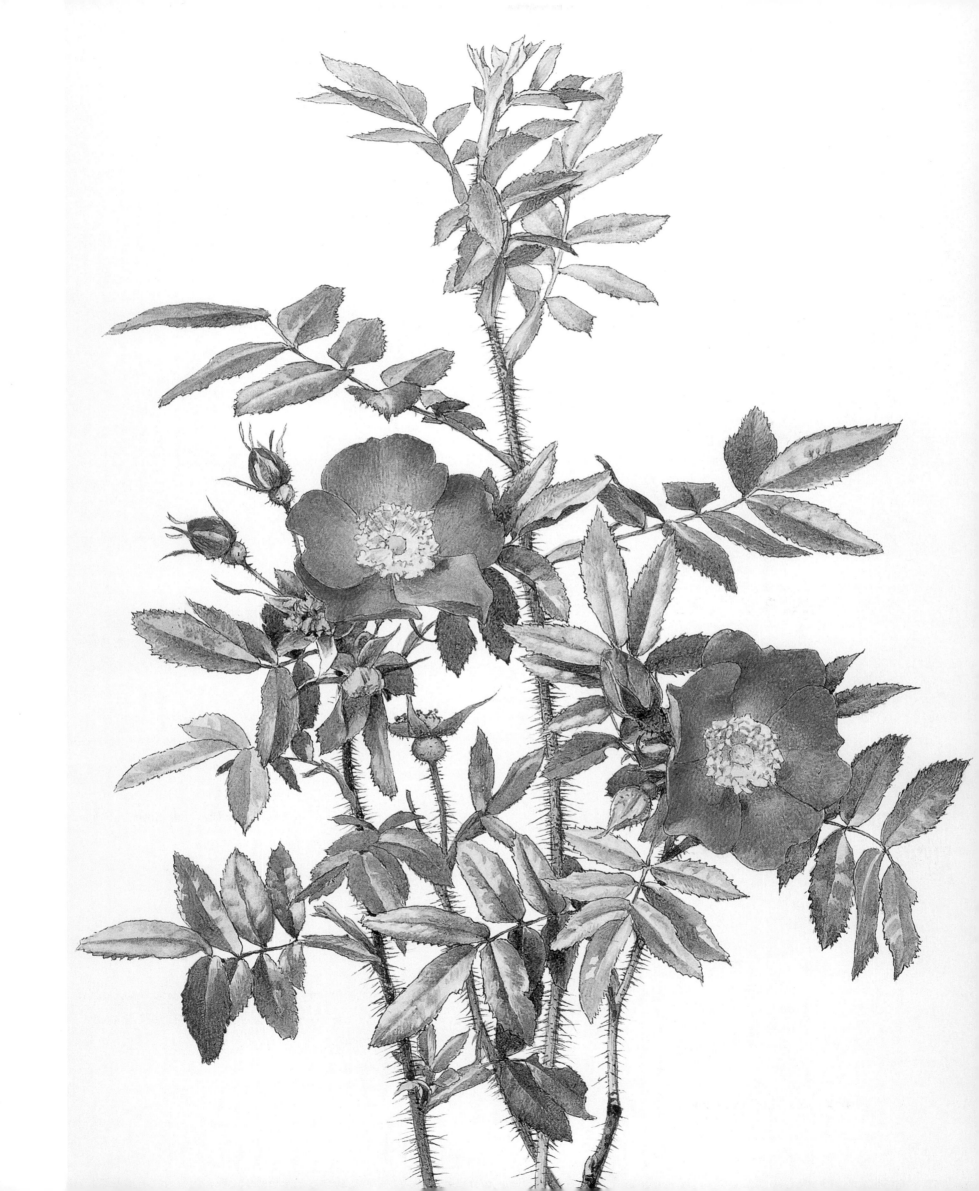

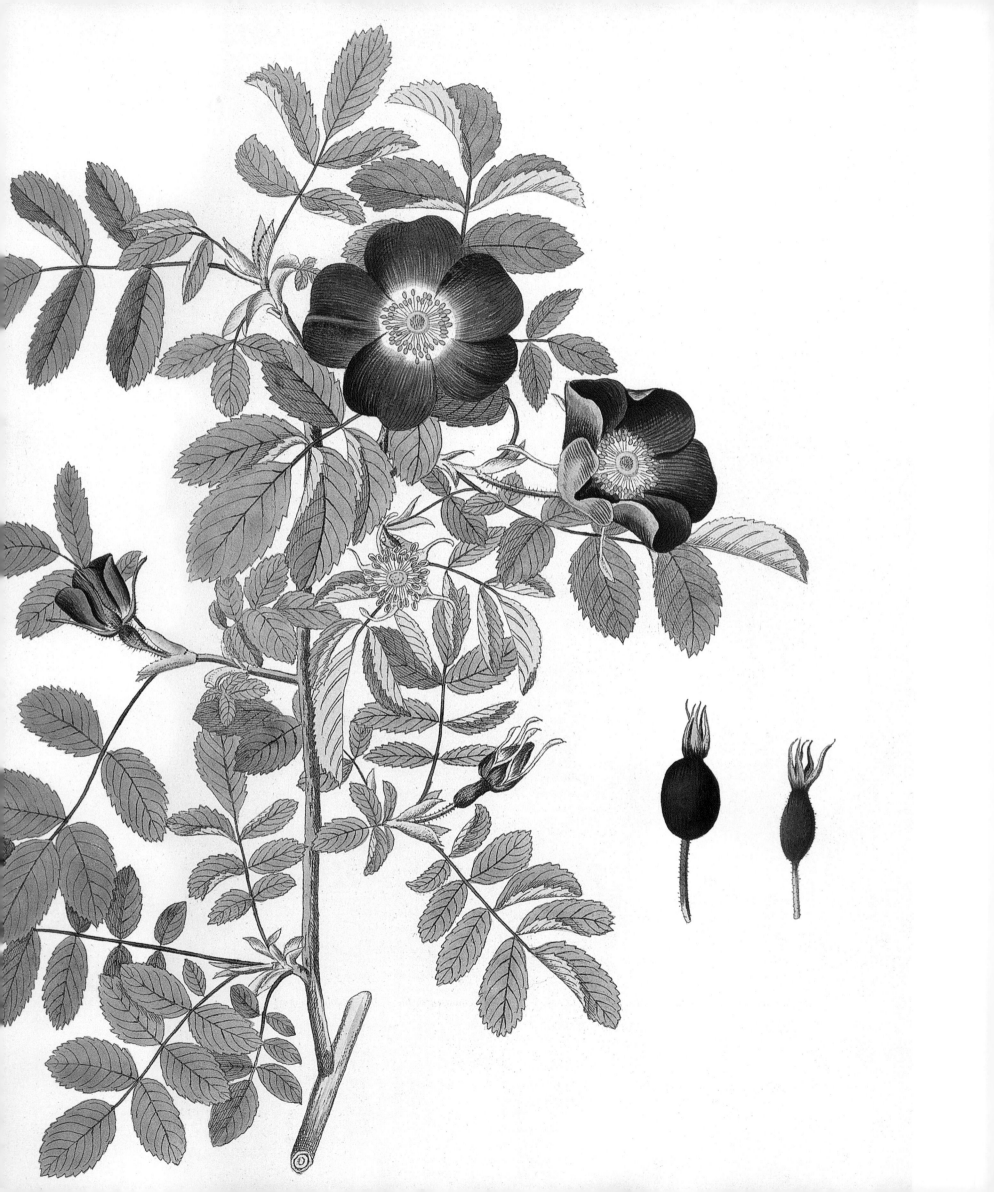

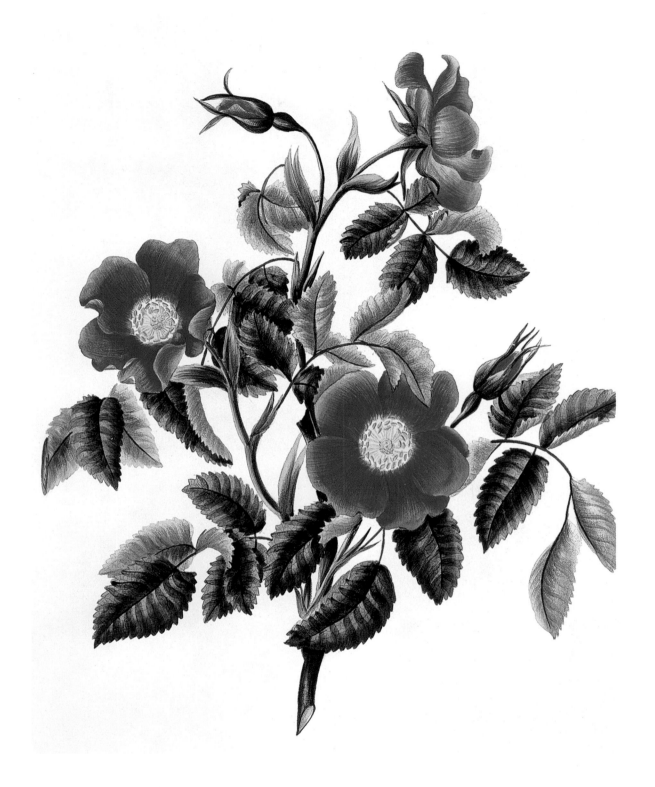

ROSA PENDULINA

This species (above & opposite) has been in cultivation since 1683, and its rather frail appearance belies its hardy

nature, for it thrives in mountainous regions of central Europe. One of its common names is Alpine Rose and

another is Drop-Hip Rose. The illustrations faithfully portray the smoothness of its stems and the weak flower stems,

which cause first the blooms and then the hips to nod. Tests at Sangerhausen in the 1940s established that

the hips of a related form in the Caucasus provide the richest source of Vitamin C of any rose.

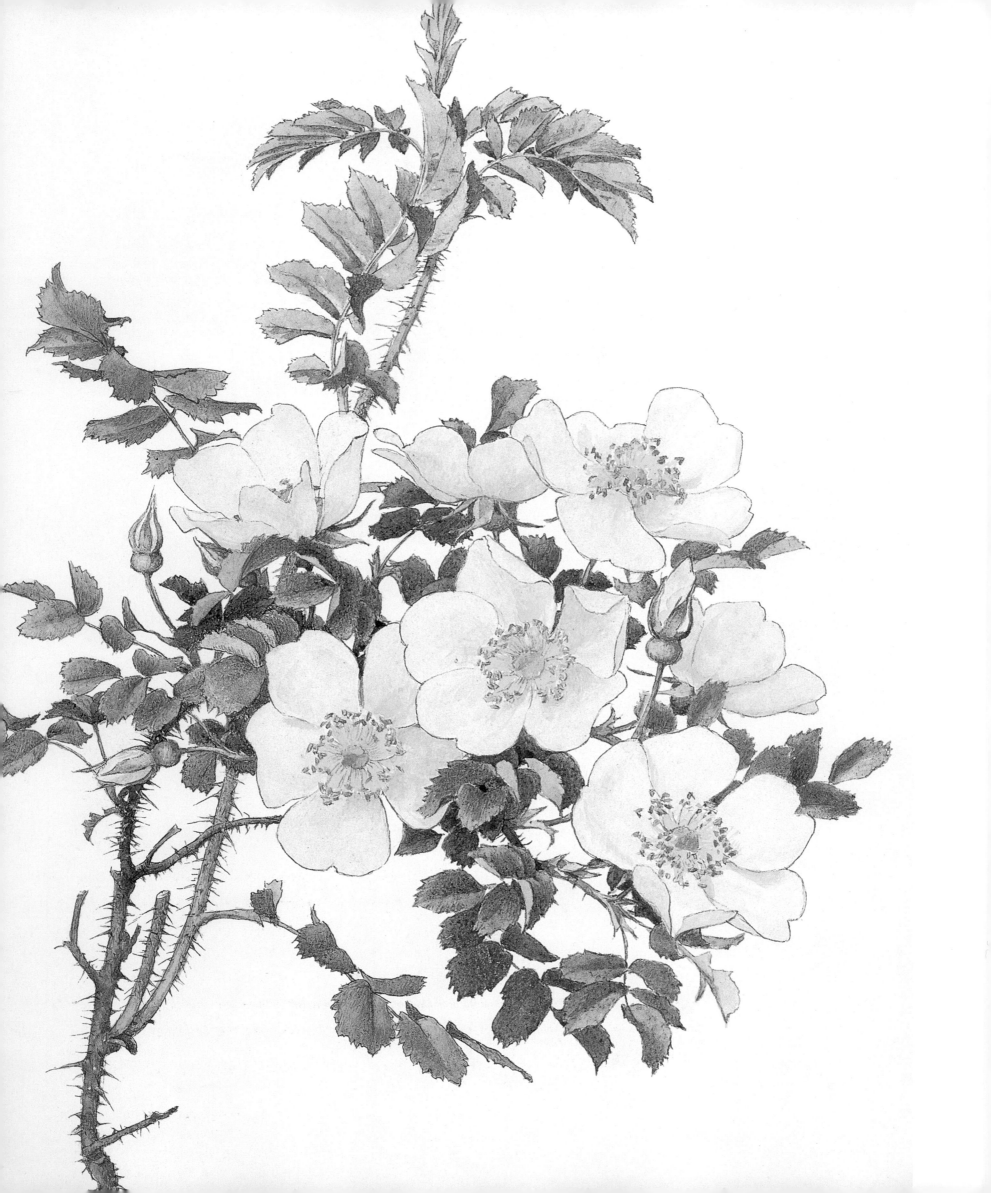

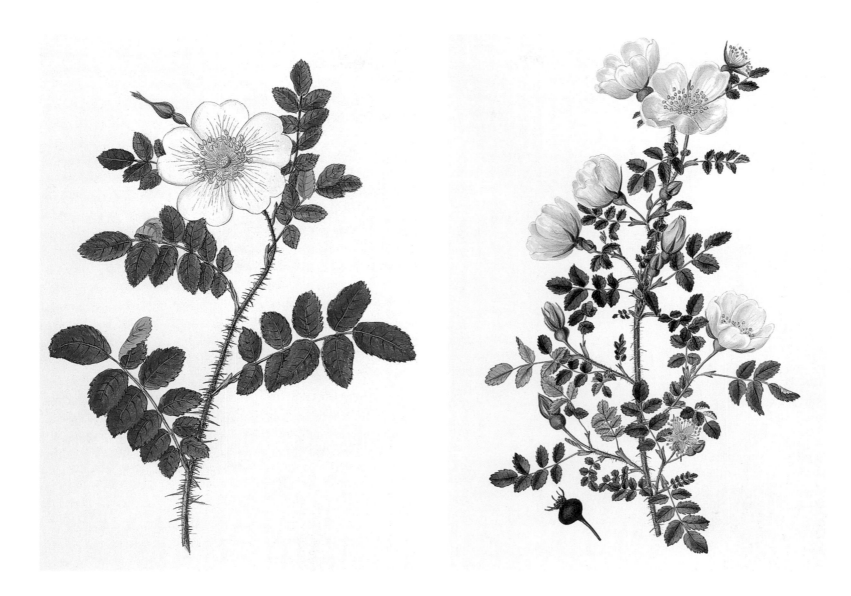

ROSA PIMPINELLIFOLIA VAR. ALTAICA

Brought to Europe from the Altai region of central Asia in 1818, this vigorous dark leaved form of the Scots rose (opposite) is a welcome herald of summer, flaunting its saucer-shaped yellowish-white flowers with their prominent gold stamens in great profusion. These blooms reach a good size, up to 3 inches (7cm) across, produce a pleasing fragrance, and are succeeded by plump round black hips

ROSA PIMPINELLIFOLIA

These renderings by Roessig (above left) and Lindley (above right) illustrate the comparatively large size of R. pimpinellifolia's flowers in relation to the leaves and stems, and the pleasing manner in which the cupped young blooms open wide to display the stamens. Commonly known as Burnet Rose and Scots Rose, it adapts remarkably to local terrain. On windswept Herm in the Channel Islands it grows so prostrate that it was thought to be a specialised local form, but seeds taken from the plants and sown on the mainland produced bushes of normal size. A national collection of Scots roses is maintained near Dundee, and acquired several additions after a successful 'Burnet Rose Day' in 1993, when forty four distinct varieties were botanically identified from over 160 specimens.

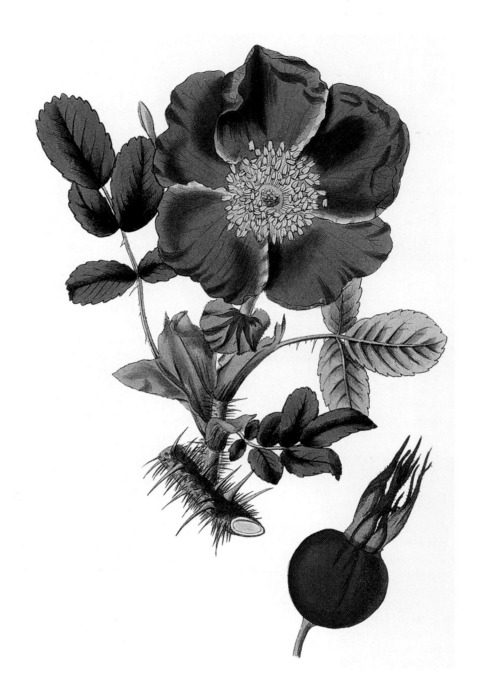

ROSA RUGOSA

Rugosas have a long history of cultivation. A form known to the Chinese as Mai Kwai
*appears in a twelfth-century painting. It readily hybridises with other roses, creating
numerous variant forms. Both these botanical drawings depict the typically wrinkled
(rugose) leaflets that give the species its name, and the fine hairs that coat the stems.
However, closer inspection reveals that one specimen has smooth hips (above) and the
other bristly ones (opposite), evidence of the variation that occurs in nature.*

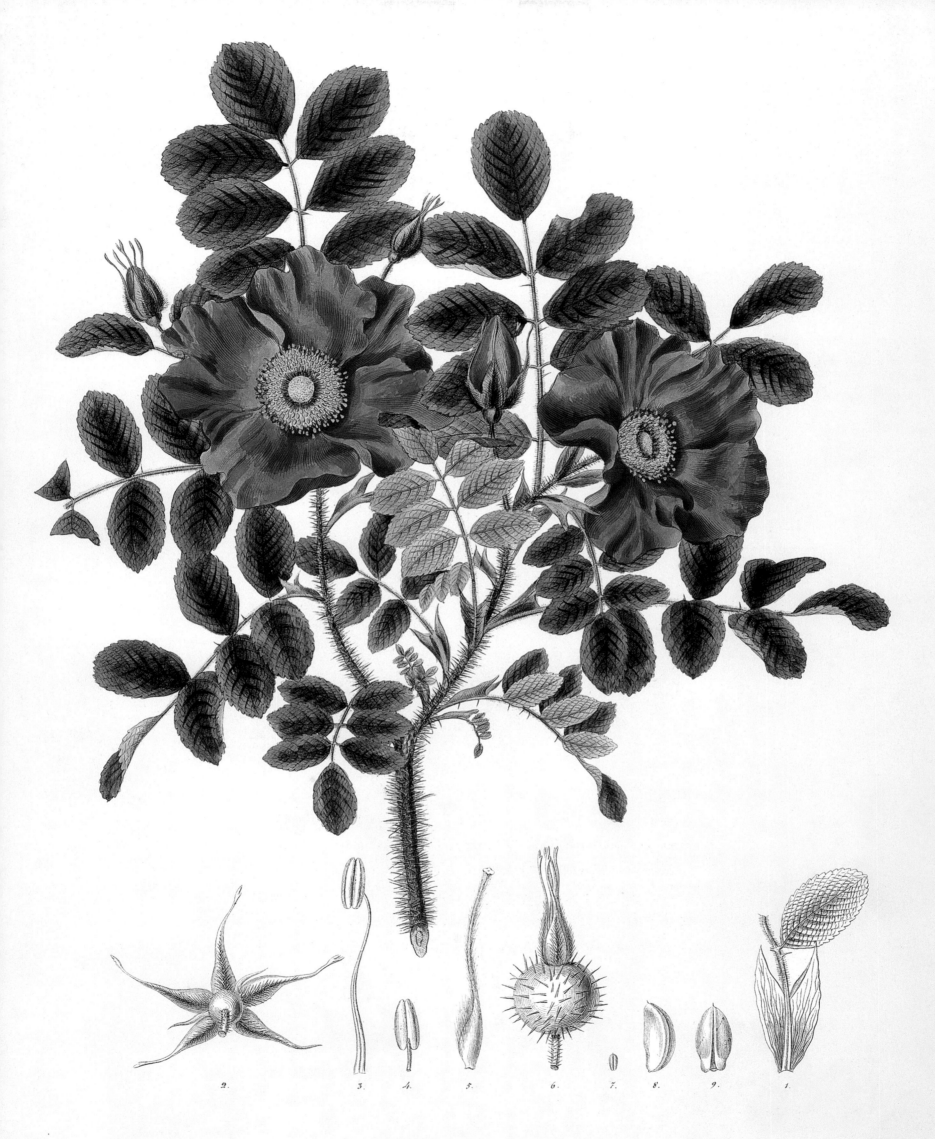

2. 3. 4. 5. 6. 7. 8. 9. 1.

ROSA rugosa.

J. Mensinger del. Wilh. Siegrist sc.

ROSA RUGOSA ALBA

Rosa rugosa alba *makes a slightly larger plant than the typical mauve species and is capable of reaching 6 feet (2m) tall and wide in average conditions. It has good scent with a hint of cloves. This white Rugosa was recorded by the botanist Thunberg in 1784 following his visit to Japan in 1775–77. There is no firm date for its European introduction, but the English nurseryman T. S. Ware of Tottenham was offering a garden form of it in the 1870s.*

ROSA RUGOSA

Rugosa roses enjoy good health because their leaves are protected with fine hairs, which prevent spores of blackspot and mildew from settling. Breeders have used Rugosas in the hope that their good health record will be transmitted, but with mixed results to date. If the leaves are the rugose type the flowers tend to be coarse, and if the flowers are refined the genes that make them that way generally alter the character of the foliage and so reduce resistance to disease. The ideal marriage of beautifully structured blooms and rugose foliage has yet to be achieved.

*Rosa Sempervirens.
Ever Green Rose*

ROSA SEMPERVIRENS

The distribution of this rose (above & opposite) around the Mediterranean basin, its intrinsic beauty and the evergreen nature of its foliage make this a likely candidate for the Coroniola rose described by the elder Pliny in ancient Roman texts, and referred to by Sappho and in the biblical book of Wisdom *in connection with the festive wearing of rose garlands. Its growth varies according to location. On some island sites it can be short, while in open country it forms a substantial shrub, even clambering through other plants to extend up to 15 feet (5m), effectively becoming a climber.*

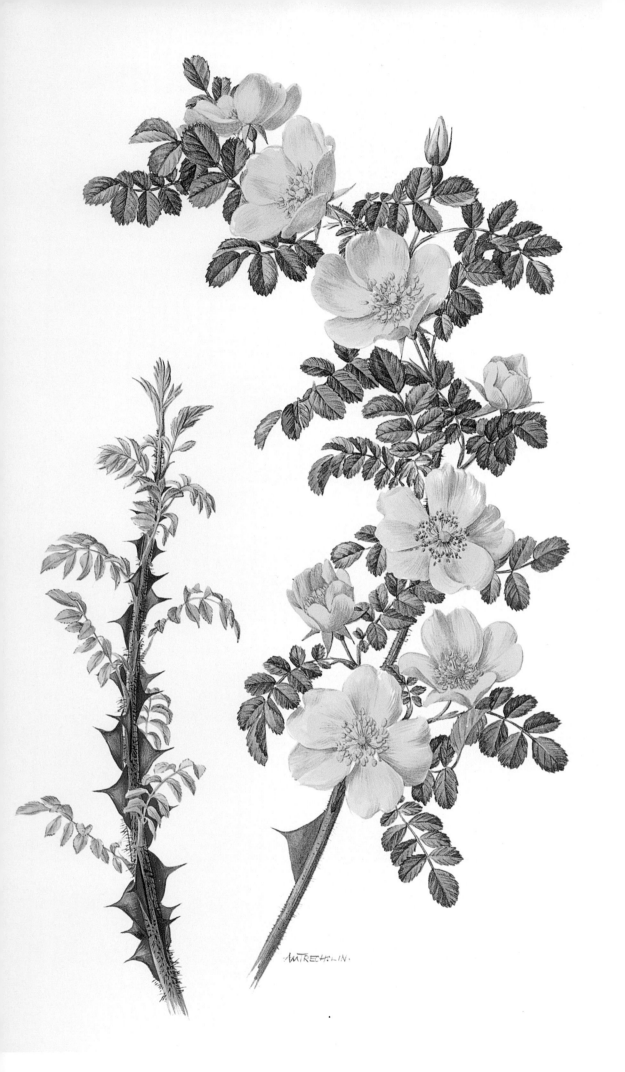

ROSA SERICEA PTERACANTHA

The claim that a rose can have prickles larger than its leaflets is justified, as shown in both these portrayals of Rosa sericea pteracantha *(left & opposite). They also indicate the variability of its petallage; it is the only wild rose regularly producing flowers with four petals as well as the usual five. It came to Europe from western China in 1890 and is noted for its beautiful young shoots with translucent, red 'winged thorns' – hence the common name Winged Thorn Rose.*

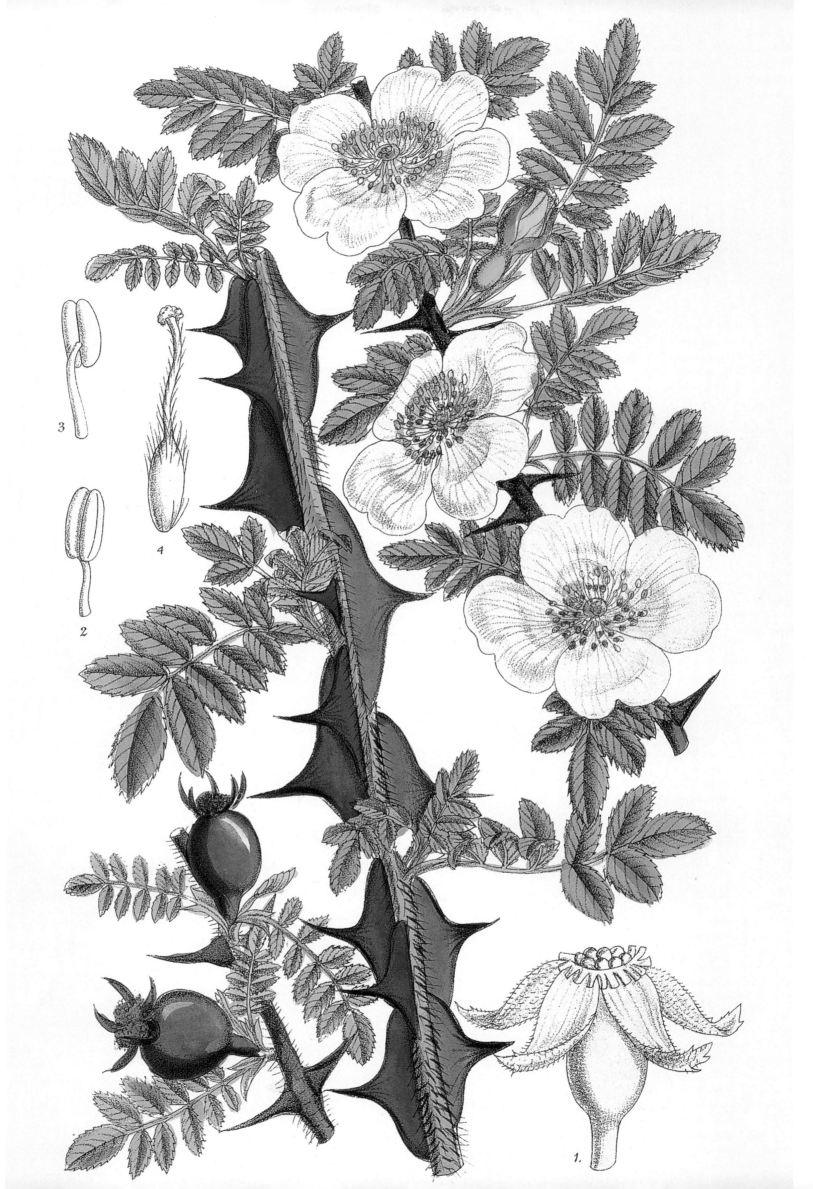

1.

2.

3.

4.

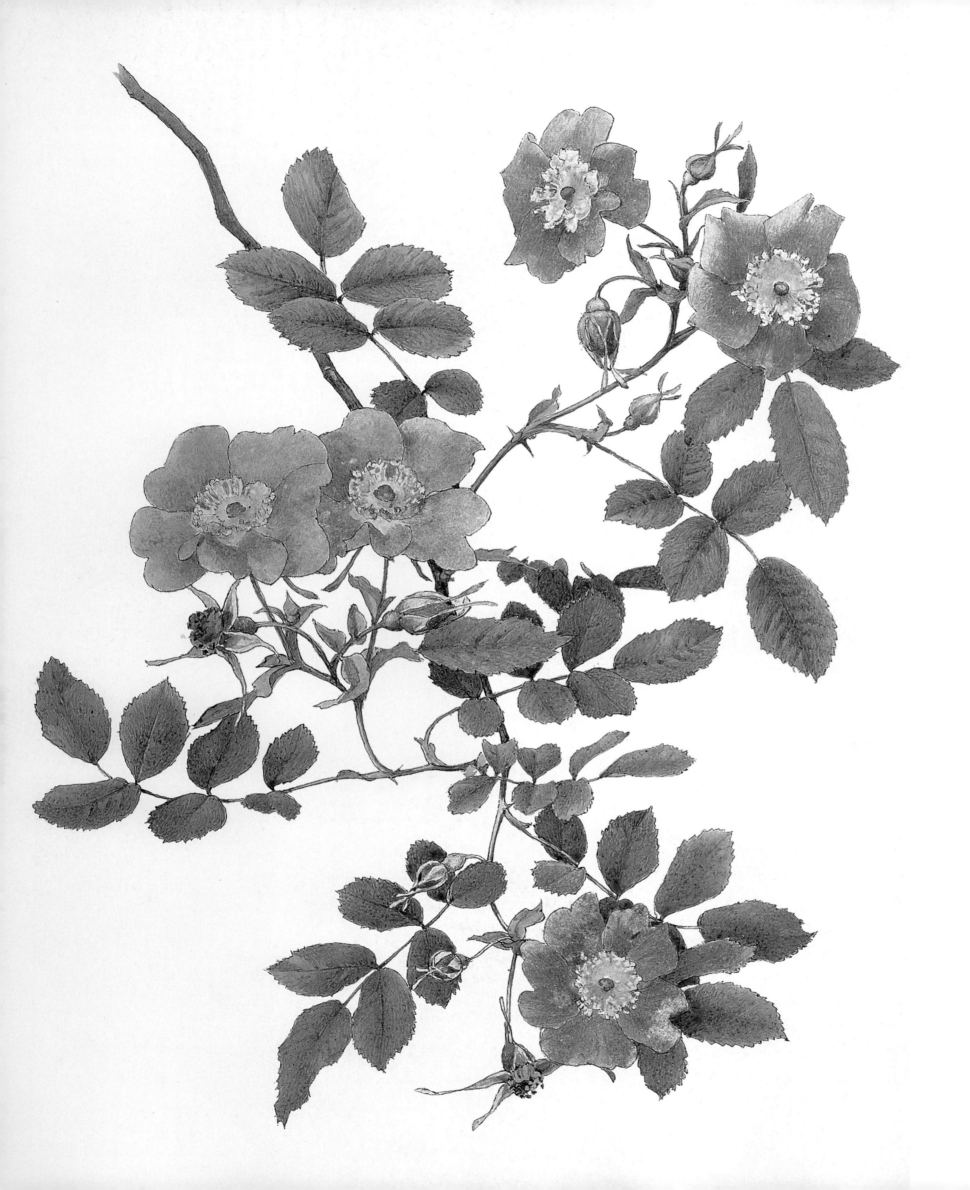

ROSA VIRGINIANA

The Virginia Rose (right & opposite) is found in east-ern and mid-western regions of North America, and is considered by many to be the prettiest of the American native roses. Its habit is graceful, the foliage beautiful and the flowers neatly presented in a cheerful shade of bright pink. It has been grown in Europe since 1724 though its reputation preceded it, for it was being men-tioned as far back as 1640. It was formerly known as R. lucida, *a reference to the lustrous leaves.*

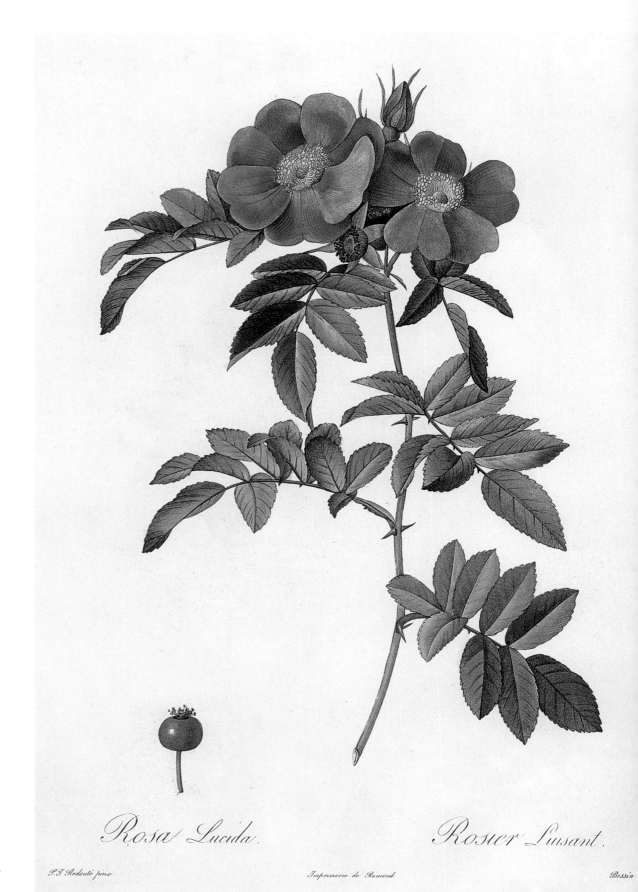

Rosa Lucida.

Rosier Luisant.

P.J. Redouté pinx.

Imprimerie de Remond

Bessin

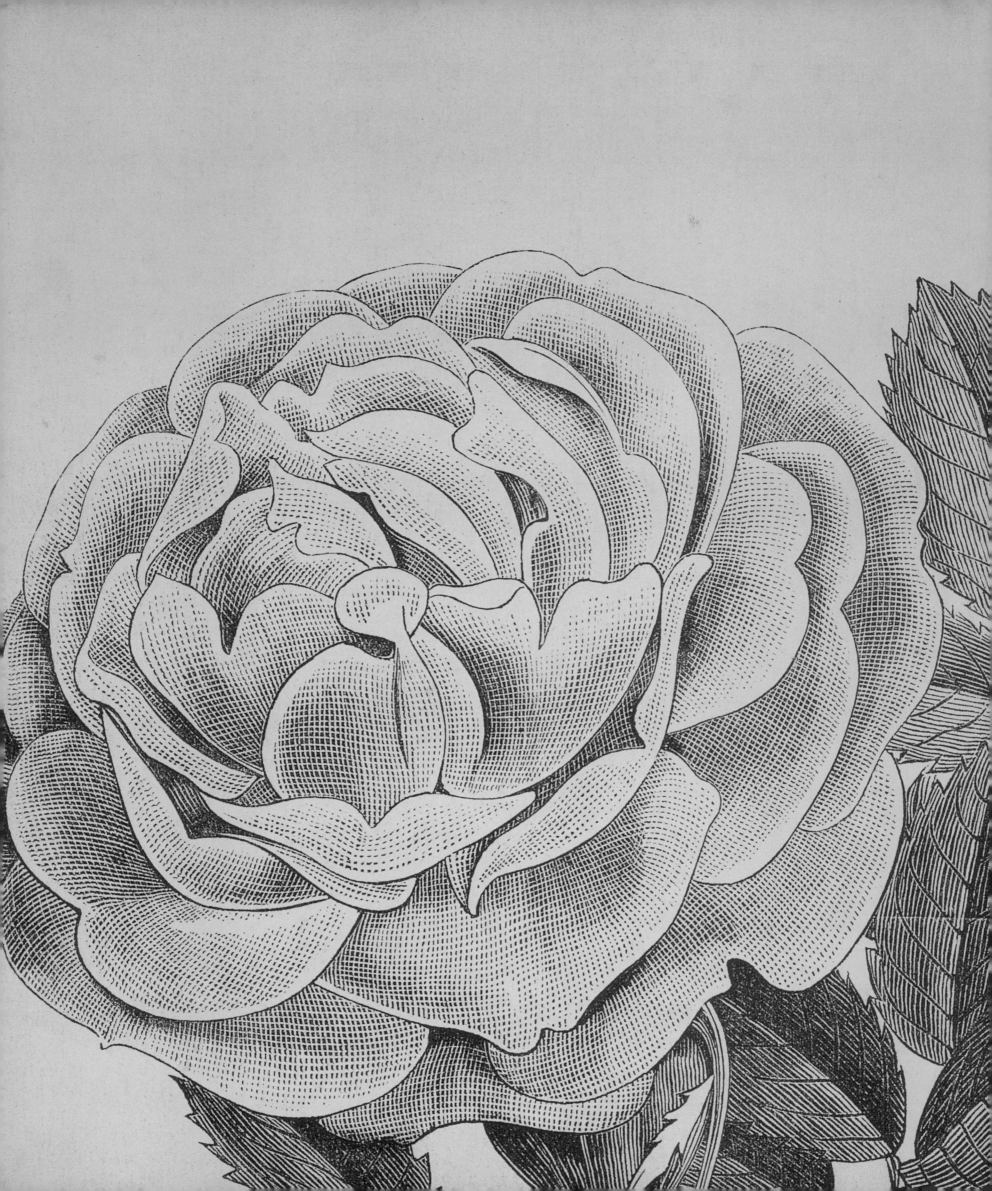

Roses *of* History

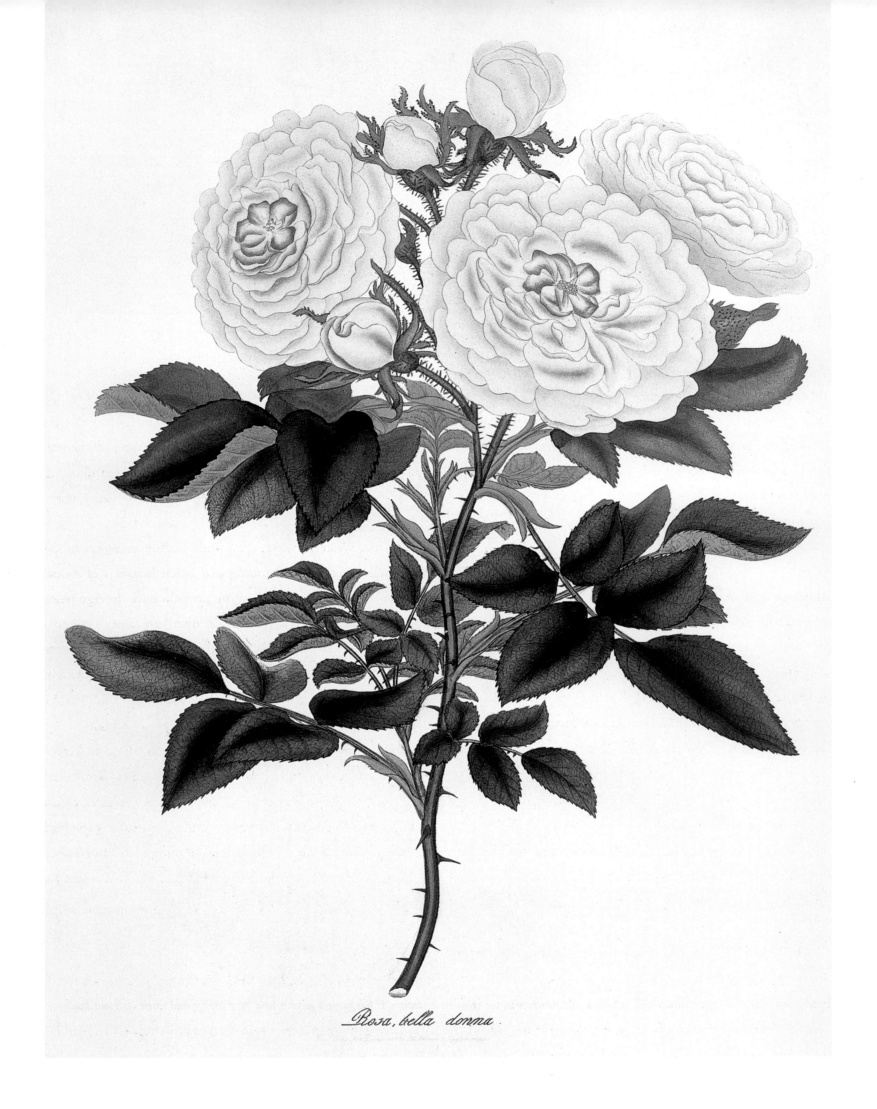

Rosa, bella donna.

Roses *of* History

A GLOBAL EVOLUTION

The Plant of Roses, though it be a shrub full of prickles, yet it had bin more fit and convenient to have placed it with the most glorious floure of the world, than to insert same here among base and thorny shrubs; for the Rose doth deserve the chief and prime place among all floures whatsoever; beeing not only esteemed for his beauty, virtues, and his fragrant and odiferous smell; but also because it is the honor and ornament of our English Sceptre...

(JOHN GERARDE'S *HERBALL*, 1636)

Although wild roses extend throughout the northern hemisphere, their development into cultivated forms was confined for centuries to two distinct regions divided along East-West lines. In the context of rose history, East takes in the gardeners of China, Korea, Japan and neighbouring regions, while West embraces everyone from the Himalayas to the Atlantic, including the shoreline of North Africa. Neither was aware of the achievements of the other until improved navigation opened up the seaways from the sixteenth century onwards.

By the year 1600 gardeners of the East enjoyed a diverse selection of roses. They included a wide range of colours, including buff and scarlet tones, roses that continued flowering through the summer and autumn, and vigorous upright climbers that were almost entirely absent in the West. Sweet fragrance was not their strong point, with the exception of the Rugosa roses. Meanwhile, most gardeners in the West could grow roses in white, cream, rose pink, light crimson and mauve, plus yellow and flame roses that had been recently introduced. Most were vigorous growers, all with one exception flowered in summer only, and many were beautifully fragrant.

In the Western world, the earliest written mention of the rose is an inscription recording that when Sargon I of Akkad invaded Turkey about 2350 BC he brought back 'foreign trees, vines, figs and roses' to grow in his own land. But not everyone agrees that the word taken for 'roses' is an accurate translation. A thousand years later, an inscribed stone tablet at Pylos in Greece is said to refer to 'oil with rose scent', but the language is obscure and scholars are unsure.

However, it is hard to dispute the ancient botanical remnants that have given historians and scientists alike clear evidence of the rose's existence and cultural uses. The oldest known rose fragments, apart from fossils, are prickles preserved in the flooded levels of Hera's Temple on the island of Samos in Greece. These date from around 500 BC, and DNA might yet determine to which rose species they belong.

'GREAT MAIDEN'S BLUSH'

The many names for this old garden rose – Bella Donna, Cuisse De Nymphe Emue, Incarnata, La Royale, La Séduisante – indicate how popular it has been. It was probably in cultivation well before its first mention in the eighteenth century. It has greyish green 'Alba' type foliage and carries fragrant blush pink flowers, full of petals and cupped in form, on strong upright plants. When grown on its own roots it extends by suckering, and a cottage garden plant tended by generations of the same family in East Hendred, Oxfordshire, has survived in this way for over a hundred years.

Even more compelling are the vials of rosewater and rose oil that were placed among the personal adornments in the Sumerian royal tombs at Ur. Entombed together with servants, warriors, food and cattle, the rose preparations were considered necessary for the afterlife. Although the water and oil have long since evaporated, their existence is confirmed by writing on clay tablets found in the tombs. The Akkadian word *šilasar*, which is inscribed on the 4000-year-old tablets, is very likely the first written reference to the rose.

Which rose was responsible for these fragrant products? A strong contender is the one mentioned by Herodotus, writing in the mid fifth century BC. It is the first recorded reference to a specific cultivated rose:

> *So the brothers Temenus came to another part of Macedonia and dwelt there, near what are called the Gardens of Midas, son of Gordias. In these gardens there grow, without planting, roses, each bearing sixty blossoms and in scent exceeding every rose anywhere.*

'Grow, without planting' seems an odd phrase, and may mean the plants were growing in containers, a practice well known to the Greeks. Alternatively, it may mean that the Gardens of Midas were stocked with well established plants providing flowers over many years. 'Sixty blossoms' is sometimes translated as 'sixty petals', leading to speculation that some unknown Centifolia was the rose to which Herodotus referred. Yet there is a strong case for assuming it is some form of what we know today as the Damask rose.

The summer flowering Damask rose is known to botany as *R.* x *damascena trigintipetala*. Not only beautiful in itself and without peer for fragrance, it is also the most lucrative rose the world has seen and its products still find eager buyers in a trade continuous from ancient times. It grows about 6 feet (2m) tall and wide, carrying heads of cupped, loosely formed rosy pink blooms on long bowing stems.

Damask cultivation began within the region loosely bounded by the Caspian Sea, the Black Sea, the Mediterranean and the Persian Gulf. The first townships of the Western world sprang up here along the Fertile Crescent, especially in Iraq. Having abandoned their country ways, the prosperous inhabitants of the new urban centres also wanted to banish country smells. Providers of rosewater and rose oil never lacked for custom, especially as rosewater was known as a cure for all ills, good for the complexion and a powerful aphrodisiac.

The first requirement for making rosewater and rose oil was well-watered land, and that was no great problem because the climate in the Near East was wetter then than now. Equipment was devised for distilling, and techniques were eventually perfected for producing rosewater, scented oil and attar, the precious essential oil made from rose petals. Attar is a Persian word meaning 'fragrant', and the process of creating it

ROSA X *DAMASCENA BIFERA,* AUTUMN DAMASK

Both the summer flowering Damask and the Autumn Damask pictured here came to Europe from the Near East, and perhaps North Africa. Nicholas Monardes in 1551 wrote that the Summer Damask came from Persia and Alexandria, arriving in Italy, Framce and Germany about 1520, and later in Spain. The explorer Richard Hakluyt stated that the Damask rose was brought to England by 'Doctour Linaker, King Henry the seuenth and King Henrie the eight's Physician'. Linaker was in Italy from 1485 to 1496 and died in 1524. Other names for this rose include Four Seasons and Quatre Saisons.

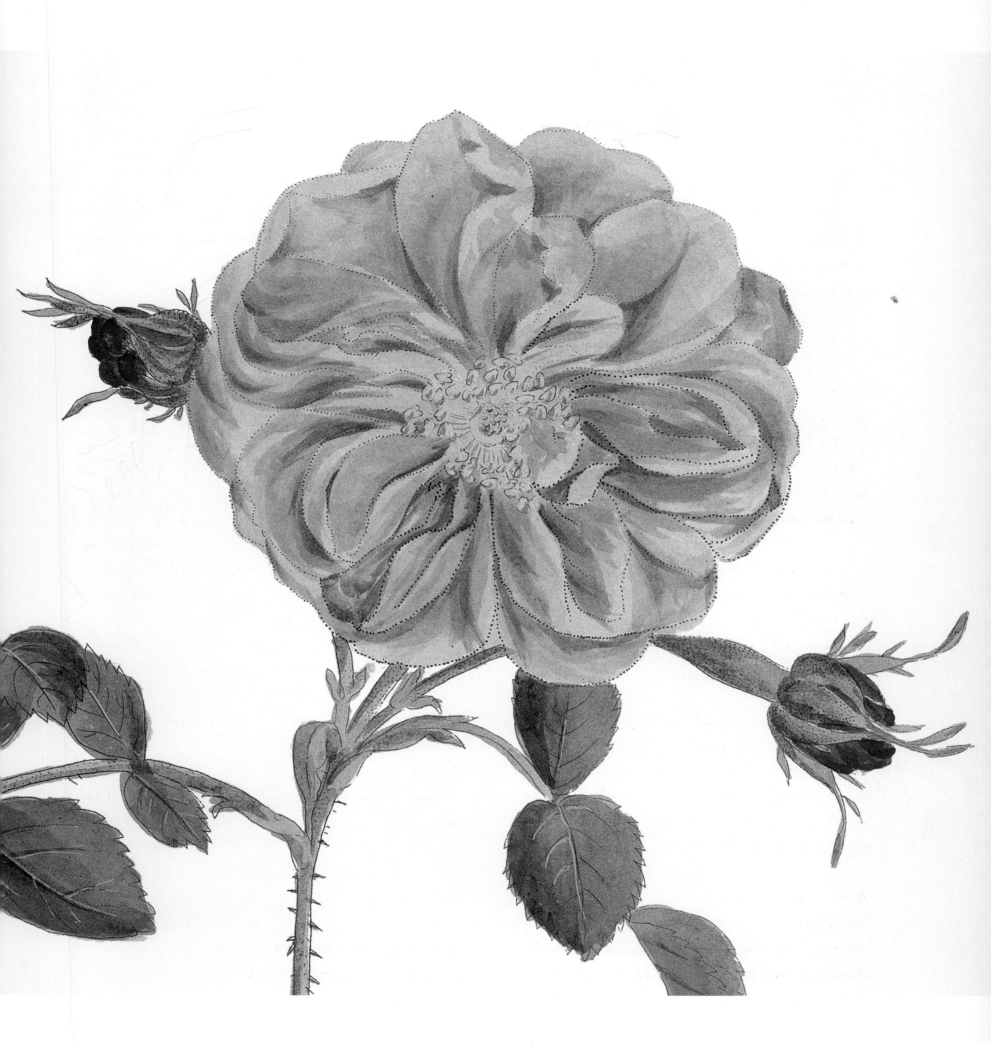

by distillation was mastered by the ninth century AD. Ancient documents show that in the years 810–817 AD the province of Faristan was supplying thirty thousand bottles of rosewater per annum to the Caliph of Baghdad, and exports were being made to China, India, Egypt, Andalusia and Morocco, as well as to the court of Charlemagne in Aachen.

The Damask rose became the basis of this industry because its petals are rich in fragrant oils. It grows easily and is not difficult to propagate by rough and ready means such as splitting up old bushes and setting rooted pieces in trenches. Generously mulched with camel dung, the plants would provide blooms to harvest in three years, with the prospect of further harvests for fifteen years. Success required large quantities of bloom. To create 10cc of attar, ten thousand flowers were picked at dawn with the dew still on them, steeped in water, boiled within four hours and distilled – the distillation may have been repeated several times to obtain the purest essence. This explains why the finest attar has always been so costly. Weight for weight it is more valuable than gold.

The birthplace of the Damask has always been a mystery. The people farming it use local names. To the Persians it is simply 'Gul' or 'rose'; the Greeks call it 'Triantaphyllo' or 'thirty petals'; and the Saudis 'Rose of Taif', after the town near Mecca where its products are sold to passing pilgrims. The Turks use a word meaning 'for the distiller's kettle' and the Bulgars name is 'Kazanlik', after the district where they grow the plants. The

Saudis say they got it from the Indians, the Indians from the Persians, the Spaniards from the Alexandrians, the Bulgars from the Turks, and the Turks that it originated near Shiraz in southern Persia and reached them by way of Syria's capital, Damascus.

Intriguingly the Damask has never been found growing wild, which raises the question of how it originated. This long-standing mystery was resolved in December 2000 by a team of Japanese scientists using DNA analysis. No one had foreseen the result: there were three parental roses involved, *R. moschata*, *R. gallica* and *R. fedtschenkoana*. The first of these is a creamy white semi-climber, the second a reddish species, and the last a vigorous white species with grey-green leaves. The parentage is expressed as (*R. moschata* x *R. gallica*) x *R. fedtschenkoana*. This means that a flower of the creamy white Moschata was pollinated by the red Gallica. From the resulting rose hip, a seed germinated and grew into a new kind of rose. When this new rose came into flower, it was pollinated in turn by the white Fedtschenkoana. The outcome of that second mating was the Damask Rose: warm rosy pink in colour, vigorous in growth, enduring in history and fantastically fragrant.

Northern Persia is the only area where all three of the parents might be found growing naturally so it is reasonable to suppose that this is where the Damask first appeared. The two successive hybridisations might have occurred by chance, but it is also possible that some antique rosarians created a haven for

ROSA X *DAMASCENA* 'TRIGINTIPETALA', KAZANLIK

This ancient rose and its closely allied forms provided the foundation of the attar industry. It flowers for a few weeks during which fresh flowers must be harvested soon after sunrise with the dew upon them, so that the essential oils are not lost. The crown blooms appear some time before the side buds mature, which ensures the pickers can obtain a daily harvest while the season lasts. At Kazanlik in Bulgaria this work has been undertaken for generations; the rose was introduced from Turkey when both countries were under Ottoman rule. Its original home is likely to have been Persia.

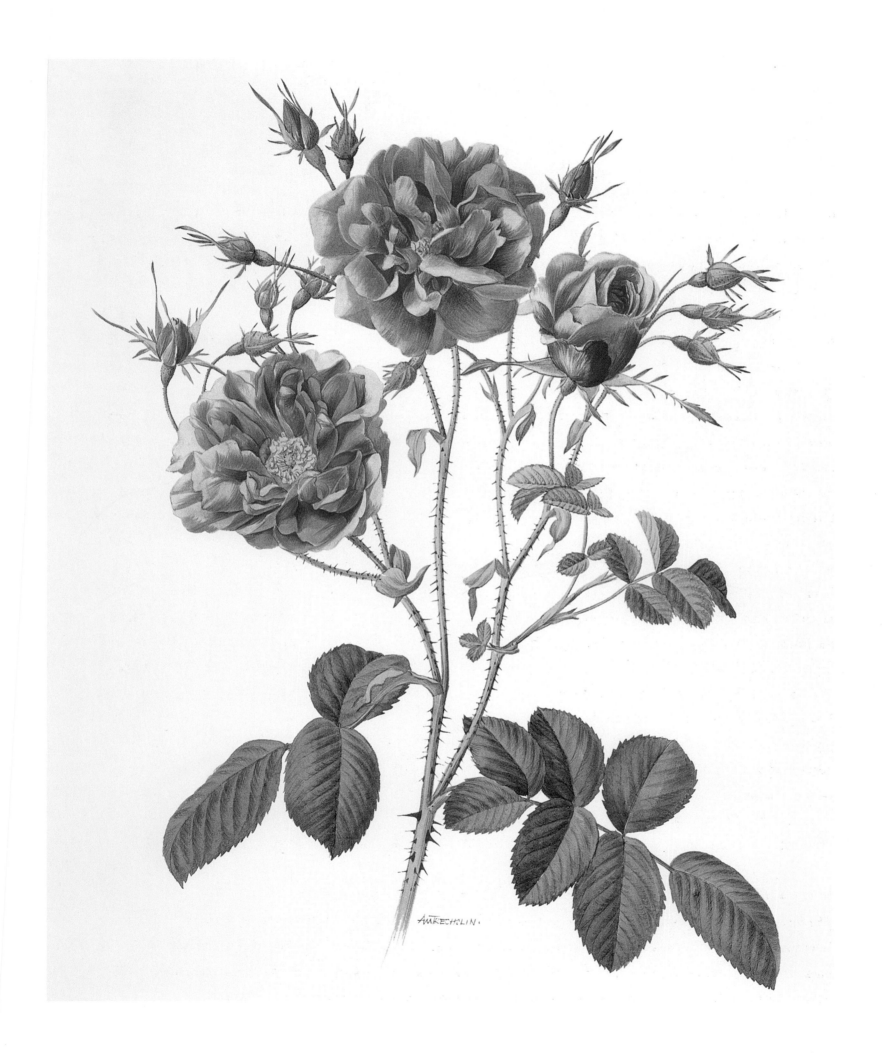

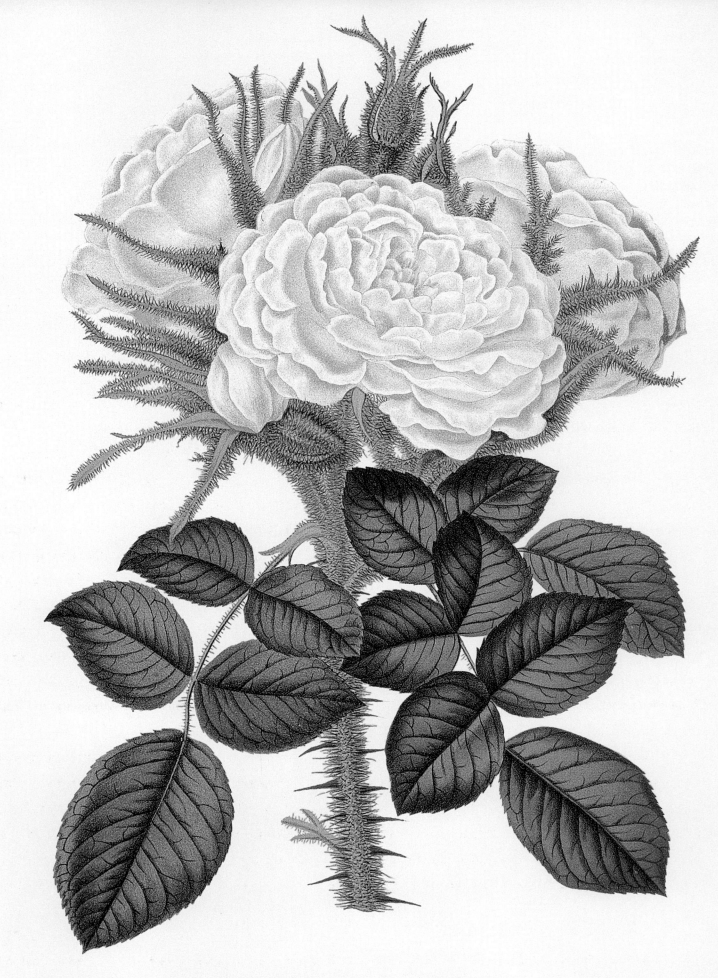

PERPETUAL WHITE MOSS

their favourite plants and placed the species close together. This would increase the chances of interbreeding and make it more likely that any unusual hips would be noticed and safeguarded, their seed sown and any seedlings that came up properly looked after. It seems certain that Persia was the early centre for Damask cultivation, and that from there it spread east to India, south to Arabia and west into North Africa and Europe.

There is another form of Damask that has fewer petals and is not as fragrant, but which is capable of blooming on through the summer and the autumn until forced into dormancy by winter cold. Its botanical name is *R. x damascena bifera* and it has also been called Autumn Damask, Monthly Rose, Quatre Saisons and Rose of Castile. No other Western rose enjoyed so long a period of flower.

Bifera means 'twice-bearing' and rosarians have often wondered how Autumn Damask inherited the ability to repeat its bloom through the growing year. The recent DNA research in Japan revealed that it has the same parents as the summer Damask: (*R. moschata* x *R. gallica*) x *R. fedtschenkoana*. Both Moschata and Fedtschenkoana can produce late blooms, so it is the combination of their genes that has enabled this characteristic to be not only inherited by Autumn Damask but intensified in its expression.

Despite having the same parents, the summer-flowering Damask is unable to repeat its flower. This is not surprising because when a rose is pollinated and seeds are formed each seed contains its individual and unique allotment of the parents' genes. The seeds share the same parents, but when they germinate they will vary, just as brothers and sisters do. The variation may be observed in altered colour, habit, vigour, foliage, degree of scent or any other external factor. The variation might be more fundamental still, with chromosomes actually altering within the plant cells and creating long term implications for the character of their descendants.

Variations are especially likely to occur with hybrids, and indeed one way of testing whether a rose is a species or a hybrid is to see if its seeds breed true, replicating the parents exactly. With Autumn Damask, for example, several variations appeared over the centuries. An improved form emerged in the gardens of Louis XIV and was named Tous les Mois, and by 1838 four colour variations were on offer in blush, pink, scarlet and white. About that time a very curious form appeared with white rather than pink blooms and a soft moss-like growth covering the stems and buds. It is usually referred to by its French name Quatre Saisons Blanc Mousseux; the English call it Perpetual White Moss.

Rivalling the Damask for beauty, scent and economic worth is *R. gallica*, a species described in the previous chapter and an easy rose to cultivate. It is probably the 'Rose of Praeneste', described by Pliny the Elder as 'one of the most famous kinds recognised by our countrymen'. It has been identified in paintings on the walls of Herculaneum and

PERPETUAL WHITE MOSS

This rose resembles a white form of the pinky red Quatre Saisons, with the stems and buds are coated in a furry mosslike growth. In French it is known as Quatre Saisons Blanc Mousseaux and Rosier de Thionville. According to a French gardening journal of 1830–31 it was raised from seed near Thionville by a soldier in 1829, and its character indicated it came from Quatre Saisons. The soldier, called away on service, sold his stock which included a hundred grafted plants. A Mme. Jacquemin offered these locally at 12 francs each. This account antedates the plant's hitherto accepted introduction date of 1835.

Pompeii, where Pliny died in 79 AD after travelling there in the spirit of scientific discovery to see the eruption of Mount Vesuvius at first hand.

At some early but unknown date, a beautiful form of *R. gallica* evolved with larger flowers and more petals. It became known as *R. gallica officinalis*. *Officinalis* is Latin for 'pertaining to a pharmacist', hence its old English name of Apothecary's Rose. Other names that have been applied to it include *R. provincialis*, Provins Rose, Red Damask and Red Rose of Lancaster.

Officinalis is said to have come to Europe at the time of the Crusades. One specific claim comes from France and maintains that the Count of Champagne, on returning from a crusade in 1240, brought *officinalis* to Provins, forty miles from Paris. The townspeople of Provins were quick to grasp its commercial possibilities and developed a considerable industry, offering it for cosmetic, medicinal and culinary uses. They presented dried roses and conserves to the the Archbishop of Sens in 1310 AD, and the names of visitors similarly honoured read like a roll call of French history, from Joan of Arc through Marie Antoinette to Napoleon.

In 1860 the town shipped 36,000 kilos of *officinalis* to North America. Through all this time pharmacists continued to use it. Gerarde's revised *Herball* gave them this state-of-the-art advice in 1636:

Red roses give strength to the liver, kidnies, and other weake intrails; they dry and comfort a weake stomacke that is flashie and moist; staunch bleeding in any part of the body, stay sweatings, binde and loose, and moisten the body. Hony of Roses, or Mel Rosarum, which is made of them, is most excellent good for wounds, ulcers, issues, and generally for such things as have need to be clensed and dried.

So widespread was the consumption of rose products that the four-year-old dauphin Louis, later King Louis XIII, had written to his father Henri IV in 1605, complaining:

Papa, all the apothecaries of Provins have come to me to beg me to ask you, very humbly, to give my company a different garrison post, because my gendarmes like the conserve de roses and I am afraid they will eat it all and I shall have none left. I eat some every night when I go to bed...

A rose called 'Conditorum', also known as 'Hungarian Rose' and 'Titbit Rose', was used in eastern Europe in similar ways to 'Officinalis'. Its Latin name is connected to seasoning and spices. As well as being used for perfumes and other scented products the rose's firm magenta-crimson petals were especially favoured for jams, jellies and tarts. 'Conditorum' was probably brought to the Netherlands by the botanist Charles de L'Écluse, who saw it in Hungary in the 1560s.

ROSA GALLICA OFFICINALIS, APOTHECARY'S ROSE

In a competition to name the most successful rose in history this would certainly be a finalist, as evidenced by the names it has accumulated. It was used of old by Arab pharmacists, probably reached Europe by the mid-thirteenth century, and continues to be widely cultivated as one of the world's favourite old roses. Officinalis is a Latin word applied to plants found suitable for medical use.

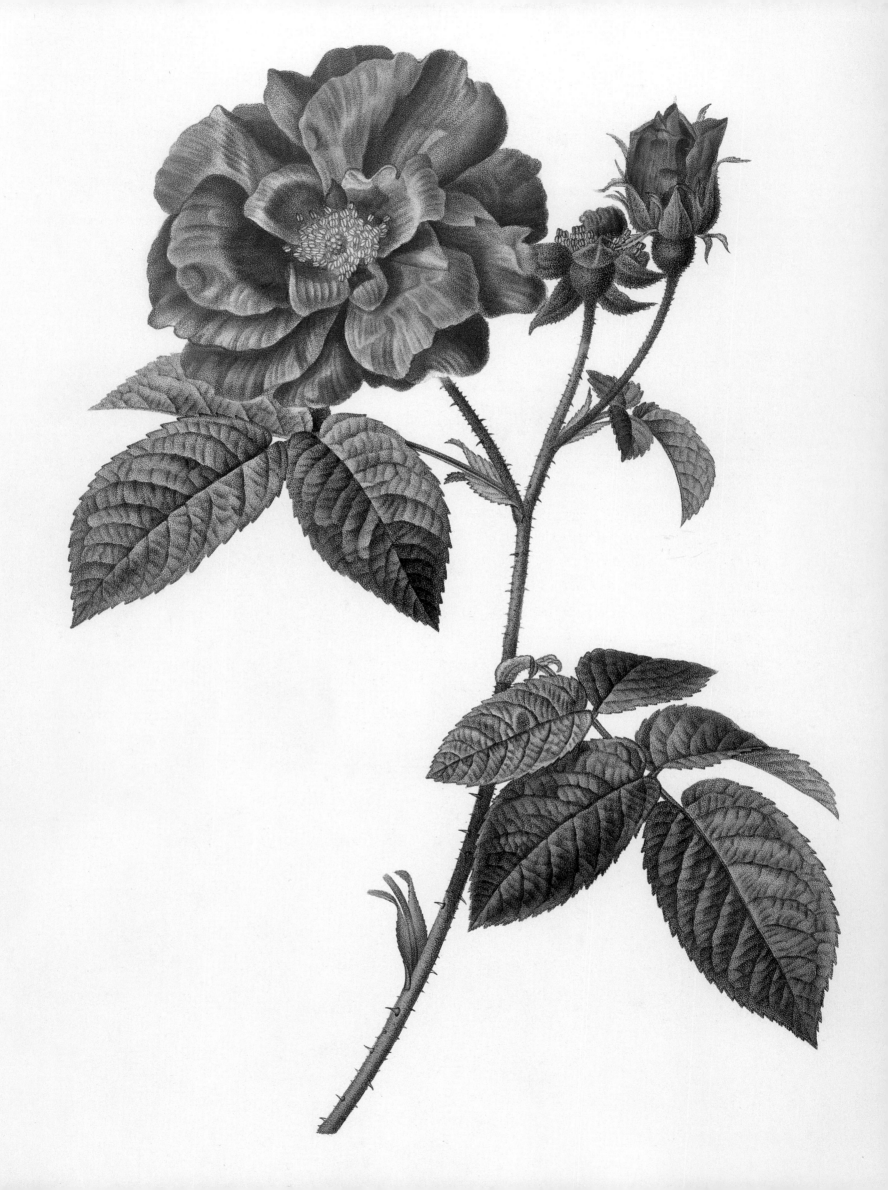

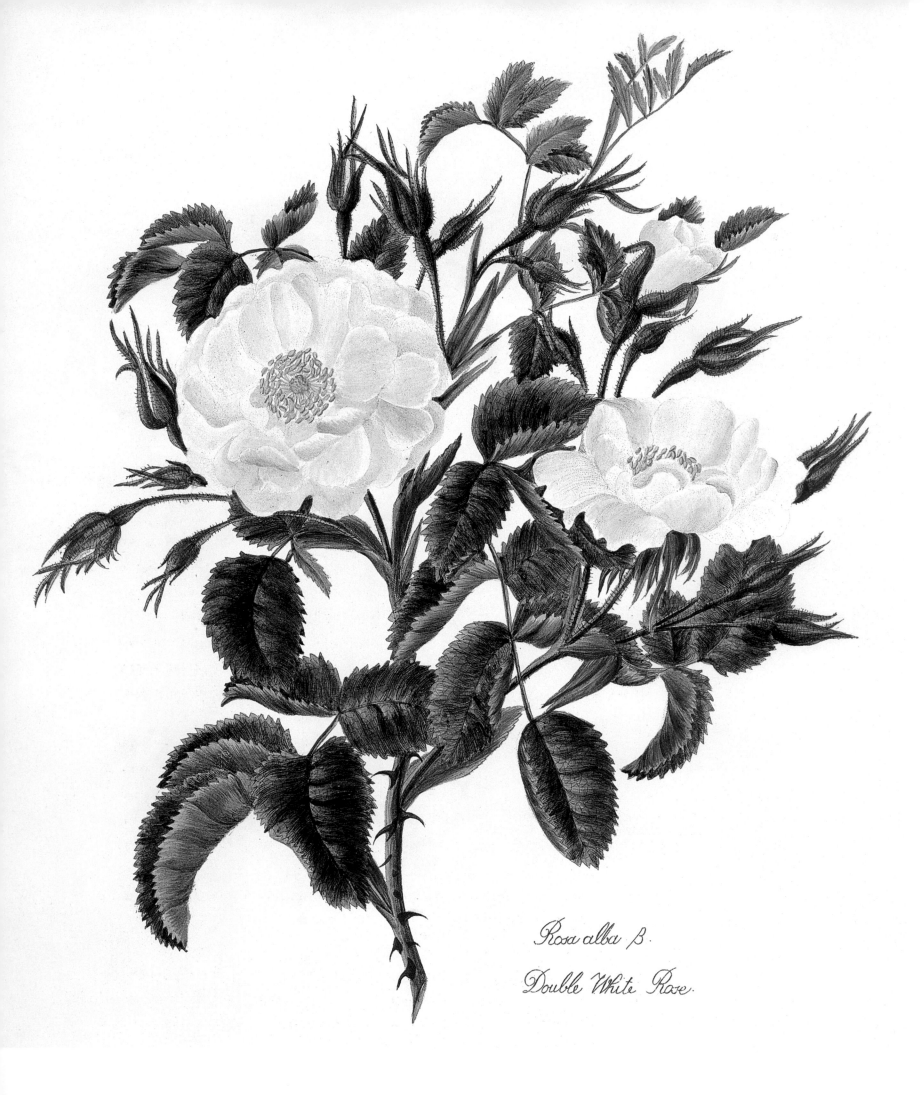

Rosa alba β.

Double White Rose.

In 1583 a beautiful Gallica rose was described which resembled *officinalis* in all respects except that the reddish petals appeared to have white stripes. This was due to a chromosome modification (a phenomenon known as 'sporting') that caused some of the red pigment to disappear, leaving the creamy white petal colour to show through. The rose was named *R. variegata*. Today it is known as *R. gallica* 'Versicolor', a term indicating its ability to revert at random to its 'all red' state, so that often both *officinalis* and 'Versicolor' are seen on the same bush. In 1640 it was painted by Nicholas Robert for Louis XIV under the name 'Versicolor'. According to *The Garden Book* of Sir Thomas Hanmer, published in England in 1659, it was 'first found in Norfolk a few years since upon a branch of the common red rose', a phrase that perfectly describes the appearance of a sport when the chromosomes have misbehaved.

In the seventeenth century the Netherlands became a major centre for rose growing. Thanks to the tendency of cultivated Gallicas to produce spotted, marbled, striped and variegated forms (such as *R. gallica* 'Versicolor') and to hybridise readily with their neighbours, a wide selection was available by the end of the eighteenth century. The following half-century saw an extraordinary explosion in their popularity.

The catalyst was a declaration of war by France against the Netherlands in 1792. France had occupied the Netherlands in violation of existing treaties, and the continental blockade that ensued left both countries isolated and forced to develop strong trade links with each other. Gallicas became fashionable, and to woo a promising new market the Dutch published catalogues in French and gave varieties revolutionary names like 'Tricolore'. French nurserymen saw the commercial opportunities and began to learn the skills of raising and selecting roses. It was not long before France had become the world centre for rose cultivation. The largest grower was Desportes, who in 1828 listed over 1200 Gallicas, and even more in the next decade. That was the peak of their popularity. Fewer than 300 Gallicas exist today.

White roses were popular, and the most widely grown were Albas. The Alba rose does not exist in the wild and chemical analysis has shown that it derives from one of the Caninae, probably *R. corymbifera*, which has similar downy leaves. The other parent is assumed to be *R. gallica*. It bears five-petalled white flowers in summer on rugged leafy plants and is very hardy. The old herbalists used the Alba rose medicinally, especially for ointment to soothe the eyes.

Albas are wonderfully strong, easy plants to grow, with tough greyish green leaves and upright clusters of blooms, which are blush pink in bud, opening white and sweetly scented. Their only serious weakness is a tendency to rust. Two ancient forms are particularly good in the garden. 'Alba Semiplena' has up to a dozen petals, is robust and hardy, and is sometimes planted to make a hedge around Damask roses to pro-

ROSA X 'ALBA SEMIPLENA', DOUBLE WHITE

The five-petalled Rosa x alba *occurred as a natural hybrid, probably with parentage of* R. corymbifera *and* R. gallica. *When such roses are cultivated, there can be aberrations, or sports, in which the number of petals is increased because of better growing conditions and human intervention in selecting unusual forms. That this is how 'Alba Semiplena' evolved is evident from the fact that seedlings from it show sometimes five petals and occasionally more. During the early nineteenth century in France, seedlings were raised from it for use as understocks for other garden roses.*

tect them from wind and cold. Its scented flowers are also used in making rose products. 'Alba Maxima' is similar except that it has many petals, and full-petalled white roses depicted in medieval illustrations and paintings are almost certain to be this one.

In the early sixteenth century a beautiful new white rose began to circulate in Europe. Although it was given the species name *R. moschata* there is no convincing evidence that it ever existed in the wild. The flowers, borne in big panicles, are milky white and sometimes have five petals, sometimes more, a variation that hints at a hybrid origin. Their fragrance is faint yet penetrating, rather tart and dry, and supposed to resemble the highly valued scent of the musk deer. Indeed the name Moschata is said to relate to the Sanskrit *mushka*, the receptacle where the deer's musk is held. If true, this lends weight to another supposition, that Moschata came from Persia, home to a form called Nastarana, meaning 'white rose' or 'musk rose'.

Opinion is divided over when the Musk Rose came from the East to Europe. One source states it came via Spain to England in 1521. Another that Thomas Cromwell shipped it home to England while working for a Venetian merchant house before 1513. In any event, by 1565 the rose was in Germany, and by 1586 its picture had been published in France as Rose Muscade.

In addition to its important role as a begetter of the Damasks, *R. moschata* is an ancestor of several subsequent rose groups, including the Noisettes, other climbing roses and, even

further removed, the hybrid musks. One distant relative is *R. x richardii*, a delightful rose found in Ethiopia. It is thought to be a hybrid, perhaps a result of crossing *R. gallica* with *R. phoenicia*, a white sprawling species related to Moschata.

R. x richardii bears white or pale pink flowers that open wide to display gold stamens on low leafy plants. Some historians suggest that it was brought to Ethiopia by Christians who had travelled from Asia Minor in the fourth century AD. This would account for its other names *R. sancta*, Holy Rose and Saint John's Rose. In Ethiopia it is traditionally grown around churches, and the petals are collected by priests and mixed with incense for religious use.

In the year 1603, a Flemish artist laid down his brush, having painted for the first time a new, deep-pink rose. It was rounded and deeply cupped in shape, and differed from all previous roses because of the large size and number of the petals. And there was a quality the artist could not show, a heady and delightful fragrance. In this and in other ways it showed affinity with the Damask rose, as Gerarde pointed out in the 1597 edition of his *Herball*:

> *The great Rose, which is generally called the great Province Rose, which Dutchmen cannot endure; for they say, it came first out of Holland, and therefore to be called the Holland Rose: but by all likelihood it came from the Damask Rose, as a kind thereof, but made better and fairer by art...*

ROSA X RICHARDII, HOLY ROSE

The other names of this rose include St. John's Rose and Rosa Sancta, reflecting its links with religion and Ethiopia, where in Tigré province it has been traditionally grown near churches and monasteries. Both blush pink and white forms occur. Preserved at Kew Gardens in London are remnants of rose wreaths found when graves, which dated from 170 AD or later, were excavated at Hawara in Egypt in 1888. These poignant relics have points of similarity with R. x richardii and are illustrated in The Quest for the Rose *by Roger Phillips and Martyn Rix with flowers of R. x richardii adjacent.*

The new rose was *R.* x *centifolia*, but where had it come from? The earliest record states that Charles de L'Écluse, always an energetic seeker after new plants, knew of it in Holland in the 1580s. Such a distinctive rose was in great demand and gathered new names on its travels. As its beauty was so often depicted in paintings (and on all manner of items since then, from eighteenth century porcelain to twenty-first century biscuit boxes) it was dubbed Rose des Peintres. The British gave it the down-to-earth descriptive name of Cabbage Rose. Centifolia means 'hundred-leaved', meaning one hundred petals, and it lacks normal reproductive parts in the centre of the flower because they are displaced by all the extra petals.

A beautiful variation is *R.* x *centifolia muscosa*, or Common Moss, which takes its name from the soft furze that covers the stem, bud and calyx. This was first noticed about 1696 in France and is also known as Communis and Old Pink Moss.

Other Centifolias popular in the early 1800s include the pink 'Petite de Hollande', in which the size of the flowers is charmingly scaled down, and 'Spong', named after the gardener who discovered it. This particular form of the plant is reduced in size in all its parts. 'Robert le Diable' features a mélange of purple, grey and streaky cerise tints that probably reflect Gallica influence. It first appeared in a Parisian grower's catalogue in 1837 and may have been named for a gala occasion when an opera of that name by Meyerbeer was performed in the city in 1831.

Another Centifolia, with only a few petals, had room left within the flower for functioning reproductive parts. From its seed came a group of dwarf roses. They bore sprays of small rosettes in various shades from rose to deep pink, and were very popular in the eighteenth century. 'Pompon de Bourgoyne' and 'Rose de Meaux' were particular favourites, foreshadowing the most petite of the roses of today, the Miniatures.

A relative of Centifolia, Gallica and Damask is the Portland Rose, which is something of an enigma as it has acquired eight different names: *R. Paestana*, *R.* 'Portlandica', 'Duchess of Portland', Portland Crimson, 'Monthly Rose', 'Portlandia', 'Portlandica', and 'Rosier de Portland' as well as Portland Rose itself. Descriptions of this rose in literature do not tally. It is said to originate in Dorset, or in Beaconsfield, or perhaps in Naples, in the 1770s or 1790s. Its parentage has been said to involve Gallicas alone, or a Damask and a Gallica, or a China and a Damask.

These inconsistencies could be explained if in fact there were two different Portlands. The first Portland very likely originated at Bulstrode near Beaconsfield, England in the gardens of the ducal Portland family. It was readily available in 1775 when it was being sold both as 'Portland Crimson Monthly' and 'Portlandica'. In 1782 it was catalogued as 'Portland' and was relatively inexpensive at a price of one shilling, suggesting it was not a recent novelty. The plants formerly at the gardens of the Royal National Rose Society under

PORTLAND ROSE

André Dupont, gardener to Empress Joséphine, received this rose from England in 1803 and was calling it Rosier de Portland by 1809. It reached him despite the continental blockade, perhaps given a fair wind by the duke of Portland who held high government office. For a rose with Damask and Gallica parents its red colour is unusually bright. There was speculation that this was due to genetic input from a Chinese red variety, but this has been discounted by DNA tests. A pinky red 'Portland' known since the 1770s appears to be a different rose.

the label 'Duchess of Portland' were almost certainly this very rose. Their deep, reddish pink flowers, leaves and general habit showed affinities to Gallica, and their modest extended period of flower reflected Damask influence.

Another Portland rose, grown at Bagatelle in Paris as *R. Paestana*, has a different aspect. The colour has tones of crimson, a smaller flower and prominent yellow stamens. Its origins are uncertain. One story says the third duchess of Portland brought it from Italy to England in about 1800, which cannot be true because she died in 1794 and there was no duchess until 1809. What is known is that André Dupont, gardener to Empress Joséphine, received a plant from England in 1803, and by 1809 was calling it Rosier de Portland. Rose illustrator Redouté depicted it under that name. The brightness of its colour led some to suppose that one parent was a red rose from China, though in general aspect, foliage and hips it shows more relationship to Damask. Recent biochemical and DNA analysis of five Portland roses by Olivier Raymond at University Claude Bernard in Lyon, France, shows the Portland roses relate to Damask, Gallica and Centifolia, but not to China roses.

A full-petalled yellow rose came to Europe through Charles de l'Ecluse, who worked in the imperial gardens in Vienna from 1573, travelled widely seeking out new plants. At a Turkish exhibition in Vienna he noticed a finely executed paper model of a garden, and his interest quickened when he saw that it contained a replica of a yellow rose. Unlike *R.*

foetida, which he had already discovered on his travels, this flower had many petals. If there was a rose that truly matched the model, he was determined to find it.

It took some years before he finally acquired the rose of his dreams in 1601. *R. hemisphaerica* proved a mixed blessing, for in cool weather the buds refused to open, and in wet conditions the sulphur yellow petals would stick together, causing the flowers to ball and rot. Blooms that did succeed in opening were too heavy for the slender stalks, and the plant's overall appearance was unsightly. Moreover it was difficult to propagate and its hardiness was suspect. Nevertheless a way was found of catering for the weakness of so sensational a novelty. The answer was to grow it under glass and give it appropriate support. This succeeded so well that for many years it bolstered the florist trade in Italy and France. It was successfully introduced in England in 1695 after several failed attempts.

When *R. hemisphaerica* is viewed from the side, the flower appears to be in the shape of half a sphere, which explains the reason for the name. It is not a true species, but a garden form derived from *R. hemisphaerica* var. *rapinii*, a native of Turkey, Armenia and Iran. Other names for it are *R. sulphurea* and Yellow Provence Rose.

A yellow that was brighter and easier to grow was brought to England from Iran by Sir Henry Willock, Chargé d'Affaires in Tehran from 1815 to 1826. It had been known for many years as a garden rose in Persia and is depicted on a piece of

ROSA X CENTIFOLIA 'PETITE DE HOLLANDE', 'PETIT JUNON DE HOLLANDE'
This resembles a scaled-down version of the Centifolia rose, and perhaps came from Holland, as the names suggest, towards the end of the eighteenth century. It is summer-flowering, sweetly-scented, and neat and compact in growth, reaching about 40 inches (1m) in height and width when established. It flowers freely and was a great favourite with Parisian nurserymen who grew it in frames to provide cut blooms for the florists in springtime.

PERSIAN YELLOW.

(Tribu des Rosiers Capucines).

seventeenth century embroidery from Isfahan, Iran. When Willock acquired it is not clear, but he sent it to the Royal Horticultural Society's Gardens in 1836. It was given the botanical name *R. foetida persiana* and is commonly known as Persian Yellow. It bears rich, bright yellow flowers that are globular in form and full of petals, and would prove a valuable breeding tool before the century was out.

A novel group of roses was emerging in a very different climate. In 1793 Robert Brown of Perth in Scotland gathered plants of *R. pimpinellifolia* from nearby Kinnoull Hill, put them in his nursery, looked for flowers that showed variation in petallage or colour, collected their ripened hips, sowed the seed and looked again. Like all good gardeners he was a patient man and after ten years he was in a position to advertise for sale eight full-petalled items, described as:

…the small white, the small yellow, the lady's blush, another lady's blush with small foot-stalk, the red, the light red, the dark-marbled, and the large two-coloured…

Other nurseries obtained stock and in 1817 one firm was offering 208 varieties. Hundreds more were to follow but all that now remain of them are a few meritorious survivors. One such 'William III', lives on at the Oxford Botanic Garden. It makes a low twiggy bush with abundant flowers that range in colour from an extraordinary purple crimson to lilac pink against a background of greyish leaves. There is uncertainty over which William III is being remembered here, but an obvious candidate is the William III who ruled Holland from 1849 to 1890 and sought to make his garden at Het Loo stand comparison with Versailles. Another favourite Scots rose is 'Williams' Double Yellow' which probably has *R. foetida* as its seed parent. That would account for the richness of its yellow.

The most widely grown Scots rose is undoubtedly 'Stanwell Perpetual', which was found as a seedling by plantsman James Lee at his nursery at Stanwell in Middlesex, England about 1835. As the name suggests, it repeats its flower over a long period, indicating that it may have Autumn Damask in its ancestry. The flowers are sweetly scented, light blush in colour and full of tiny petals nestling against a background of small grey leaflets.

This is one of the few Scottish roses to have retained popularity. Towards the end of the eighteenth century, roses from the Far East filtered through to Europe. The Scots roses with their transient early summer flush had no chance against Chinese roses with their extended period of bloom. As early as 1771 William Malcolm's English nursery was offering 'Evergreen Chine' and 'a new Chine'.

The first news of horticultural endeavour in China comes from the third millennium BC, when cultivation is said to have begun under the emperor Chin-Nun (2737–2697 BC). Roses in the imperial garden are mentioned by Confucius, who lived

ROSA FOETIDA PERSIANA, PERSIAN YELLOW

Sir Henry Willock obtained this rose in Persia and it was received by the Horticultural Society of London in 1836. Fifty years later Pernet-Ducher of Lyon acquired it as a possible source of bright yellow in his breeding work, for that colour was absent from hardy garden roses of the time. His persistence paid off, opening the door for other raisers to use his 'Pernetiana' strain in achieving the multitude of bright yellows available today.

551–479 BC, but the first story of a cultivated rose comes from the time of Emperor Wu Di, one of China's most powerful rulers who died in 86 BC. The emperor brought his concubine to see a favourite rose and compared its beauty to her smile. After a teasing exchange he gave her a generous present of gold. The rose in the story was ever after known as 'Mai Xiao', meaning 'to buy a smile'.

The rose garden was in the emperor's capital of Rong'an, near the starting point of the trade route to the West, popularly termed the Silk Road. Evidence of substantial trade with imperial Rome comes from Pliny the Elder, who criticised his countrymen for their extravagant purchases of Chinese silks. Goods of many kinds were traded in the centuries that followed, including fragrant herbs and spices. Certainly rosewater travelled from China as far as India. An inscription of 1244 AD tells that the local king waived customs duty on rosewater, but there is no record of rose plants being transported.

Travel along the Silk Road was frequently disrupted, and a maritime route evolved in southeast China with the port of Zaitun (later Canton, now Quangzhou) as its nexus. A few species roses exist in the humid climate of that coast, but those from which garden roses were evolving were in western China, too distant from the ports to be attainable by traders. The most fertile growing areas in China are the central to southwest regions of Yunnan, Sichuan and Gansu. They are so rich in flowering plants that Yunnan alone is estimated to hold half the

thirty thousand species of Chinese flora. Among them grow species roses, remarkable for their beauty and diversity, and it was here that the choicest ones were tended by generations of Chinese gardeners. A favoured method of propagation was to take cuttings and grow them in pots, often on verandahs. This treatment preserved the roses more successfully than if they had been planted in the open ground.

The teachings of Buddha championed horticulture, and small flower gardens were encouraged as places for spiritual refreshment. This is reflected in a poem of Hsieh Lung-yiu, describing his rural retreat in 410 AD:

'I have banished all worldly care from my garden …I have dammed up the stream and made a pond…I have planted roses in front of the windows, and beyond them appear the hills.'

One Chinese rose grower, Lo-yang, became celebrated for his garden, which boasted forty-one varieties by the time of the Sung dynasty (960–1276 AD). When species and varieties are growing close together, natural hybrids are more likely to occur. Chinese roses often grow readily from seed, and the most momentous union for the future of the rose was the combining of genes from Gigantea and Chinensis. This may well have happened in gardens like Lo-Yang's, leading in the course of time to the evolution of new bushes, climbers, shrubs and miniatures. There was also a tendency for variation among

CHINESE GARDEN ROSE

In 1812 John Reeves, a keen student of natural history, was posted to China as an inspector of tea in the service of the East India Company. His desire to study and record the local flora was severely limited by restrictions on the movement of foreigners, and he trained native Chinese to travel and bring him specimens. He commissioned artists to depict them and among the Lindley Library's most treasured possessions are portfolios containing the results of this work. Several items, like this Chinese garden rose, cannot be identified with certainty.

the seedlings, giving rise to mutations and changing petal colours. There was a wide range of rose colours – ancient lists include white, yellow, lilac, scarlet, crimson, murrey, apricot, every shade of pink and various blends of these colours. Many of the bushes flowered for several months of the year.

Awareness of these treasures was slow to reach Western botanists, partly because few roses were available near the south-east ports, and those that were often failed to survive the long voyage home. However there are tantalising suggestions of some early transfers.

A painting of 1529 by the Florentine Angelo Bronzino contains what resembles a pink China rose. 'A rose that produces flowers every month' is mentioned in *Flora Ovvero Cultura di Fiori* published in Siena in 1638. Although it may refer to Tous les Mois, a form of Autumn Damask, it is interesting to note that Sir Thomas Hanmer's book of 1659 mentions a rose named *Rosa Sinensis*, which had been brought as seed from the East Indies and grown in Italy for the past twenty years. Whatever the facts, the roses failed to make a lasting impact at the time. When they finally did begin to appear in Western gardens their popularity spread rapidly, delighting and sometimes astonishing those who grew them.

Imagine the surprise of Western rose growers when they saw the beautiful bright crimson 'everblooming China rose', *R. chinensis semperflorens*. No Western rose could match its colour because none had such pigmentation in its genes.

Nor could any Western rose sustain the long and repeated cycle of flowering, which led the Chinese to call it Monthly Rose. There seems no doubt it derives its rich red and general character from the climbing species *R. chinensis* var. *spontanea*, but as that species is summer flowering only, how could it have produced repeat-flowering offspring? One answer is that if it mutated into a bush form there is a good chance that the bush would repeat its flower, with its energy devoted to producing flower clusters instead of climbing stems and leaves.

Monthly Rose was seen in the Botanic Gardens of Calcutta by a captain in the East India Company. He took it to back to England and presented it to a director of the Company, Gilbert Slater of Leytonstone, near London. It flowered there in 1791, and though Slater died very soon afterwards his name was on many lips because the rose was sold as 'Slater's Crimson China'. Its novelty made it irresistible despite its perceived tenderness and frailty in a cooler climate. In France they called it La Bengale because of the connection with Calcutta.

Many roses were raised from it in the nineteenth century, but the variety itself seemed lost. Then, in 1953, an American rosarian named Richard Thomson visited Bermuda and was shown a mystery rose. After research he felt able to confirm that this was indeed the missing *R. chinensis semperflorens*. The Bermudians know it as 'Belfield' after the house where it grows against a wall.

ROSA CHINENSIS VAR. SEMPERFLORENS, 'SLATER'S CRIMSON CHINA'

It is not hard to imagine the delighted reaction from Western rose enthusiasts when they first caught sight of this glorious bloom in the late eighteenth century. The rich red colouring of its petals was considered quite incredible, as no native Western rose had such pigment in its make-up. A description in 1811 refers to it as 'the crimson or purple China', an indication that 'purple' implied a more reddish tone then than it does today.

When seeds of *R. chinensis semperflorens* are sown they produce colour variations. One of these variants is a red flower with white in its centre and is known as 'Chi Long Han Zhu', a charming name which translates as 'With a Pearl in the Red Dragon's Mouth'. In Europe this rose is known less imaginatively as 'Willmott's Crimson'.

Another renowned China rose was collected in Quangzhou by Peter Osbeck, a ship's chaplain and pupil of Linnaeus, and shipped to Upsala in Sweden in 1752. Known as Old Blush and also as Common Blush China, Monthly Rose and Parsons' Pink, it is a cool and pretty shade of pink, bearing sprays of neatly formed buds that open into cupped flowers with long, lightly veined and silky textured petals. It is one of the best roses for repeating its flower and makes an excellent garden plant with restrained growth and shiny pointed leaves. 'One of the greatest ornaments ever introduced to this country,' was the verdict of Henry Andrews, writing after he saw it in Mr. Parsons' garden at Rickmansworth, England. By 1823 it was said to be in every English cottage garden. Lack of fragrance and the susceptibility of those attractive leaves to blackspot were overlooked amid the general praise.

The parentage of Old Blush has been determined by DNA as *R. gigantea* x *R. chinensis semperflorens*. Therefore it inherits repeat-flowering genes from both parents, restrained growth from Semperflorens, and genes for large flowers with elegant pointed buds, as well as vigour, from Gigantea. That it did not inherit its parents' tender nature is certainly a lucky outcome because it proved a fertile parent in its turn, with momentous consequences for the history of the rose. It gave rise to Bourbons, Noisettes, possibly the Teas and by extension the Hybrid Teas, Floribundas and others. It is an ancestor of almost every cultivated rose of the present day, with the exception of the roses that originated in the West.

Resembling Old Blush in growth and thought to be a freakish variant, is a rose the Chinese call 'Lu E', which means 'green calyx'. To botanists it is *R. chinensis* 'Viridiflora', and in common parlance 'Green Rose'. Its flowers are not true flowers, for they have neither stigmas nor stamens, and the narrow 'petals' are modified leaves, fresh green when they open and turning brownish purple as they age. Although found in lists of old Chinese roses, it is usually attributed to a source in the United States. It was being grown in South Carolina by 1833.

The Chinese practice of growing rose cuttings in pots may account for the development of a miniaturised form that reached England in 1810, though whether it actually originated from China or was raised in Mauritius is unclear. It was recorded as *R. chinensis* 'Minima' but renamed in honour of Mary Lawrance, illustrator of *The Various Kinds of Roses Cultivated in England* (published at the end of the eighteenth century and a valuable record of roses then in cultivation).

LAWRANCIANA POMPOMS

The accompanying text to this illustration of 'Roses Pompons' in Belle Roses *explains that the white variety, a petite grower like the others, was raised by Margottin and known as 'Noisette a Fleurs Blanches'. The other two roses are true Lawranciana, little beauties of which thousands were being sold every year according to William Paul in 1848. They were derived from* R. chinensis minima, *or Miss Lawrance's Rose, which reached England in 1810. They later died out but one was rediscovered by chance in Switzerland by Dr. Roulet. The rose was named 'Rouletii', and with 'Oakington Ruby' (found near Cambridge a few years later) it is thought to be the only survivor of the Lawranciana era. From these two descend today's Miniature Roses.*

When seeds of 'Minima' were sown they produced a range of white, pink and red varieties, and in due course dozens of these were sold under the general heading 'Lawrancianas'. They then dropped out of general cultivation with the exception of a climbing form, 'Climbing Pompon de Paris'.

One rose demonstrates more than any other the variability of colour within the genes of this group, R. chinensis 'Mutabilis'. The way its simple flowers change colour from chamois-yellow buds to pink and soft crimson before the petals fall never ceases to amaze. This factor, together with its leaves, slender stems and rather spindly appearance, show its affinity to the China rose. Gigantea may also be in the parentage.

'Mutabilis' was known to be in north Italy in the 1890s but how it got there was a mystery until recently. Detective work by Helena Pizzi revealed that it was collected on the island of Réunion by plant hunters working on behalf of Prince Vitaliano IX Borromeo, an amateur botanist residing at Isole Madre, Lake Como. The date of acquisition has not been established, but the Prince died in 1874. His son Prince Giberto exhibited the rose in Geneva in 1894 and gave one to Henri Corrévon of Geneva who suggested the name 'Mutabilis' because of its colour changes. It also has another name, Tipo Ideale, which means 'Ideal Rose' in Italian. This caused confusion, because there was another rose in Italy of that name, a white Centifolia, known in France as 'Unique Blanche'. When Redouté painted 'Tipo Ideale' he depicted the Centifolia.

The presence of 'Mutabilis' in Réunion is not surprising because ocean islands were ports of call for sailing ships and roses followed the seaways of the world. Similarly Bermuda received many plants from ships travelling from China. These have become naturalised there in the congenial climate and have been safeguarded by the island's small but active rose society. Among the China roses on the island is 'Bermuda Kathleen', growing at Heydon House. It is reminiscent of 'Mutabilis' and thought to be its seedling, but could just as easily have been another Chinese garden variant dropped off for a garden lover at the port of call.

A prime source of the China roses that were being shipped through the trading routes was a nursery called 'Fa Tee', which means 'Flowery Land'. Potted plants in flower were always available for sale there thanks to the mild climate of the area. The nursery was situated on the estuary of the Pearl River and was readily accessible from Macao, where the agents of the East India Company lived. They had been permitted to trade upriver in Canton (now Quangzhou) since 1698, but their movements were restricted within an area of some 1000 feet x 500 feet (308m x 154m). In the early nineteenth century the agents were allowed not more than three visits a month and had to pay handsomely for that opportunity.

Roses were for sale the nursery, and could be bought in their containers or transported in specially designed cases. John Livingstone of the East India Company advised repotting them

ROSA CHINENSIS 'MUTABILIS', 'TIPO IDEALE'

Recent research indicates this rose came from the island of Réunion in the mid-nineteenth century, was taken to Italy on behalf of Prince Borromeo and disseminated from his home at Isole Madre on Lake Como. The finding of garden plants in China by the Japanese botanist Ogisu also supports the belief that it originally came from there. The flowers exhibit wonderful colour changes, darkening from ochre yellow through pink to slate purple. It can be grown as a modest sized shrub or a climber according to location and climate.

in better soil and growing them in Macao to give them the best chance of surviving their next move, which might be to Calcutta, en route for home.

John Reeves was an Inspector of Tea for the Company. He was a keen plantsman, and the collection of paintings he commissioned from Chinese artists between 1812 and 1831 forms a valuable record of the plants, including a few roses, in the Quangzhou area. He made visits to Fa Tee and employed Chinese agents to travel inland. In the course of his researches Reeves acquired a blush pink rose with silky-textured petals, elegant pointed buds and a spicy 'tea' scent. The size and texture of the petals point to *R. gigantea* as one parent, most likely from the scented strain growing in Yunnan. The character of the plant indicates that the other parent is a China Rose.

Reeves sent it to an English collector of oriental plants named Sir Abraham Hume, who planted it on his Hertfordshire estate where it bloomed in 1809. It caused great interest because it was large and shapely yet was able to repeat its bloom in continuing cycles of growth and flower. It came to be known as 'Hume's Blush Tea-Scented China' (often shortened to 'Hume's Blush') and botanically as *R. x odorata*. In time it proved rather tender, however, and was superseded by hardier and equally beautiful descendents.

The term 'tea-scented rose' was coined by a Frenchman called Le Rouge who in 1820 described the rose as being 'à odeur de Thé des Indes'. The phrase probably refers to the delicate tarry aroma of a good China tea with an admixture of herbs, especially noticeable when a new packet is opened or the tea freshly brewed. Others suggest the name was inspired by the scent of a tea leaf from a growing bush, or even by the tea chests in which plants were shipped.

Professional botanists came to China in the early nineteenth century with instructions to seek out specific plants. John Parks was employed by the Royal Horticultural Society to do just that and in 1824 he transported back to England a light yellow counterpart of 'Hume's Blush' known as 'Parks' Yellow Tea-Scented', or 'Parks' Yellow'. There were few yellow roses in the West, and none with elegant pointed form, so this was considered unique until it in turn was supplanted by hardier descendants.

As early as the twelfth century, China roses had also made their way to Japan, which developed a lively rose-growing culture. The first mention of roses in Japan is contained in a poem, one of a thousand poems collected in an eighth-century work entitled *Manyoshu*. The lines of verse translate as: 'How can I separate from you who embrace me like pea vines, twining round as the thorns of roses?' The word used by the poet for 'rose' denotes 'Noibara' or 'White Rose' and is a reference to *R. multiflora*, a native plant.

Although there are fourteen other rose species native to Japan, the Japanese showed an early preference for imported plants, which were regarded more highly. These they called

ROSA X *ODORATA*, 'HUME'S BLUSH TEA-SCENTED'

This ancient and beautiful Chinese garden rose appears to be a hybrid between a strain of R. gigantea *and a cultivated descendant of* R. chinensis var. spontanea. *Alexander Hume, head of the East India Company trading post in Quangzhou, arranged through John Reeves for it to be sent along with other Chinese plants to his cousin in England, Sir Abraham Hume, who was a keen gardener. It first flowered in the west in 1809 and won immediate praise from European gardeners for the novelty of its pointed buds, long petalled, silky-textured flowers and ability to flower repeatedly until stopped by cold weather.*

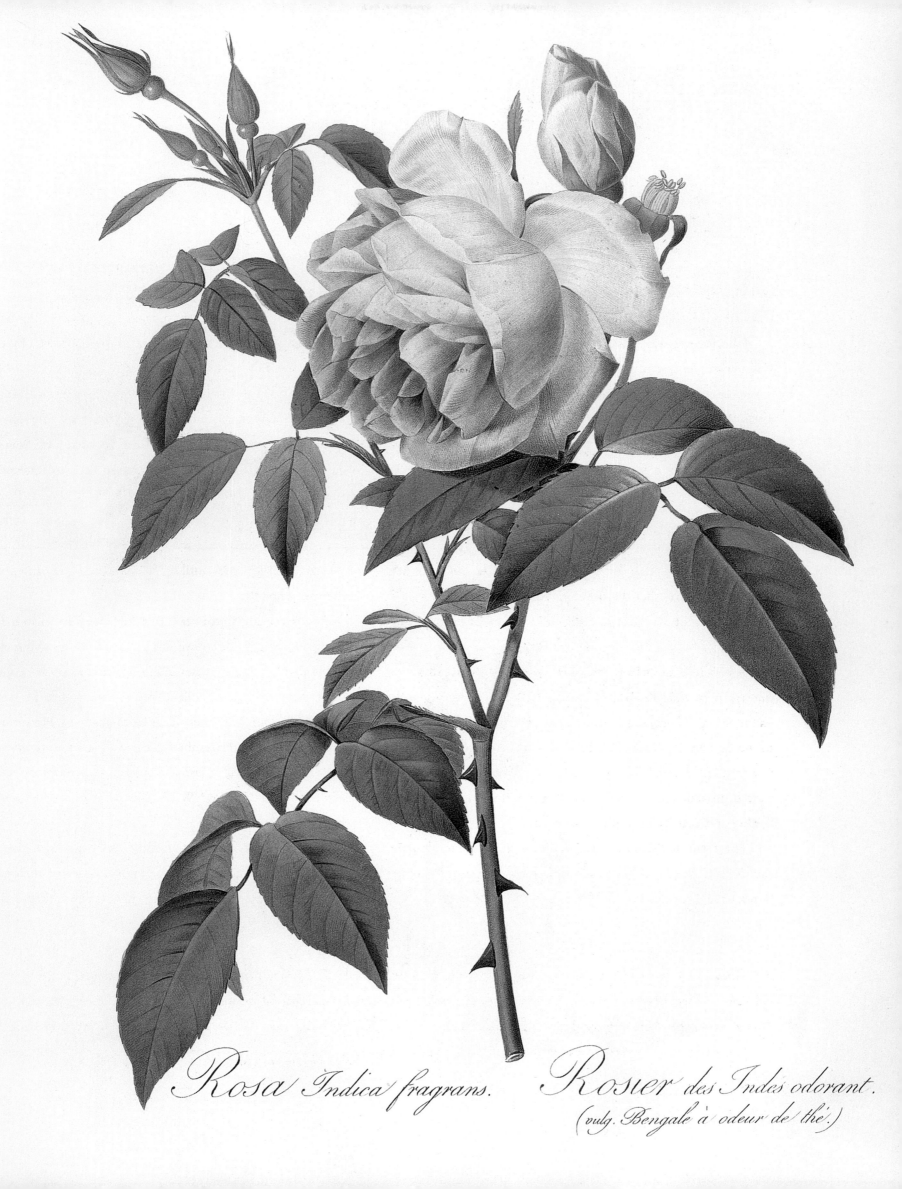

Rosa Indica fragrans. *Rosier des Indes odorant.*

(*vulg. Bengale à odeur de thé.*)

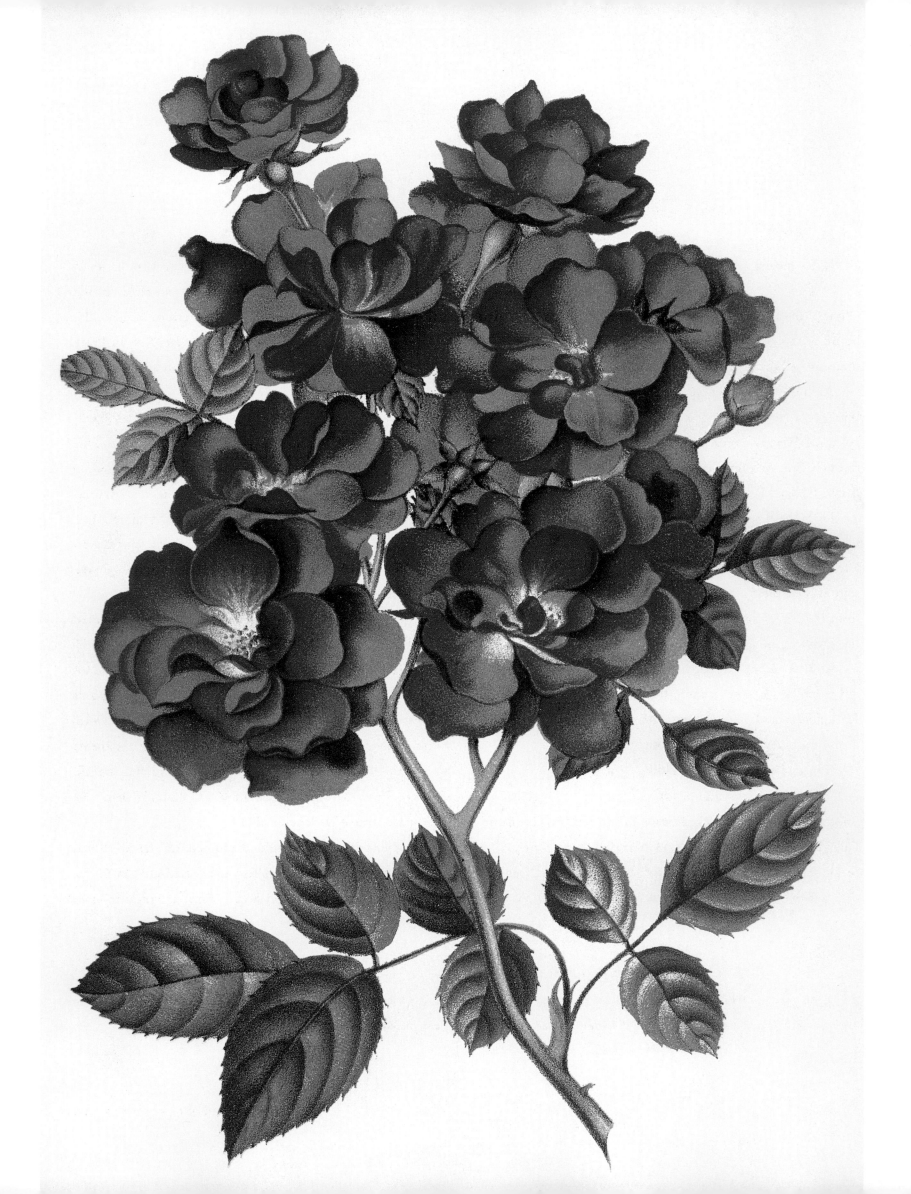

koshinbara meaning 'roses which flower for sixty days'. It is assumed that they were repeat-flowering pinks and reds from China. Fujiwara Teika (1162–1241) used a similar word when he made this observation in his diary: 'In December in 1213 there are still roses with red petals under the fence.'

As in China, roses in Japan were grown from cuttings, and books on their care were appearing in the seventeenth century. Some Western roses were acquired at this time, perhaps through Christian missionaries. One was *Oranda-ibara*, which means Holland Rose.

From the seventeenth century to the mid nineteenth century Japan closed its doors to external influences, as Christianity was regarded as a threat by the Shogun regime. In spite of this, the Swedish botanist Thunberg did stay in Japan from 1775–77. He took the opportunity to conduct a study of the flora and published the results in 1784. He also introduced *R. rugosa* to Europe. This was the first of Japan's four direct contributions to rose history, the others being the species *R. multiflora* and *R. wichurana* and the rambler they called *Sahura-ibara*, meaning Cherry Rose.

This last was a form of Multiflora, one of several cultivated for their beauty in midsummer, when their trailing stems are smothered in densely packed heads of blossom. As the name Cherry Rose suggests, it is red. In China they call it *Shi Tse Mei*, or Ten Sisters. It caught the eye of Robert Smith during his time as Professor of Engineering in Tokyo, and in 1878 he sent it to a friend in Scotland called Robert Jenner, who passed it on to a nurseryman in Lincoln. It was exhibited as the Engineer's Rose and earned an Award of Merit from the RHS. Writing about the new rose in *The Book of The Rose* in 1910, the Reverend Andrew Foster-Melliar had this to say: '"Rambler" does not seem a very good name for it, for though it is of strong long growth, it has not a true rambling habit, fresh strong shoots constantly trying to rise from the base… the trusses of small crimson flowers which come, in perfection, in the shape of a bunch of grapes, produced quite a sensation from their unique character when the rose was first exhibited. It is not an autumnal, but lasts in bloom a fair time. It does not do well against a wall, fairly as a bush with the shoots supported by bamboos, and decidedly well as a pillar rose… '.

The impact of the massed colour when the rose bloomed stirred the commercial instincts of Charles Turner, and in 1893 his nursery at Slough was marketing it as 'Turner's Crimson Rambler'. So sensational was it that Queen Victoria is said to have made a special journey to Slough to see it. Its popularity soon waned though when the rose proved a martyr to mildew, but its descendants have proved more enduring and include such treasures as 'Blush Rambler', 'Goldfinch' and the remarkable mauve 'Veilchenblau'.

Another Japanese Multiflora adopted in the West was *R. multiflora platyphylla*. It had also been cultivated in China where it was known as Seven Sisters. This extraordinary rose

'TURNER'S CRIMSON RAMBLER'

This Multiflora rose came to Scotland from Japan in 1878, but its commercial possibilities were not appreciated until Charles Turner of Slough realised the novelty value of a rich red climber flowering en masse. Its sensational impact can be judged from the fact that this picture was appearing in a French magazine while Turner's first customers were still waiting for their plants. The flower also goes by the names Cherry Rose and Engineer's Rose.

bears flowers of seven different colours in the cluster, from white through pinks and reds to mulberry. It is very vigorous, and the broad, rather rough leaves account for its botanical name. In 1817 the French nurseryman Louis Noisette glimpsed a specimen growing near London and was so enthused by it that the gardener felt compelled to give him the plant.

R. multiflora 'Carnea', or Lotus Rose, inspired a similar degree of excitement when it reached Europe in 1804. This variety from China was widely cultivated in its homeland because of its spectacular, if short-lived, display in summer when it carries masses of semi-double pink flowers on vigorous arching stems. It became extremely popular when Thomas Evans of the East India Company brought it to England, as there were few climbing roses available in Europe at that time.

Also a Chinese species, *R. multiflora cathayensis* grows in the wild, often by rivers and streams, and in cultivation makes another effective rambler for the garden. The flowers are more refined than in *R. multiflora* itself, appearing in corymbs crowded with flowers that may be white or various shades of pink, sometimes single and sometimes full of petals, packed closely together and opening flat to show their stamens. The spectacle of so many blooms inspires its Chinese name Powderpuff Rose. En masse they create a delicious wafting scent.

Perhaps even more beautiful than the Multifloras are the Banksian climbers. The story of how they reached the West reveals the difficulties and privations faced by the botanists who sought them. In 1803 a Scotsman working at Kew, William Kerr, was sent by the Director of the gardens, Sir Joseph Banks, to look for plants that might have an economic or ornamental use. This was his reception in Canton (Guangzhou): 'He found he was almost a prisoner and to go any distance into the city was both dangerous and highly distressing. The natives surrounded this strange garden clothed figure, felt at his clothing and filched from him any moveable parts of his equipment such as hand trowels, carrying bag and even his cap. Any move of a defensive nature would set the crowd on him.' (K. Lemmon in *RNRS Annual*, 1978)

Kerr completed his assignment nonetheless, and among the many important plants he took back home was *R. banksiae alba-plena*. Its name indicates the flowers are full, and the flower sprays certainly have an attractive fluffy look when all the blooms are open. They are milky in colour, set off to perfection by dark green foliage.

A plant of 'Alba Plena' in Tombstone, Arizona enjoys the distinction of being the world's largest rose. A miner's wife, Mary Gee, received it from her family in Scotland in the 1880s. It became established and by 1919 was extending some 800 square feet (72sqm). Proper supports were constructed to enable it to spread. By 1964 it was covering 5380 square feet (490sqm), and thirty years later an astonishing 8000 square feet (730sqm), with a trunk 12 feet (3.7m) in circumference. According to the family who have been tending it for three

ROSA MULTIFLORA 'CARNEA', LOTUS ROSE

This beautiful rose from China delighted gardeners when it arrived in England in 1804, at a time when the few climbers the West could offer were white singles or semi-doubles. Because it was the first Multiflora Europe had seen it was given the species name, though referred to as 'Carnea', meaning 'flesh pink'. When the true R. multiflora *appeared later in the century, the botanical name of this one was changed to* R. multiflora multiflora.

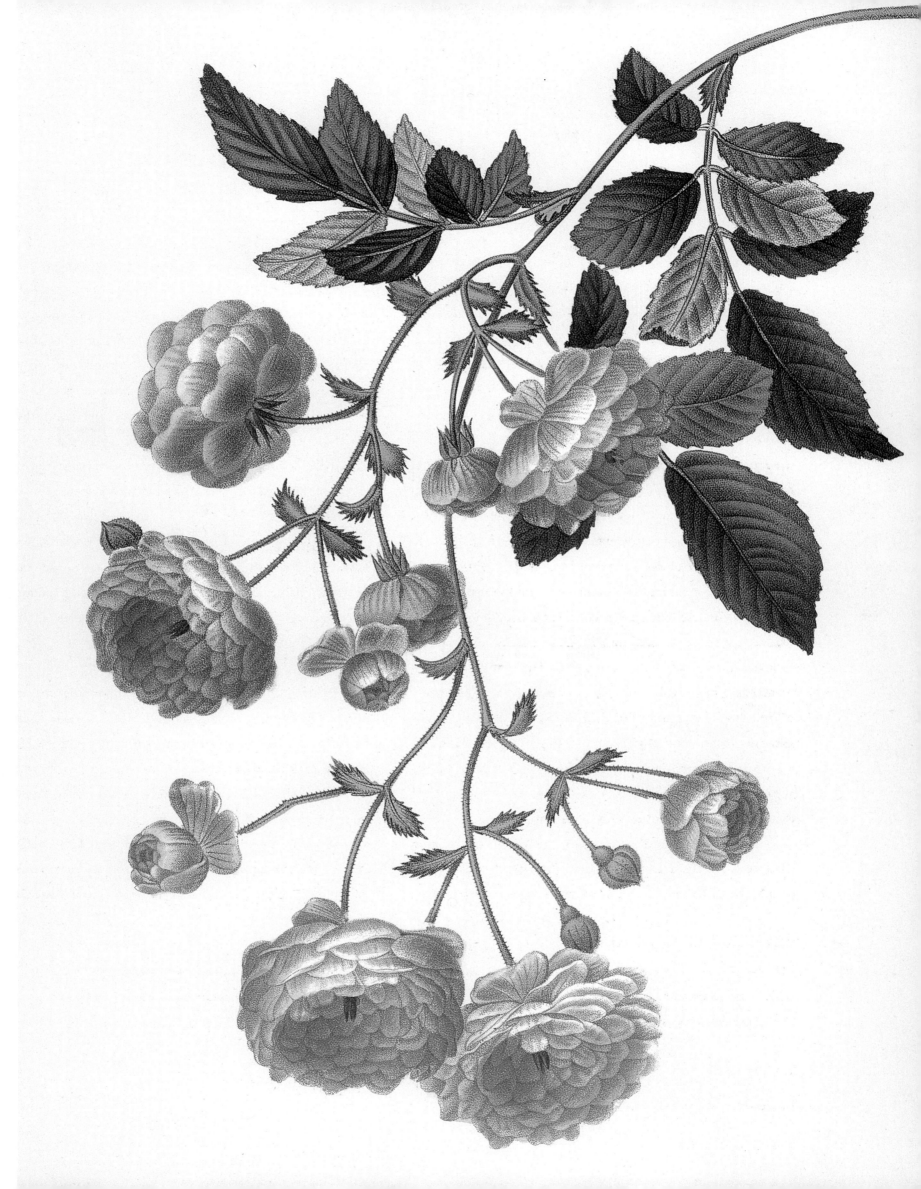

generations, the plant receives no feeding. It is watered and any dead wood is removed from the branches, but that is the only care it receives. This rose is a popular tourist attraction, especially in springtime when millions of its white, violet-scented blossoms make an unforgettable display. Visitors enjoy the shade it provides against the hot Arizona sun, and have accorded it a local name, The Shady Lady of Tombstone. No doubt William Kerr would have been pleased to see his legacy so well appreciated.

One of the prettiest Banksians is *R. banksiae lutea* or Banksian Yellow. Its dainty yellow rosettes are borne very freely in early summer on long stems well furnished with the narrow, smooth light green leaflets characteristic of the Banksians. Some forms are completely without prickles which is a great boon at pruning time. The flower buds develop in microcosm at a very early stage, which explains why it needs a site where frost cannot damage the little buds. The sight of the delicate flowers out together on a well grown plant is nothing short of spectacular. It entranced John Parks in the Calcutta Botanic Gardens and he went to China specifically to seek it out, bringing it to London in 1824.

Less well known is the delightful *R. banksiae lutescens*, resembling *R. banksiae normalis* except that the flowers are sulphur yellow instead of white. It seems to be rare in its land of origin, China, for when the plant explorer E. N. Wilson searched, he found only one in remote mountain country. The flowers are prettily formed with five petals, and they are slightly larger and more scented than those of *R. banksiae lutea*. There are also creamy yellow forms. It reached Europe in the 1870s by way of Italy, where many years later Quinto Mansuino used its pollen on the miniature 'Tom Thumb' and obtained 'Purezza', a vigorous and beautiful white climber introduced in 1961.

Similar in habit to *R. banksiae alba-plena*, and thought to be a hybrid with *R. laevigata*, is *R. x fortuniana*. It grows into a huge scrambling shrub to 30 feet (9m) or more, but it differs from 'Alba Plena' in several ways, notably by having larger flowers with many small petals, smoother stems and greater vigour. It is also far easier to propagate, which tempted some French growers to pass it off as 'Alba Plena'. Its name commemorates Robert Fortune who was sent to China by the Royal Horticultural Society in 1842 and returned with many choice plants, among them *R. x fortuniana* and two more climbers.

The first was 'Fortune's Double Yellow', which shows the influence of a Gigantea parent and grows vigorously to make a superb plant halfway between a climber and a shrub. It flowers in summer, covering itself with semi-double blooms, openng wide to display a kaleidoscope of fawn, copper and sometimes reddish tints, so beautiful that in a mixed planting it is the first rose the viewer is drawn to. Rose Kingsley described it as a source of pride and delight to its possessor, with the caveat that 'it is without exception the most cruelly prickly, thorny Rose

ROSA BANKSIAE LUTESCENS

This sulphur yellow form of the Banksian rose came from China to Italy in the 1870s but proved hard to rediscover in its land of origin. A search by Ernest Wilson was rewarded in 'a wild entrancing gorge' near Xiangtan in June 1910. The scented flowers open flat as they age, creating a pretty starlike effect. Their array of stamens attracted the attention of Quinto Mansuino of Italy who utilised their pollen to raise the white climber 'Purezza'.

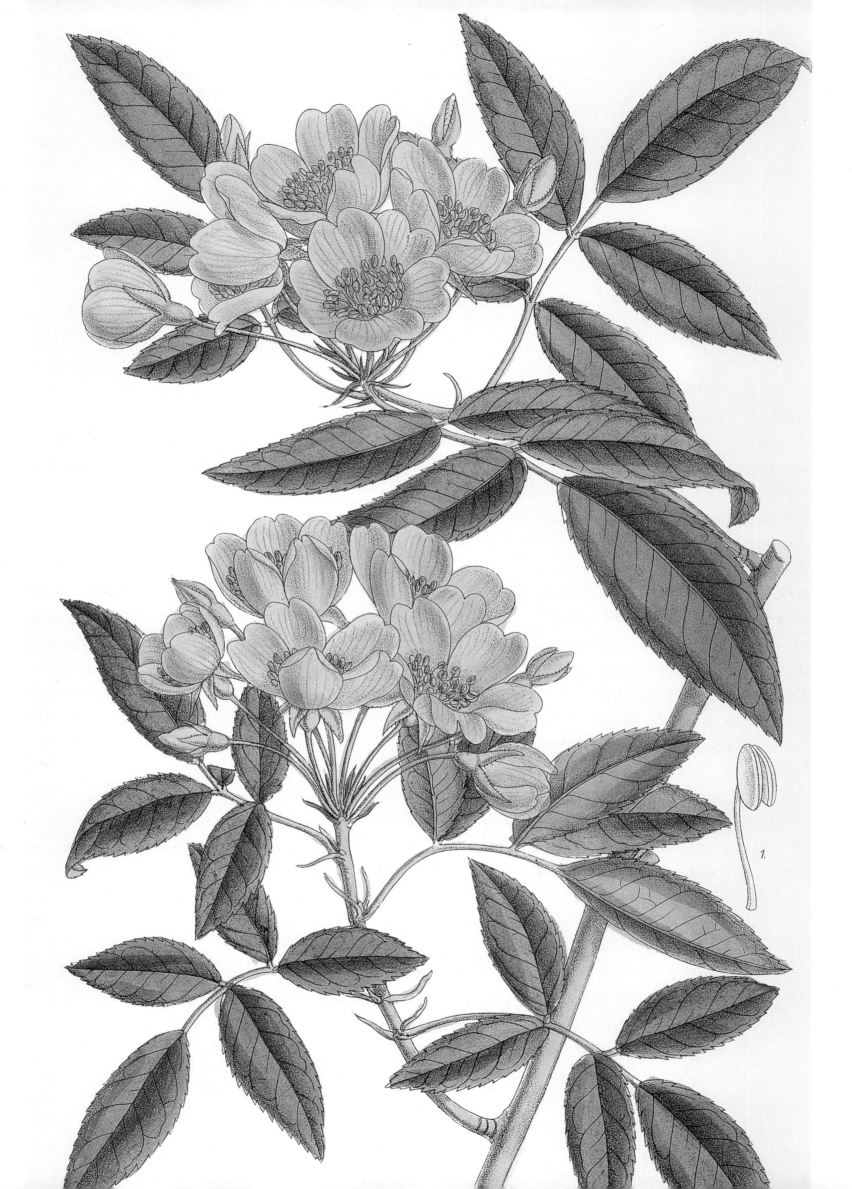

1.

I know – every dainty twig, every shiny leaf being armed with ferocious fish hooks.' Robert Fortune's own account of his discovery at Ningpo in 1842 captures the plant hunters' spirit of wonder and excitement on making a new discovery:

'On entering one of the gardens on a fine morning in May, I was struck with a mass of yellow flowers which completely covered a distant part of the wall. The colour was not a common yellow, but had something of buff in it, which gave the flowers a striking uncommon appearance. I immediately ran up to the place and, to my surprise and delight, found that it was a most beautiful new double yellow climbing rose.'

Robert Fortune's travels were officially restricted to the Guangzhou area, but by shaving his head, growing a pigtail and wearing Chinese costume he was able to move around freely. In a garden in Shanghai he stumbled upon another special rose, a semi-climber called *R. anemoniflora* that appeared frail and rather tender. The pale blush flowers are carried in loose clusters and show up to good effect against dark smooth leaves. Although it has a species name it is not found in the wild, and because it bears three leaflets, Laevigata is one likely parent.

Two other charming shrub roses were both accorded the status of a species although their many petals makes it plain they must be of hybrid origin. One of them is *R. roxburghii*, a lowland plant suited to the climate of Guangzhou. For this reason it was among the first to come to the attention of Western visitors, and is figured in the drawings commissioned by John Reeves. The flowers are remarkable, full of petals in colours from crimson to lilac-pink. Jack Harkness described the leaves as 'sprucely arranged in a brushed and combed style which once seen is not readily forgotten.'

The rose bears the name of William Roxburgh, who served as Director of the Calcutta Botanic Gardens in India from 1793 to 1813. By his agency *R. roxburghii* came to England, where it flowered in 1824 and was described by the Austrian botanist Leopold Trattinick.

Apart from its rich colouring it is distinctive in other ways: for the unusual form of the substantial blooms, packed with scores of narrow upturned petals; the way some flowers are on such short stems they become lost within the branches; how a hand seeking to explore them risks being stabbed by concealed prickles; the 'chestnut casing' that encloses the buds and hips (and gives it the common names of Chestnut Rose and Burr Rose); and the disconcerting readiness of the grey brown bark to peel away, the mark of a member of the Platyrhodon or 'Flaky-bark' subgenus.

Like *R. roxburghii*, *R. xanthina*, is not the original wild form but a Chinese garden plant known in its homeland as *Huang Tz'u Mei* and Manchu Rose. The Latin name means 'yellow rose'. Whereas most wild roses have five wide petals, *R. xanthina* has twenty or so small narrow ones. The plants

'FORTUNE'S DOUBLE YELLOW'

As well as 'Fortune's Double Yellow' this plant is known as Beauty of Glazenwood and Gold of Ophir. It seems unfair for one rose to have three such glorious names, but it lives up to them all, except that the 'yellow' in 'Fortune's Double Yellow' embraces rich tints of fawn and reddish copper.

In order to flourish it requires a warm climate and a frost-free site. Here, Parsons' illustration in Willmott's The Genus Rosa *accurately captures the engagingly ragged formation of the blooms and the prickly twiggy nature of the growth.*

grow into rounded shrubs and are likely to reach 9 feet x 9 feet (3m x 3m), covered in many tiny ferny leaflets. It was originally found growing in the garden of a mandarin and had been known from early paintings before its introduction to the West, having been described by John Lindley in 1820.

Seeds eventually found their way to the United States in 1907, and both full-petalled and single forms, including the well-known 'Canary Bird', were raised from them. The true species, *R. xanthina spontanea*, was subsequently found in its natural habitat in northern China and Korea.

Among the illustrations executed by Chinese artists for John Reeves is one showing Mai Kwai, a garden rose that can also be seen in medieval paintings. Rose historians Martyn Rix and Roger Phillips encountered Mai Kwai during a research trip to China in the 1990s at a place called the Emperor's Tea Mountain. Martin Rix wrote about, explaining:

'This is a familiar rose to the Chinese, commonly planted in gardens and by houses, in places where its heavy, damask-like scent can be enjoyed…The large flowers are purplish-pink and nodding…Its origin is a mystery, and it has been suggested that it may be a hybrid with an old damask rose. This is not as far-fetched as it might seem, as there was much trade between central Asia and China throughout the middle ages, when damask roses were popular in Iran…'

This account from Rix, which appeared in *Roses Anciennes de France* in autumn 1998, suggests that the East-West traffic in plants has not been all one way. From such early instances of rose importing, the roses of the East and West gradually began to travel beyond their national boundaries. This rose migration accelerated in the early nineteenth century thanks to a combination of factors: increased commercial traffic along the seaways of the world; the interest of botanists and plant seekers; and the developing nursery trade in western Europe.

As rosarians in the West were introduced to a whole array of new species from the East, they realised the potential within their grasp. They could pool the best characteristics of roses from both regions to create new and superior forms. They noticed, for example, that the predominantly pink Western roses of history had a strength of fragrance that their oriental counterparts lacked. Roses from the East, meanwhile, boasted vibrant colours. Where the Eastern roses used strong colour to attract insects for pollination, the Western roses lured them with scent. The Eastern roses also offered long cycles of sustained and repeated flowering, unlike any Western rose.

It would not be long before ambitious nineteenth-century gardeners, botanists and entrepreneurs began to look for ways of overcoming this division, creating new varieties, never seen before in nature, that would marry the ideal combination of colour and fragrance. Even more significantly, their efforts would focus on developing repeat-flowering roses.

ROSA ROXBURGHII, CHESTNUT ROSE

This picture by one of John Reeves' artists shows some of the remarkable characteristics of this old Chinese garden rose, such as the unusual formation of the petals, spruce foliage, rugged 'chestnut' casing of the bud and vicious prickles ready to trap anyone unwary enough to cradle the blooms. There is considerable colour variation in its flowers. This belongs to the primitive Platyrhodon or 'flaky rose' sub-family of roses, so called because their bark peels naturally.

海東紅

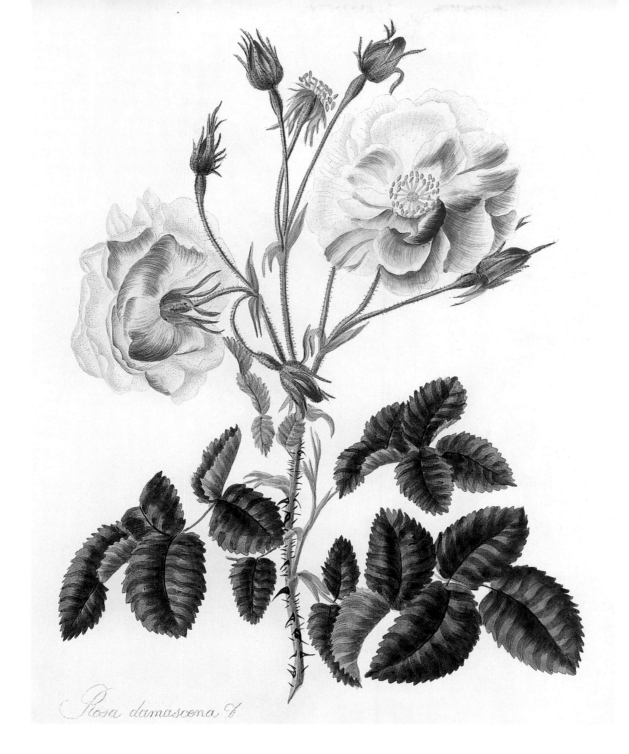

Rosa damascena v.

ROSA X *DAMASCENA* VAR. *VERSICOLOR*, YORK & LANCASTER

This Damask rose (above) has no great merit other than that of antiquity, its origins supposedly dating back to before 1551, though the name is credited to John Parkinson who referred to it in 1629 as 'Rosa versicolor – the party coloured rose, of some Yorke and Lancaster'. The growth is spindly and untidy, and the flowers appear fleetingly in summer, made up of a few petals that are sometimes white, sometimes blush and sometimes a random mixture of the two as the illustration by Mary Lawrance shows. This rose is often confused with R. gallica 'Versicolor'.

'CELSIANA'

This rose (opposite) with its graceful carriage, crinkled petals and gold stamens is classed as a Damask and shows Centifolia influence. It is thought to have come from Holland into France, where it was described in 1817 under the name 'Belle Couronnée' with reference to the way the fringes of the sepals surround the half-closed buds. In his text for Les Roses, Claude Antoine Thory changed the name as a tribute to nurseryman Jacques-Martin Cels.

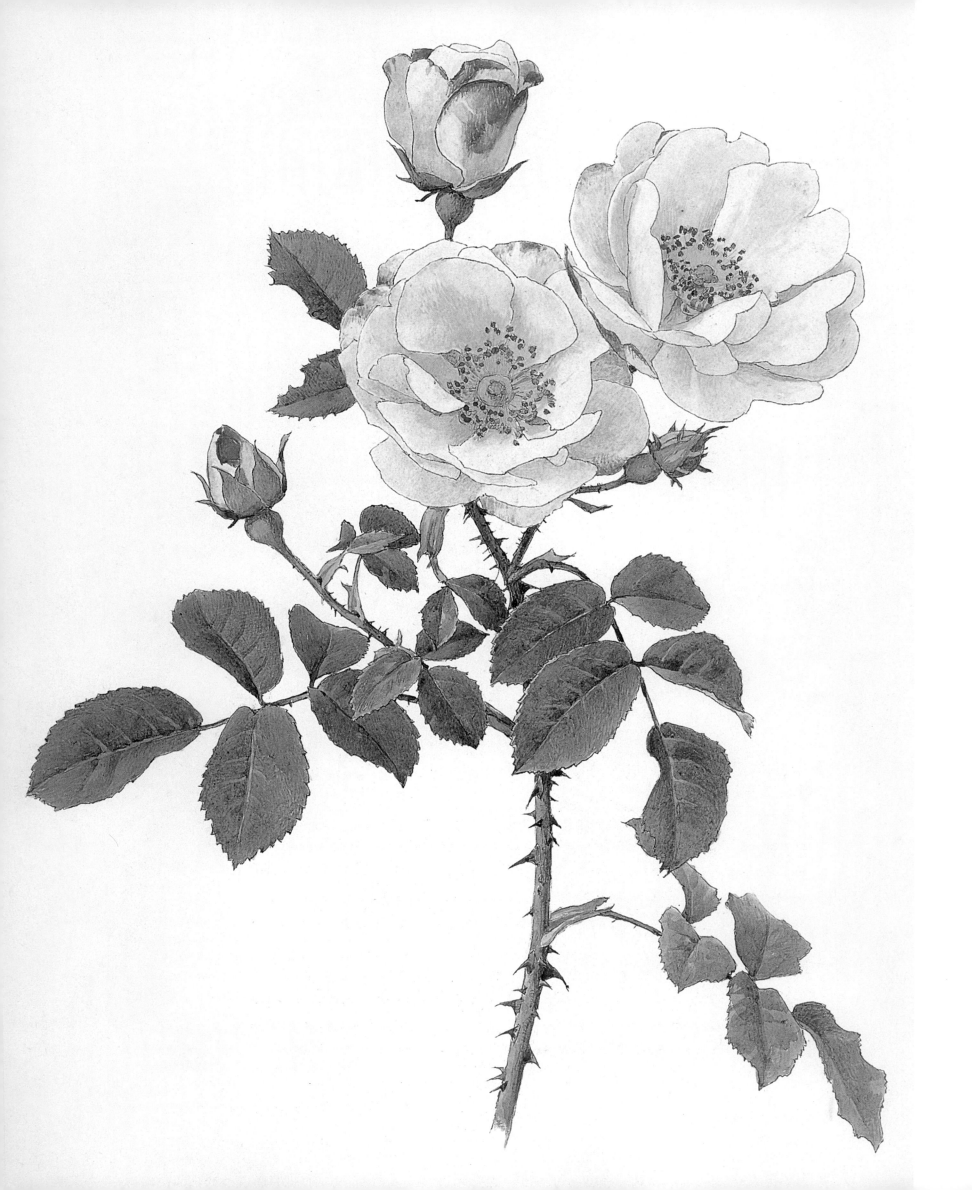

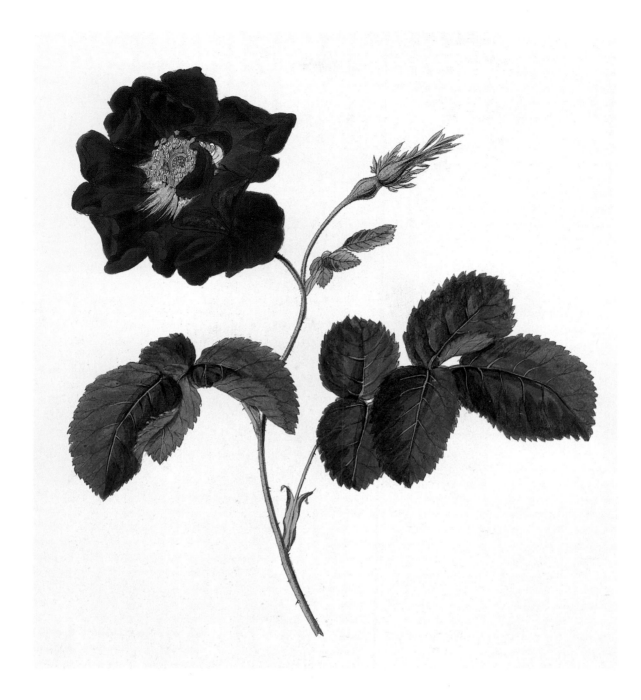

'HOLOSERICA DUPLEX'

The name of this summer blooming rose (above) indicates the petals have a sheen on them, which is true when they are lit up from the sun. Many purplish (actually murray coloured roses) were being grown in the eighteenth century, this one distinguished by speckles of violet on both rows of its petals. The rounded drooping leaves may indicate some Damask in the parentage. John Parkinson described a similar rose in 1629 as having 'two rows of petals, the outer ones larger than the inner ones… and yet for all the double row of petals these Roses stand but like single flowers'.

'RUBROTINCTA'

The restrained touches of crimson at the petal rims give these scented flowers (opposite) an appealing and delicate effect. They appear in midsummer on robust, prickly plants about 4 feet (1.2m) tall and wide, furnished with fresh green leaves. Known also as Hebe's Lip, it probably has Damask and Sweet Briar ancestry.

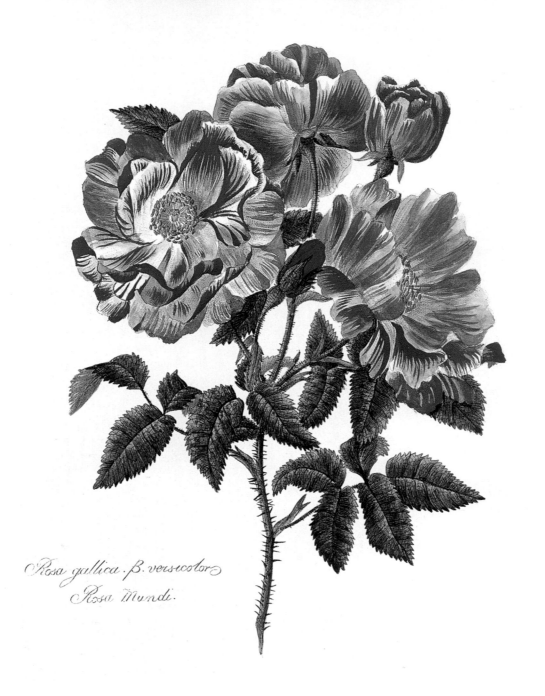

Rosa gallica. β. versicolor
Rosa Mundi.

ROSA GALLICA 'VERSICOLOR', ROSA MUNDI

Neither picture does justice to the subtle beauty of this rose (above & right). It is a sport of R. gallica
officinalis in which some of the red pigment has been lost, leaving random patterns where the
paleness of the natural petal colour shows through. Recorded in Europe in 1583 as R. variegata, it
acquired the name 'Rosa Mundi' in England, which means 'Rose of the World'. It is also known as
La Villageoise. Henry Andrews, whose books contains the illustration on the right, gave a confused
account, stating that 'Rosamund' means 'Rose-mouth' (it actually means 'illustrious protector') and
likening the colour of Rosa Mundi to a royal courtesan known as 'Fair Rosamund', in whose
complexion 'the lillye and the rose for mastership did strive'. This misinformation has led some to sup-
pose that the woman, who died in 1176, and the rose, first mentioned in 1583, were contemporary.
Although clearly incorrect, the notion proved irresistible to writers in search of a romantic tale.

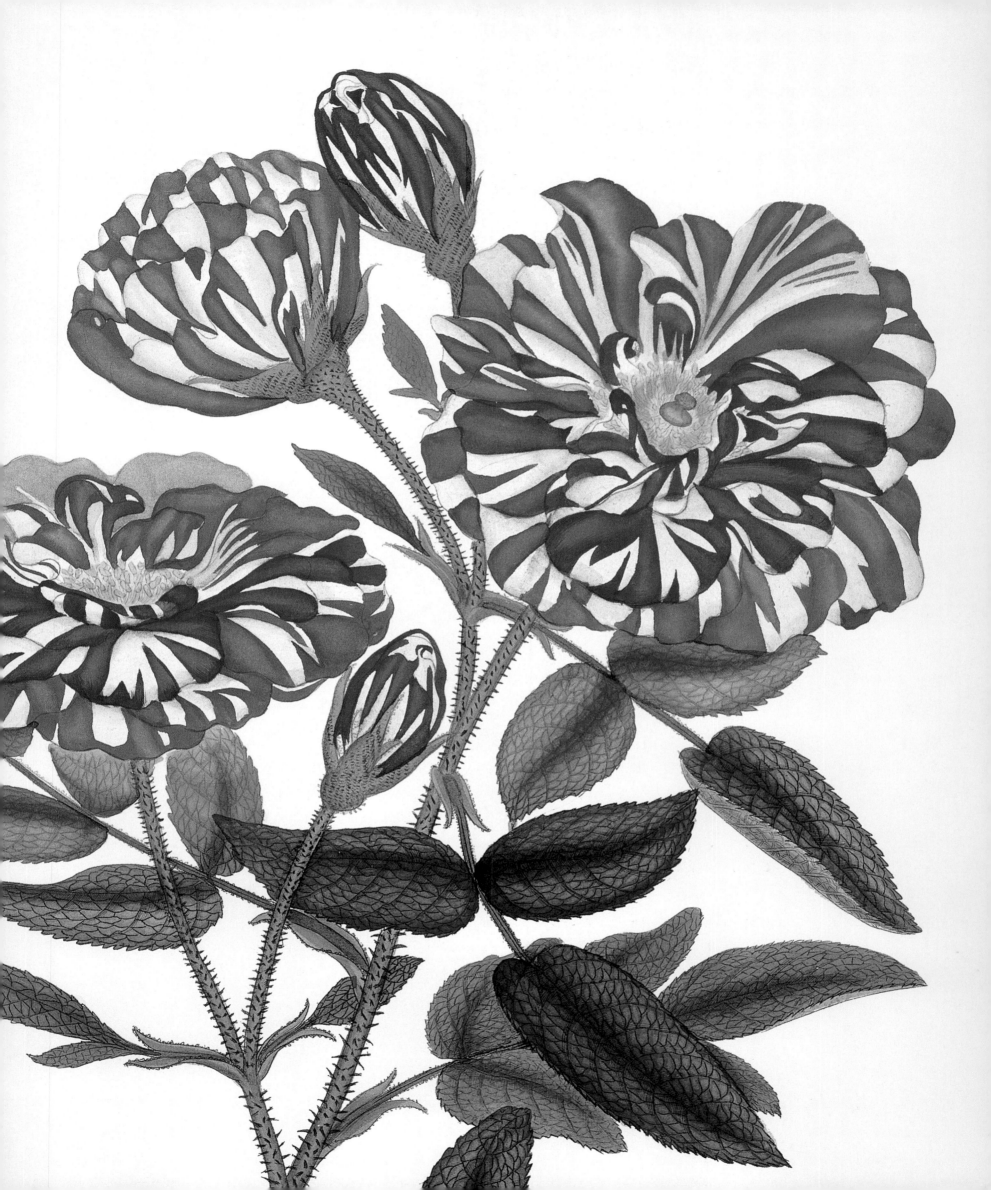

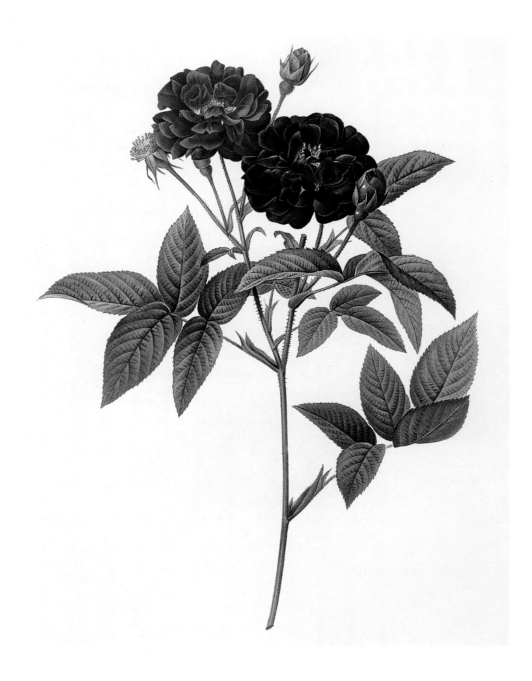

'DE VAN EEDEN'

This Gallica rose (above) is known only from Thory's description in 1819. He tells us it was grown from seed by a Haarlem nurseryman called Van Eeden, adorned the Empress Joséphine's garden at Malmaison in 1810, but disappeared after her death in 1814 and survived only as a grafted plant in a few private gardens. He describes the brilliance of the flowers and the manner in which the petals darken as they age to give the impression of a black rose.

'STAPELIAE FLORA'

Redouté's picture (right) with text by Thory appeared in the early 1820s, and little else is recorded of this now extinct Gallica rose. The name refers to a fancied resemblance between the flower of the Stapelia, an African plant described by the Dutch botanist van Stapel in the 1800s, and the starry shape of the rose's sepals after the petals have fallen.

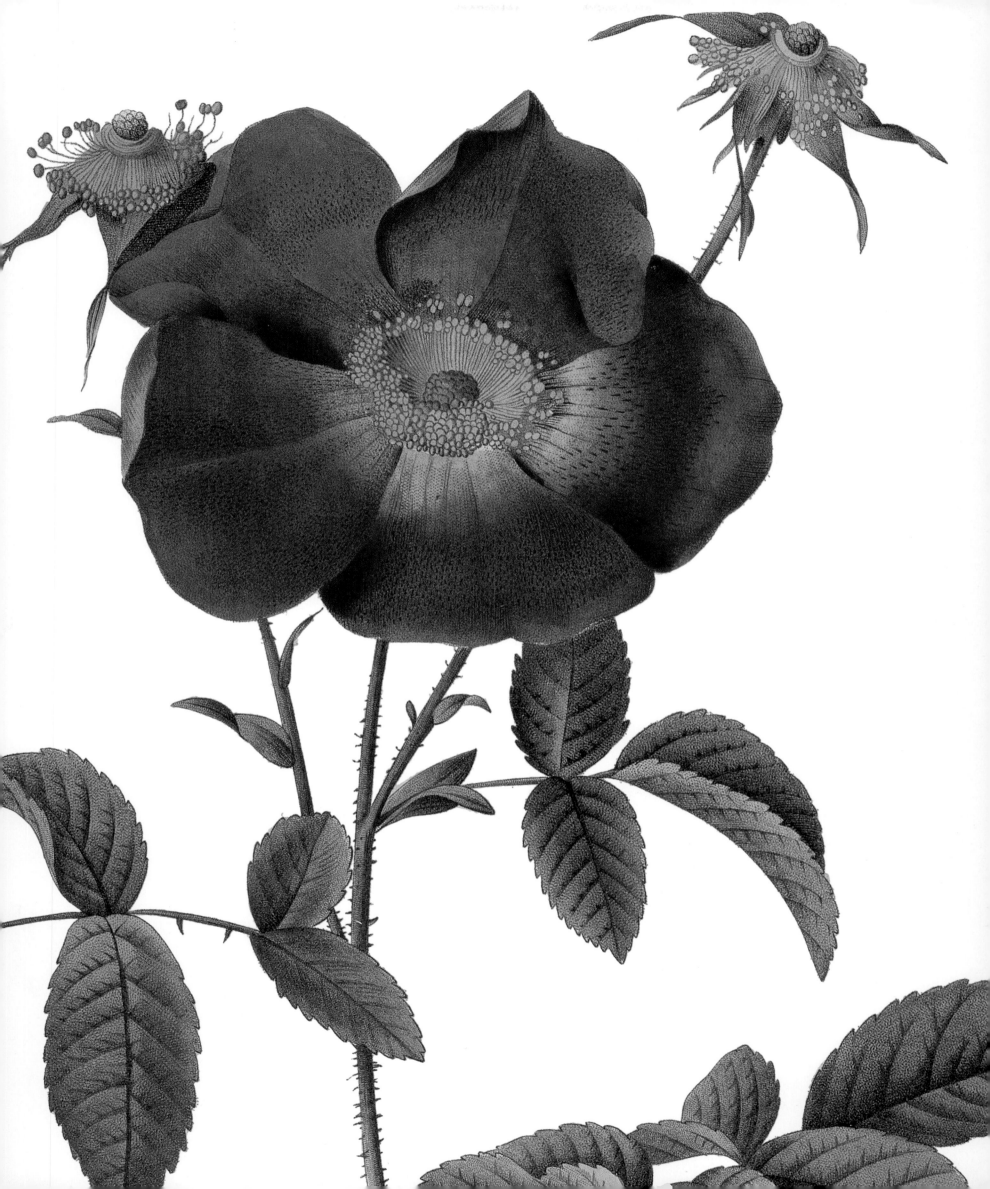

'DOUBLE VELVET'

Miss Lawrence's rendering (left) shows the flat shape, yellow stamens and slightly recurving form of this violet-purple rose, to which the description 'velvet' was applied to express the effect of light reflected off the petals. Gerarde's Herball *of 1596 refers to 'The Velvet Rose', which if not identical is doubtless in the ancestry of 'Double Velvet' and of a similar rose grown today under the name of 'Tuscany'.*

ROSA X *CENTIFOLIA* 'TUSCANY'

This illustration (overleaf) is labelled in Andrews' Roses as 'centifolia Varietates subnigrae' and resembles the Gallica rose 'Tuscany', one form (on the left) showing white petal flecks and one without. 'Tuscany' may date from the eighteenth century when, according to Philip Miller (who was himself responsible for three 'Velvet Roses') more roses were propagated than any other trees or shrubs. The fact remains that the rose 'Tuscany' is not recorded before 1820. The reason for the name is unclear.

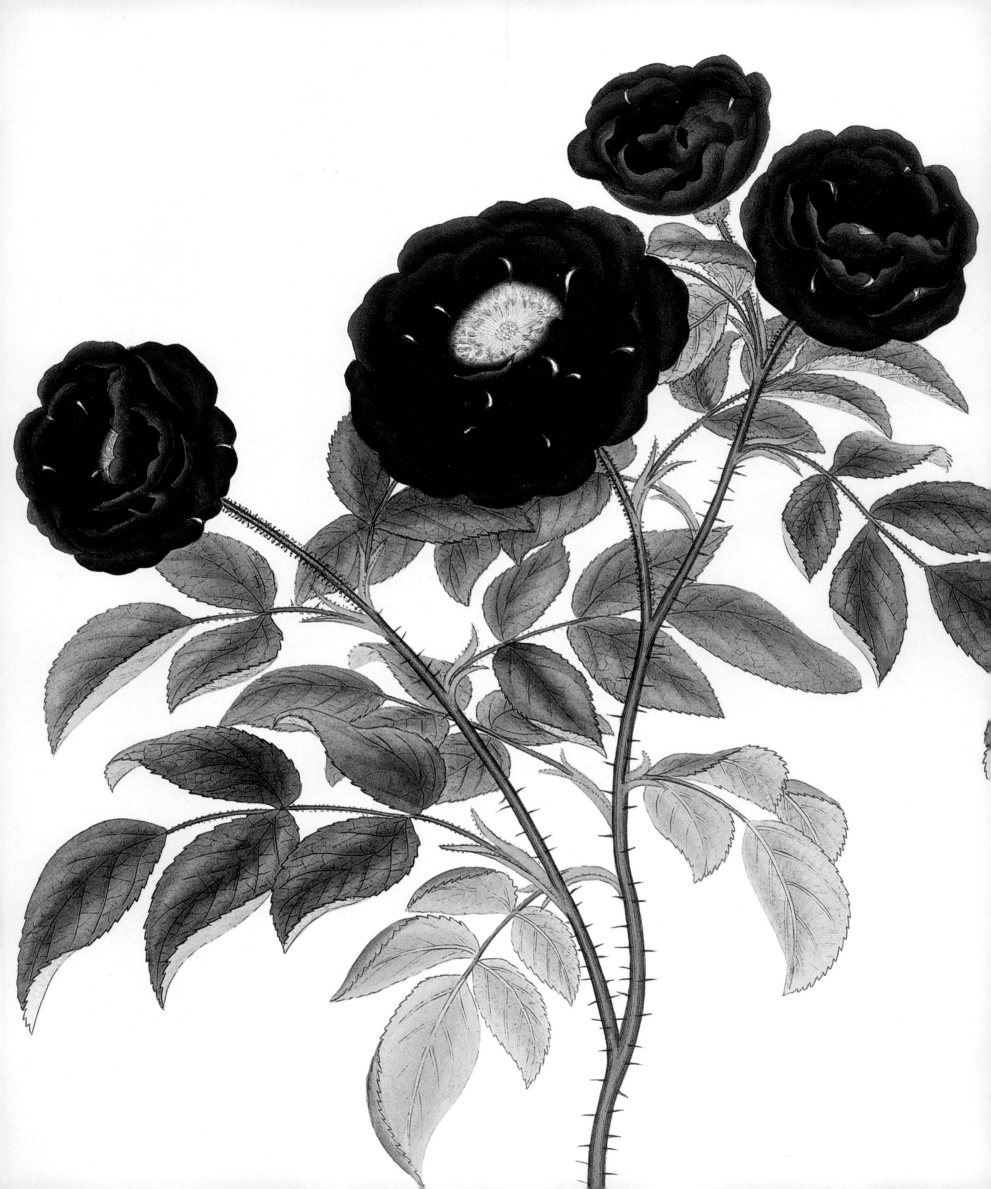

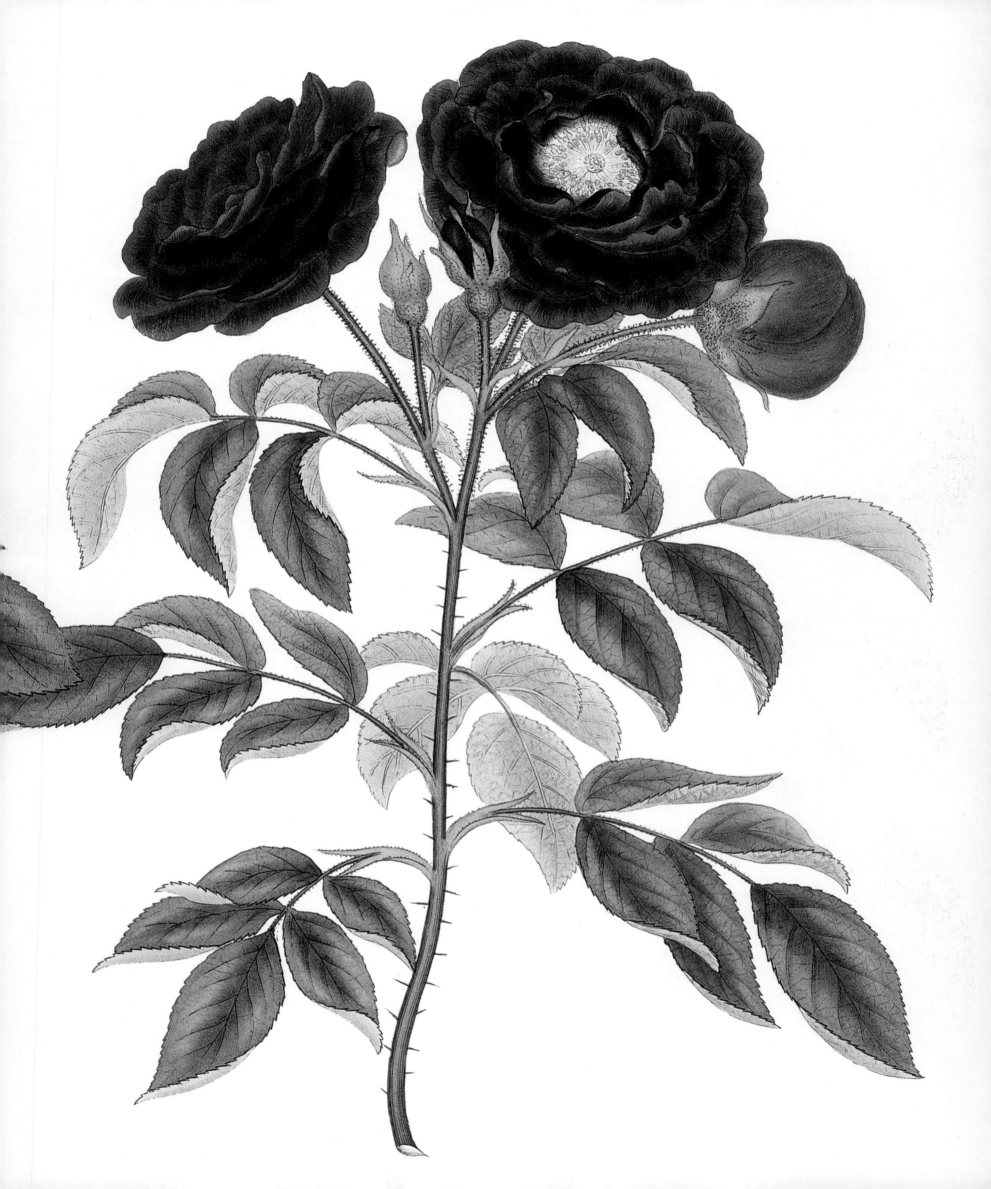

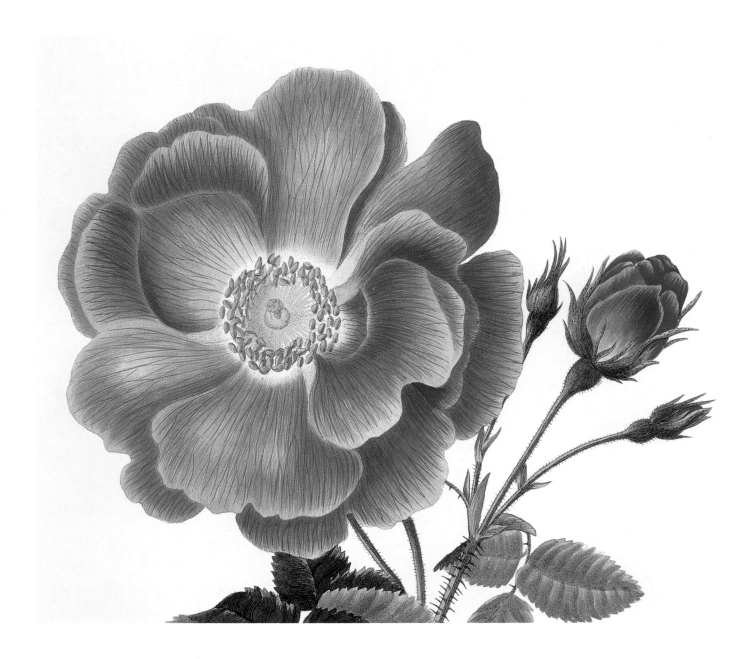

GIANT ROSE

Linnaeus established the name Rosa gallica *in 1759. Gallicas produce seed readily, and growers in the Low Countries and France raised between 1500 and 2000 commercial varieties before demand for them declined in the 1840s. Some 250 varieties are traceable today, but among those lost is Miss Lawrance's Giant Rose (above). Gallicas with big flowers are rare, which is no doubt why she included it in her work.*

'MAHEKA'

The stamens of the Gallica 'Maheka' (opposite) contrast beautifully with its velvety purple petals. It is believed to have come from the Netherlands and was introduced in France by Du Pont before 1811, acquiring the name 'La Belle Sultane'. A romantic story associates it with Aimée Dubucq de Rivery, cousin of the Empress Josephine, who came from Martinique to France to complete her education. On the return voyage she was captured by Barbary pirates, taken to Algiers, and sent to the Sultan of Turkey for his harem. She won high favour and became the mother of Sultan Mahmud II, on whose accession in 1808 she was honoured by the title of 'La Sultane'.

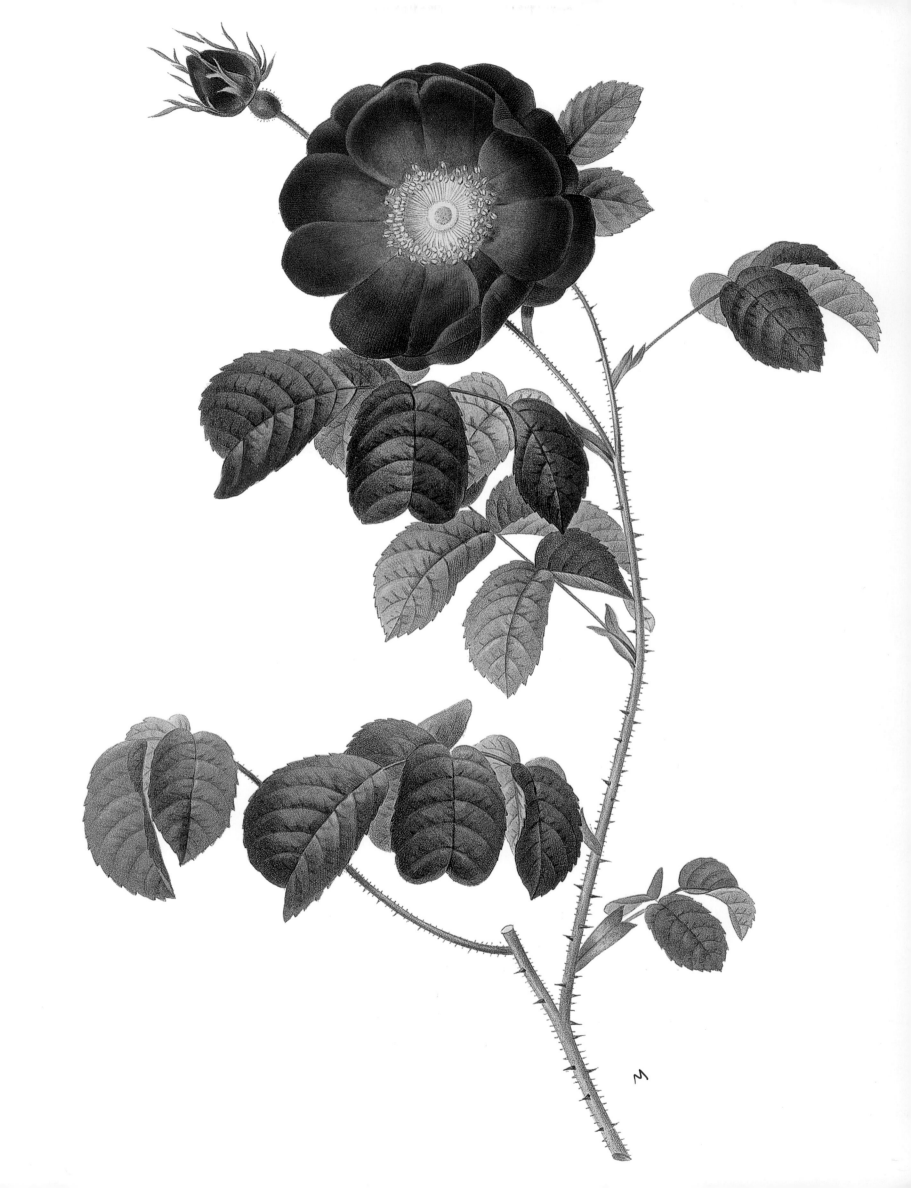

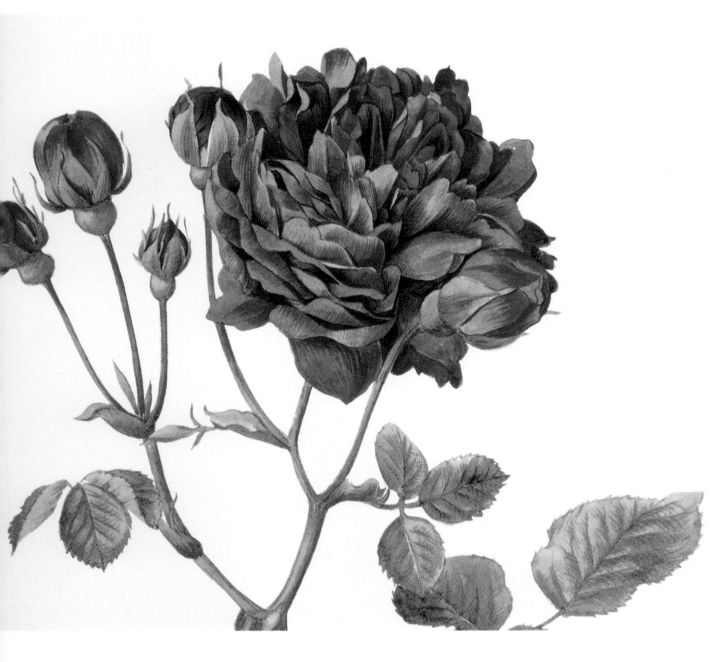

'CARDINAL DE RICHELIEU'

The rich violet-purple colour makes this rose (above) easy to recognise. It is one of the darkest Gallicas. The bushes grow to about 3 feet (1m) tall and a little wider and are covered in bloom in summer. According to Van Houtte's catalogue of 1851 the raiser was the Belgian Louis Parmentier (1782–1847) of Enghien. The rose is named after Cardinal Richelieu, who created the famous Jardin des Plantes for Louis XIII.

ROSA X FRANCOFURTANA, TURBINATA

According to Thory this rose (opposite) was a chance hybrid discovered by Dr. Nees in Saxony, and it also existed in France. It could be the rose found in 1583 at Frankfurt by Charles de l'Écluse, and the botanical name bestowed in 1774 reflects that link. It has also been called Thornless Rose and Turbinata because the hips are shaped like a spinning top. Redouté shows more petals than are normally present, and the flower may have been selected because it was unusually full, or it could be an improved variant, perhaps associated with the Empress Joséphine.

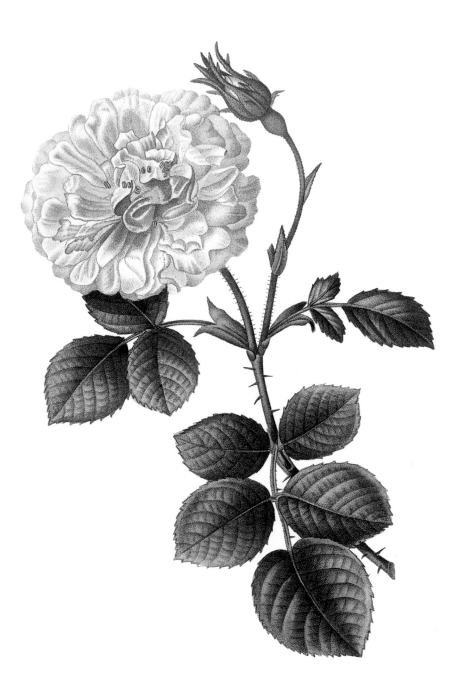

ROSA X ALBA MAXIMA, WHITE ROSE OF YORK

This vigorous fragrant rose (above) is the most fully petalled of the ancient Alba roses, and was used to make ointment to soothe the eyes as well as for cosmetics. It is probably the R. *flore albo pleno referred to by Basilius Besler (1581–1629) and the 'Rosa Alba' of Gerarde's Herball (1636). However, its depiction in medieval paintings suggests it has a much older history. In fact it may have developed from* R. x alba *in classical times.*

ROSA X ALBA, SINGLE WHITE ROSE

The Single White Rose (opposite) makes a vigorous plant with strong arching stems, well covered in greyish green leaves and bearing fragrant flowers in summer. Pliny the Elder, who died in 79 AD, mentions a scented white rose having bright green or bluish foliage which may well be the same rose and was known to him as 'Rose of Campania'. It has botanical interest but the closely related 'Alba Semi-Plena' and 'Alba Maxima' give better value in the garden.

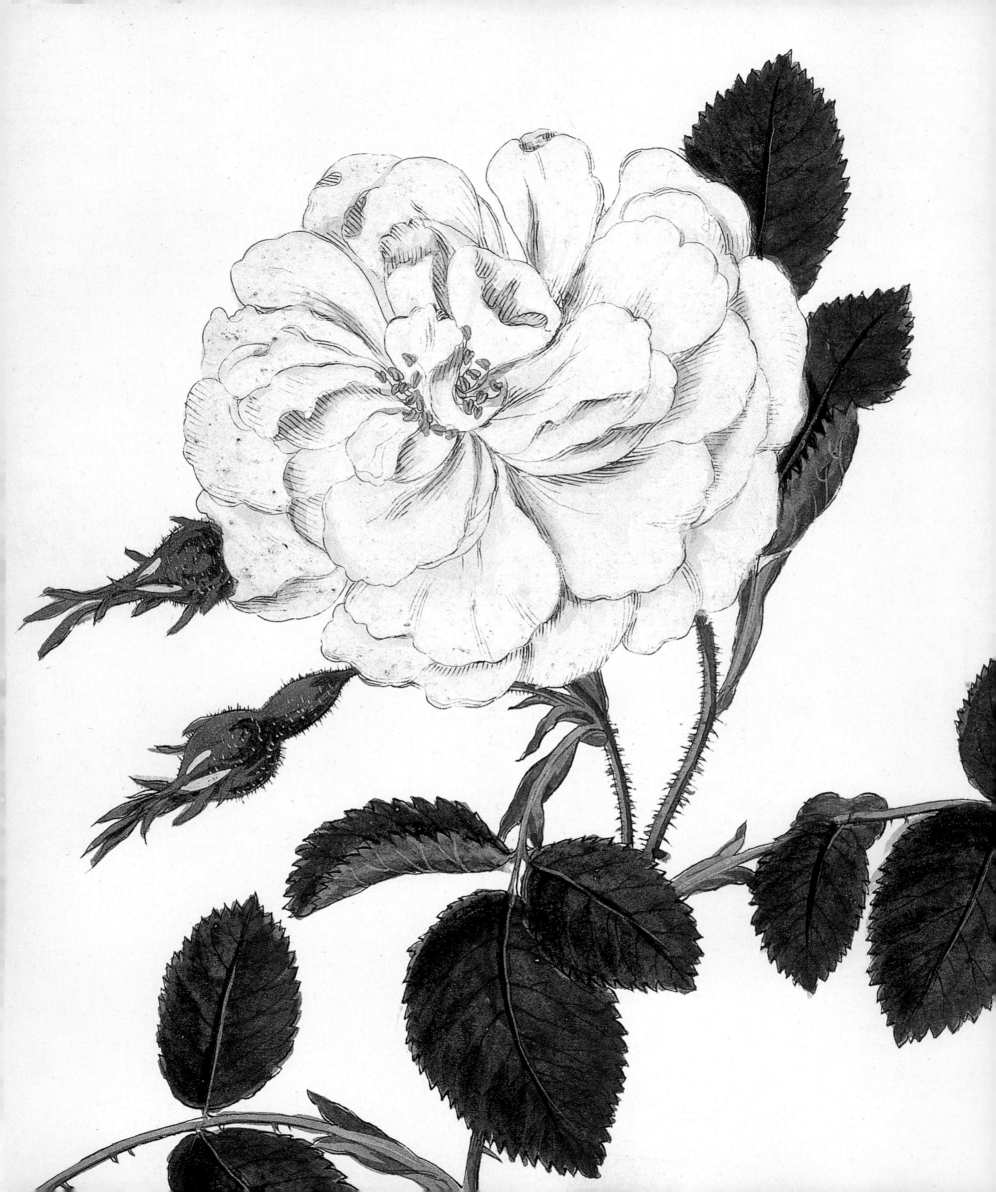

ROSA X *ALBA MAXIMA*, WHITE ROSE OF YORK

This full-petalled Alba was adopted as a badge by the dukes of York in the early fifteenth century. A later duke of York became king of England as James II, and when he was exiled his supporters continued to wear the white rose as a mark of allegiance. This explains the other common name, Jacobite Rose – Jacobus is the Latin for James.

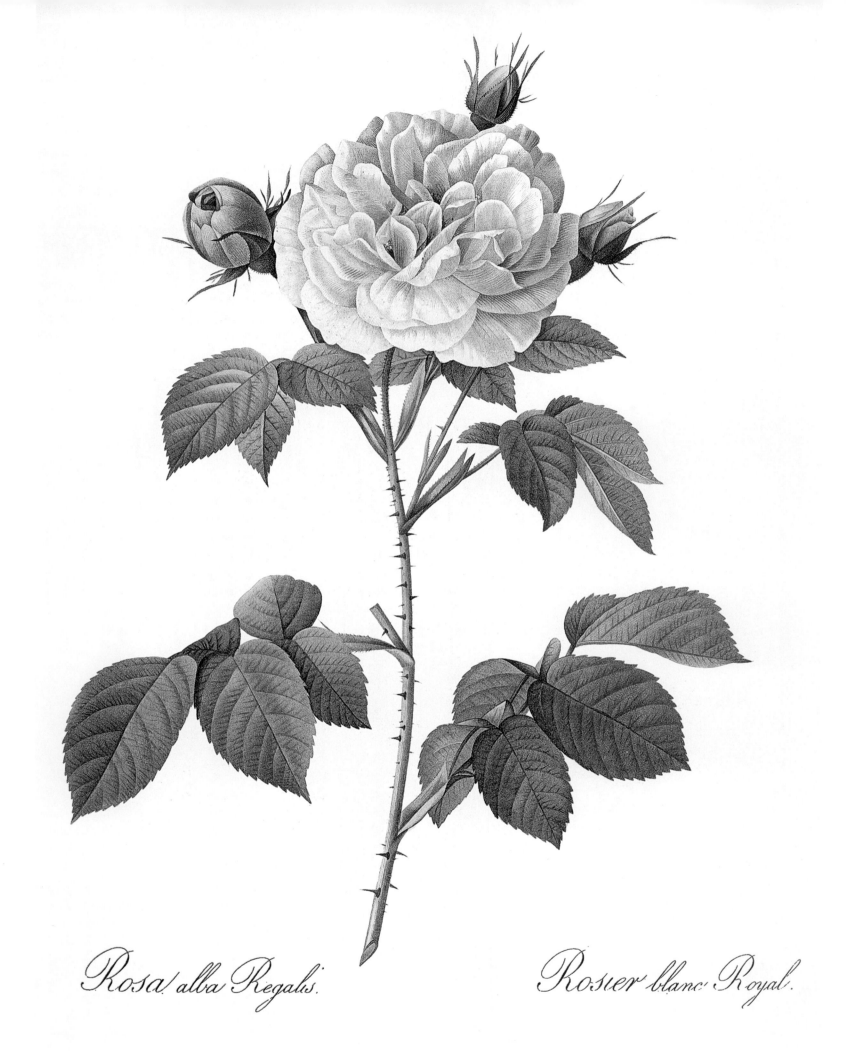

Rosa alba Regalis.

Rosier blanc Royal.

'GREAT MAIDEN'S BLUSH & SMALL MAIDEN'S BLUSH'

The 'Great' and 'Small' forms of 'Maiden's Blush' (above & opposite) are judged according to the size of both plant and flower, but the distinctions are blurred because many synonyms (some common to both) have accrued through history: 'La Royale', 'Cuisse de Nymph Emue', 'Incarnata' and 'La Séduisante' are just a few. Redouté, in calling his portrayal (opposite) R. alba Regalis, created yet another one.

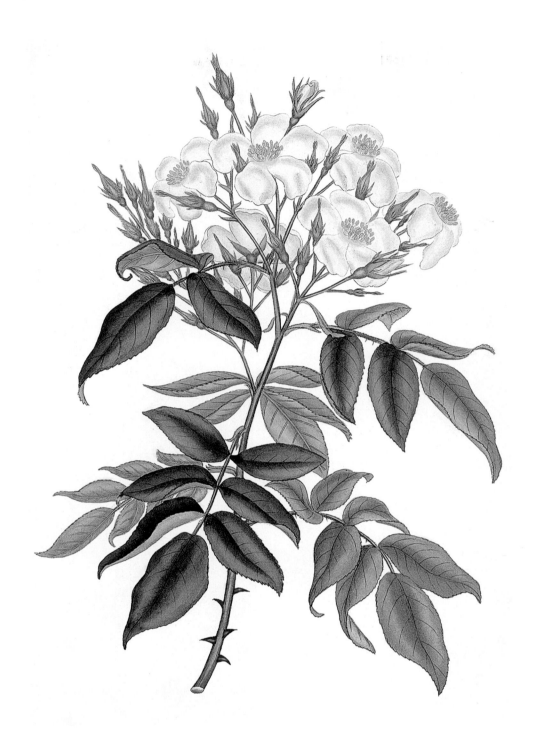

ROSA MOSCHATA, MUSK ROSE

This old rose (above & opposite) is thought to have originated in Persia, and is remarkable for the fact that its flowers consistently recurve their petals. It was in Europe by the early sixteenth century but was not botanically described until 1762. Its history contains some mysteries, including the issue of why so graceful a plant should have been 'dying out through the kingdom' in England in 1859. It was indeed lost and remained so for years until Graham Thomas rediscovered it in 1963, neglected and overgrown but still surviving in a garden where it had been recorded long before. It is one of the last roses to come into bloom, which means that although it will repeat its flower in a warm climate, only one flush is likely in cooler countries.

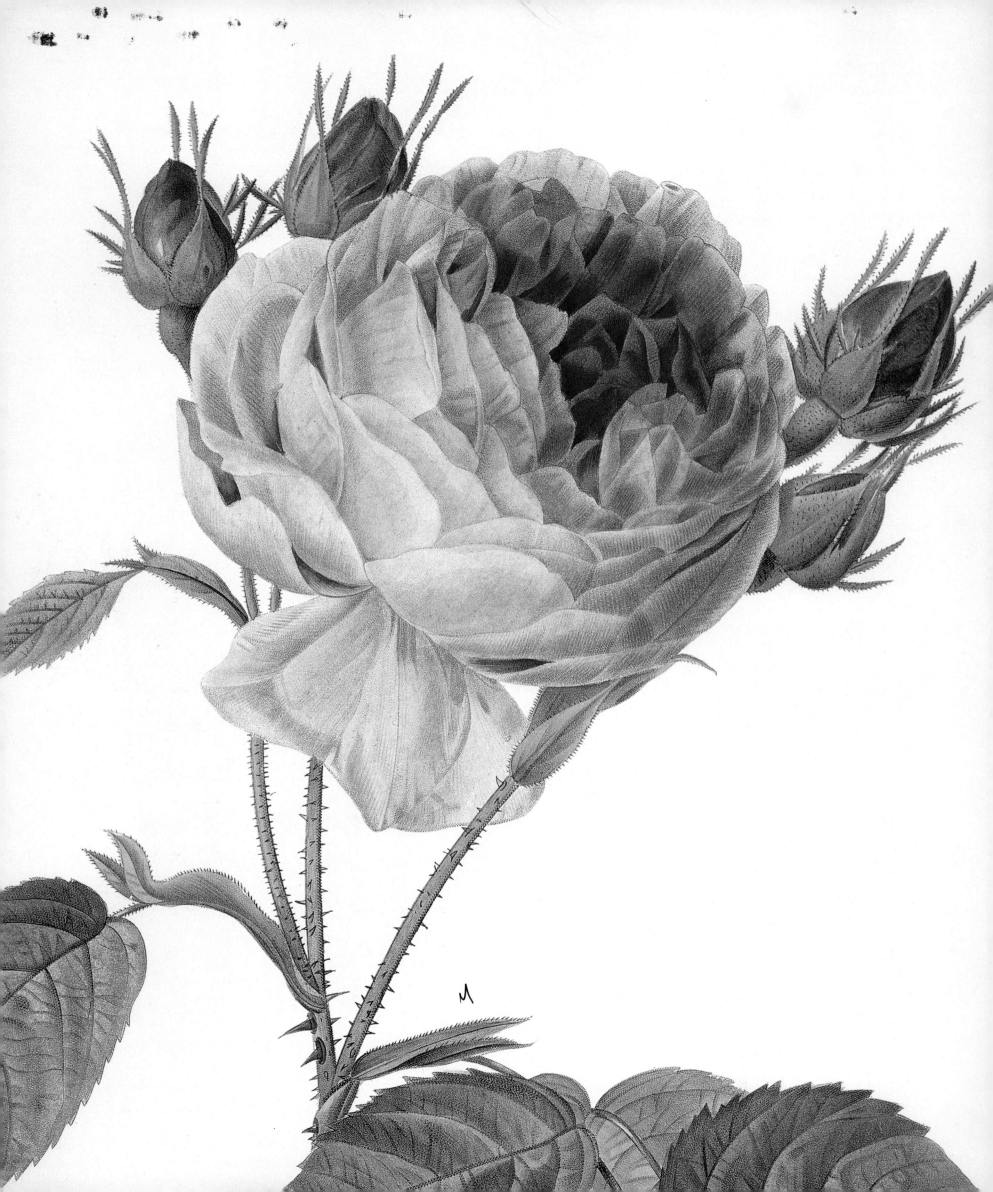

ROSA X *CENTIFOLIA*, CABBAGE ROSE,

Both representations (right & opposite) show the fullness of petals, rounded form and depressed centre of the Centifolia rose, which appears to have originated in the Netherlands in the 1580s. The name, literally 'a hundred leaves' means 'a hundred petals'. Its common names include Rose des Peintres and Provence Rose. It is wonderfully fragrant and used in the south of France for the manufacture of perfume. In the garden it is a vigorous but sprawling plant, and rarely looks effective because the stems bow under the heavy flowers.

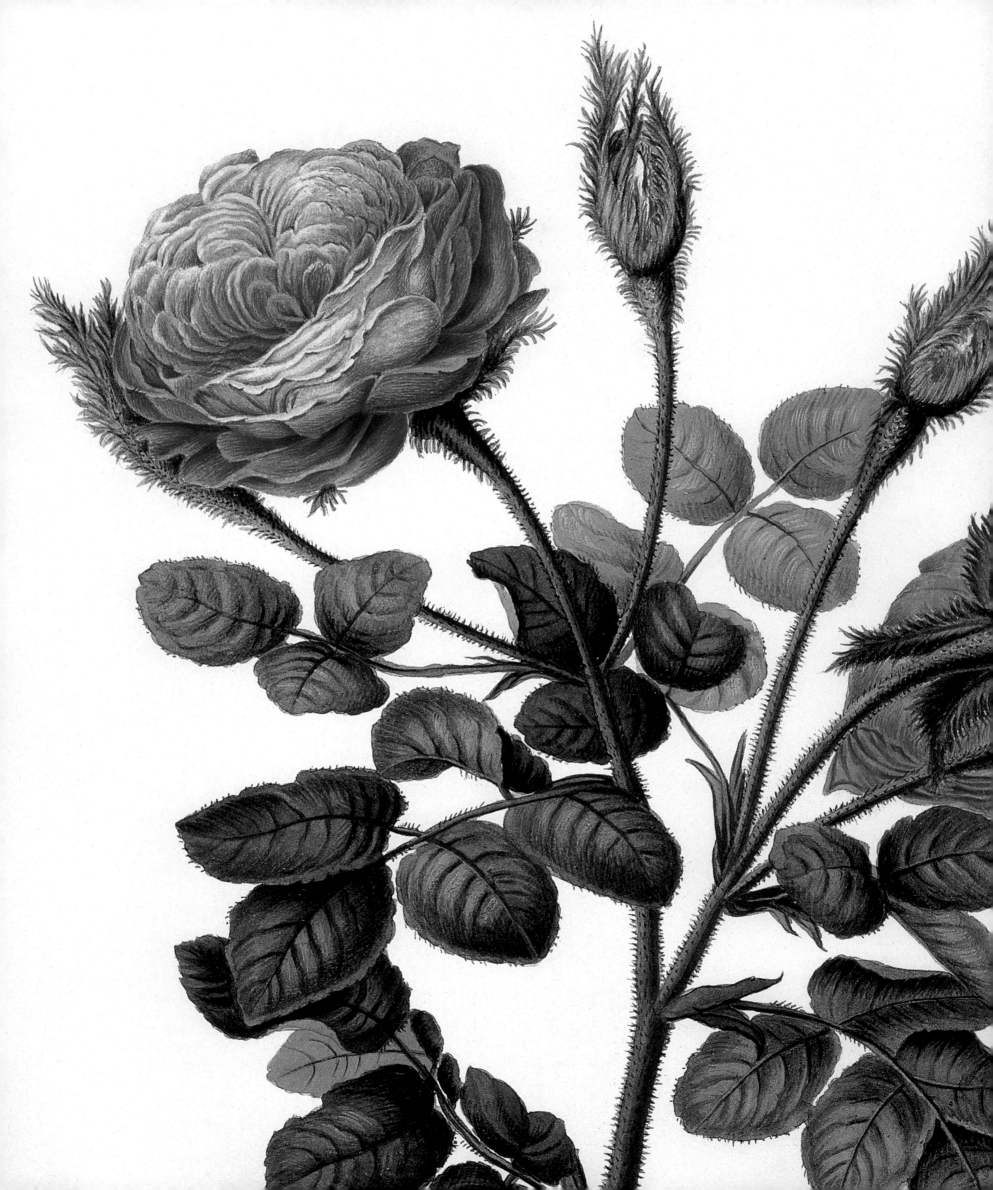

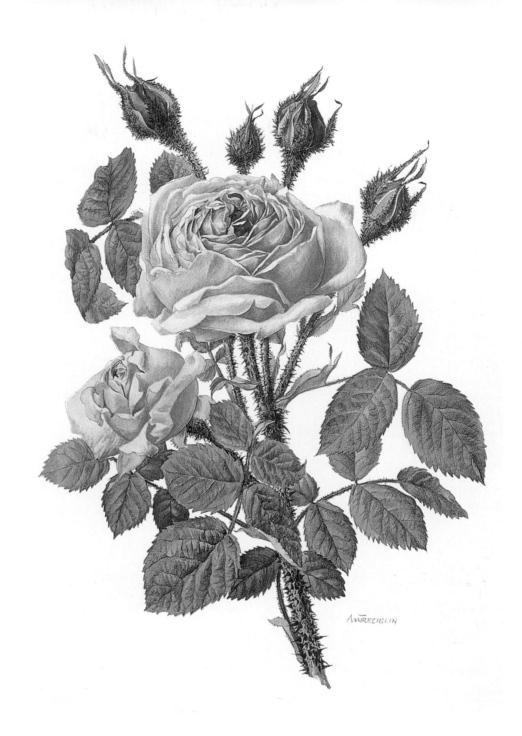

ROSA X CENTIFOLIA MUSCOSA, COMMON MOSS

'Moss' describes the curious furry growth over the buds and stems of this rose (left & above).
The moss-like covering is especially noticeable and attractive in the bud stage. A Centifolia rose
with this feature was discovered in France about 1696. It was sterile but provided some
beautiful variant forms. 'Mossing' can occur on some Damask and Miniature roses as well as the
Centifolia rose — it is softer to the touch on Centifolias.

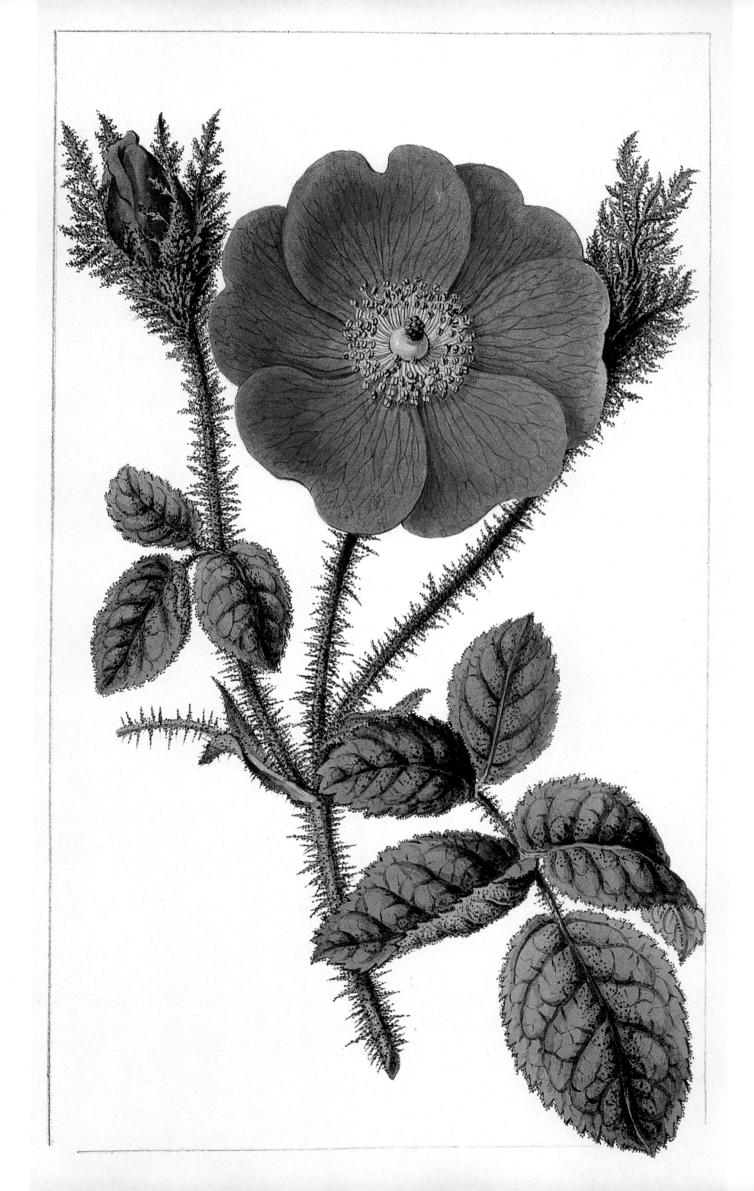

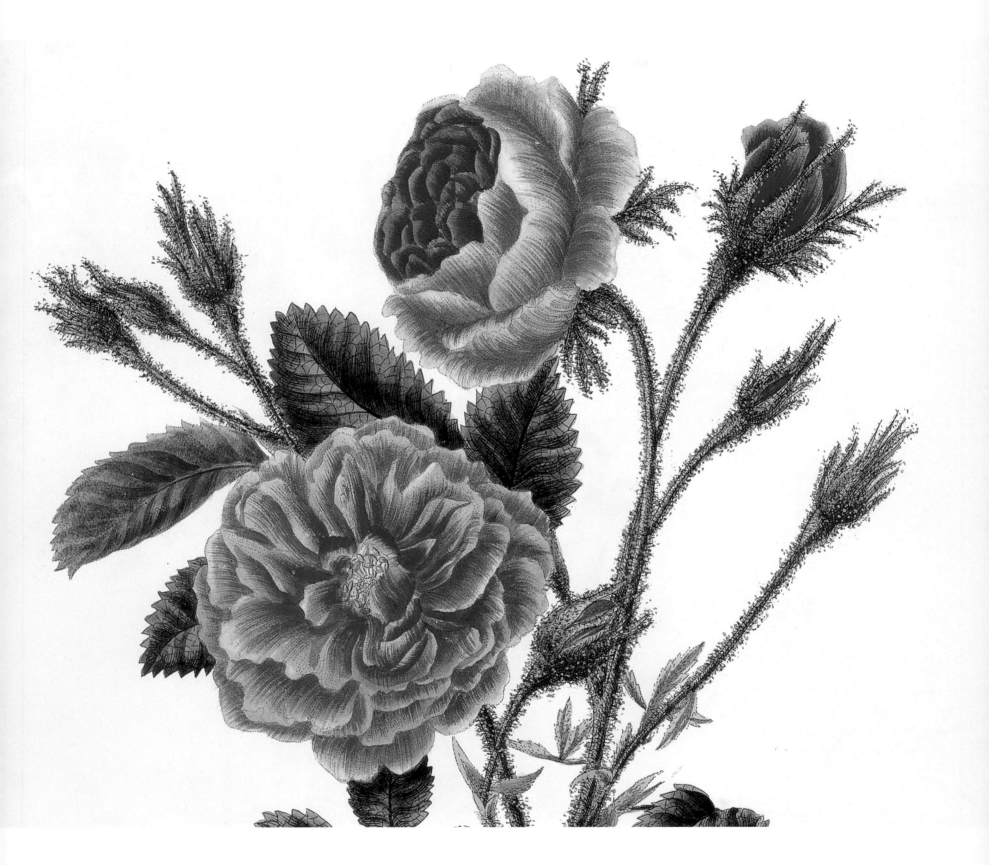

ROSA X CENTIFOLIA MUSCOSA, COMMON MOSS & SINGLE MOSS

The full-petalled character of the original Common Moss (above) left scant room for the flower's sexual parts, and consequently it failed as a source of viable seed. It did however sport forms with fewer petals such as Single Moss (opposite), which proved fertile. From their seed, pink, white, red and purple Moss roses were raised, the first being 'De La Flèche' about 1824, followed by many more in the period 1840–1870.

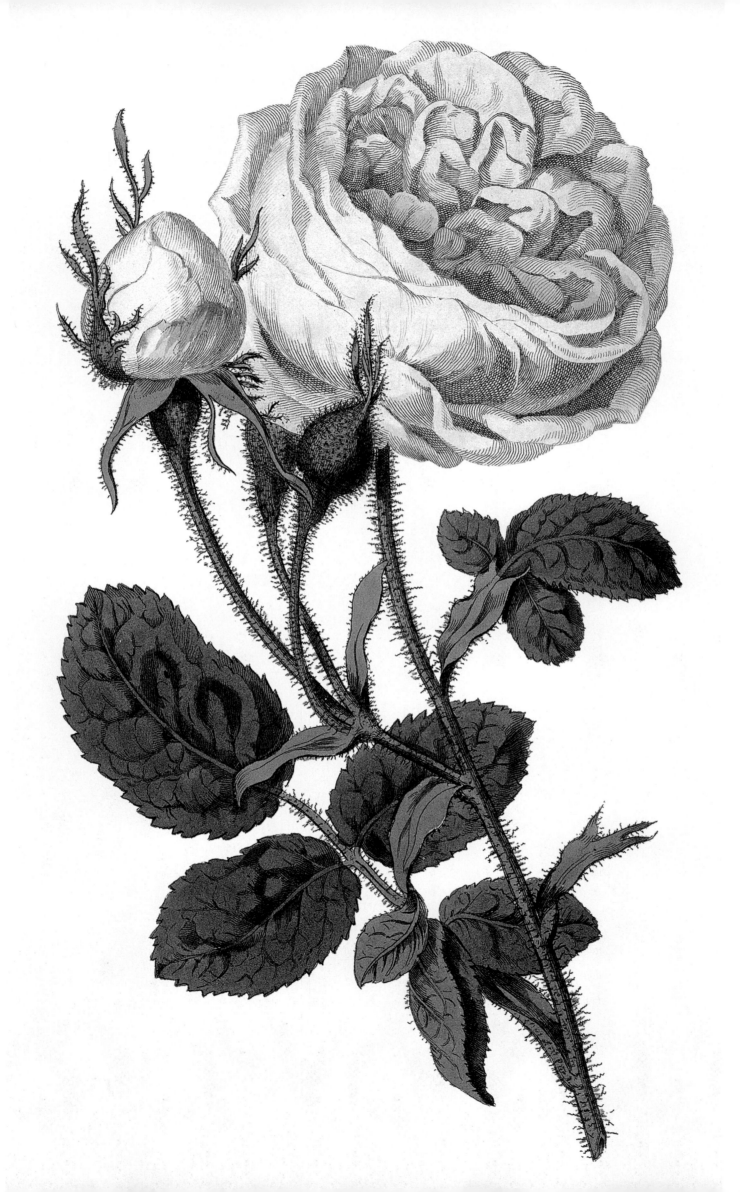

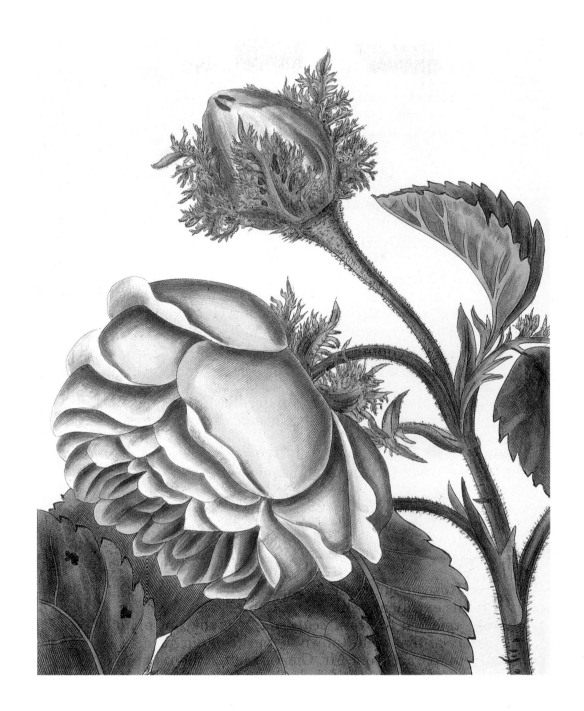

ROSA X *CENTIFOLIA CRISTATA*, CRESTED MOSS

This form of Centifolia (above) with prettily tufted sepals was found in a romantic setting when a botanist encountered it on the tower of an ancient castle near Fribourg in Switzerland. It was introduced in 1827, and many consider it the most endearing Centifolia for garden cultivation.

ROSA X *CENTIFOLIA MUSCOSA ALBA*, DOUBLE WHITE MOSS

According to Henry Shailer in 1852, this sweet scented rose (opposite) originated on his father's London nursery 'from a sucker or underground shoot' of 'Rubra', a red Moss rose. After propagation he obtained first blush and then white roses. Another name for this rose is 'Shailer's White Moss'.

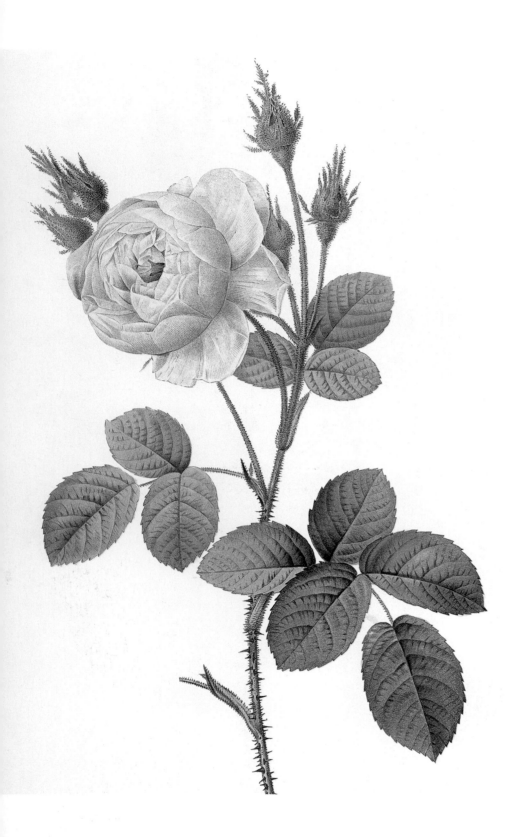

ROSA X CENTIFOLIA MUSCOSA ALBA, 'WHITE BATH'

This sport of the pink Common Moss produces white flowers (left), often with a trace of carmine or blush. It was discovered at Clifton near Bristol in 1817 – which explains its other common name, Clifton Moss – and is generally thought superior to the earlier 'Shailer's White Moss' because of its stronger growth and larger, fuller flowers.

'CRIMSON GLOBE'

Although this rose (opposite) was praised for its rich and beautiful moss, little of it is evident in the illustration from William Paul's catalogue for 1890, the year it was introduced. Moss roses were going out of fashion by that date, and the tendency of this one to 'ball' due to the thick petals did not win it many friends. However it is still cultivated in warmer climates.

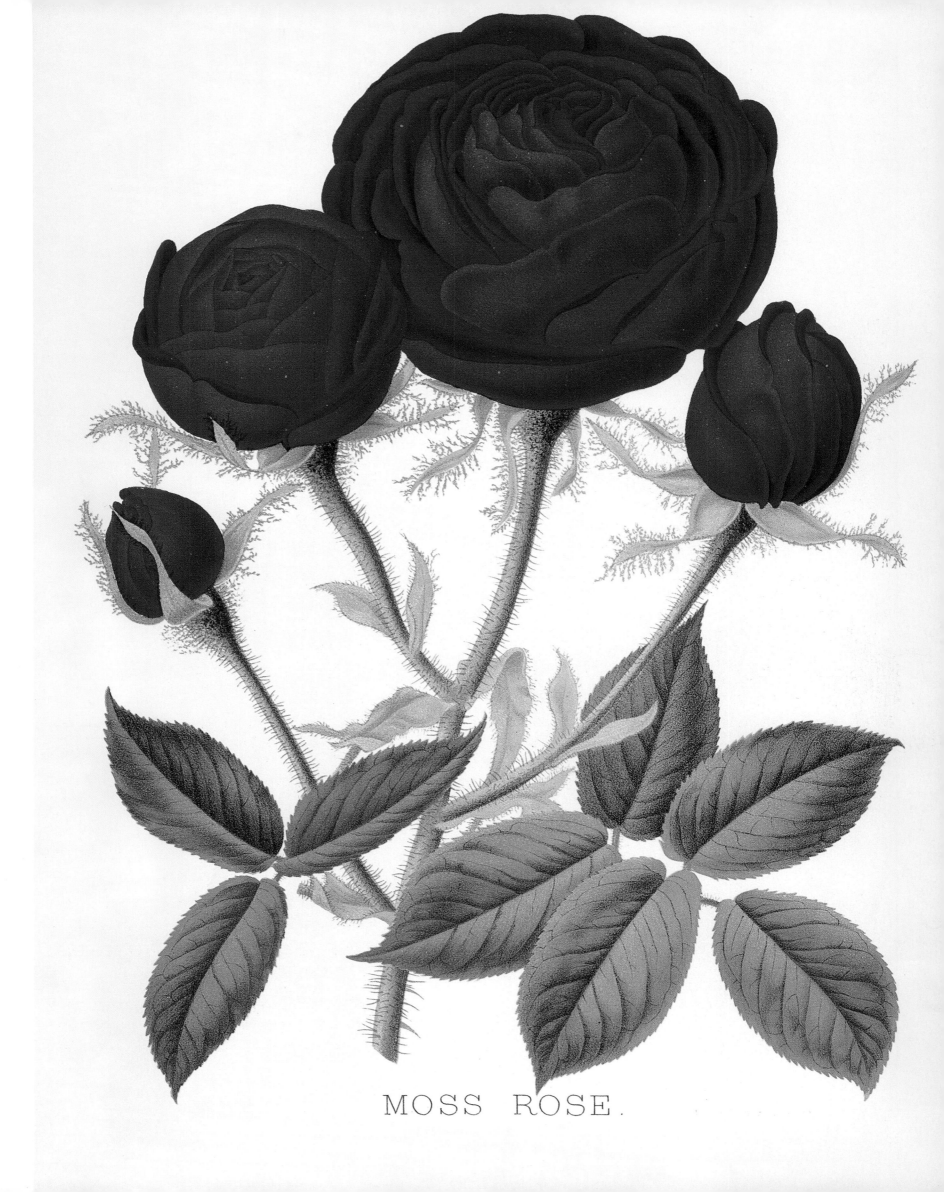

MOSS ROSE.

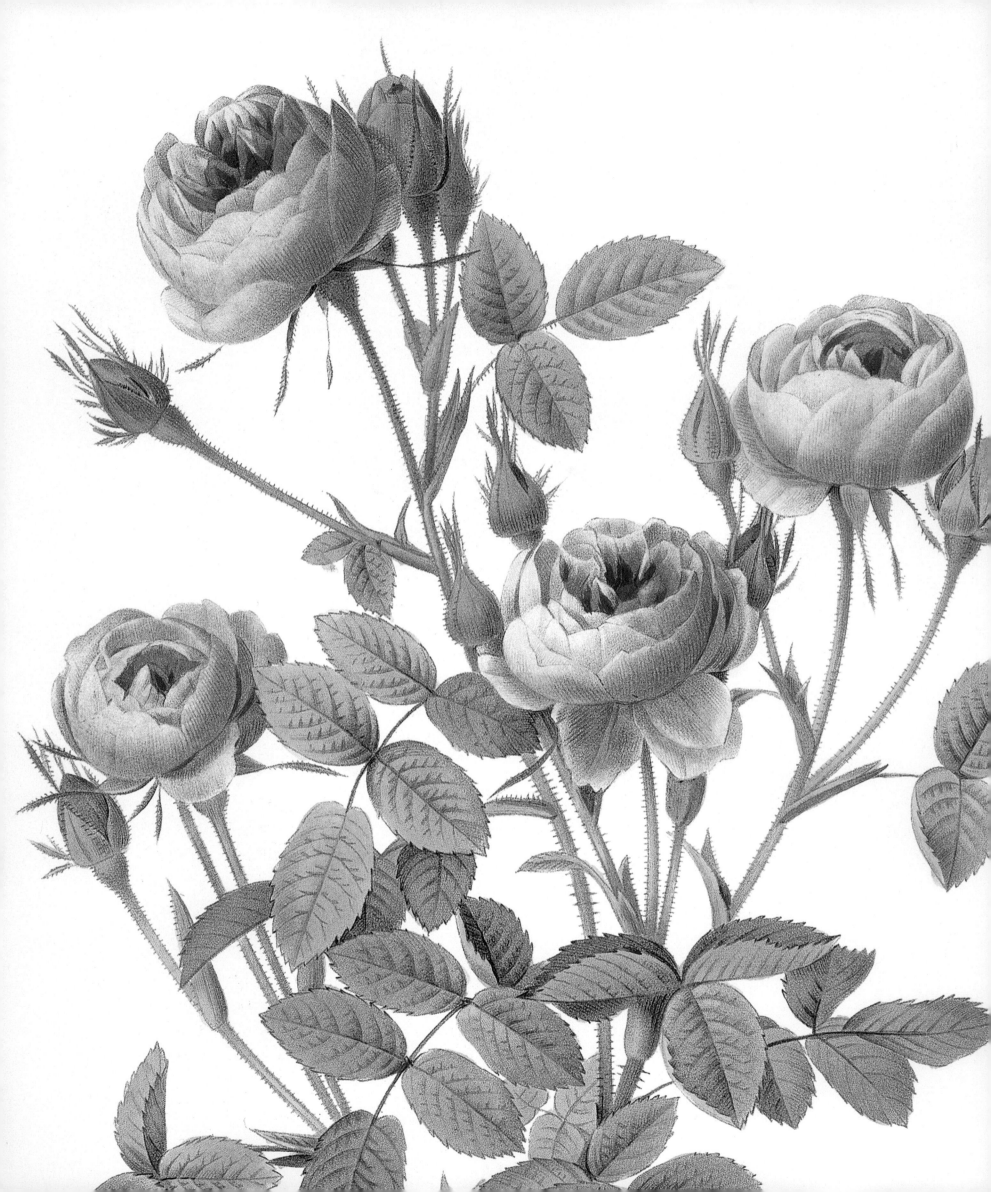

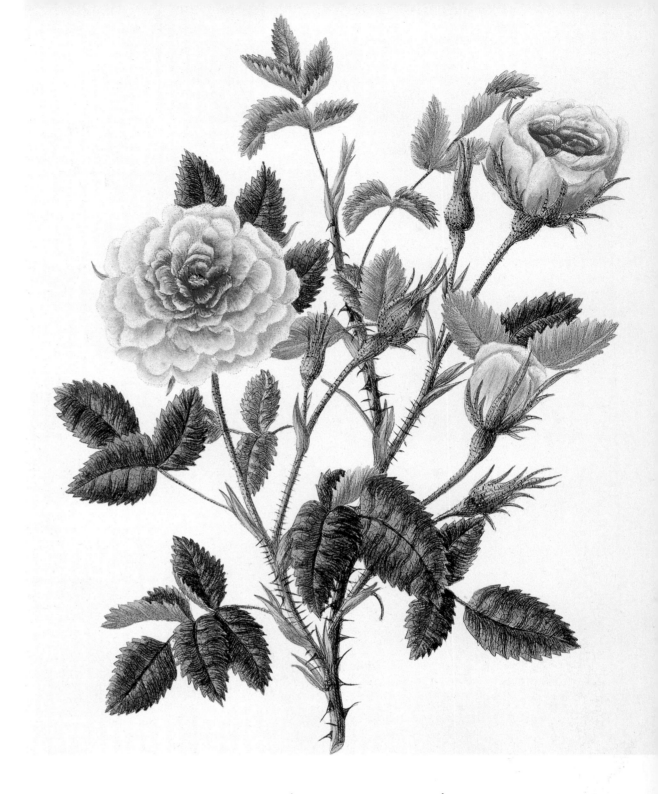

ROSA X CENTIFOLIA PARVIFOLIA, 'LESSER DE MEAUX'

This plate by Mary Lawrance (above) is believed to show 'Lesser De Meaux', also called 'Pompon de Burgoyne' and 'Rose de Pompon', a smaller growing form of the French pompom rose, of which there were many variants in the eighteenth century. In Britain in the 1770s this and related dwarf plants were fetching high prices, five or more times as much as many garden roses.

ROSA X CENTIFOLIA VAR. POMPONIA, 'ROSE DE MEAUX'

The word 'pompom' or 'pompon' originated in eighteenth-century France and referred to a small ball of wool or silk used to ornament clothing or curtains. It was applied to this rose (left) due to the shape of the buds. Along with similar forms it became very popular. 'De Meaux' is still widely cultivated.

ROSA X *CENTIFOLIA* VAR. *POMPONIA*, 'ROSE DE MEAUX'

This rose was popular in the eighteenth century. Resembling a Centifolia with flowers and leaves reduced in scale, it is sweetly scented and flowers in summer. Some forms make low bushy plants, others have an upright habit and can reach 4 feet (1.2m). France is almost certainly its place of origin, perhaps in the time of Dominic Séguier, who was appointed Bishop of Meaux in 1637 and was a keen rosarian with eighteen varieties in his garden, or possibly later, in the eighteenth century. Botanists before the time of Linnaeus (1707–1778) do not mention it.

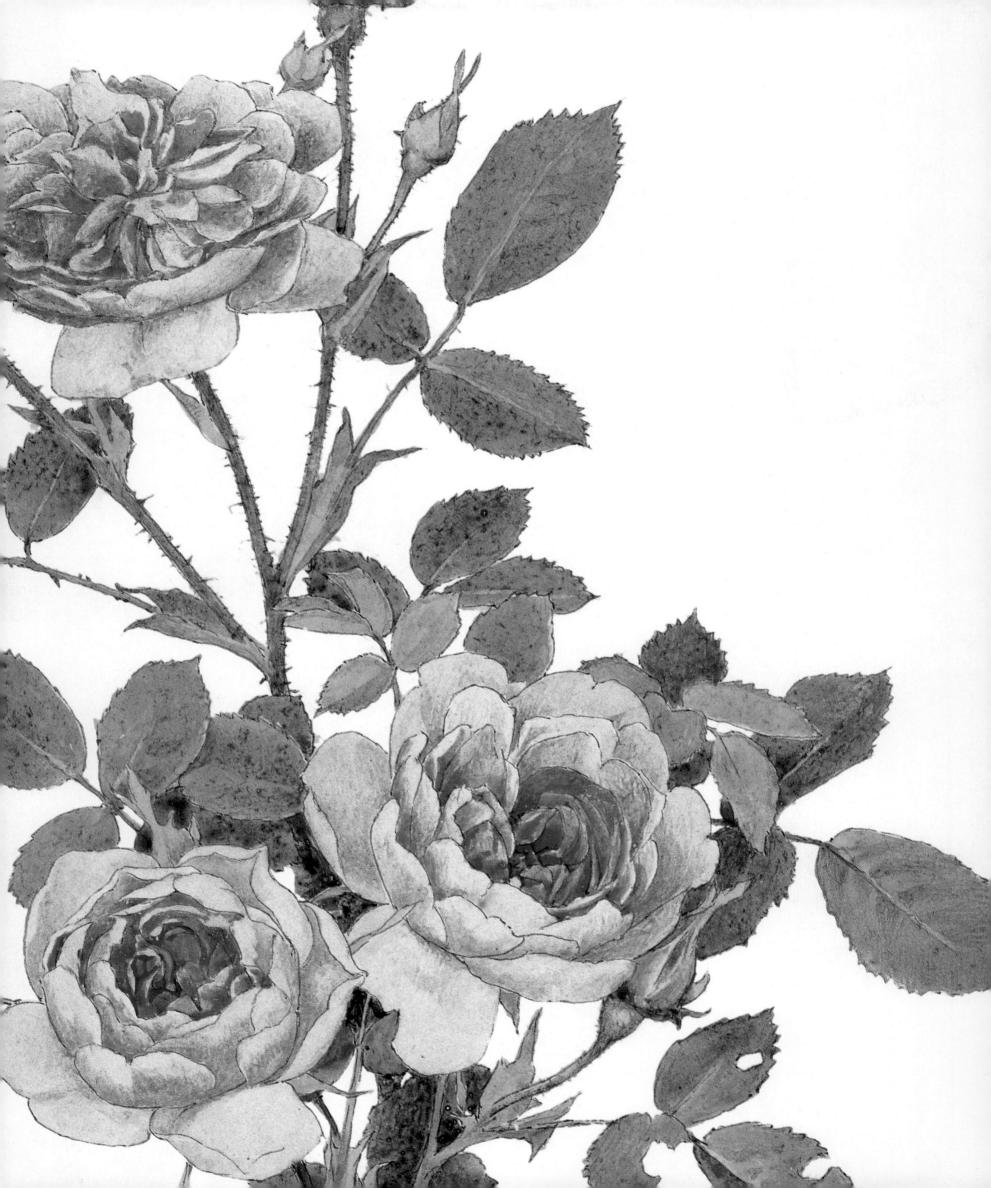

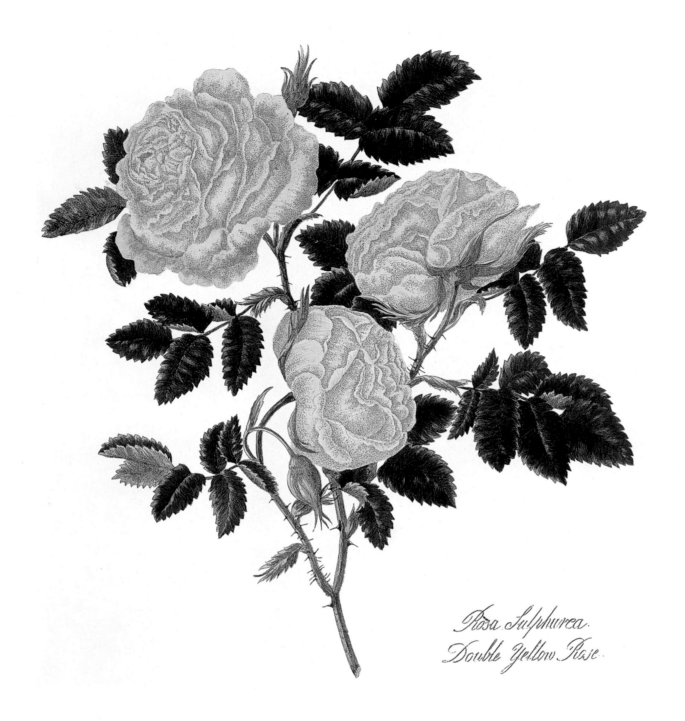

Rosa Sulphurea.
Double Yellow Rose.

ROSA HEMISPHAERICA, YELLOW PROVENCE ROSE

A mention of full-petalled yellow roses in Calcutta in 1503 may refer to this rose (above & opposite) which came to Europe from Turkey a century later. It was a wonderful novelty because no other large yellow roses existed in the West at that time. In Italy and France it was widely grown for sale as a cut flower. Its five-petalled species ancestor was botanically recorded as R. hemisphaerica *var.* rapinii *in 1859, and another name for it is* R. sulphurea. *The Hemisphaerica roses are distinguished from the yellow Foetidas by their prickles, which are straight rather than curved.*

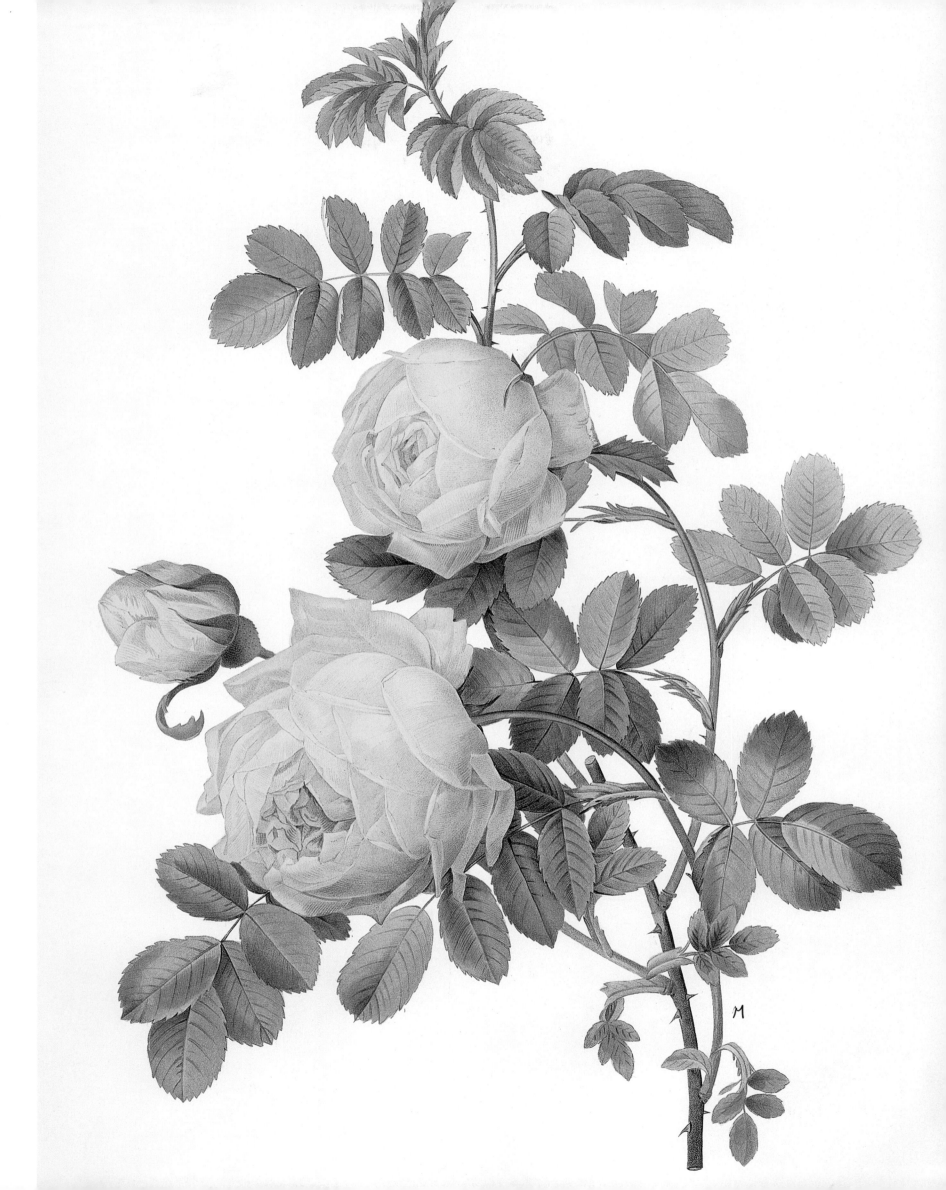

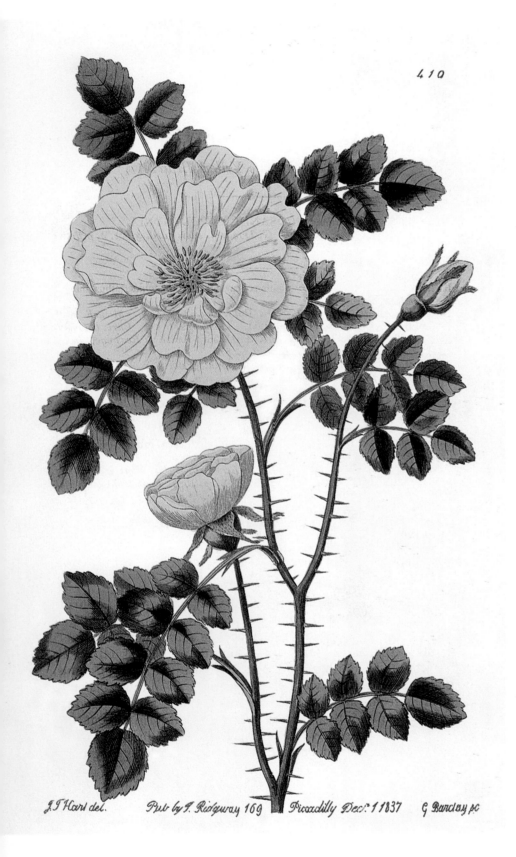

410

J.T.Hart del. Pub.by J. Ridgway 169 Piccadilly Dec.r 1 1837 G. Barclay sc.

ROSA LUTEA VAR. *HOGGII*, 'HARISONII'

R. foetida, *despite its low fertility, is credited with the parentage of two roses that appeared in the late 1820s, both thought to be crosses with a Scots rose. One is the short growing 'Williams' Double Yellow' and the other is 'Harisonii' (left). For several years they had the field to themselves as the only hardy bright unfading yellow garden roses. 'Harisonii' makes a gaunt twiggy plant of about 6 by 4 feet (1.8 by 1.2m), generously covered with bloom in early summer. It is credited to the Rev. George F. Harison of Trinity Church, New York. Another name for it is 'Harison's Yellow'.*

'MARBLED SCOTS'

Hundreds of Scots roses have been raised and all but a handful are now lost, including this distinctive looking one (opposite) depicted in the late 1790s. Nurserymen's lists show that a rose of this name was being offered from 1760. This was well before Scots roses became a horticultural fashion for a brief period, encouraging the Glasgow firm of Austin & McAslan to offer 208 varieties to their customers in 1817.

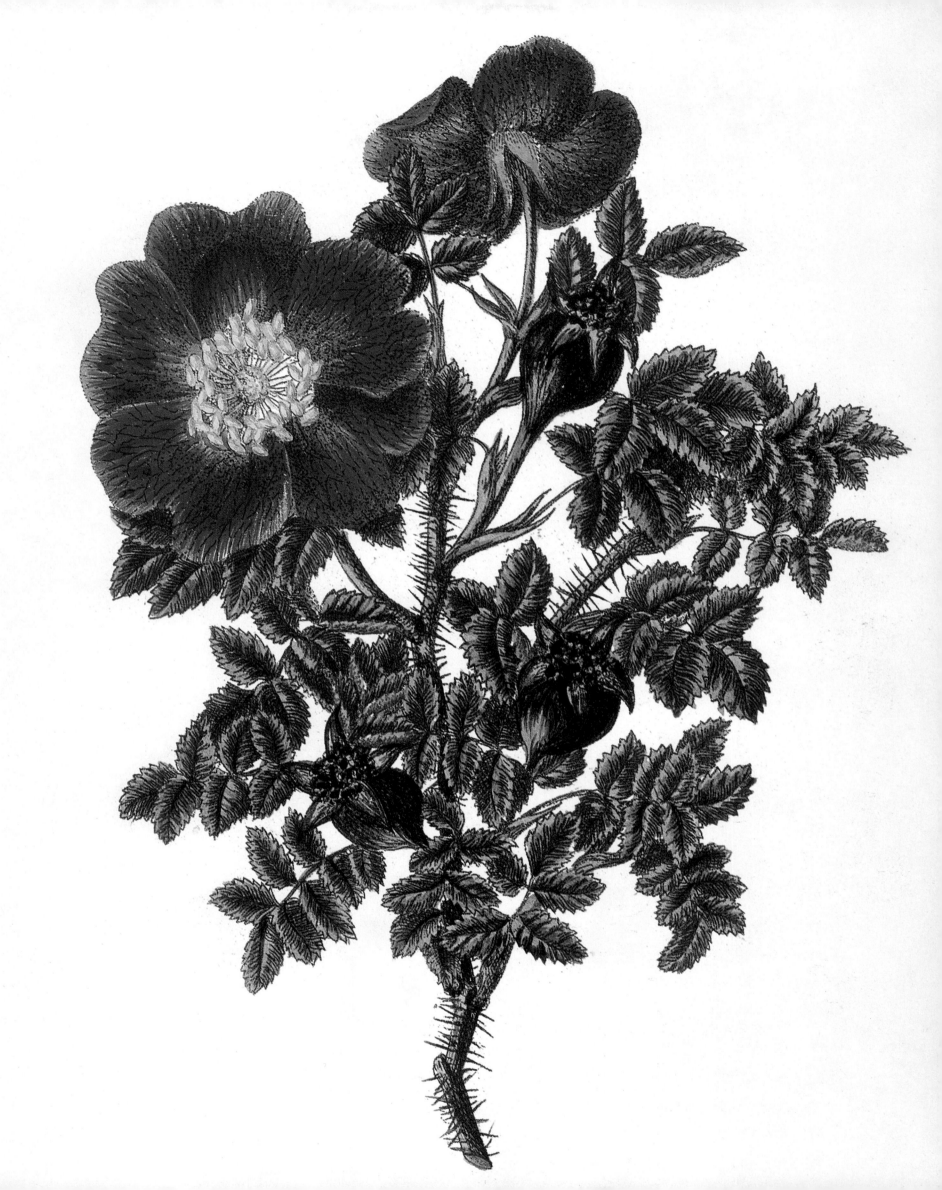

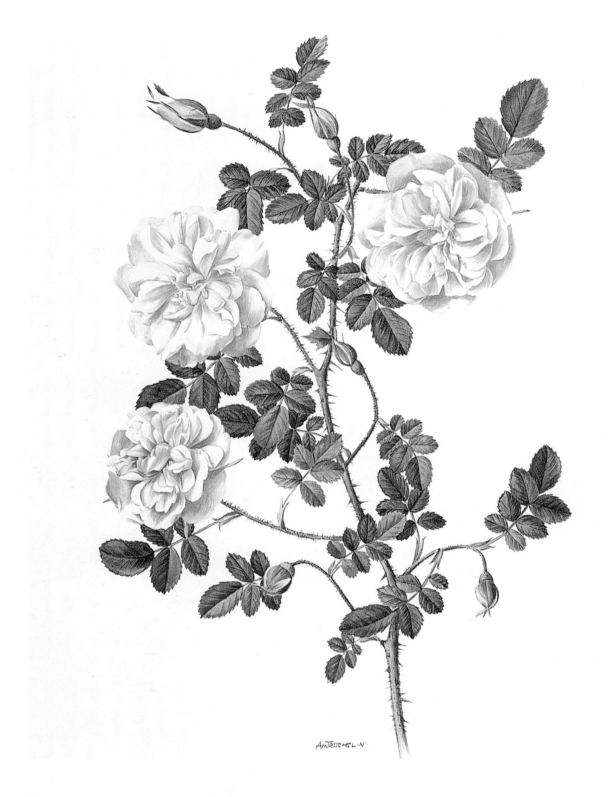

'STANWELL PERPETUAL'

This remarkable and beautiful shrub rose (above & opposite) is a rare survivor of a group known as the 'Perpetuals',
because they flower in autumn as well as summer. It shows affinity with the Scots roses in its dense rounded habit of
growth, and with the Autumn Damasks in its flowering, and is thought to be a hybrid between them. It was found
'as a seedling in the garden of Mrs. Lee' at Stanwell in Middlesex, and soon won popularity, being recommended in
1838 by nurseryman Charles Wood as one of the best roses to grow.

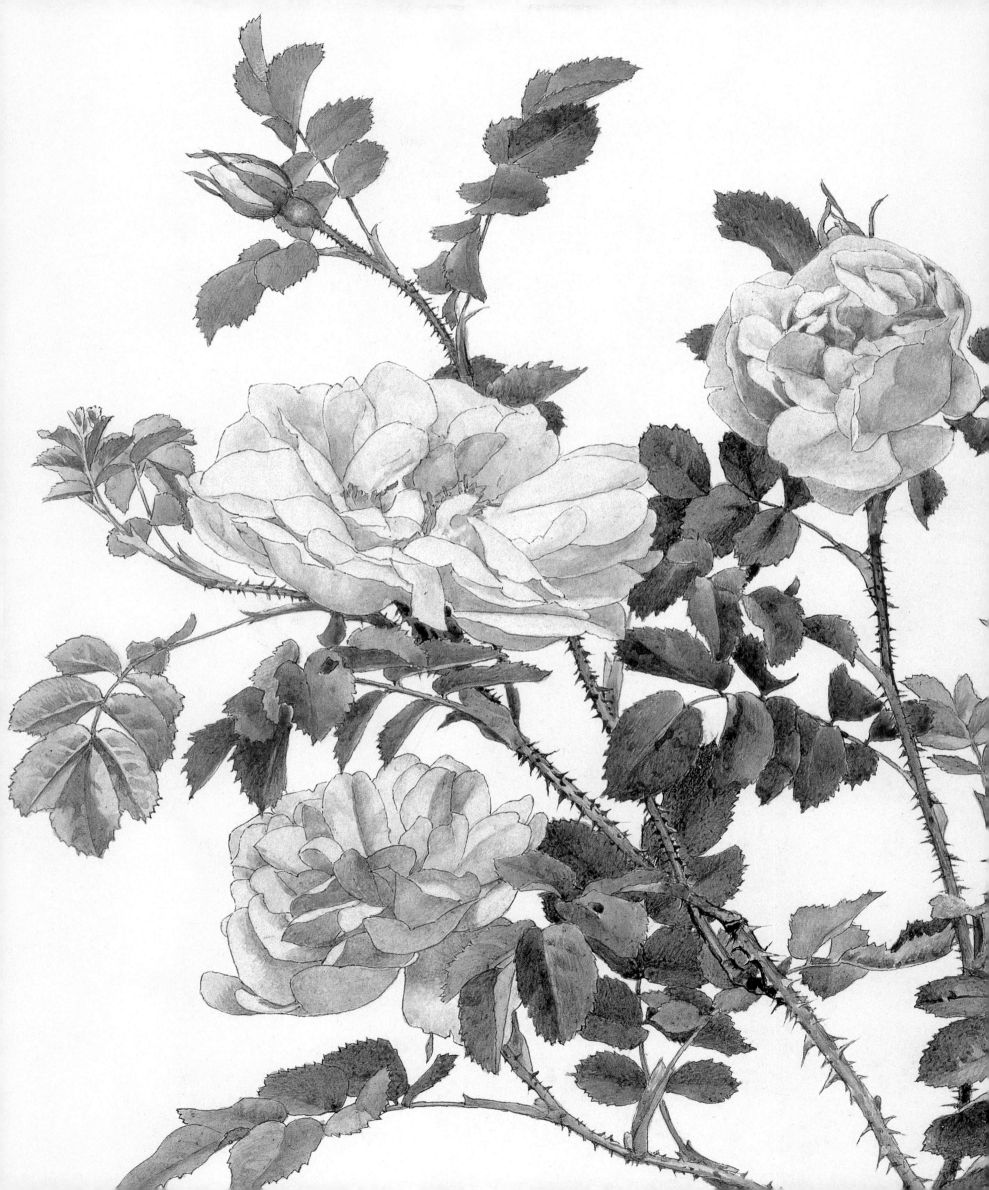

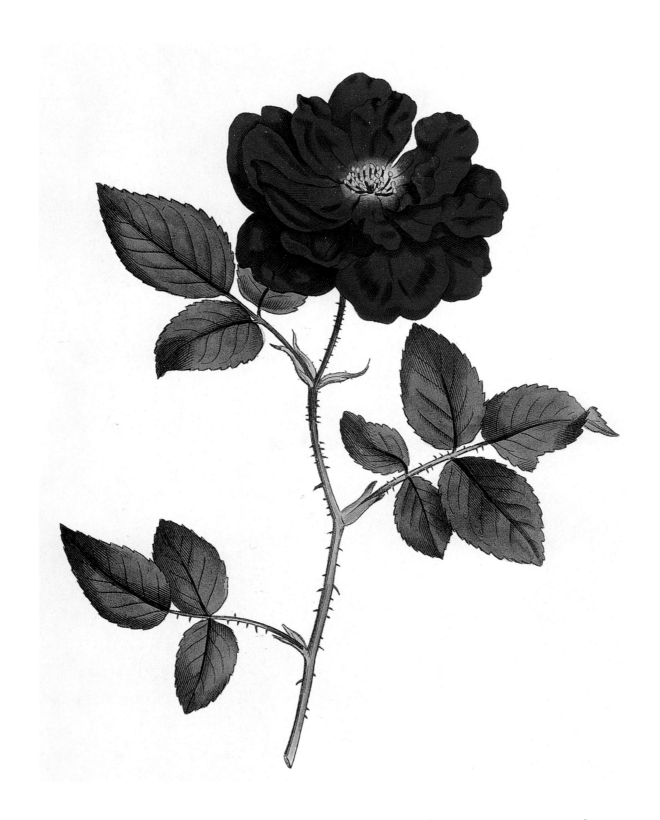

ROSA CHINENSIS VAR. *SEMPERFLORENS*, 'SLATER'S CRIMSON CHINA'

In the Botanical Magazine *for 1st Dec 1794, William Curtis describes the 'Ever-Blowing Rose' as 'one of the most desirable plants in point of ornament ever introduced to this country'. This gives some idea of the impact the new import from China was making, admired for its novel rich crimson colour and ability to keep on flowering in repeated cycles of growth and bloom. Curtis' reference to its 'most delightful fragrance' suggests he got carried away in his enthusiasm, as does his expectation that it 'will grow in so small a compass of earth, that it may be reared almost in a coffee cup'. He would soon discover that a greenhouse gave the best chance of seeing it through the winter.*

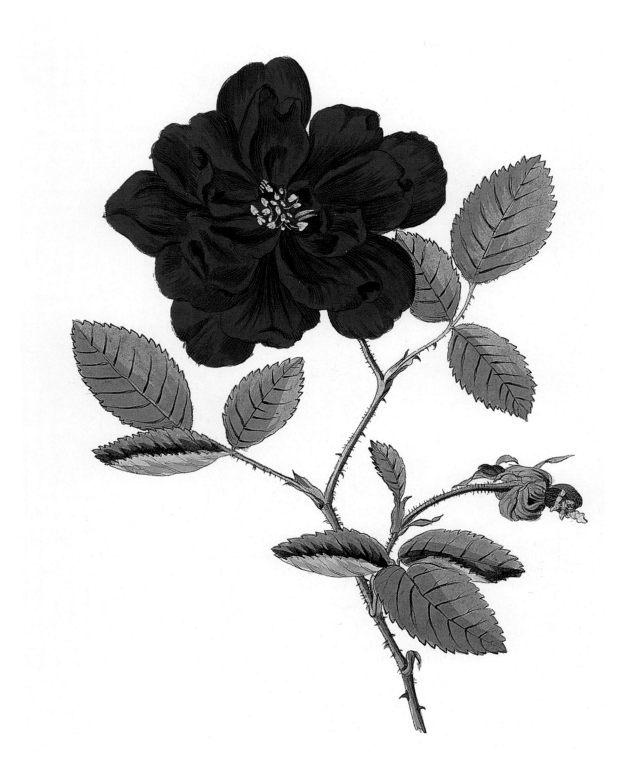

ROSA CHINENSIS VAR. *SEMPERFLORENS,* 'SLATER'S CRIMSON CHINA'

In describing the red China rose that bore the name of Gilbert Slater, recently deceased, the Botanical Magazine paid tribute to the man himself as 'indefatigable… there was no contrivance that ingenuity could suggest, no labour, no expence [sic] withheld… It is now about three years since he obtained this rose from China [viz. 1791]; as he readily imparted his most valuable acquisitions to those who were most likely to increase them, this plant soon became conspicuous in the collections of the principal Nurserymen near town, and in the course of a few years will, no doubt, decorate the window of every amateur.'

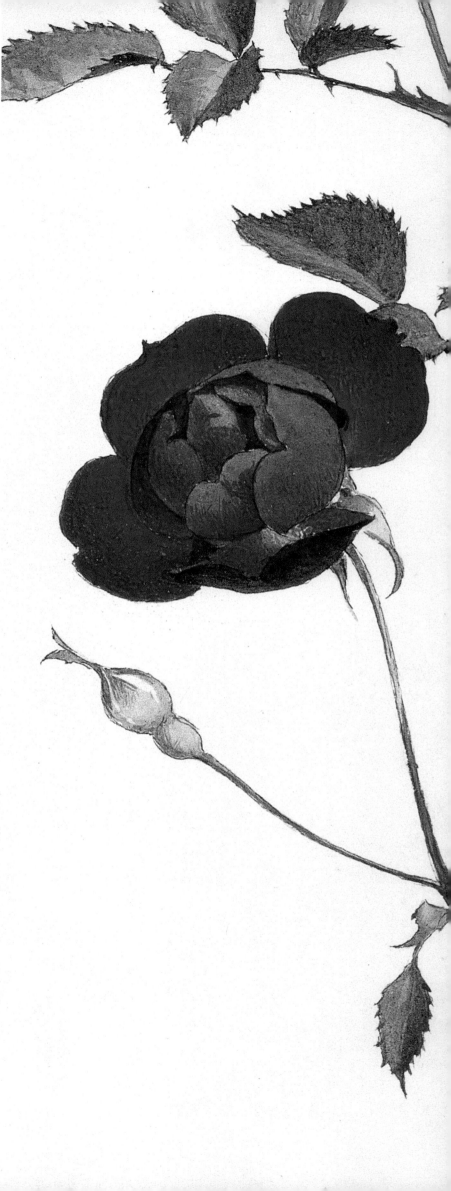

ROSA CHINENSIS VAR. SEMPERFLORENS, 'SLATER'S CRIMSON CHINA'

This was the second China rose to come to the West, and was doubly sensational because, apart from its ability to continue flowering for many months, its rich scarlet crimson colour was a complete novelty. Although not completely hardy, it proved in time a fertile parent. All modern red roses and most others cultivated today can trace it in their ancestry. Its other names include Belfield, Crimson China Rose, Ever-blowing Rose, La Bengale, Monthly Rose, Old Crimson China and Semperflorens.

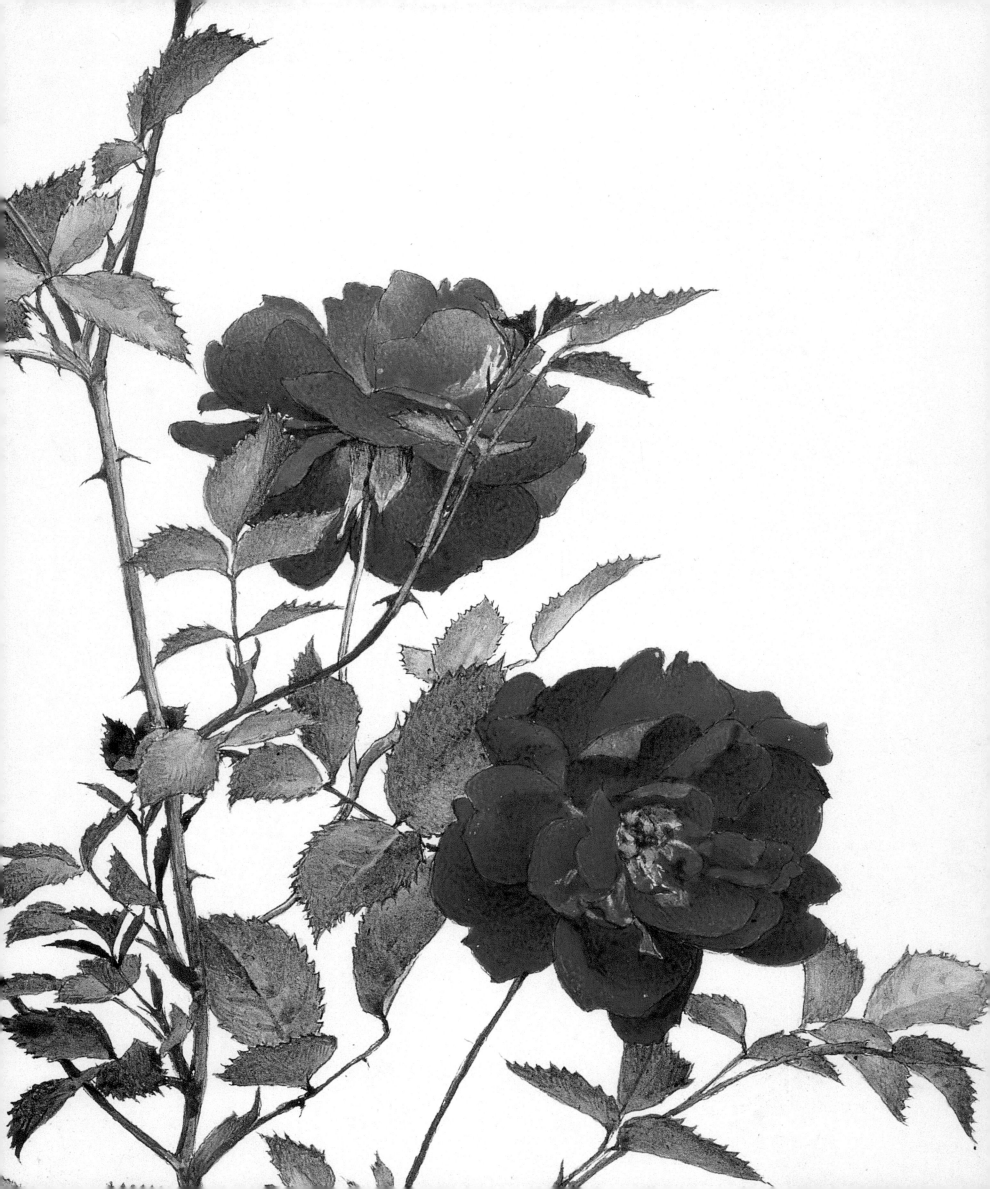

ROSA CHINENSIS VAR. SEMPERFLORENS, 'SLATER'S CRIMSON CHINA'

The inherent variability of Chinese roses is well illustrated in these two reproductions. One (opposite) shows a five-petalled form of R. chinensis semperflorens known as Simplex. The other (right) demonstrates that pink as well as red flowers can occur. In Bermuda these characteristics are combined in a remarkable mystery rose called 'Emmie Gray' which bears close resemblance to the early Chinas. It has five-petalled flowers and is capable of carrying light pink, dark pink and scarlet blossoms simultaneously in the same cluster.

Rosa semperflorens.

'OLD BLUSH'

Parsons gives a handsome depiction of this beguiling ancient Chinese garden rose (above), which is also called Parson's Pink, Pallida, Common Blush China or Monthly Rose. Duhamel's early nineteenth century portrayal (opposite) is less realistic or may show a variant form. 'Old Blush' descends from R. gigantea *and* R. chinensis *var.* semperflorens *and it is an important ancestor of modern repeat-flowering roses. Some early roses brought from China became extinct, but this one has always been in cultivation. It is cherished for its excellent plant qualities, being hardy, beautiful, neat in habit, long lived and quick to repeat its flower – indeed in a mild climate it hardly ever stops. One quality it lacks is good fragrance.*

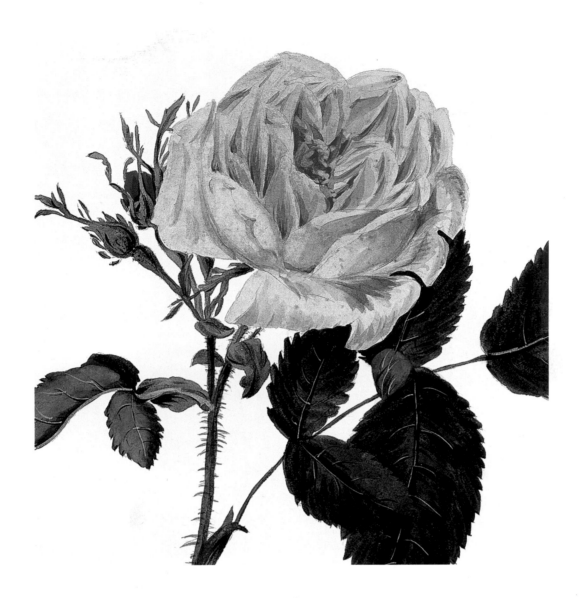

'OLD BLUSH'

The Swedish botanist Peter Osbeck is said to have brought this splendid rose to Uppsala from China when serving as a ship's chaplain in 1752. It reached England before 1759, France by 1798, was mentioned as being in Germany by Roessig in 1799, and was certainly in the United States by 1800. The picture (above) from Roessig's Die Rosen, published in parts between 1802 and 1820, shows a variety described as 'semper florens carnea'. Redouté's version (opposite) is titled 'Rosa indica vulgaris', and shows much more faithfully the 'China' type foliage. On account of its wonderful qualities 'Old Blush' was widely planted and by 1823 was said to be 'in every English cottage garden'. Thomas Moore caught sight of a flower in the autumn of 1815 at Jenkinstown House, Kilkenny in Ireland. It inspired his poem 'The Last Rose of Summer', which begins: 'Tis the last rose of summer, left blooming alone.'

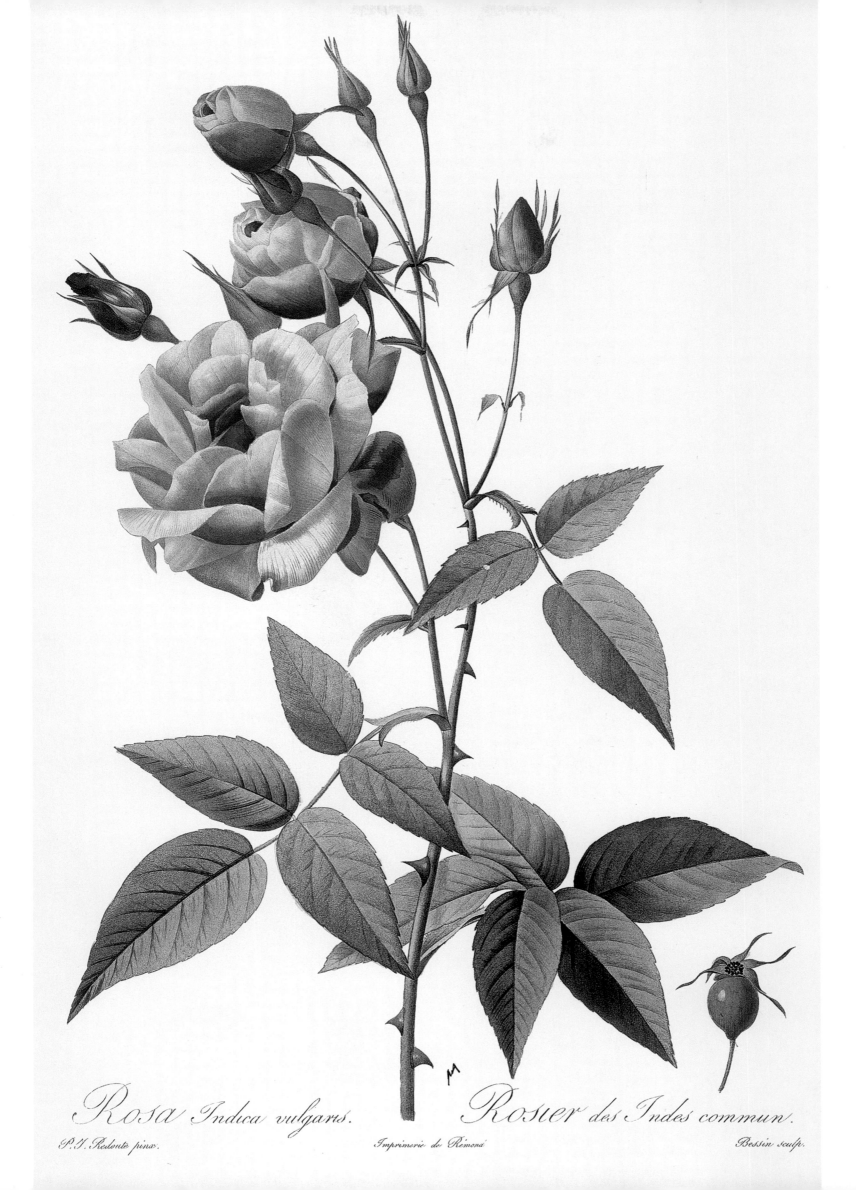

Rosa Indica vulgaris.　　　*Rosier des Indes commun.*

P.J. Redouté pinx.　　　Imprimerie de Rémond　　　Bessin sculp.

BENGAL CENTFEUILLES

The French rosarian Dr. Cartier grew seedlings of 'Slater's Crimson China' in 1804 and selected this one because of its full-petalled form. It is the first China rose known to have been raised in the West, and the forerunner of many. Its flowers darken with age, from intense pink to crimson to mulberry red. Redouté's caption says 'Indica – Rosier de Bengale (Cent feuille)', a reminder that the species name used for China roses was R. indica because many came via India, and more specifically from the Howrah Botanic Garden near Calcutta in Bengal.

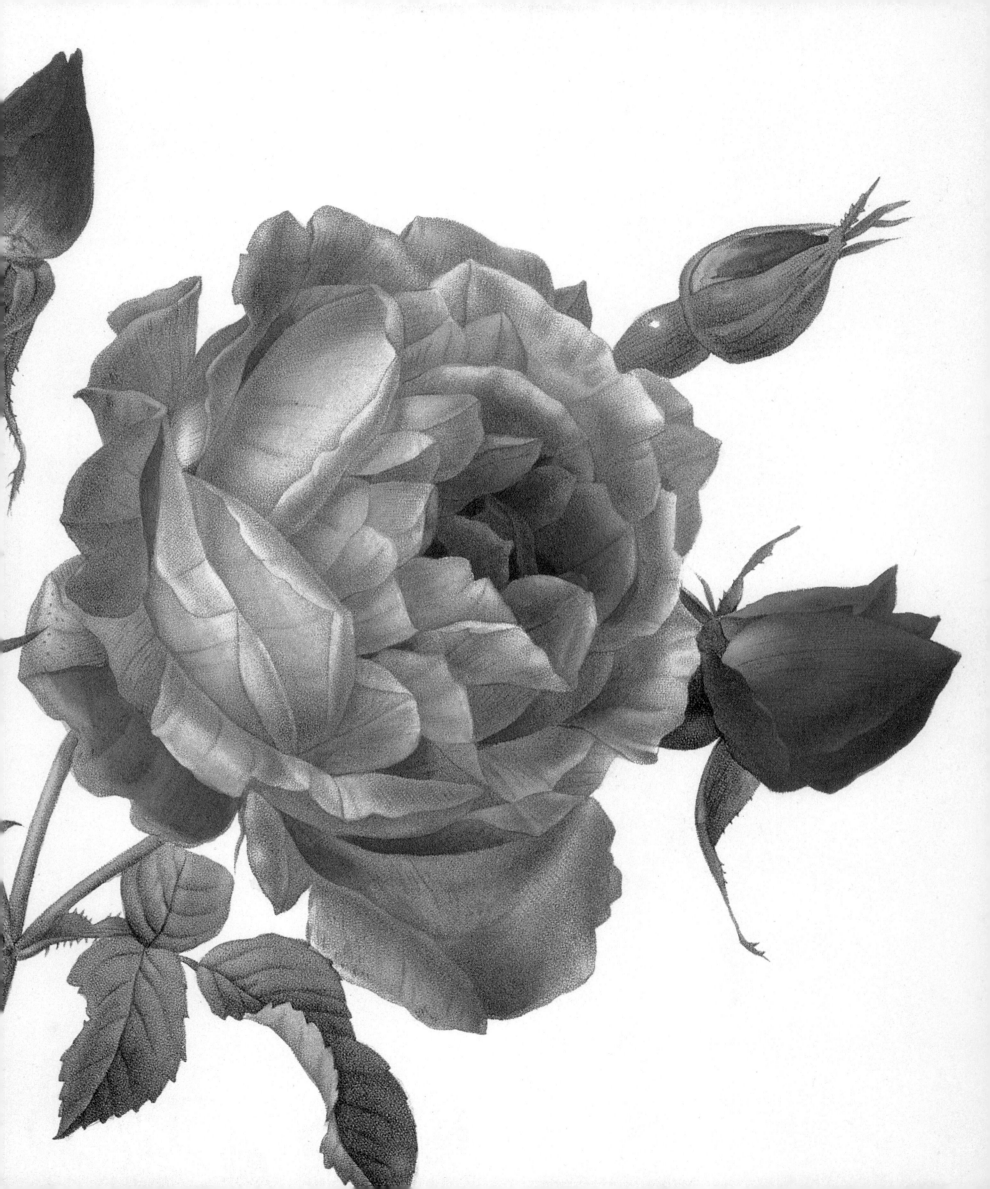

ROSA VIRIDIFLORA GREEN ROSE

This freakish curiosity (left) bears flowers that are not true flowers, for they have neither stigmas nor stamens, and the narrow 'petals' are modified leaves, fresh green when they open and becoming brownish purple as they age. It is similar to 'Old Blush' in growth, and may be a mutation of that rose. It appears under the name of 'Lü E' in lists of old roses cultivated in China, but there is no record to say how it came to be in South Carolina by 1833. In 1855 the Green Rose was exhibited in Paris and an illustration of it (opposite) was reproduced in France the following year.

Off. Lith. & pict. in Horto Van Houtteano.

ROSIER BENGALE à fleurs vertes.

accident de culture. Rustique.

XI, 131.

Rosa Multiflora platyphylla Rosier Multiflore à grandes feuilles

ROSA MULTIFLORA PLATYPHYLLA, 'SEVEN SISTERS'

These pictures (above & opposite) show related forms of a very vigorous climbing rose long cultivated in the Far East. The name 'Seven Sisters' refers to the varied colours of the flowers in the spray. One form came from Japan to England through the agency of the Hon. Charles Greville some time before 1809. A plant grown from seed in England was given to Louis Noisette of France in 1817 and is presumed to be the one above, illustrated by Redouté.

ROSA BANKSIAE LUTEA, BANKSIAN, YELLOW

Most of the Chinese artists commissioned by John Reeves are anonymous, but in this instance the name of Wang Heang Kow appears. Although the picture shows the grace and delicacy of the flower sprays, it cannot convey the wonderful impact made by an established plant extending 20 feet (6m) in all directions and laden with bloom. In 1824 John Parks brought it to London for the Royal Horticultural Society. It flourishes in frost-protected sites.

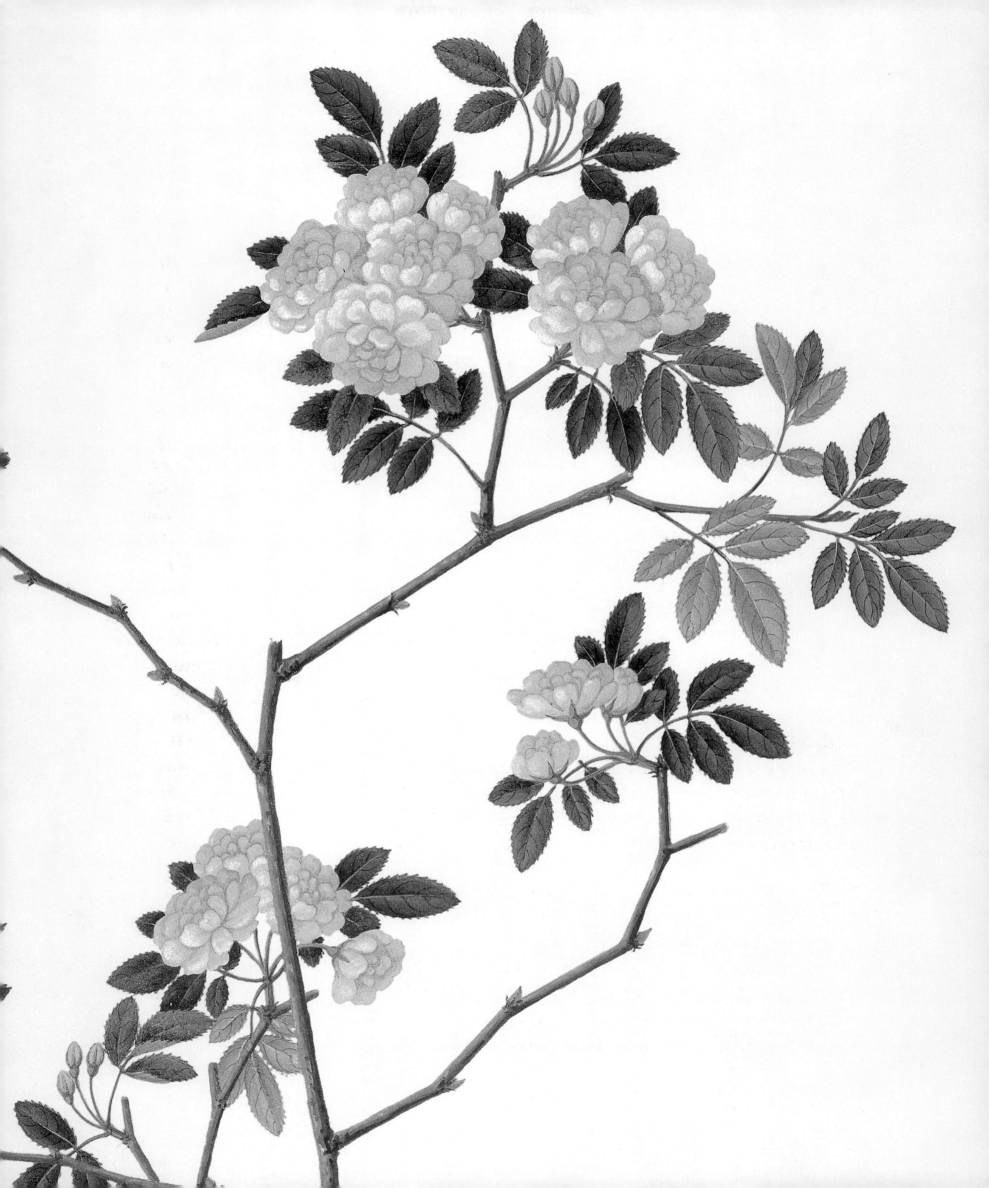

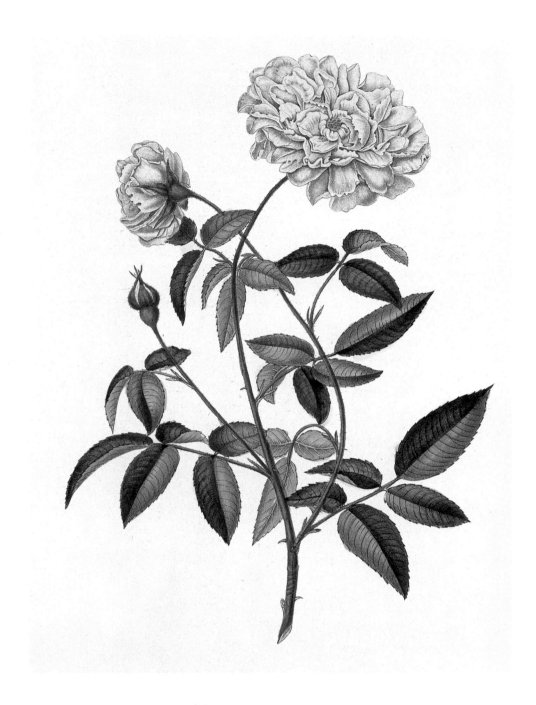

ROSA X *FORTUNIANA*, BANKSIAN EPINEUX

Discovered by Robert Fortune in China in 1840, this vigorous plant (above & opposite) needs frost free conditions, not easily provided in northern climates due to its natural preference for 'making a great show from tree tops'. The flowers are larger and fuller than those of the parent Banksian 'Alba Plena'. The other parent is R. laevigata. In warm climates such as that of Florida in the United States it makes a successful understock.

FORTUNE'S DOUBLE YELLOW

These illustrations make an interesting contrast, for while both agree on the prickles, thorns and bowing stems, the flowers look so different, those from the Botanical Magazine (left) being pale in colour, unrecognizable in shape and hardly likely, in Graham Thomas's words, 'to make people blink even today'. The blooms in Nestel's picture (opposite) are a fairer depiction.

ROSA ROXBURGHII, CHESTNUT ROSE

This beautiful rose (above & opposite) came to Europe via Calcutta in 1824 and was prematurely given the status of a species, which it still retains, having been recorded before Western botanists became aware of its five-petalled progenitor R. roxburghii normalis. Some of its common names refer to the vaguely chestnut-like hips – Chestnut Rose, Burr Rose and Chinquapan Rose, which is an American species of chestnut. It has been used in rose breeding, notably by Tantau of Germany, and features in the ancestry of 'Super Star' and 'Queen Elizabeth'.

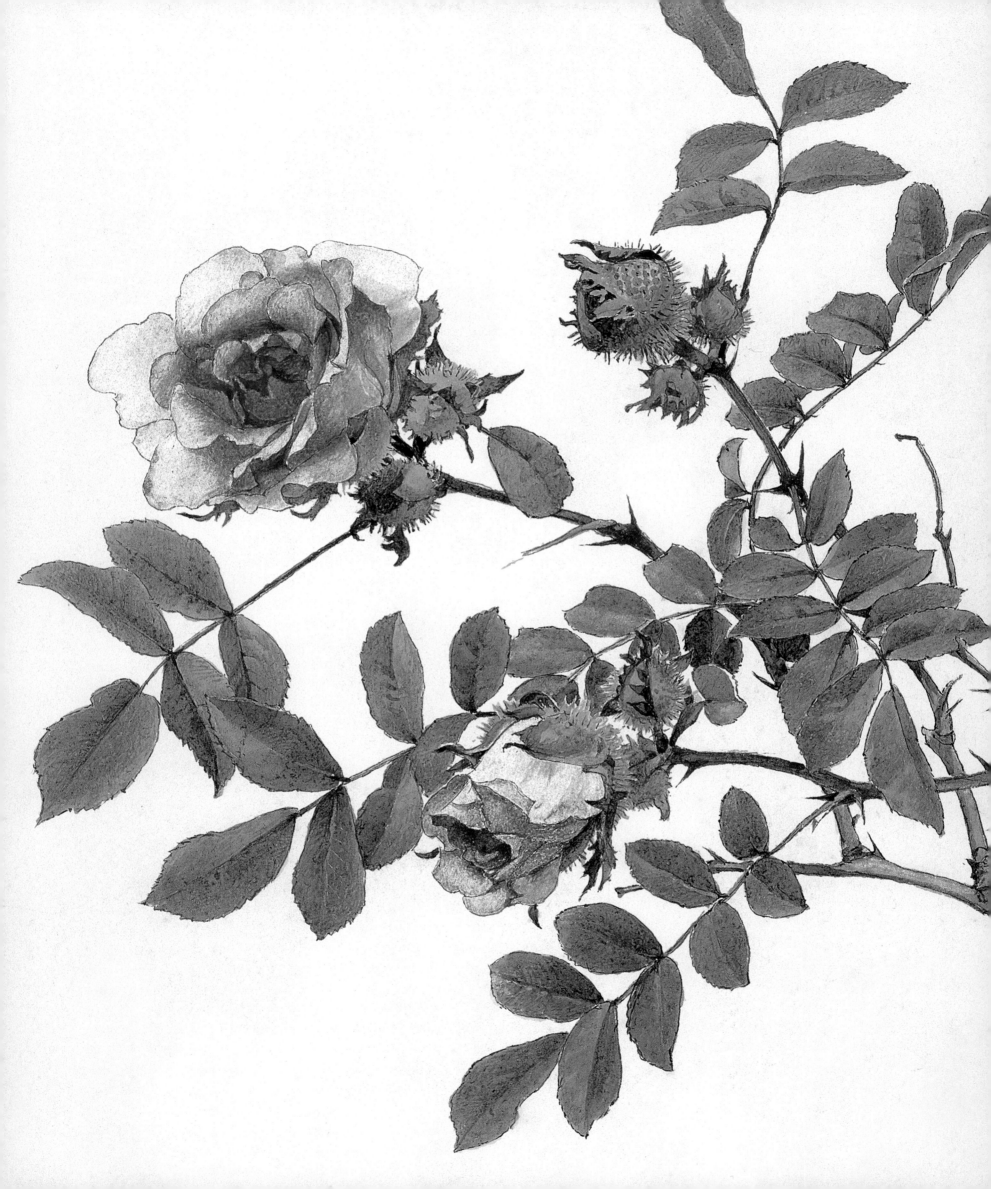

Roses *by* Design

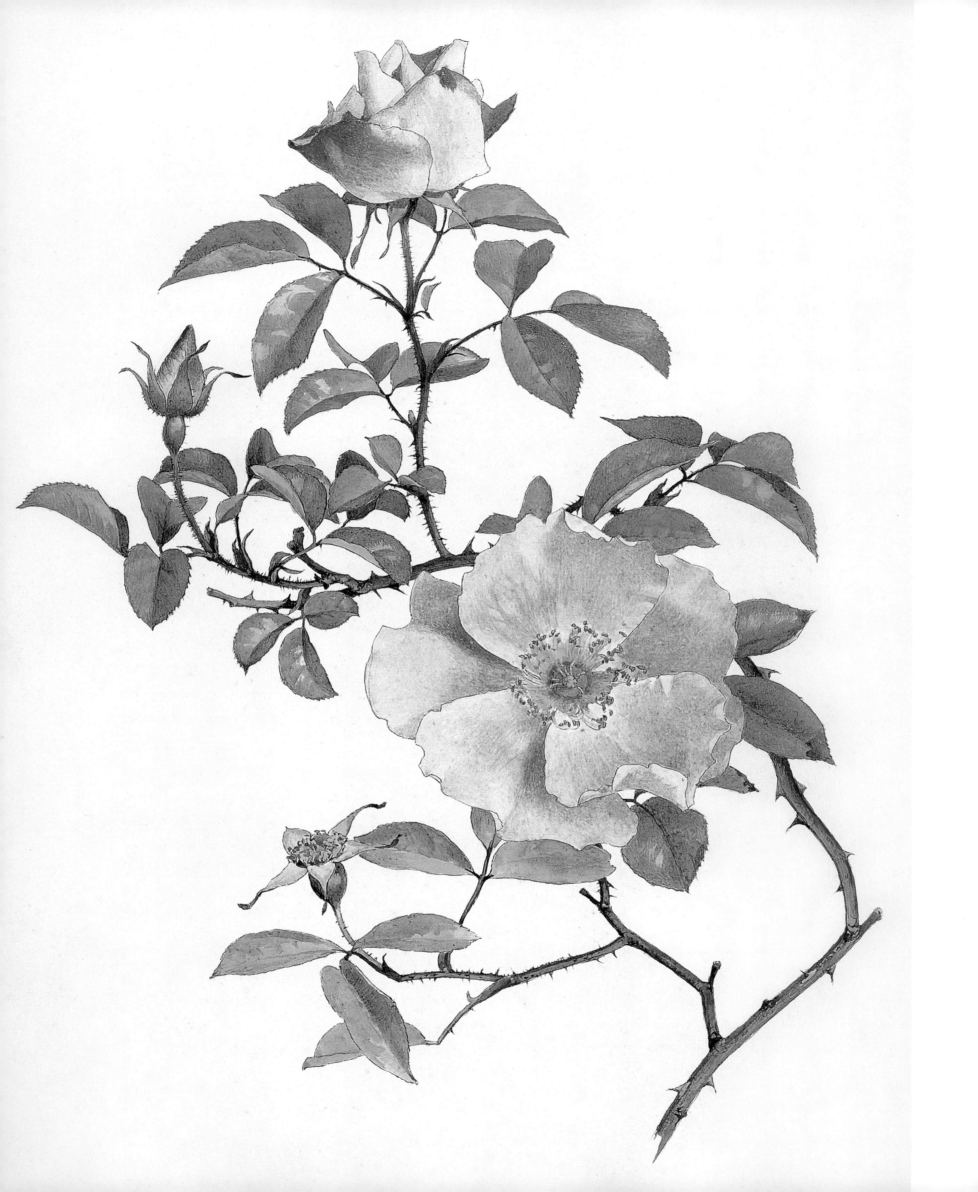

Roses *by* Design

CREATIVE CULTIVATION

The dawn of the nineteenth century saw enormous changes in the world of roses as varieties from distant lands were brought together in Europe. The presence of better and more versatile roses enhanced their value as garden plants; they became fashionable, attracting royal patrons and an enthusiastic following. Nursery skills improved to satisfy demand and leading horticulturists moved up the social scale, becoming specialists and further promoting the merits of the rose. All these developments sprang from the linking of rose genes from East and West. Graham Thomas summed it up beautifully in his foreword to *Heritage of Roses:* 'The resulting confluence has been like the uniting of two great rivers, determined by the flow of civilisation crossing from east to west and back again and from north to south with reverse traffic likewise.'

For the conjoining of these 'two great rivers' to be effective, the rose world needed nurserymen of the highest calibre to nurture the plants (many of which were tender), to propagate them and then exploit this genetic heritage by creating new forms. In this field the French held sway.

Modern methods of hybridising involve the planned transfer of pollen from one specific parent on to the pistils of another, utilising the male and female plants in a deliberate way to increase the chances of a desired outcome – in other words, creating roses by design. The principles had been studied and shown to work by Joseph Koelreuter in 1761, and André Du Pont (1756–1817) is claimed to be the first to raise roses by transferring pollen manually. Yet Antoine Jacques (1782–1866), another major plantsman of that era, declared his new roses came by chance, thanks to wind or pollinating insects. Perhaps he was being discreet, for he contradicted this view in his later writings, and England's William Paul wrote in 1840 that he learned his technique of 'reasoned pollination' from French breeders.

Du Pont and others were certainly aware of the mechanics of hybridising, even if they did not fully understand the biology involved. They proceeded to reap the benefits for France, assisted by royal patronage. Du Pont was the foremost amateur rosarian of his time, and on retirement in 1813 he offered his collection of 537 varieties to the Palais Luxembourg in Paris in return for a state pension. His offer was accepted and many of the roses were given a prominent site in the terrace garden. The only detail missing from the transaction was the agreed pension of 600 francs, which Du Pont was still waiting for in the last year of his life.

ROSA X ANEMONOIDES, ANEMONE ROSE

The rose fancier Lord Brougham and Vaux described this in 1898 as 'a bad imitation of R. laevigata*', but it differs from that species in one important quality – it is hardier and therefore gives gardeners from many nations the chance to enjoy the exquisite character of Laevigata type blooms. However, the plant itself rarely looks attractive, perhaps because it is typically planted against a sunny wall, which suits the rose but also harbours spider mites and leaf hoppers to spoil its skimpy foliage. J. C. Schmidt of Erfurt in Germany raised it by breeding* R. laevigata *and a Tea rose, and it was introduced in 1896.*

Du Pont was the confidant of Empress Joséphine, and the supremacy of France as the centre of rose excellence in this period is largely due to their combined enthusiasm. One of Joséphine's Christian names was Rose, and perhaps this ignited her interest in the flower. As wife of Napoleon, First Consul of France, she undertook the care of the gardens at La Malmaison when it was purchased in 1799. In 1809 her marriage to Napoleon was annulled and five years later she died aged 51, yet within this brief span she established an amazing plant collection, securing new varieties from the European countries controlled by Napoleon. Officially there was a continental blockade preventing trade with Britain, but through Joséphine's intervention Louis Parmentier in Belgium received a licence to bring plants across from England. According to William Paul, John Kennedy in Hammersmith, London, had a similar concession. Three years after the death of Joséphine, the first of Redouté's famous pictures were published in *Les Roses*, with a commentary by the botanist Thory. By then a Bourbon king was on the throne, which explains why the volume makes no reference to Joséphine and only one to Malmaison.

When Du Pont had offered his roses to the Palais Luxembourg, he stated that he grew each variety both on its own roots and as a budded plant – in other words, by transferring a dormant leaf bud into the stem of a plant grown as an understock for this purpose. Budding or grafting had been practised since classical times but now gained new importance.

One reason was that most China roses were shy growers, but if budded on understocks they would produce strong shoots and so provide more material for propagation. Another reason was that more plants could be generated from budding than from cuttings. As the public appetite for roses grew, budding the Chinas gave them a popularity they could hardly have otherwise achieved. Cuttings taken from the Dog Rose and the Sweet Briar were the understocks generally preferred. In 1849 Jean-Baptiste Guillot showed that if hips were collected and the seeds sown, the seedlings made better and cheaper understocks than cuttings, and this method was universally adopted.

The consequence was a dramatic increase in numbers grown. A French list of 1690 gives only fourteen rose varieties (compared with 225 carnations and 437 tulips). After that the choice widened, reaching over a hundred by the end of the next century and well in excess of a thousand by 1830. In the 1850s the Palais Luxembourg under Alexandre Hardy held 1800 different species and varieties, perhaps the greatest single collection in the world.

The basis for the hundreds of rose varieties were the new exotics from abroad: the Chinas, Teas, Bourbons and Noisettes. Chinas are particularly useful for hybridisers as they are good producers of seed, and four stud Chinas are often considered responsible for the modern rose, namely 'Old Blush', 'Slater's Crimson China' and the Tea-scented China roses 'Hume's Blush' and 'Parks' Yellow'. These four were certainly significant

'ARCHDUKE CHARLES'

This hand coloured lithograph by Henry Curtis (1819–1889) is from The Beauties of the Rose *published in 1850, and endorsed in his own hand 'drawn from nature and on stone'. It shows the remarkably full flowers of what is believed to be a seedling of 'Old Blush', raised about 1825, attributed to Jean Laffay of Auteuil near Paris, and classified as a Hybrid China. Because of its many colours it is given the local name 'Seven Sisters' in Bermuda, where it has long been a favourite and survives in many old gardens. The name honours Archduke Charles of Austria (1771–1847) son of the Emperor Leopold II.*

but pioneering breeders could spread their net much wider. By 1817 there were three new imports: 'Cruenta', a beautiful and tender crimson-purple rose that reached England about 1810; 'Indica Purpurea' or 'Blue Rose', which faded from reddish purple to puce; and 'Animating', described as pinkish red with a Tea scent and with leaves and flowers like 'Old Blush'. Also by 1817, thirteen more Chinas had been grown from seed and launched into the European market. During the next decade many repeat-flowering Hybrid Chinas were raised, including 'Cramoisi Supérieur' with its rich, bright crimson blooms, and 'Archduke Charles', a cheerful blend of pinks.

Results with Tea roses were not as easy to achieve because they were more fragile. 'Hume's Blush' was so tender it had to be grown indoors. Only one of the early Teas showed outstanding vigour: the semi-climber 'Indica Major', introduced from China around 1823. It bears charming silky-looking flowers made up of pink-rimmed primrose petals, and though tender it is sturdy enough to serve as an understock in warm climates. Of the sixty Teas introduced in this period 'Indica Major' appears to be the only survivor. The rest were superseded, but not before they had the chance to contribute new Tea colours, adding deep pink, red and mauve to the existing white, blush and pale yellow sorts. Their parentage is something of a mystery. The mingling of varieties, random sowing of seed and lack of accurate records make it impossible to pinpoint the precise ancestors of most roses until much later in the century.

The identity of one rose, however, is well known. It was raised in Charleston, on the South Carolina coast of the United States, a stopping-off point for ships voyaging from the Orient, often carrying cultivated plants. Charleston was also home to a nurseryman named Philippe Noisette, son of a gardener and French by birth. He had emigrated to the West Indies, fallen in love with a slave girl and fled with her during an uprising to Charleston where he set up his own nursery. Through the local Botanical Society he was introduced to the rice farmer John Champneys (1743–1820), who around 1802–5 found a chance seedling in his garden. According to W. R. Prince in his *Manual of Roses* (1846), it came 'from the seed of the White Musk Rose, or *Rosa moschata*, fertilised by the Old Blush China.'

The seedling flourished and produced extremely pretty semi-double flowers in blush pink with just a hint of violet on the outer petals, neatly formed and carried gracefully in open sprays. It grew quickly into an effective climbing rose, becoming known locally as 'Champneys' Pink Cluster'. The farmer was proud to own such a special rose and passed on cuttings to his friends, including Philippe Noisette.

Noisette's cuttings grew and produced flowers followed by hips. He sowed the seeds and from one of them raised a dark-leaved shrub bearing sprays of small, blush-white flowers that were prettily formed and full of petals. The plant's growth was compact, but it could be trained up a pillar to excellent effect. Moreover, it repeated its flower as readily as a China rose.

ROSA X NOISETTIANA, 'BLUSH NOISETTE'

Philippe Noisette raised this from seed of 'Champney's Pink Cluster' in Charleston, in the United States, in the early years of the nineteenth century. It was introduced in Europe by his brother Louis in 1818, and can be regarded as the first repeat-flowering climber, ideal on a pillar where a restrained grower is required, or grown as a shrub. The buff-pink flowers have a pale lilac tint and pleasing scent. The plant was used for hybridising further Noisette roses though to what extent is arguable, because raisers also worked with its parent, which proved a better seed producer.

Noisette recognised its merits and in 1814 sent plant material to his brother Louis, one of France's leading horticulturists. He also supplied stock to Jacques Durand of Rouen. Others forwarded 'Champneys' Pink Cluster' from the United States to France and England and more seedlings were raised directly from it. In the race to exploit the potential of these remarkable varieties Louis hoped to be the winner, and in 1818 he introduced the new strain as 'Le Rosier de Philippe Noisette', later shortened to 'Blush Noisette' and 'Noisette'.

The Noisette story is reasonably straightforward when compared with the saga of the Bourbons. Even trying to identify the original Bourbon rose has proved impossible, and speculation still remains over whether it was indeed the rose known as 'Rose Edouard'.

According to one account 'Rose Edouard' was named after farmer and landowner Edouard Périchon, who lived in St. Benoît on the island of Réunion, previously called Ile Bourbon. He planted a rose hedge as a field boundary, using two varieties often chosen for that purpose and well known to him, the China rose 'Parsons' Pink' (also called 'Old Blush') and a reddish pink form of the 'Autumn Damask', perhaps 'Tous les Mois'. He noticed one of the plants appeared different from the rest in its growth, leaf and flower, which was a lively light crimson so he transferred it to his garden where by 1818 it was being admired by visitors. By 1820 the rose had been named after Edouard Périchon.

A different story says that 'Rose Edouard' was discovered by Jean-Nicolas Bréon, who 'noticed it growing among a lot of seedlings of a different cast, raised for forming a hedge'. Bréon had arrived in Réunion in 1817 as an agent of the government of France and curator of the island's Botanic Garden. He had a trained eye for the unusual in plants, and perhaps the important difference in these two accounts is that while Périchon knew he had a different rose, Bréon was the one who realised that the seedling, as a carrier of genes from East and West, was potentially important.

Cuttings and seeds of 'Rose Edouard' found their way to France. The cuttings were sent to Parisian horticulturist Joseph Neumann, who introduced the rose in 1821. These 'Rose Edouard' plants were renamed and marketed as 'Rose Neumann' and 'Rose Dubreuil'. Seeds from Bréon, with a label 'Rosier de l'Ile Bourbon', were received in 1819 by Antoine Jacques. Five germinated and two bloomed in 1821. As seedlings, these were different from 'Rose Edouard' and from one another. One had semi-double flowers of a brilliant purplish pink, and was depicted by Redouté under the name *R. canina borboniana*, despite having no connection whatsoever with Canina. The other had a red flower with five petals and was also introduced. There was the utmost confusion over names: 'Rose Jacques', 'Bourbon Jacques', 'Rose de Bourbon' and 'Rosier de Bourbon' were all being used. More 'Rose Edouard' seeds were sent to Alexandre Hardy of the Palais

'BOURBON QUEEN'

The Bourbon roses had a confused origin and there is some question over whether this rose, introduced about 1834 and attributed to Mauget of Orléans, is the same as the rose grown today under the name 'Bourbon Queen', which has flowers that are more magenta in tone rather than the 'delicate salmon-flesh, often tinged with buff' of earlier descriptions. Its scented blooms appear in summer, rarely later, and it is ideal for training on a pillar or being left to grow naturally as a sprawling shrub. The rose is also known as 'Reine des Iles Bourbon' and 'Souvenir de la Princesse de Lamballe'.

Chromolith. v. Conrad Grefe.

Termeszet uta.KomlosyFrenzel.

II.
KLASSE VI GRUPPE 37 (ROSA. INDICA)

Druck a.d.k.k.Hof.u.Staasdruckerei.

REIN DE ILES BOURBON.

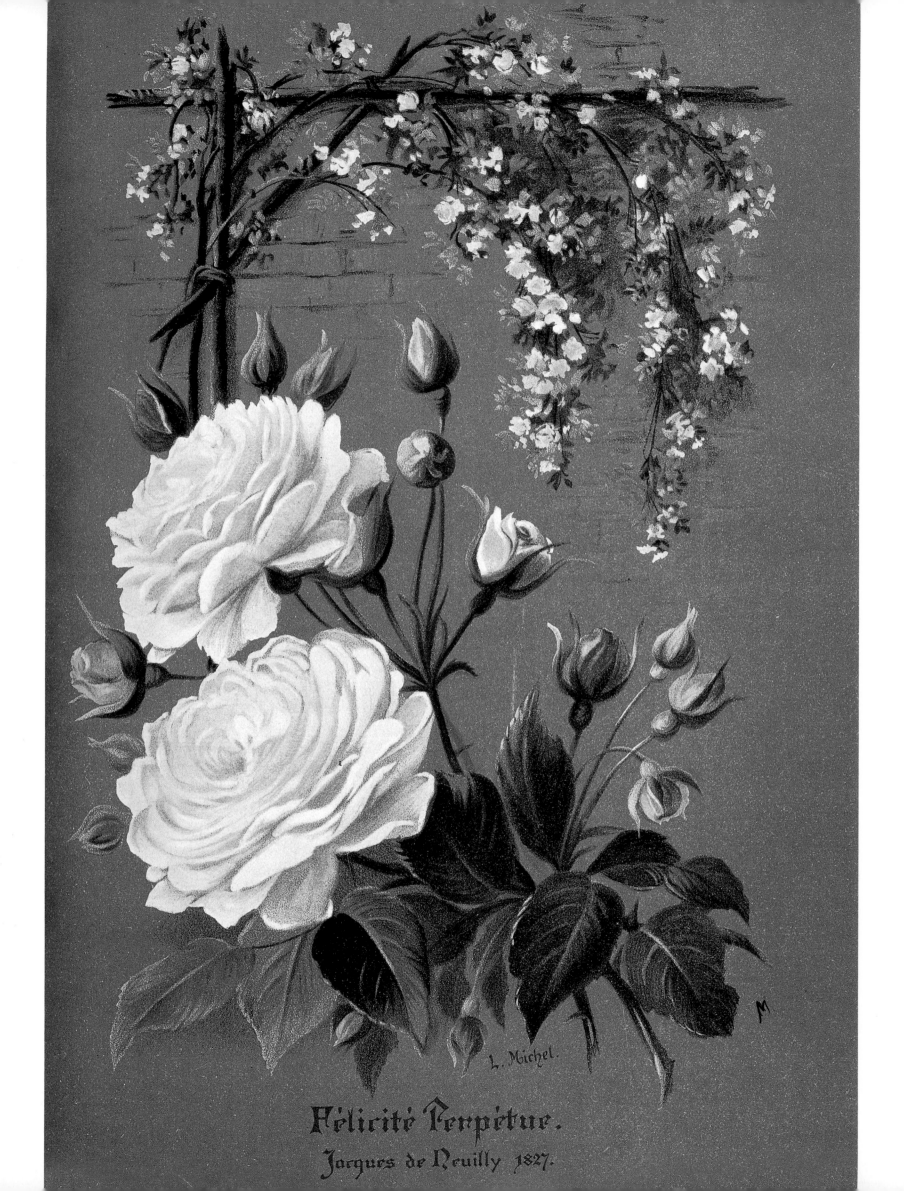

Félicité Perpétue.

Jacques de Neuilly 1827.

Luxembourg in 1822, perhaps from Mauritius this time, and a light-coloured seedling raised from them was called 'Rosier de l'Ile de France'.

So which is the original 'Bourbon Rose' that spawned a whole class of graceful shrubs and climbers? The seedling of 'Rose Edouard', raised by Jacques and painted by Redouté, seems a likely candidate, but its purplish pink colour does not match the description of the variety being sold, which was flesh pink. DNA analysis of what are thought to be the earliest Bourbons may provide some answers.

The reputation of the flesh pink Bourbon quickly spread. It was on sale in France in 1823, in England two years later and in 1828 it reached the United States. Progress in raising new varieties was slow for the first ten years. They were criticised because of their 'sad colours' and failure to open in damp weather. Success was assured after 1833, however, when Jean Desprez brought out 'Charles Desprez' and 'Mme. Desprez'. The last one, in addition to its pretty, varied shades of mauve, pink and lilac, proved a fecund ancestor. From then on progress was rapid and by 1870 nearly five hundred Bourbons had been introduced. Suddenly, they fell so quickly from grace that in 1914 George Paul was moved to write: 'The Bourbons are almost a dying race, and will probably be absorbed by the Hybrid Perpetuals and the Hybrid Teas, so that while they must be retained for the present, the family will not long survive.' (G. Paul, NRS Rose Annual 1914). This death certificate

proved premature, for several dozen Bourbons are still around today. The Carla Fineschi Botanical Rose Garden at Cavriglia in Italy holds what is probably the largest collection, numbering eighty or so varieties.

These developments brought gardeners a wealth of delightful climbing roses and more were created as the nineteenth century unfolded, in particular the Sempervirens and the Boursault roses. The Sempervirens ramblers were introduced around 1830 by Antoine Jacques, gardener for thirty years to the Duc d'Orléans, later King Louis-Philippe. As his seed parent, Jacques used R. sempervirens, the handsome 'evergreen' species found around the Mediterranean. The choice was well justified by the results, for the application of pollen from 'Old Blush' gave rise to 'Adélaïde d'Orléans'. 'Old Blush' and R. moschata appear in the genetic 'fingerprints' of 'Félicité-Perpétue' and 'Princesse Louise'.

The second group of climbing roses owes its name to Jean-François Boursault (1750–1842). A comic actor, he came to Paris at the Revolution, founded a theatre group and became a deputy in support of the 1792 Convention, enriching himself by extortion. He combined this unsavoury career path with a passion for horticulture and in 1808 succeeded in bringing R. multiflora 'Carnea' from England into France despite the continental blockades. His botanic garden became one of the finest in Paris. Like other amateur rosarians of his day Boursault raised new roses from seed, entrusting the practicalities to his

'FELICITE-PERPETUE'

This is the most widely grown of the Sempervirens ramblers raised by Antoine Jacques, easily recognisable in midsummer when its long arching stems carry hundreds of white rosettes, each full of tiny petals. Most of Jacques' roses are named for his royal Orléans employers, and it is suggested that this one commemorates the early Christian saints who suffered a cruel martyrdom together in Carthage in 203 AD. The connection with the Orléans family is that, in the words of Barbara Tchertoff who researched Jacques' work, they 'had a particular attachment to Carthage and had endowed a chapel there.'

daughter. A little before 1820 his efforts produced a climber, known as the 'Boursault Rose', introduced by horticulturist Jean-Pierre Vibert (c.1777–1866). It is likely to have derived from the Alpine Rose, *R. pendulina* because it has smooth wood and is very hardy. In early summer its bright pink flowers give a colourful display, though their form lacks refinement. The handsome pink 'Mme. de Sancy de Parabère' is easily the best of the Boursaults, which has remained a very small group.

It is clear from all this that the eager raisers of France, Germany, Britain and elsewhere had fashioned a tremendous range of novelties, cajoling from the gene soup Hybrid Chinas, Teas, Noisettes, Bourbons, Sempervirens and Boursaults. The Portlands stand outside this charmed circle, showing no DNA evidence of Eastern genes and deriving any repeat-flowering tendencies (known in botanical terms as remontancy) from Autumn Damask. DNA analysis also indicates this is true of early Hybrid Perpetuals, whose 'perpetual' name in some cases owes more to optimism than reality.

In due course Eastern genes did influence the Hybrid Perpetuals, and this can be detected in details such as arching growth, rich crimson colour and improved remontancy. Within the class, and it became a huge one with 4000 varieties at its zenith, a dozen groupings have been identified to demonstrate the influence of various parental strains. One of the most important parents identified was 'Général Jacqueminot', introduced in 1853. It is said to be a seedling of 'Gloire des Rosomanes', a Bourbon introduced in 1825. 'Gloire des Rosomanes' is exceptional because it is deep crimson, in contrast to all the Bourbons preceding it which were pinks and reddish purples. The supposition is that one parent of 'Gloire des Rosomanes' was 'Slater's Crimson China' or another Chinese red because only such a source can account for its rich colour. If that is true it means that 'Général Jacqueminot' has a double dose of China with both 'Old Blush' and a red China in its inheritance. It was described in Parkman's *The Book of Roses* (1871) as being: 'Of a fine crimson…and one of the most splendid of roses. Its size, under good cultures, is immense. It is a strong grower and abundant bloomer, and glows like a fire-brand among the pale hues around it. It is one of the hardier kinds, and is easily managed. Its offspring are innumerable.'

This rose brought together the best qualities of West and East. It was raised by an amateur called Roussel, but he did not live to see his masterpiece, dying before the seed he had sown came into flower. But his gardener, named Rousselet, picked out 'Général Jacqueminot' as a winner and put it into commerce. It is an important ancestor of red Hybrid Perpetuals and Hybrid Teas, and an antecedent of 'Queen Elizabeth'.

Rousselet had brought his find to public notice at a rose show, an event for which the big Hybrid Perpetual blooms were ideally suited because they kept their shape so well. They were easy for nurserymen to propagate and came into their own in the second half of the nineteenth century, which saw a

'GLOIRE DES ROSOMANES'

The importance of this rose lies not so much in its garden merit as in its genes, for one of its parents is 'Slater's Crimson China' from which it inherits its red tones. It is also a vigorous grower and as a fertile parent has transmitted its qualities to many Hybrid Perpetuals and later roses. The popular name 'Ragged Robin' truly demonstrates that its flower form lacks refinement, and yet more plants of this Bourbon have probably been grown than any other, particularly in warm climates where it has proved useful as an understock. It was raised by Plantier of Lyon and introduced in Paris by Vibert in 1825.

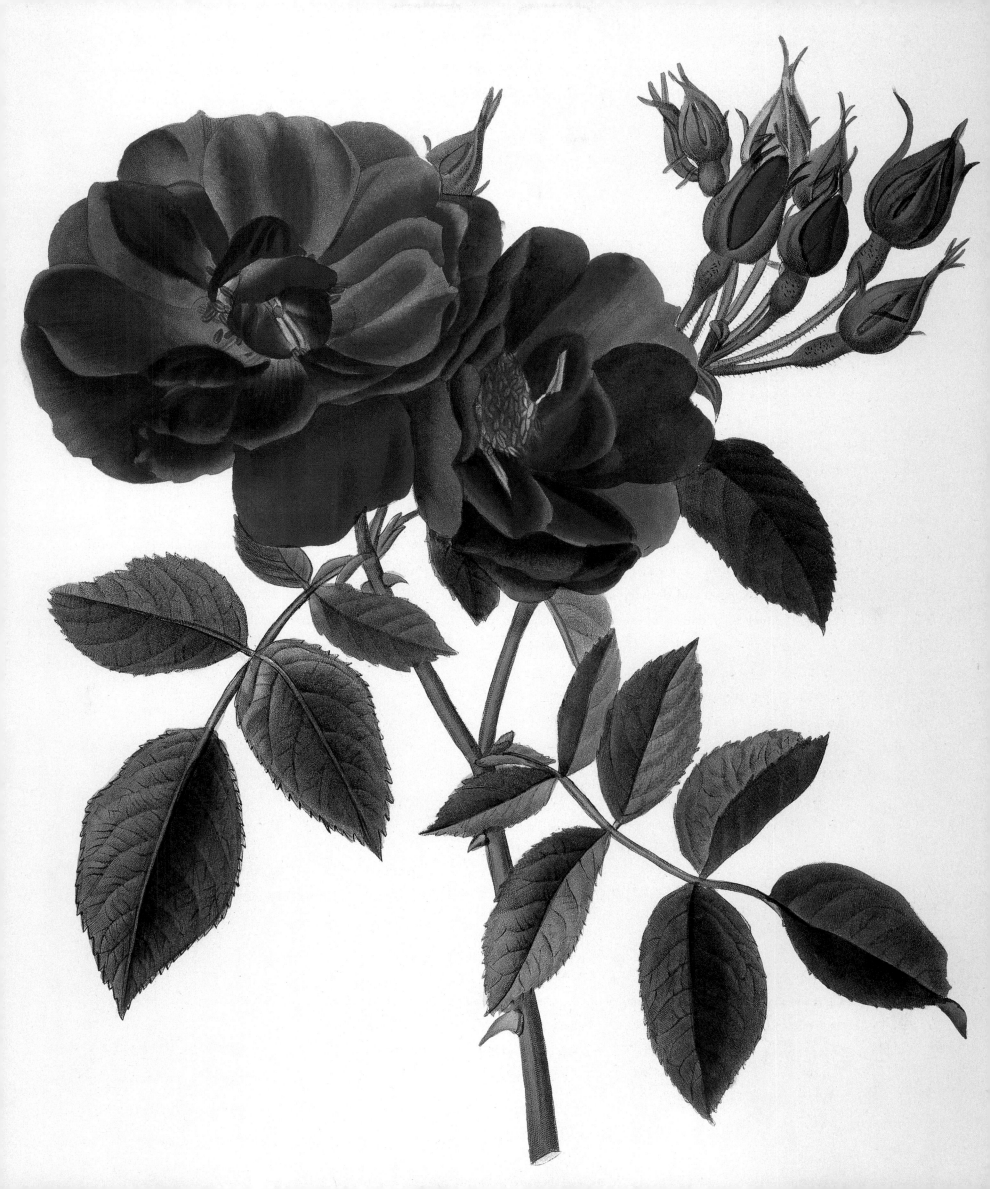

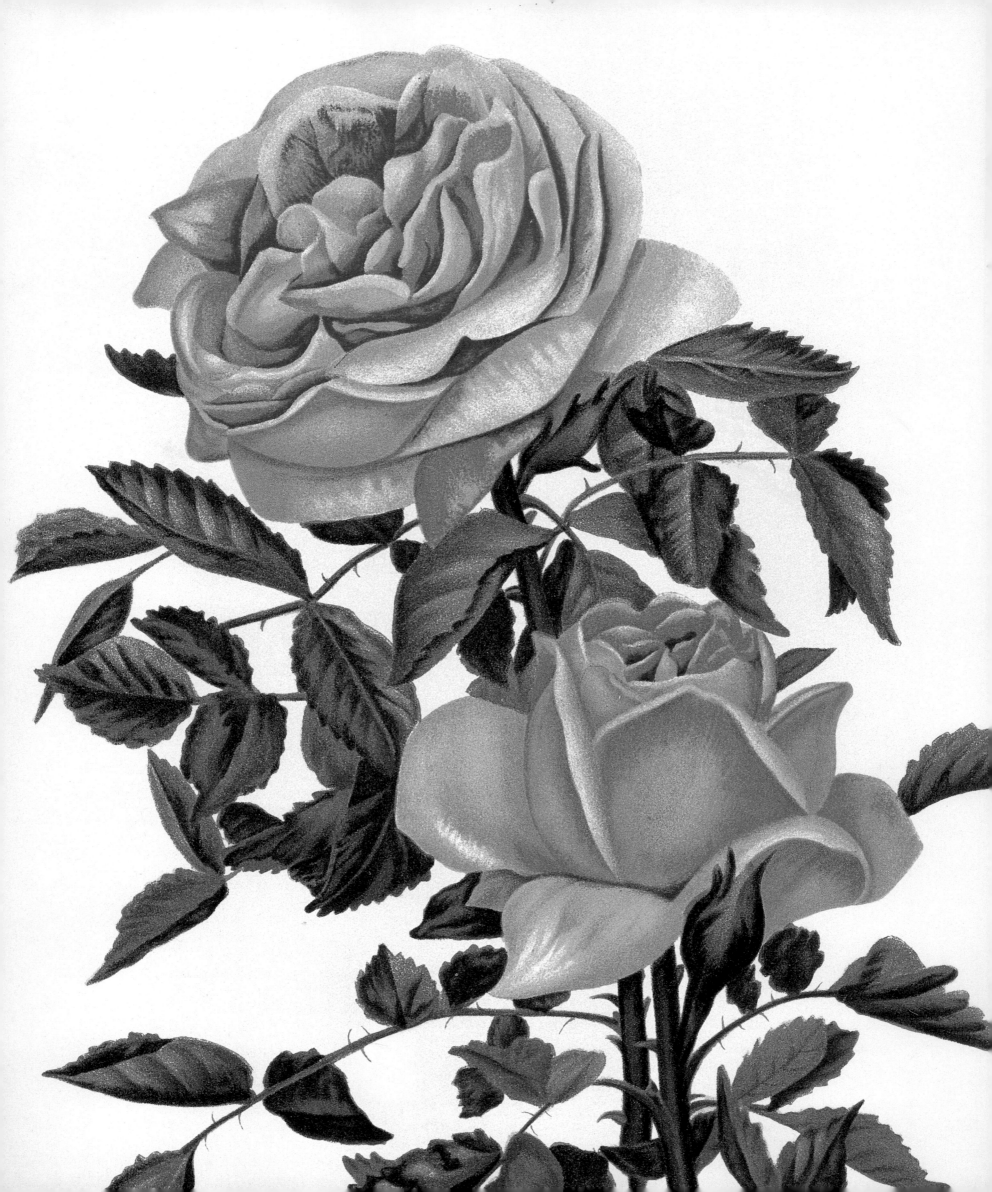

tremendous increase in gardening as a hobby and a heightened demand for roses. Tea roses remained popular in the latter part of the nineteenth century. Over 1400 were introduced but many made a rapid exit due to their tenderness.

To say that Teas had wonderful flowers on indifferent plants and Hybrid Perpetuals coarse flowers on strong plants is a sweeping statement with much truth in it. The good qualities of both groups were united in a rose raised in Lyon by Jean-Baptiste Guillot, and in 1867 it came before a panel of fifty judges charged with finding a rose worthy of the name of France. Out of a thousand candidates they chose Guillot's entry as the most distinctive, adding that they considered it a new class of rose. It was pink in colour, quite large and with a high centre, holding its blooms on reasonably firm stems and framed by crisp semi-glossy foliage. Named 'La France' and introduced as a Hybrid Perpetual, it was a few years later declared the first 'Hybride de Thé', indicating its connection with both the groups that had supplied its genes. It proved a good garden rose but its chromosome count of twenty-one made it virtually sterile. Work continued to furnish other lines of Hybrid Teas. The red 'Cheshunt Hybrid' of 1872 and the pinks 'Lady Mary Fitzwilliam' of 1883 and 'Mme. Caroline Testout' of 1890 became important ancestors of the class.

The first two were raised by Englishmen, William Paul and Henry Bennett, but 'Mme. Caroline Testout' came from the nursery of Joseph Pernet-Ducher. It was named for a Parisian dress designer and became a great success, though Pernet-Ducher did not regard it highly. His sights were set on a different aim, to raise a Hybrid Tea in a bold bright yellow, a hue the pale Teas never could provide. The brightest yellows were found among the Foetidas. In 1883 he crossed a red Hybrid Perpetual with R. foetida 'Persiana', the rose brought by Sir Henry Willock from Tehran some fifty years before. Only a few seeds were harvested and the plants that grew from them were unimpressive. Pernet-Ducher kept the strongest specimens and found that one produced semi-double blooms of pink and yellow, a sign that he was edging nearer to his goal. But it flowered in summer only, as is expected in the first generation when crossing remontant roses, or repeat-flowering, and non-remontant roses.

One day in 1893 a visitor called on Pernet-Ducher to see his work. As they approached the bush, a bright splash of colour caught their eyes. Alongside the old plant was a new one, only a few inches high and bearing orange-yellow petals with shades of apricot and reddish pink. The old plant had apparently produced a seedling of its own accord. The new seedling repeated its bloom, showing that breeders could yield valuable results by allowing a hybrid to self-pollinate. It also revealed that although genetic laws had decreed the earlier hybrid would flower in summer only, the offspring of that hybrid could be remontant and come into flower more than once during the year.

'SOLEIL D'OR'

Introduced by Pernet-Ducher in 1900, this rose came about through a chance self-hybridisation of an 'Antoine Ducher' x R. foetida 'Persiana' seedling, and was an interim reward for the raiser's patient endeavours to raise a hardy, large-flowered, bright yellow rose. As the illustration shows, it was only a step on the way, but a vital one because the R. foetida 'Persiana' genes worked through 'Soleil d'Or' to fulfil his aim a generation later. 'Soleil d'Or' was classed as an Austrian Briar Rose for some years, reflecting its Foetida origin. From 1914 it joined a new class of Pernetianas, now subsumed within the Hybrid Teas.

After Pernet-Ducher exhibited this new rose as 'Soleil d'Or' in 1898, he became known as the 'Wizard of Lyon'. Few would give the product of his magic a second glance today, and that is a tribute to its fertility, for the effects of its genes are visible wherever vivid yellow, flame and salmon-orange appear in the modern rose. The first really yellow Hybrid Tea is 'Rayon d'Or', which Pernet-Ducher introduced in 1910. Other yellows and salmon pinks followed. They were called 'Pernetianas' for some years before being subsumed within the Hybrid Teas.

Hybrid Teas with their large size and elegant form remained the most popular roses throughout the twentieth century, as records of nursery sales bear witness. The vigour, flower quality and especially the foliage of Hybrid Teas were significantly improved by another Frenchman's work.

François Meilland named his prize seedling 'Mme. A. Meilland' in memory of his mother. It was introduced in France in 1942, became 'Gioia' (meaning 'joy') in Italy and 'Gloria Dei' ('Glory of God') in Germany before being taken up by the Conard-Pyle nursery in the United States and introduced at the war's end as 'Peace'.

The launch of 'Peace', at an inaugural session of the United Nations in San Francisco, when each delegate was presented with a flower, must rank as the most successful rose promotion ever. 'Peace' more than justified the high expectations held by its raisers, and many roses descended from it inherit its leafiness, lovely flower form and general stamina.

Parallel to the development of the Hybrid Teas, another new class of roses was evolving in Lyon, where in the 1860s the Mayor of the city had planted a short blush-pink form of *R. multiflora*, admired for its showy panicles of tiny blooms even though its display was fleeting. Hips were taken from the plants and a repeat-flowering descendant was raised.

The outcome was that in 1875 the firm of Guillot introduced 'Ma Pâquerette', meaning 'My Daisy', which was white with many little petals, about fifteen inches (37cm) high, and more than making up for lack of stature by the generous continuity of its bloom. This became recognised as the world's first 'many-flowered' or Polyantha rose. Pink forms followed; one of them, 'Gloire des Polyantha' of 1887, confirming the status of this new class. Crosses with Teas gave two delightful novelties, 'Cécile Brunner' in 1881 and 'Perle d'Or' in 1883. With their exquisitely pointed buds these two resembled scaled-down Teas rather than Polyanthas, but they proved tough and hardy, and were evidence of the versatile results that could be obtained from this new breeding line. They are still widely grown.

In Germany, Peter Lambert of Trier had the idea of mixing Polyanthas with the Noisettes and achieved a startling result with the fiery yellow and copper 'Léonie Lamesch', introduced in 1899. Bringing red into the Polyanthas was achieved by using 'Crimson Rambler', the Multiflora from Japan launched in 1893. This influence produced 'Orléans Rose' in 1909. It was a rather unpleasant shade of puce, but its

'CECILE BRUNNER' & 'PERLE D'OR

The widow of Jean-Claude Ducher of Lyon used a white variety of the novel Polyantha roses and a Tea rose called 'Madame de Tartas' and introduced the light pink 'Cécile Brunner' in 1880, naming it for the daughter of Ulrich Brunner, a grower in Lausanne. The petite urn-shaped buds have decorated countless wedding cakes, lapels and posies for over a hundred years. In Chile the variety is known as 'Benitos', meaning 'little kisses'. The honey-pink 'Perle d'Or' (seen at top) was raised by Philippe Rambaux of Lyon also from a Polyantha and a Tea, and introduced by his son-in-law Francis Dubreuil in 1883.

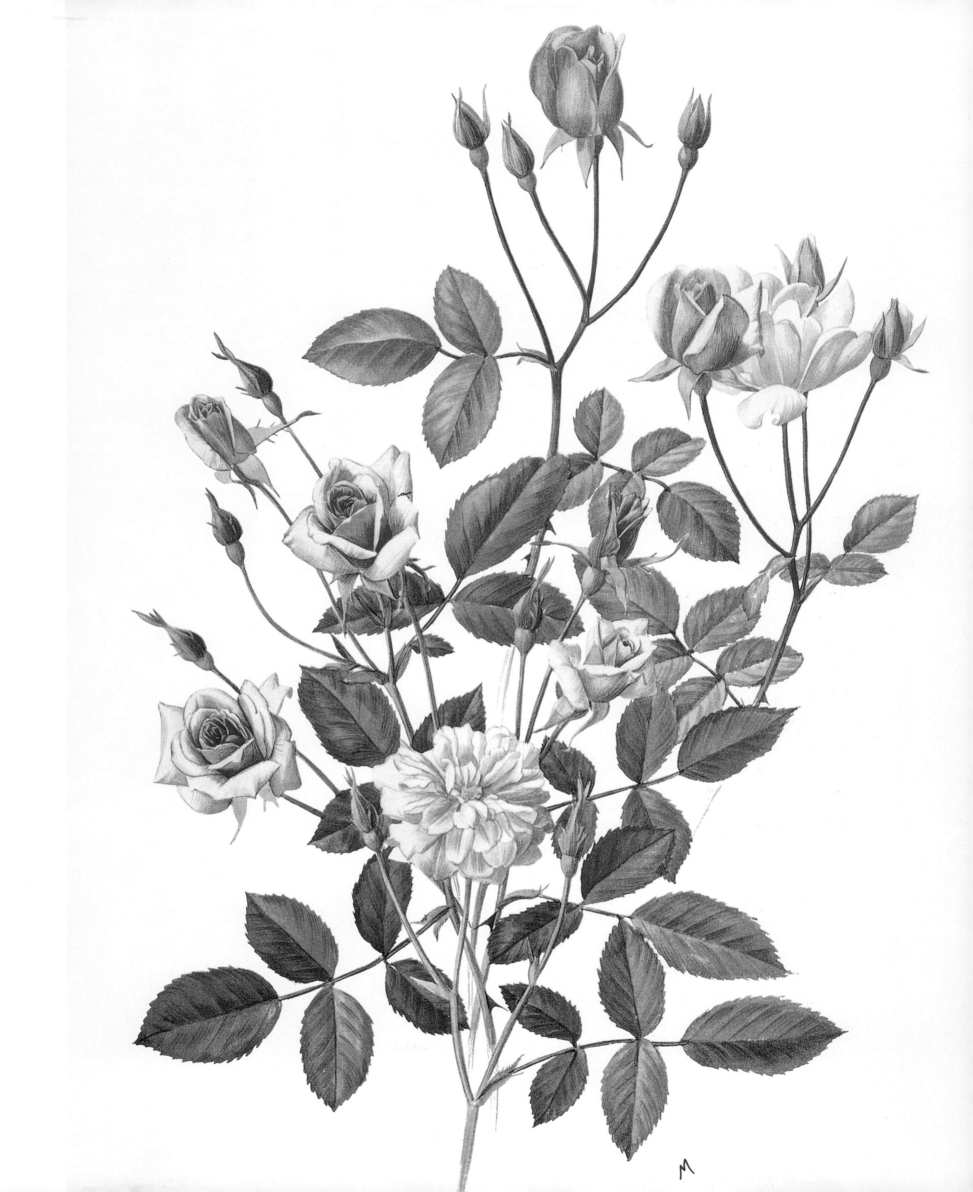

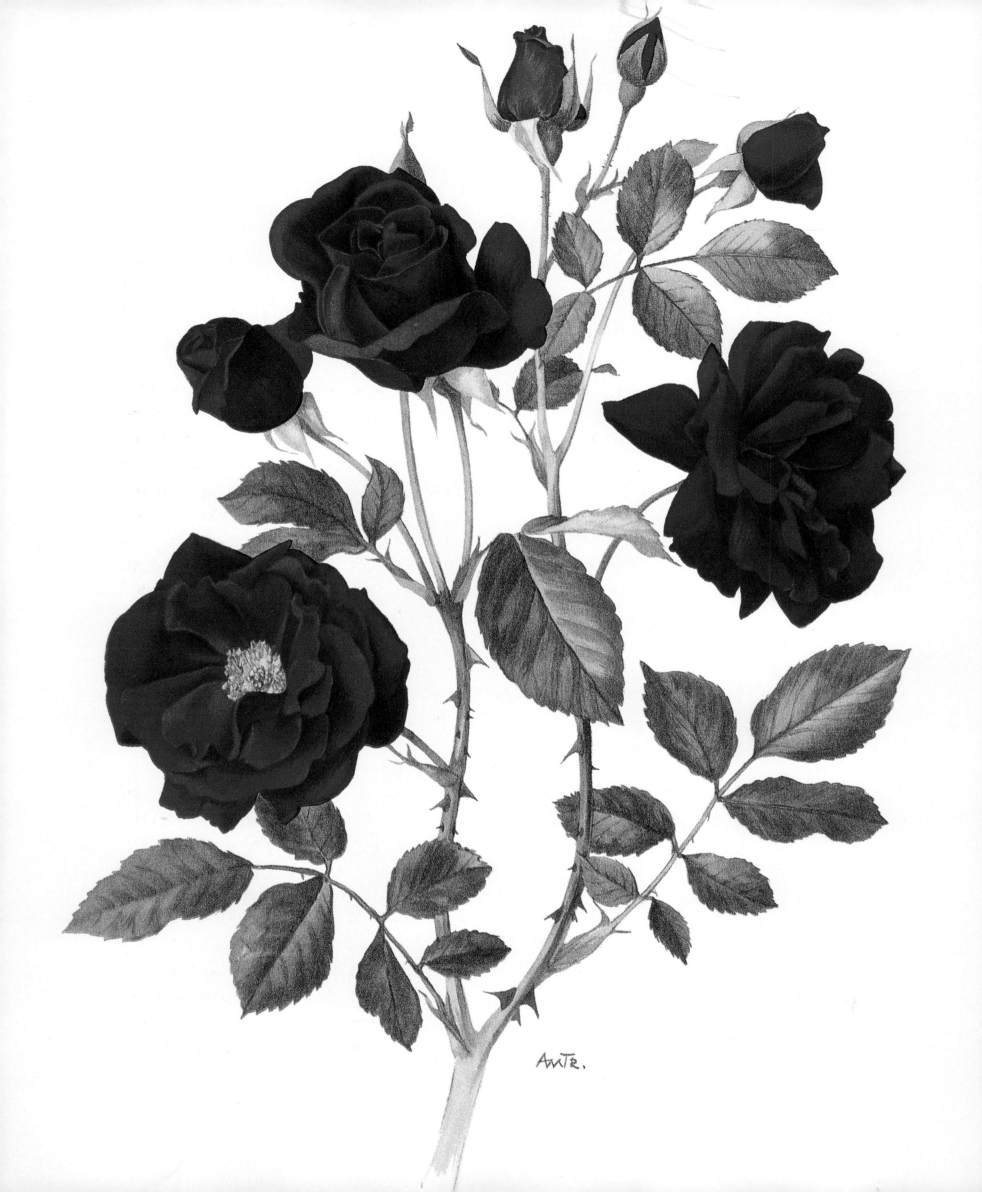

true value lay in its readiness to sport new forms. Two, 'Gloria Mundi' in 1929 and 'Paul Crampel' in 1930, proved sensational because they introduced the new colour of brilliant orange-scarlet. A chemical change made this transformation possible. 'Orléans Rose' had 'lost' a molecule of oxygen from its magenta pigment, thus admitting the scarlet pigment of pelargonidin, and furnishing the brilliant hues seen in many roses of today.

The Polyantha roses, now available in many colours, were often called Poly Pompons because of their little rosette flowers. They were planted in their thousands in parks and gardens between the two World Wars. Few survived the 1950s, perhaps due to changing public taste, and because mildew affected some and ruined the autumn bloom. They were supplanted by the Hybrid Polyanthas, later termed Floribundas. These were originally developed by the Danish Poulsen family through the crossing of Polyanthas with Hybrid Teas.

The first success was a red named 'Rödhätte' (Red Riding Hood), which was repeat flowering and hardy enough for the northern climate but did not provide the hoped-for breakthrough due to its sterility. Svend Poulsen was more fortunate with his roses. One still grown is 'Else Poulsen' of 1924, whose big clusters of simple pink flowers with prettily waved petals have won prizes at many rose shows. In 1938 Svend Poulsen raised a pure yellow, something no one had managed satisfactorily with Polyanthas. It was a good rose but ill-timed. World War II interrupted what should have been its most successful years in commerce. The same was true of the delightful rose pink 'Dainty Maid' and blackish crimson 'Dusky Maiden', both raised by Edward Le Grice in England. These roses were ideal for bedding schemes, and breeders of the best varieties reaped the commercial rewards.

In the 1940s Eugene Boerner of the United States introduced some beauties including 'Goldilocks', 'Fashion' and 'Masquerade'. Their flowers had more petals than the Poulsen roses and resembled scaled-down Hybrid Teas. Boerner obtained them by using 'Pinocchio', which had come from the German breeder Wilhelm Kordes, who himself was to launch the most famous Floribunda of the century, a white one, in 1958. Called 'Iceberg', it set a standard for vigour, flower production and ease of cultivation that is arguably unmatched.

As gardens became smaller, breeders were encouraged to produce dwarf forms. Miniature roses were raised from the 1920s onwards, with the help of 'Rouletii' from Switzerland and 'Oakington Ruby' from Cambridgeshire, England. Present-day Miniatures are usually grown in pots from cuttings, or by micropropagation, techniques that permit mass production and tempt purchasers to treat them as house plants.

The next development was the raising of Patio roses, which look like small-scale Floribundas. These are ideal roses for small spaces, and 'Cider Cup' of 1988 is especially fine. In the same period the general character of rose plants was being transformed, due to the influence of garden designers who

'FRENSHAM'

Albert Norman was a diamond setter by profession and raised rose seedlings as a hobby in his Surrey greenhouse. In the 1930s he sent some to Bill Harkness at his nursery in Hitchin 'to see if they are any good'. One was named 'Frensham' after a town near Norman's home and it was introduced as a Hybrid Polyantha in 1946. It became popular because of its freely borne and prettily formed flowers, and the ease with which it grows. 'Frensham' is sterile and does not form hips, which enables it to reflower more rapidly but makes breeders wonder what roses it could give the world if its chromosomes were viable.

were concerned with the whole appearance of a plant, not just the flower. The new fashion in roses favoured plants with a spreading leafy growth rather than a stalky upright habit. Ground Cover roses fulfilled these ideals, and their breeders and introducers found a receptive market. The first to make an impact was a blush-white trailing rose of 1968. It was raised by Toru Onodera of Japan who named it 'Nozomi' (meaning hope) in memory of his four year old niece who died shortly after the end of World War II on the long journey from Manchuria to her home and family in Japan.

A bewildering succession of Ground Cover roses have come and gone in recent years. Flowering periods have been extended, the range of colour increased, and the current selection offers everything from the white 'Grouse', which unchecked will make a barrier several metres wide, to 'Rutland', also white, with creeping compact growth and only 9 inches (25cm) tall, to 'Surrey', a pink with shapely frilly-petalled flowers. 'Grouse' has good scent but this desirable quality is lacking from most varieties in the group.

Before Ground Cover roses, gardeners used prostrate growing ramblers for a similar purpose. Ramblers derive from *R. arvensis*, *R. sempervirens*, *R. multiflora*, *R. setigera* and *R. wichurana*, and it is the influence of the last that has been most important in the twentieth century. Blending *R. wichurana* with a Tea and Hybrid Tea gave a Maryland breeder the rose that bears his name, 'Dr. W. Van Fleet'. Introduced in 1902, it

carries sweetly fragrant blooms of pearly blush, is stiff enough to be called a climber and supple enough to be trained in the manner of a rambler. It flowers only in summer.

In the 1920s an American grower made an over-optimistic sales forecast and planted too many roses. He decided to leave his surplus plants in the ground, hoping for better luck next year. During the course of his regular visits to check them he noticed that one of the 'Dr. W. Van Fleet' roses was still flowering well beyond its summer span. Further trials established that he had a repeat-flowering sport, or mutation.

Sports often have little value but this one was exceptional. In 1930 it was marketed as 'The New Dawn', also known as 'New Dawn'. It was the first rose ever to receive a Plant Patent, which ensured royalties from sales. In 1997 it attained the highest possible accolade as 'The World's Favourite Rose', an honour given every three years to a variety garnering the most votes from national rose societies. The influence of 'New Dawn' continues, for many of today's best climbers descend from it, 'Aloha', 'Compassion', 'Morning Jewel' and 'Dublin Bay' among them.

Some climbers are sports of Tea, Hybrid Tea and Polyantha bushes, though there is no guarantee when or if a bush will produce a climbing sport. The Tea bush 'Niphetos' existed for forty-six years before the climbing form appeared. In complete contrast and thanks to quick reactions by breeders, the bush and climbing forms of 'Sutter's Gold' were brought out at the

'NEW DAWN'

The tale of this rose is a Cinderella story, for it started as a foundling and became 'The World's Favourite Rose'. Its pretty blush flowers open in all weathers, they have the sweetest of scents and keep blooming for weeks. The stems are pliable, the leaves are attractive and rarely touched by ailments. It will make an extensive climber or can be trimmed and kept as a wide hedge. It looks equally at home in the company of old garden roses and modern ones, and is a parent of many popular shrub and climbing roses. 'New Dawn' came from Somerset Rose Nurseries of New Brunswick, in the United States, in 1930.

same time. Many climbing sports are summer flowering only, but 'Climbing Cécile Brunner', a Polyantha sport, is an exception, giving an extended period of bloom.

Miniatures can also produce climbing sports, such as 'Climbing Pompon de Paris' whose rose-red blooms appear in profusion early in the summer. In recent years breeder Chris Warner has been raising Climbing Miniatures that repeat their flower. They have small leaves and flowers and grow vigorously but to a manageable height. The same breeder's blush-pink 'Little Rambler' of 1995 is likely to prove important because it has brought repeat flowering into ramblers.

A rose everyone seems to recognise is the cyclamen pink 'Queen Elizabeth', introduced in 1954. It is usually classed as a Floribunda though in the United States the preferred term is Grandiflora because of its size. Some say that since it can grow as tall as fifteen feet (4.9m) and is difficult to keep below six feet (2m) on fertile soil, it should be termed a Shrub.

Shrub roses form such a rich miscellany that classifiers have not yet decided whether to split them into a score of different classes or keep them all together. Essentially they are varieties that do not fit into other classes and have been raised since 1867. That was the year 'La France' was introduced and it is considered a watershed, marking the divide between Old Garden and Modern Rose varieties. Many Shrub roses grow like extra-vigorous Floribundas. Others stand out through their distinctive character. Examples include 'Ballerina' with its

sprays like apple-blossom, and 'Nevada' and 'Jacqueline du Pré', both of which bear large creamy flowers that open wide to reveal the stamens. The flowers of 'Raubritter' are pink and shaped like little globes, swaying down bowing stems that touch the ground.

Other Shrub roses include forms from the oriental Rugosa rose, Hybrid Musks with their graceful leafy habits and pastel colours, and the 'English Roses', which include 'Graham Thomas' raised by David Austin. 'Graham Thomas' is remarkable because for the first time it brings a rich yellow colour into roses of Centifolia shape, an achievement that would have amazed rose breeders of the nineteenth century.

The enthusiasm of rose breeders has remained undimmed now for more than two centuries. Since the first introductions of the China roses from the late 1700s, the pace of development has not slowed, providing an incredible range of roses. Over thirteen thousand varieties are now recorded as being commercially available.

What of the future? Given the advances of the past 200 years, it is not impossible to envisage roses that are thornless, evergreen, blue, with scented foliage, in new colour patterns, bearing flowers in spikes and spirals, repellent to aphids, resistant to disease and universally fragrant. Already the rose is considered the most versatile of garden plants, yet new forms will continue to appear, as they have for centuries, in the ongoing quest to bring roses to perfection.

'ÉTOILÉ'

Étoilé, or Rosa indica stelligera, *is an example of early European attempts to produce new China roses. In his accompanying comments Thory states that 'we obtained it in 1819 from seed of* Indica Linneana*'. A previous portrayal by Redouté showed '*Indica Linneana*' was akin to 'Slater's Crimson China' but with only five petals. 'Étoilé' also had white markings at the base of its heart-shaped petals. The petals narrow towards the base to give a starry effect which is reflected in both the Latin and French names. The plant was very short ('eight to ten thumbs tall') and needed winter protection.*

ROSA X *CENTIFOLIA* 'PURPUREA'

*The name purpurea was given to distinguish this 'velvet' rose from many
similar ones being grown by the early nineteenth century. Henry Andrews
rather ponderously explains that 'the buds when half expanded are finely
contrasted by the dark upper surface of the petals opposed to the light purple
of the under side. Some other dark roses are equally distinct in this
particular; but this is the only one we have ever noticed expanding in this
slow partial manner, to show the difference of colour to so much advantage.'*

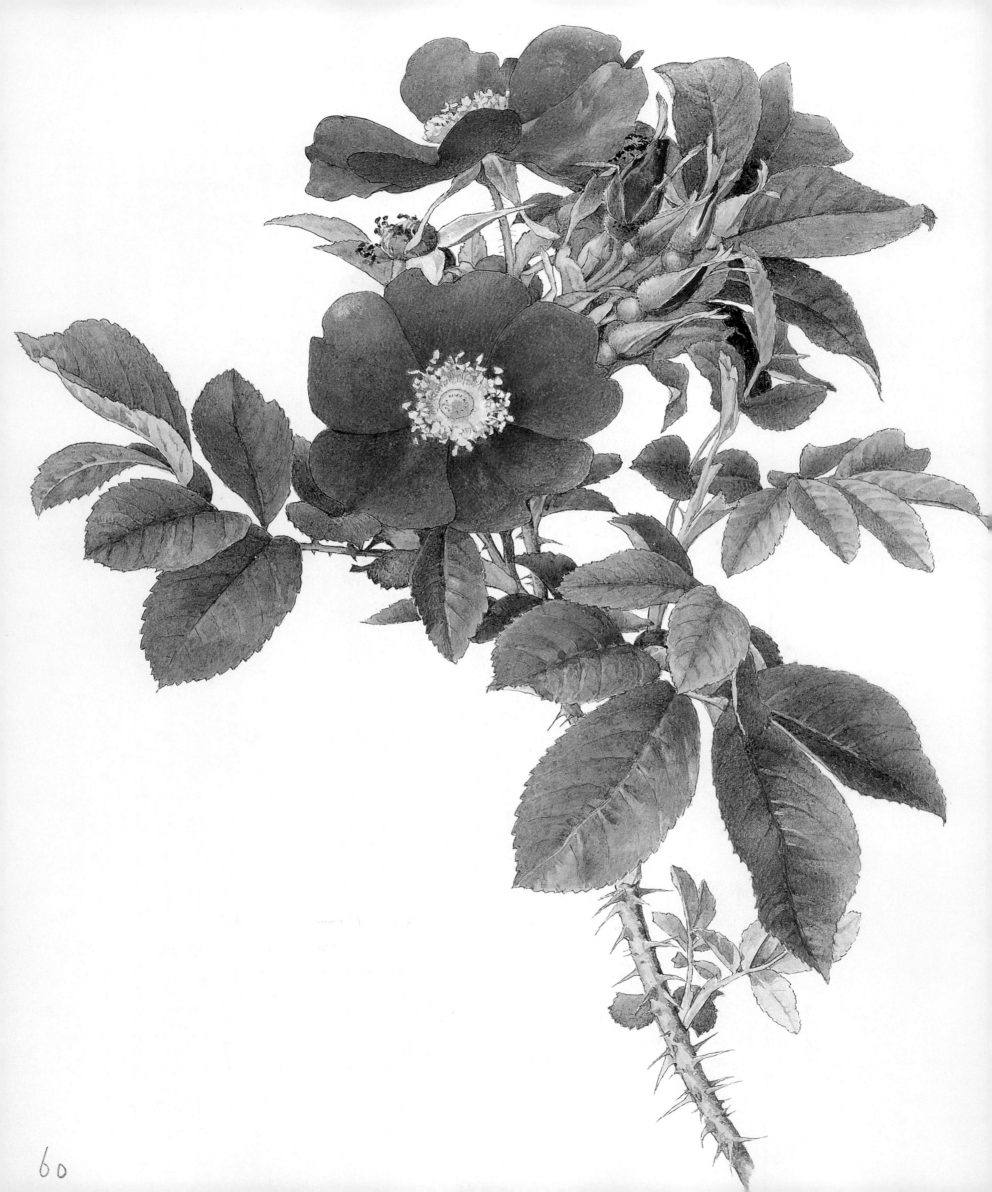

60

'GÉNÉRAL FABVIER'

The brilliant crimson hues and occasional streaks of white indicate that this rose (above) came from 'Slater's Crimson China', which French raisers were using extensively in the 1820s. 'Général Fabvier' was in commerce around 1832 and is credited to Jean Laffay (1794–1878) of Auteuil near Paris, who bred roses for some fifty years from 1816 onwards. He was a dedicated rose collector, and it was said that his efforts 'have not let him miss a single beautiful rose nor fail to make any sacrifice to obtain it'. He named 'Général Fabvier' after a distinguished Frenchman. It was considered a fine bedding rose in its heyday, though the foliage cover tends to look sparse to modern eyes.

'CALOCARPA'

This sturdy Rugosa hybrid (opposite) was raised by François-René Bruant of Poitiers and introduced in the 1890s. A red China rose seems to have been used with R. rugosa in the parentage, and the blooms are somewhat smaller than those of Rugosa. The China rose parentage may be responsible for some variability in the colour of the sweet-scented blooms, for rich red, deep rose pink and lilac crimson forms occur. The plants bear their handsome crumpled flowers through summer and autumn and provide a good display of round scarlet hips.

'CRAMOISI SUPERIEUR'

In a mild climate this rose (above & opposite) makes a prickly thicket, arching its canes in all directions and carrying open clusters of bloom for most months of the year. The leaves are pointed and shiny, and their small size makes the plants appear barely furnished. In Bermuda this is so widespread it has become semi-naturalised as the Old Bermuda Red Rose. One parent is thought to be 'Slater's Crimson China' (cramoisi is French for crimson) and its influence is seen in the rich red colour of the flowers. It was raised by M. Coquereau of La Maître École near Angers in 1832 and introduced by Vibert in 1835. A climbing form, introduced in 1885, is credited to Couturier of Paris, and is a vigorous grower, though in cool climates it requires a site sheltered from cold spring winds.

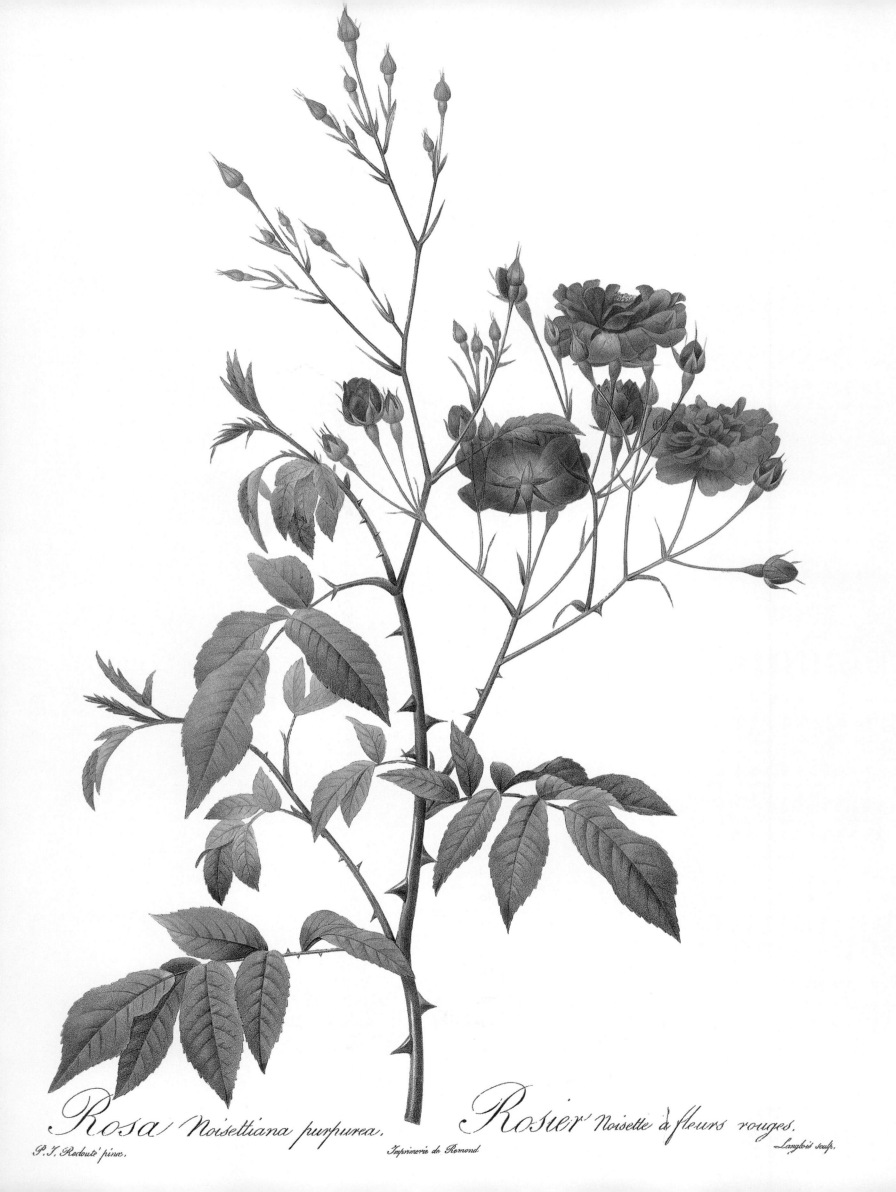

Rosa Noisettiana purpurea. *Rosier* Noisette à fleurs rouges.

P.J. Redouté pinx. Imprimerie de Remond. Langlois sculp.

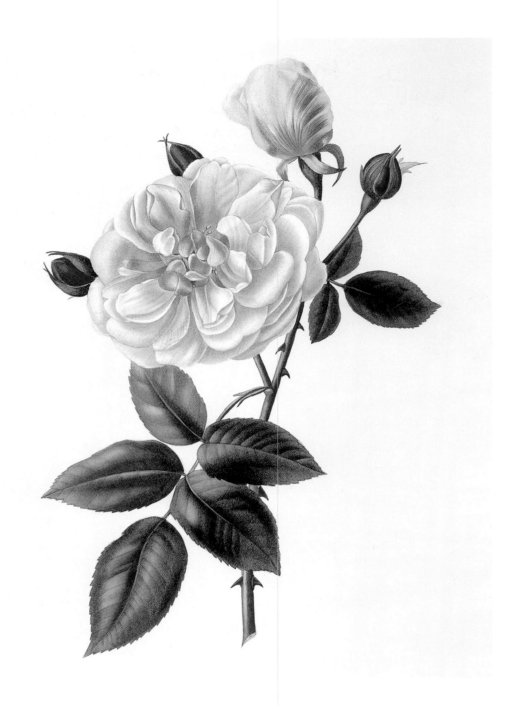

'DESPREZ A FLEUR JAUNE'

There are many subtle shades of buff, cream and yellow within the folded petals of this early Noisette (above), raised from 'Blush Noisette' and one of the yellow Tea roses, probably 'Parks' Yellow' which at the time had been recently introduced from China. It therefore has a claim to be regarded as the first yellowish climber ever raised. Jean Desprez of Yèbles to the south of Paris is said to have raised it about 1828, which explains why it is also known as 'Jaune Desprez'.

'TERNAUXIANA A FLEURS ROUGES'

This early Noisette rose illustrated by Redouté (opposite) dates from 1822 and is described as 'a very beautiful and curious variant of the Noisette Rose but smaller in all its parts'. It is clearly different in colour from its presumed parent 'Blush Noisette', being a bright pink that deepens as the petals age.

'LAMARQUE'

This early cross between 'Blush Noisette' and a yellow Tea rose (above & opposite) is a beautiful and vigorous climber, but needs a mild climate for its lemon buds to open cleanly and display their delightful saucer-shaped flowers, filled with narrow quilled petals. The pleasing fragrance is variously likened to that of lemons and violets. A keen amateur gardener named Maréchal, described as a shoemaker of Angers, raised the rose around 1830. It was called 'Thé Maréchal' because of its perceived affinities with Tea roses, and renamed 'Lamarque' after a distinguished French general.

Chromolith v Conrad Grefe

Druck a.d.k.k.Hof u.Staatsdruckerei

Termeszet utan Komlosy Berenczei.

KLASSE II GRUPPE 39 (ROSA MOSCHATA)

AIMÉ VIBERT.

Abstammung Származás Origine Originally from	China —Moschata	Gezogen von Felnewelte Cultivée par Cultivated by	Vibert

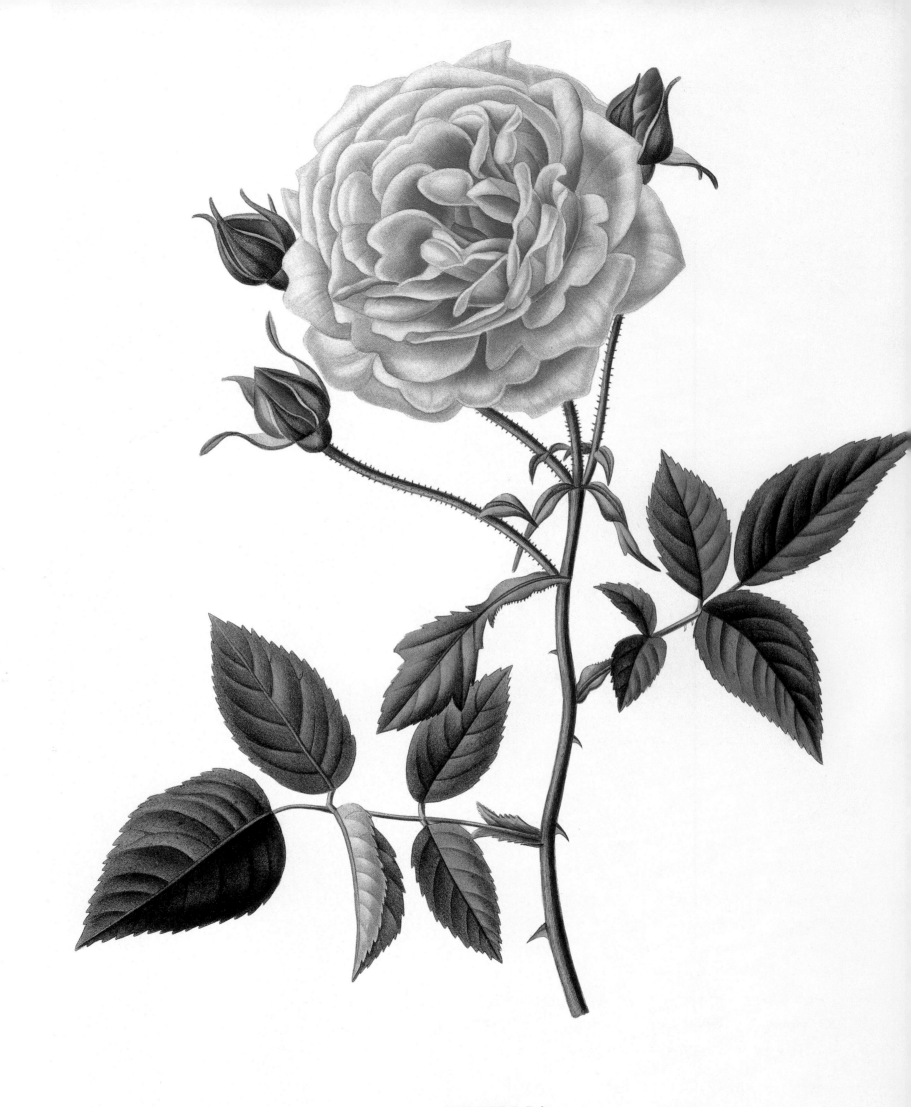

HERMOSA.

(Tribu des Rosiers ile Bourbon.)

'LOUISE ODIER'

This Bourbon shrub (right) or semi-climber of classic beauty bears sweetly fragrant camellia shaped flowers, often singly, sometimes in small clusters, on arching stems. Its perfect symmetry of form, pleasing colour and lasting qualities make this a lovely rose for cutting, and account for its continuing popularity after a century and a half. Jacques-Julien Margottin of Paris raised it from a lilac cerise Bourbon called 'Emile Courtier' and introduced in 1851. The name 'Louise Odier' is probably linked to the family of James Odier, also from near Paris. Odier raised 'Gigantesque', a bush rose sent out in 1849, and it is a possibility that he also raised 'Louise Odier' and sold the rights to Margottin.

'HERMOSA'

Derived from a China and a Bourbon, 'Hermosa' (opposite) has at various times been classed with both. It was raised in 1840 by Marcheseau and introduced by Rousseau of Angers. It makes a short bushy plant and was a favourite choice for a low hedge in the nineteenth century, not least because it repeats its flower so well, being, as the American Rose Annual baldly put it in 1920, 'Quite ordinary and unexciting, but liberal in yield'. The raiser thought it deserved more than this faint praise, for hermosa *is the Spanish for 'beautiful'. King Edward VII, no mean judge of beauty, ordered twenty thousand plants for the royal estate at Sandringham.*

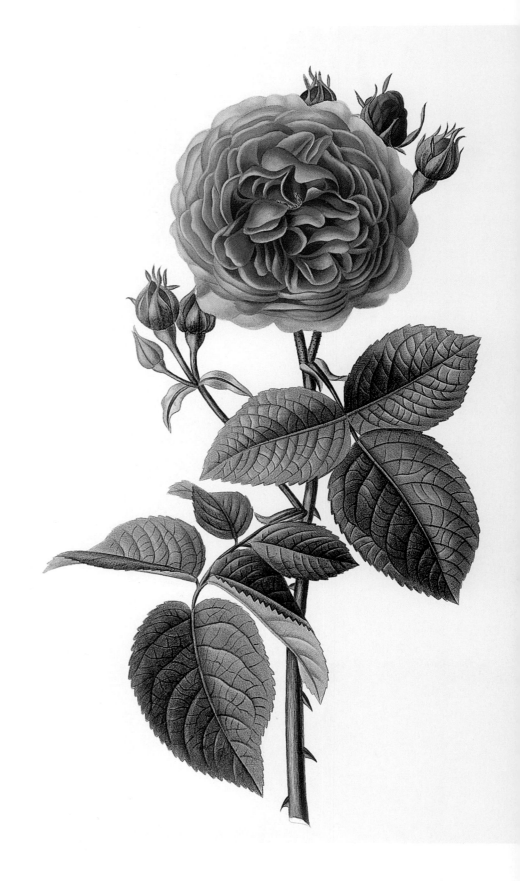

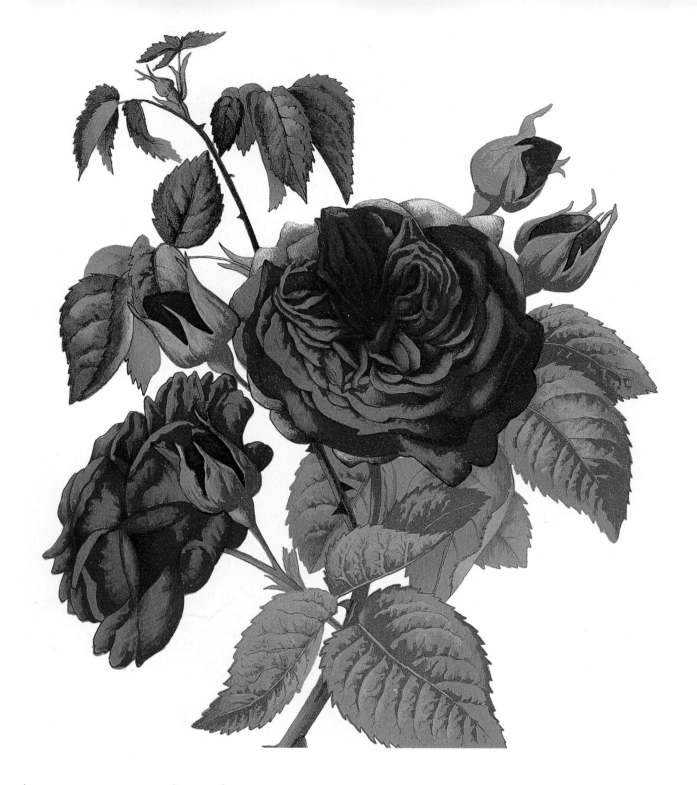

'MADAME ISAAC PEREIRE'

The rich colour of this rose (above & opposite) is not to everyone's taste, but there is no denying the beauty of its wonderfully structured flowers with their double quartered petals. They are heavily scented and carried on stems that appear strong yet nevertheless arch over beneath the weight of bloom. It has a long flowering period, the latecomers tending to be more perfect in form than those in the first flush. The foliage is a disappointingly dull shade of green. Of unknown parentage, this was raised by Garçon of Rouen and sent out in 1881. The woman whose name it bears is described by Barbara Abbs as 'a dazzling figure, wife of the younger Pereire brother who was a celebrated financier of the Empire' under Napoleon III.

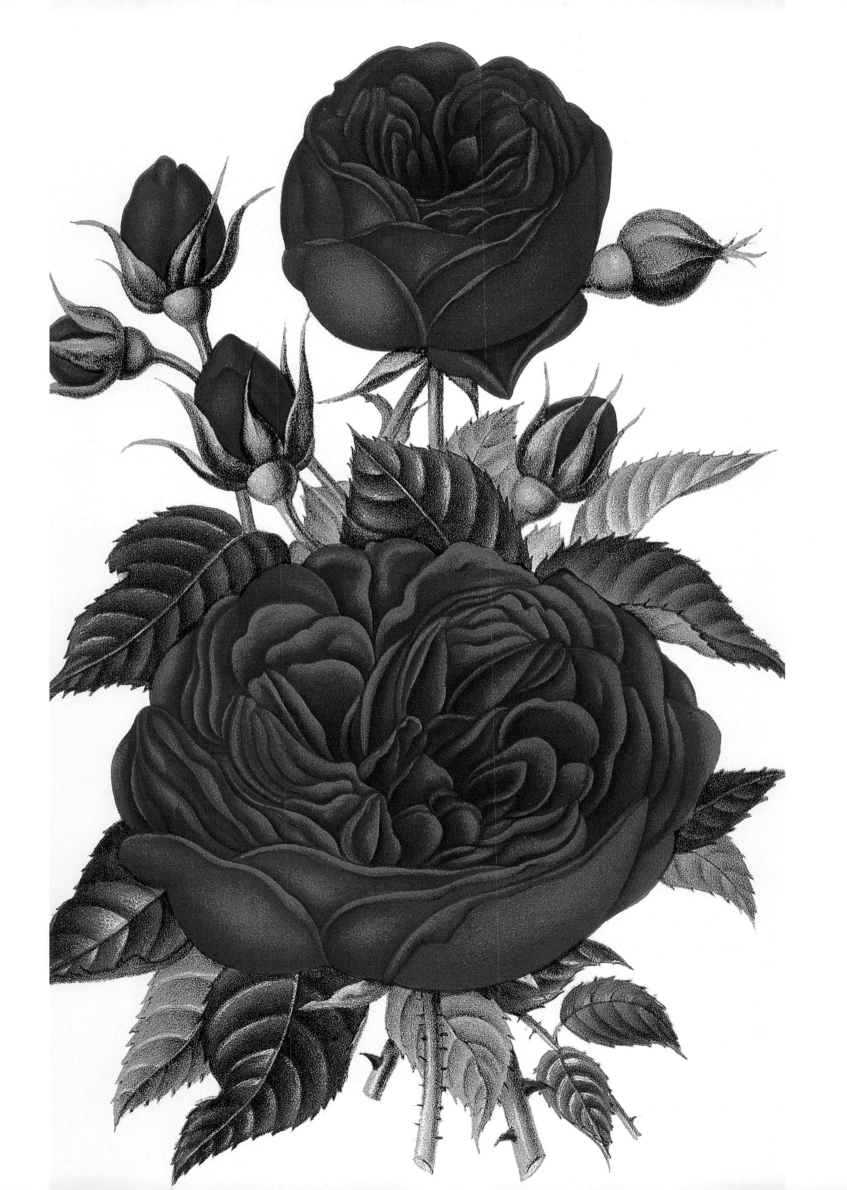

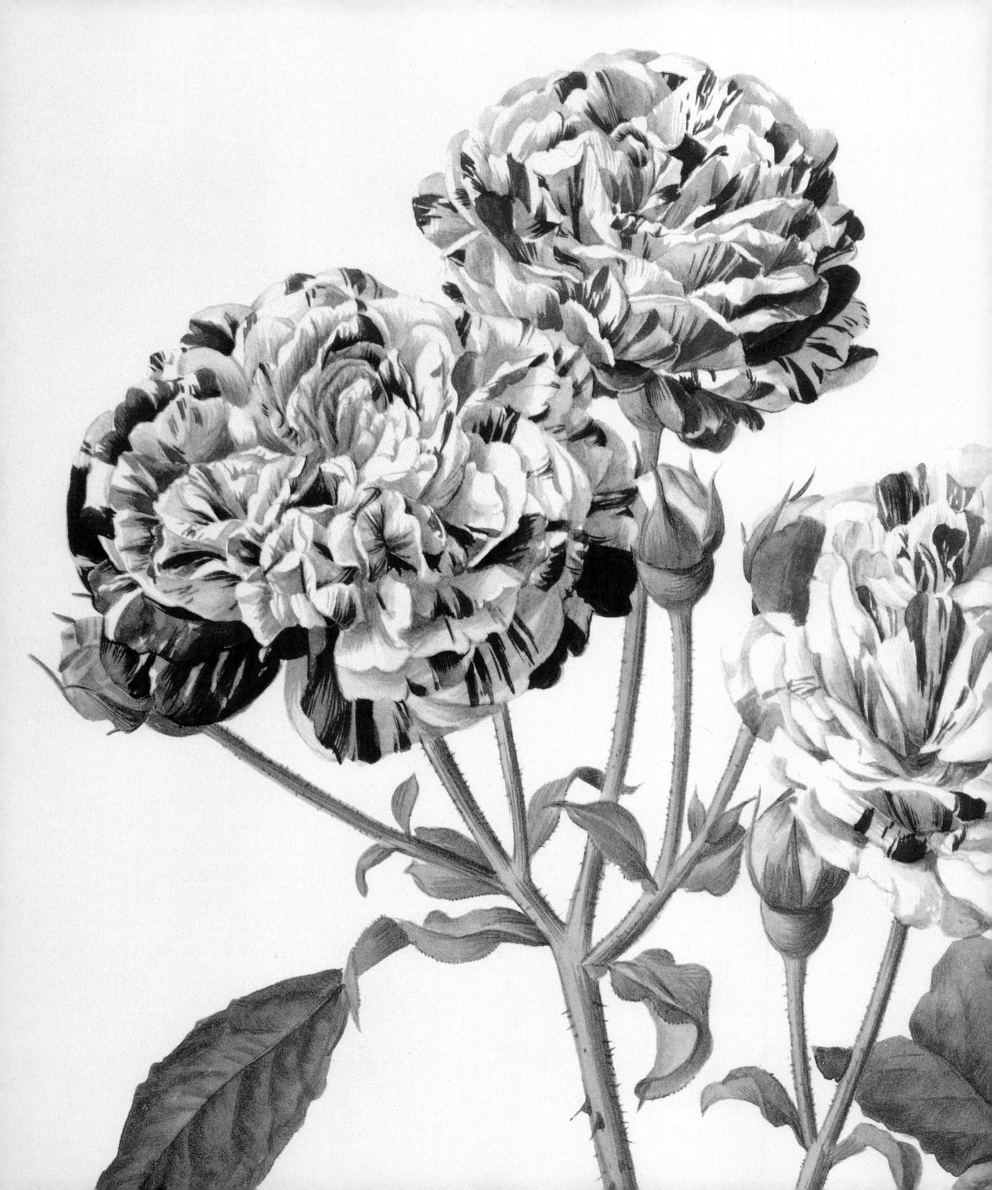

'VARIEGATA DI BOLOGNA'

This is a Bourbon born out of its time: its introduction date was 1909 when the class had fallen right out of favour. The bizarre colour variegation in the petals has been described as 'the semolina and blackcurrant jam of school dinner days'. This is the feature that has kept it in commerce, for in other respects it is easy to find fault with its pale foliage, willowy stems and liability to blackspot, mildew and rust; nor can it be relied on to furnish autumn flower. It does have good fragrance. The rose is a sport of the dark violet 'Victor Emmanuel' and sometimes reverts. It is attributed to Lodi and Bonfiglioli of Bologna, Italy.

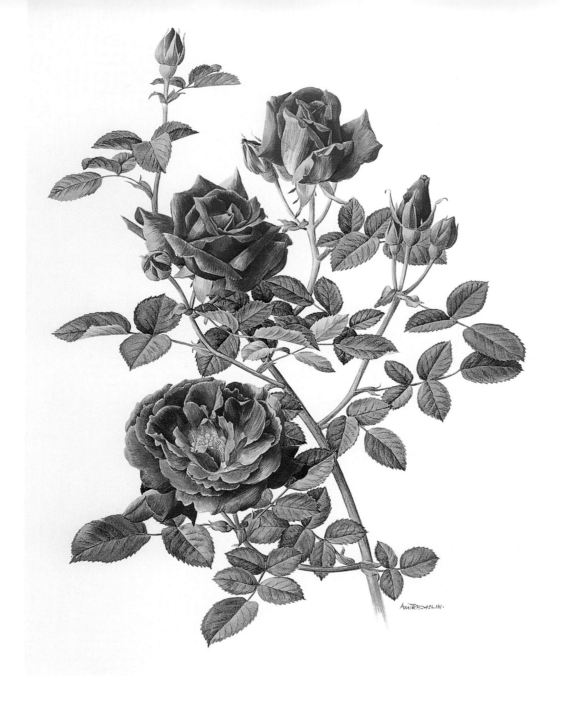

'ZEPHIRINE DROUHIN'

Probably the most widely grown rose of its era, 'Zephrine Drouhin' (above) is attributed to Bizot of France in 1868 and was dedicated to 'the wife of an amateur horticulturalist of Sémur on the Côte d'Or'. It is still available from scores of growers all over the world, Gwen Fagan of South Africa has dubbed it 'The Perfect Rose'. The warm cherry-pink tone, pretty flower form, wonderful scent and continuity of bloom are all in its favour, and the absence of prickles is an excellent selling point.

'DIAMOND JUBILEE'

This superbly beautiful Hybrid Tea (right) was raised from 'Maréchal Niel' and captures the spirit of that old Tea-Noisette in its long furled buds and full-petalled, fragrant blooms. Unlike its parent it is winter hardy in most climates. Introduced in 1947, it was raised by Gene Boerner of Jackson & Perkins in the United States. Boerner had a novel sales technique with clients looking to buy a scented rose. He would select a bloom and put it under his cap, where the warmth would activate the scent glands. A few minutes later he would retrieve the rose, by now delightfully fragrant.

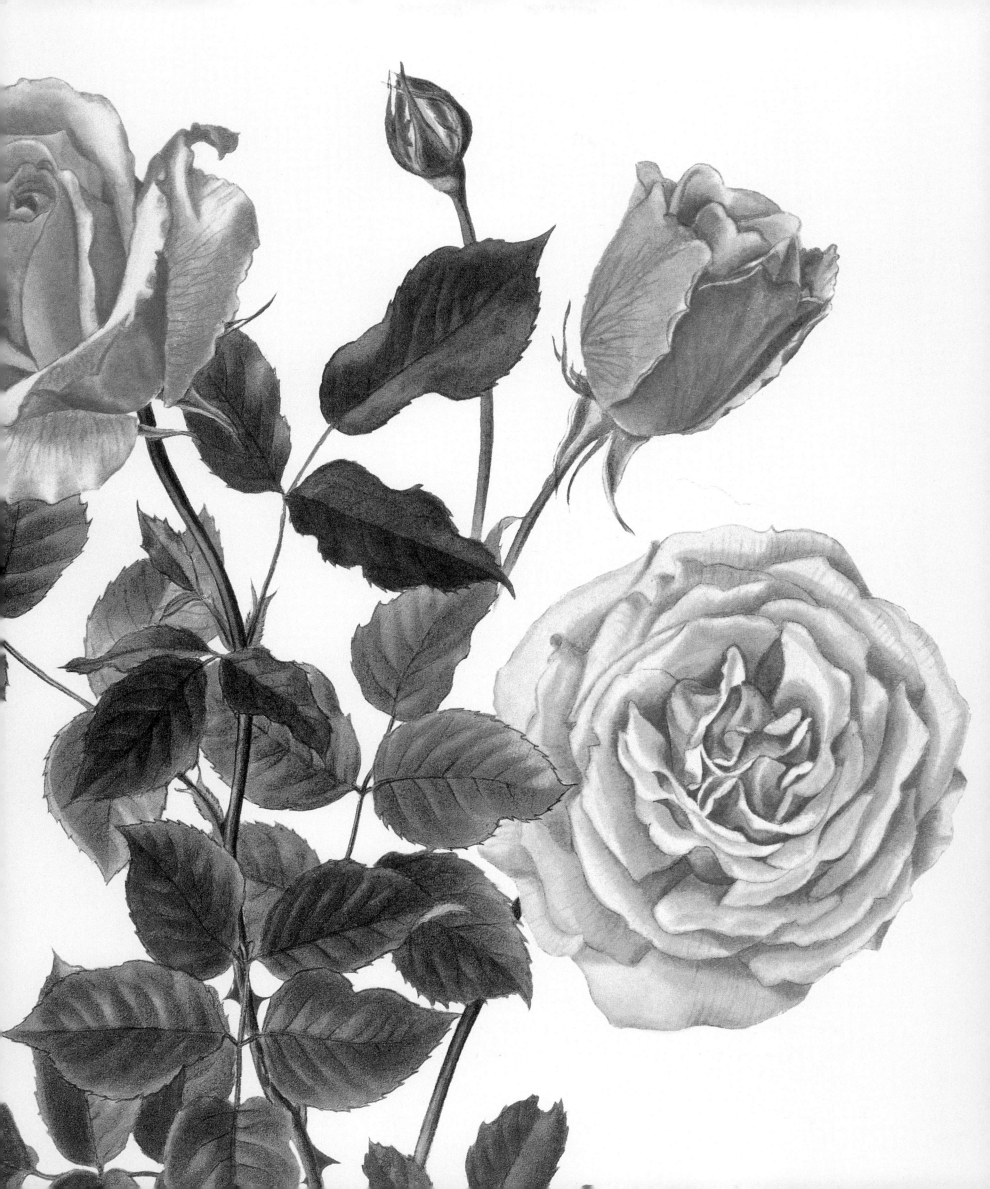

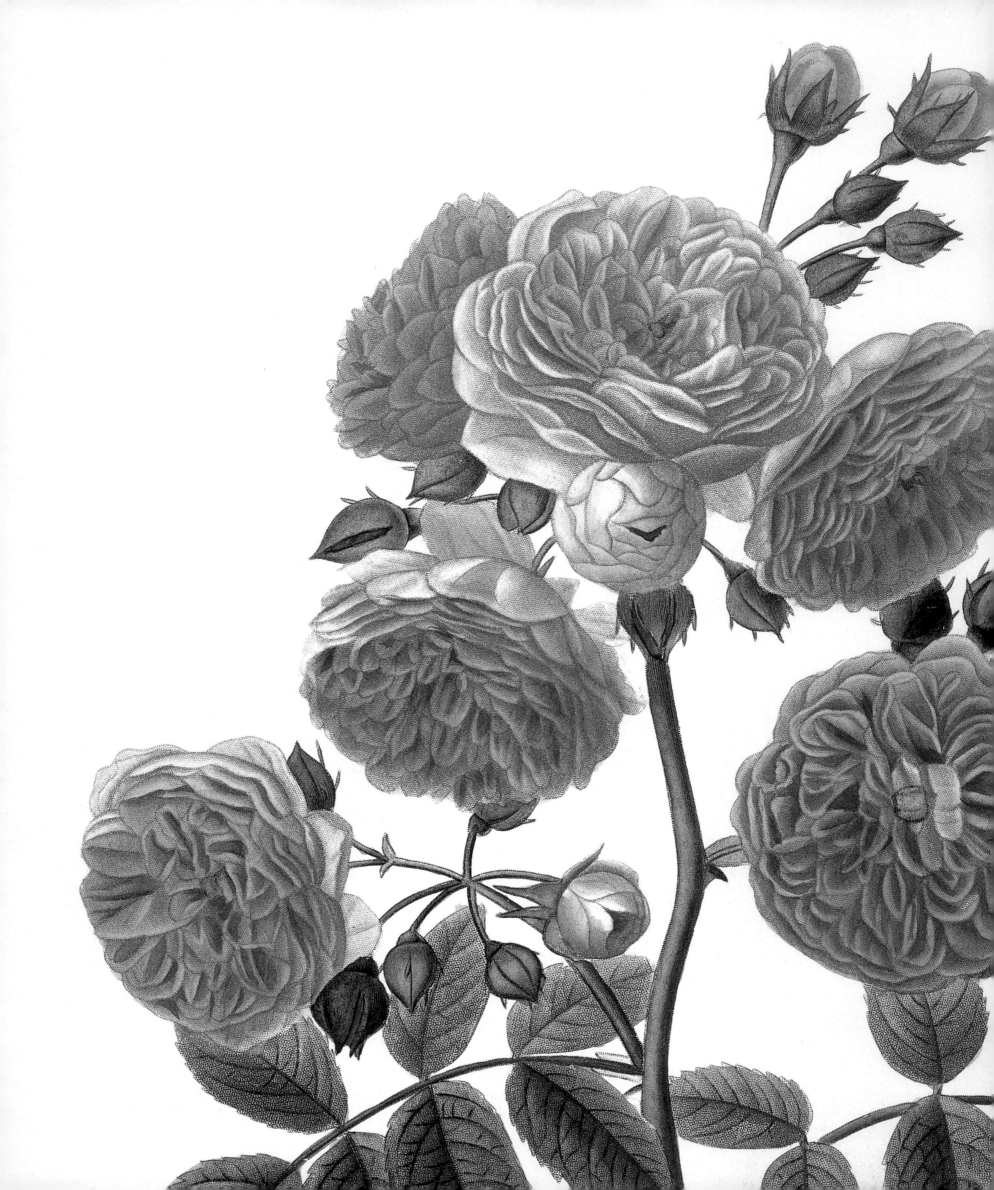

'LAURE DAVOUST'

Credited to Jean Laffay and introduced in 1834, this vigorous and fragrant
Multiflora climbing rose was described in Robert Buist's Rose Manual
a few years later as 'the climax of perfection in this family; with all the aid
of the imagination its beauty on a well grown plant cannot be pictured.'
Another observer thought the flowers were 'like little fairy balls made of
tiny rose petals'. Though liable to frost damage in severe winters, it is still
in commerce. Like others of its family, it has excellent recuperative powers.

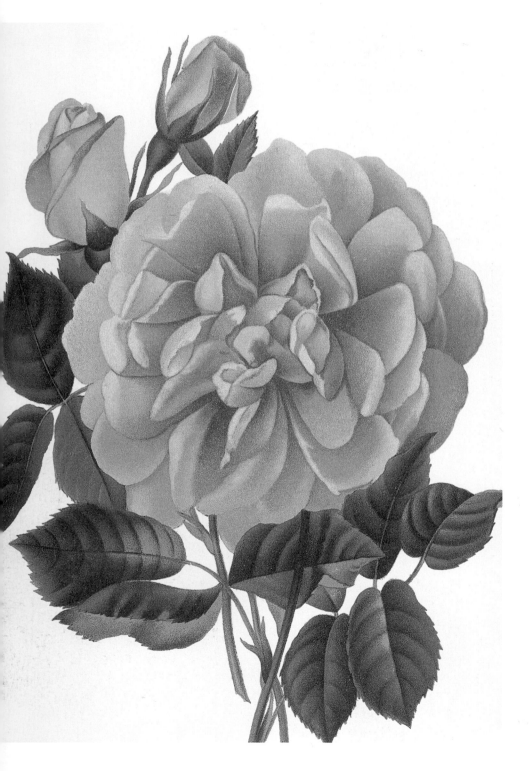

'MME DE SANCY DE PARABERE'

This is the best known of the Boursault roses (left), characterized by their smooth stems and vigorous arching growth and thought to derive from R. pendulina and a China rose. The large pink flowers display a touch of mauve, and as the outer petals reflex to produce a rounded outline, the inner ones enfold to create pleasing muddled centres. The stems bow naturally under the weight of the bloom, and this rose looks most effective when seen from underneath. Its origin is a mystery. Noticed in 1873 by a visitor to a French garden, it was claimed by others to have been in circulation up to forty years before. The garden owner was M. Bonnet and the visitor M. Jamin; they are jointly credited with it. Mme. Bonnet suggested the name.

'ROSE DU ROI'

Whether it was M. Souchet or his gardener M. Écoffay who grew this rose (opposite) from seed is not clear, but in 1819 both were delighted to see it in flower. The bright red colour was a welcome surprise, especially as the flower was well-formed and a good size. Its novelty value increased when it was seen to repeat its flowering in the autumn. M. Souchet's employer, in charge of the royal palace of St. Cloud, decided that the rose should bear his name of 'Comte Lelieur', but after Louis XVIII admired it the name was changed to 'Rose du Roi', much to Lelieur's chagrin. Its parents are thought to be 'Rosier de Portland' and an Autumn Damask and in its time it has been called a Portland, Damask Perpetual, Perpetual and Hybrid Perpetual. Its genes contributed much of their character to the early members of the last group, but their success dimmed its own commercial prospects.

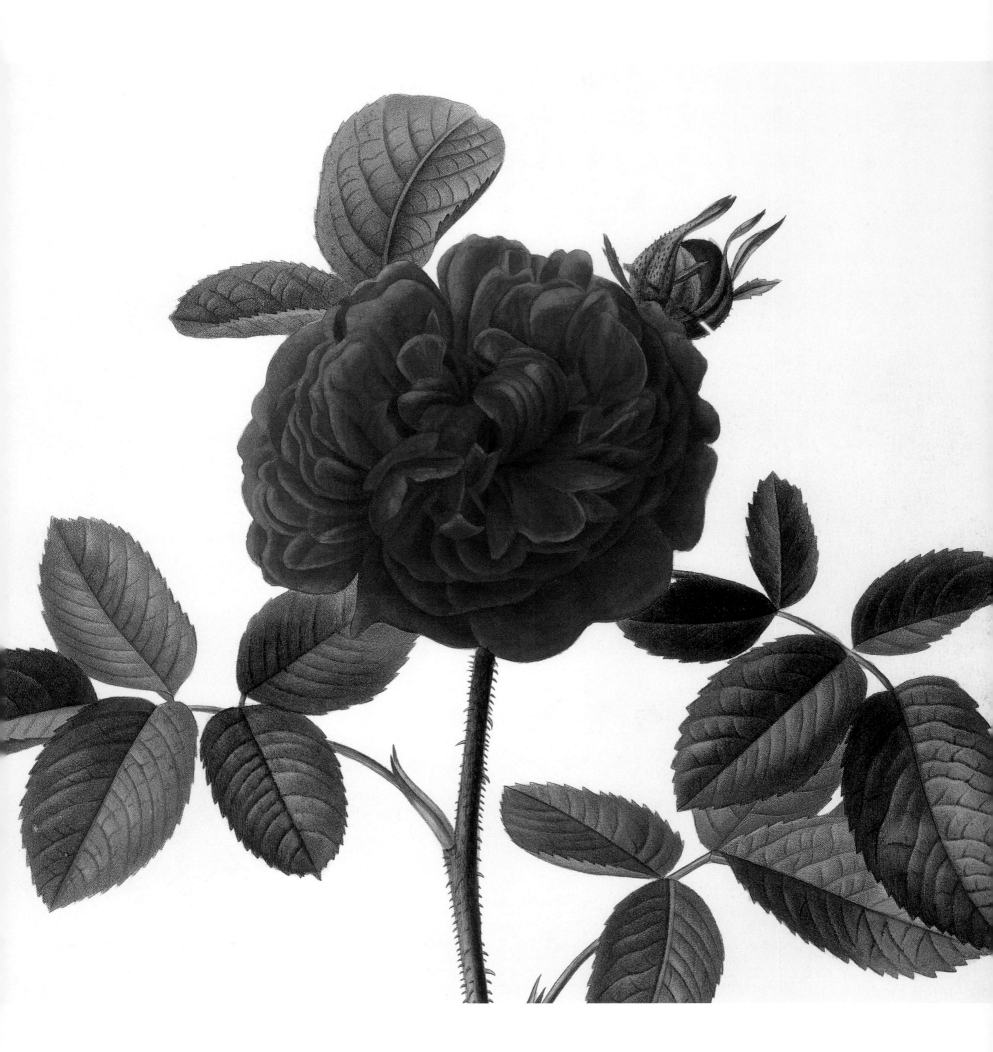

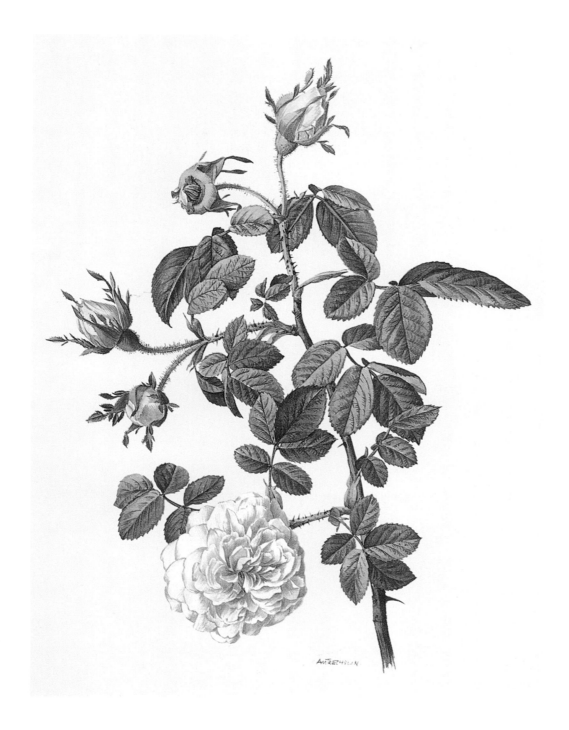

'MADAME HARDY'

Although this variety (above) is sold universally today as 'Madame Hardy', the raiser called it by his wife's name, 'Félicité Hardy'. It was a hybrid of Portland and Damask, though a good measure of Centifolia influence can be inferred from its exceedingly full-petalled flowers, delightful fragrance and summer flowering character. The flowers often show a 'button eye' in the centre.

'MARQUISE BOCCELLA'

Raised by Jean Desprez and introduced in 1840, this Damask Perpetual, or Portland, rose (right), also known as 'Marquesa di Bocella', illustrates how hybridisers of the period achieved blooms of extraordinary fullness. Eighty-five petals are crowded in a flower 4.5 inches (11cm) in diamater.

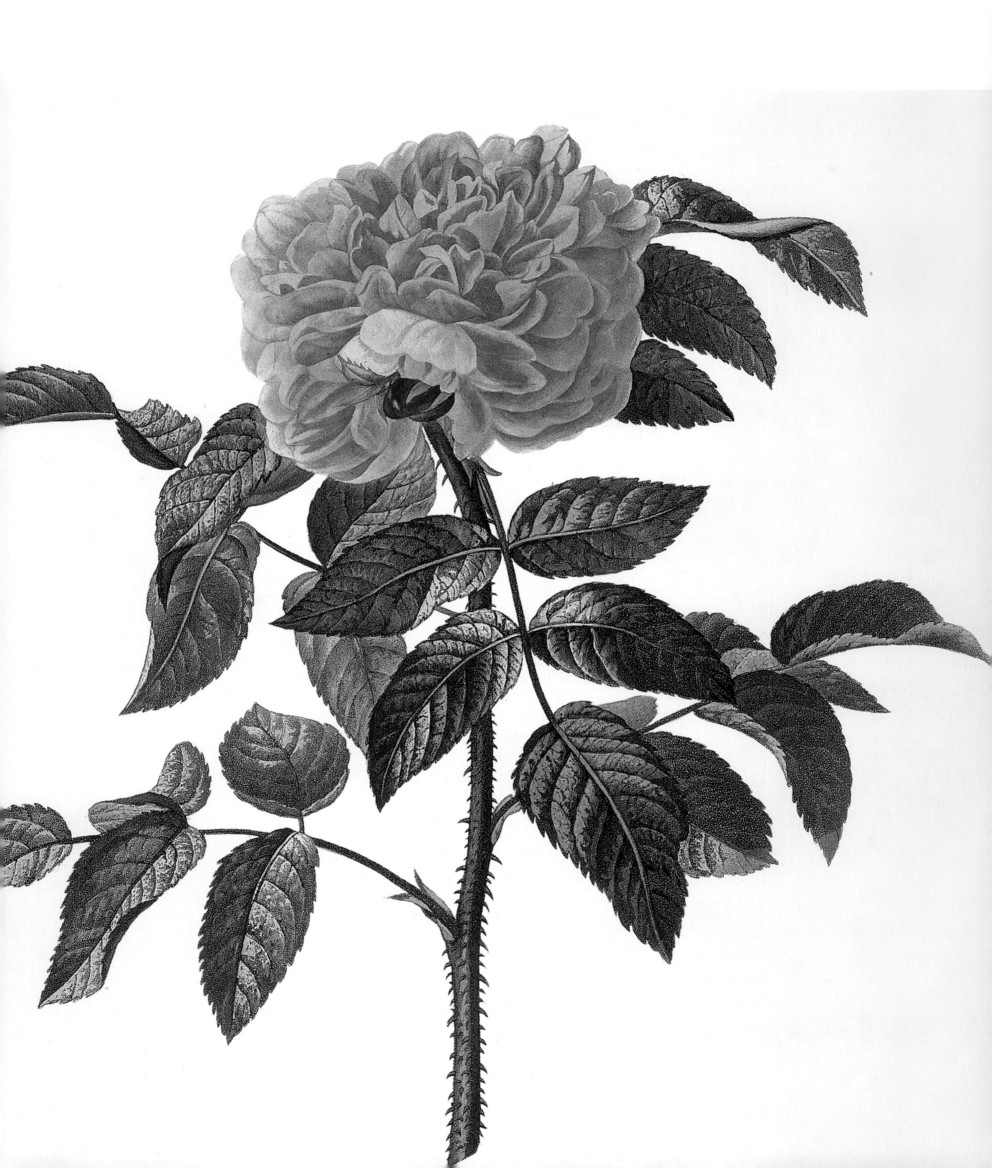

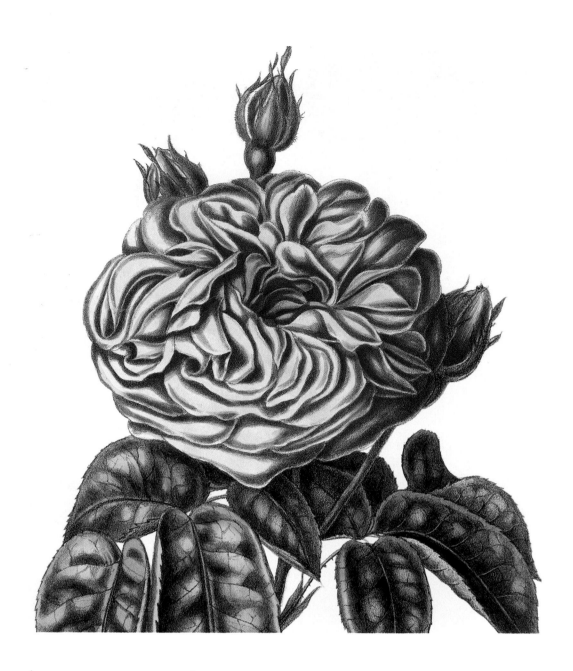

'BARONNE PREVOST'

The full flat rose pink blooms of this early Hybrid Perpetual (above) attain great size and appear to have more petals than they can reasonably hold. In 1841 the raiser Jean Desprez is said to have sold his interest in it to the firm of Cochet for one hundred francs. Cochet introduced it the following year, and it is one of the few Hybrid Perpetuals still widely in cultivation today. The name was given by Desprez as a compliment to the sister of a friend, a raiser of dahlias.

'JULES MARGOTTIN'

From Jean Laffay's 'La Reine' of 1844, Jacques-Julien Margottin raised a vigorous repeat-flowering seedling, naming it 'Jules Margottin' (opposite) after his son. It was introduced in 1853. This was a happy episode in Margottin's life. From a penniless orphan at fourteen he became chief rose gardener in the Jardin du Luxembourg before establishing his flourishing business as a grower and raiser.

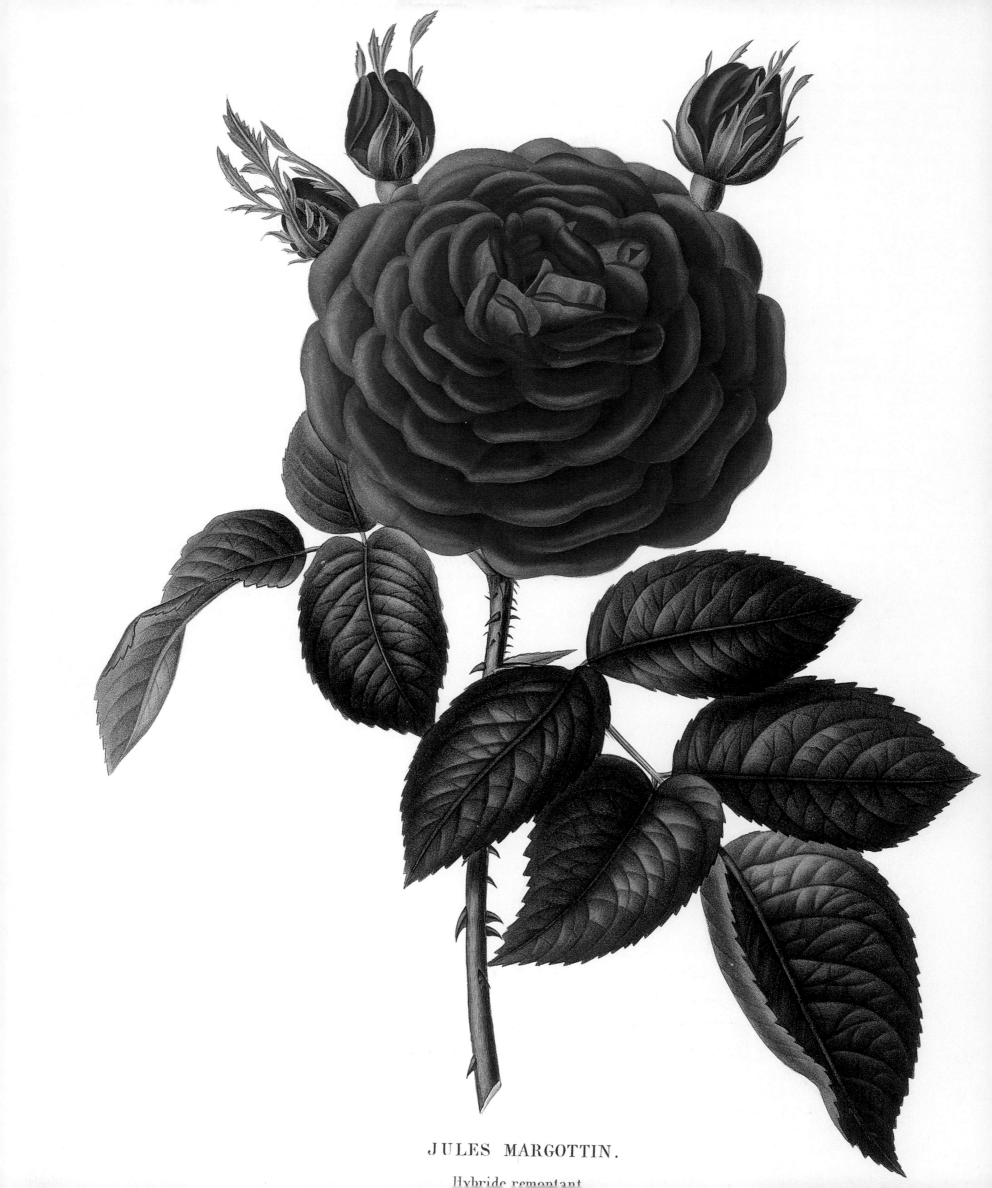

JULES MARGOTTIN.

Hybride remontant.

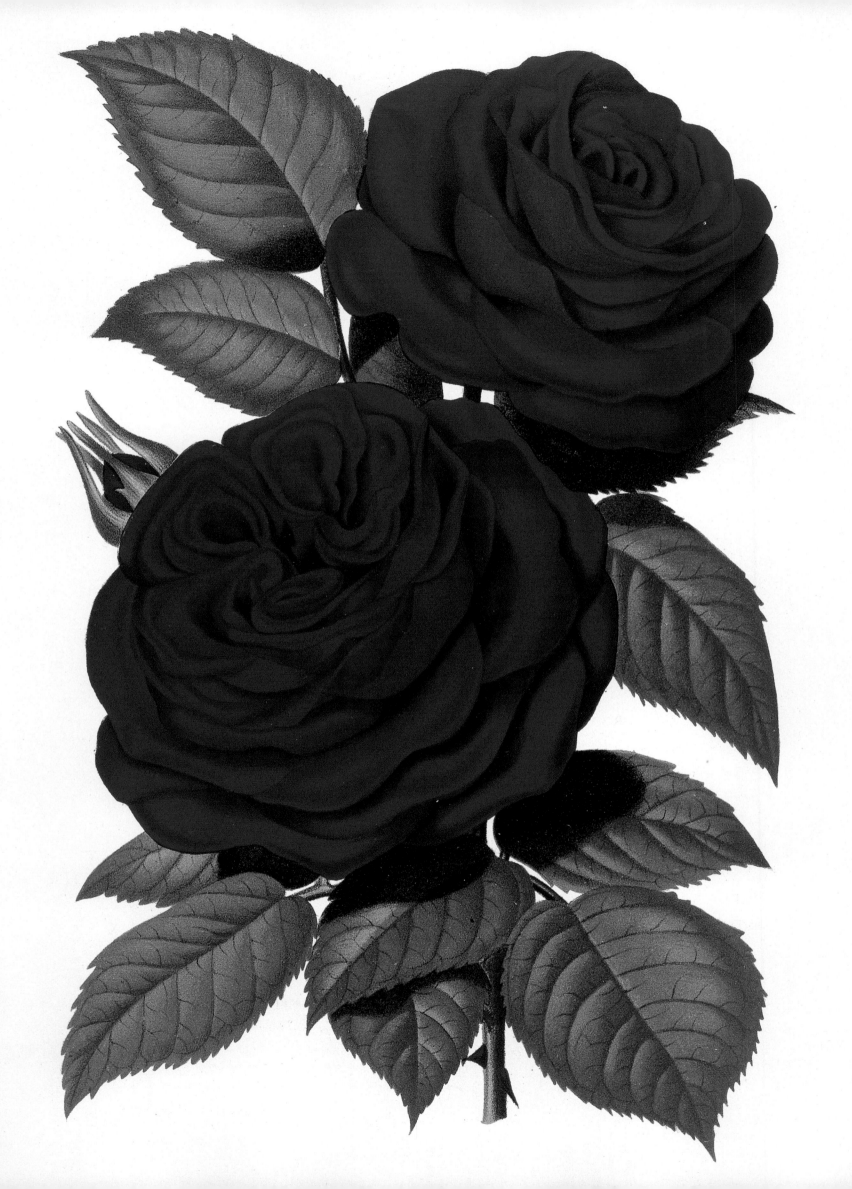

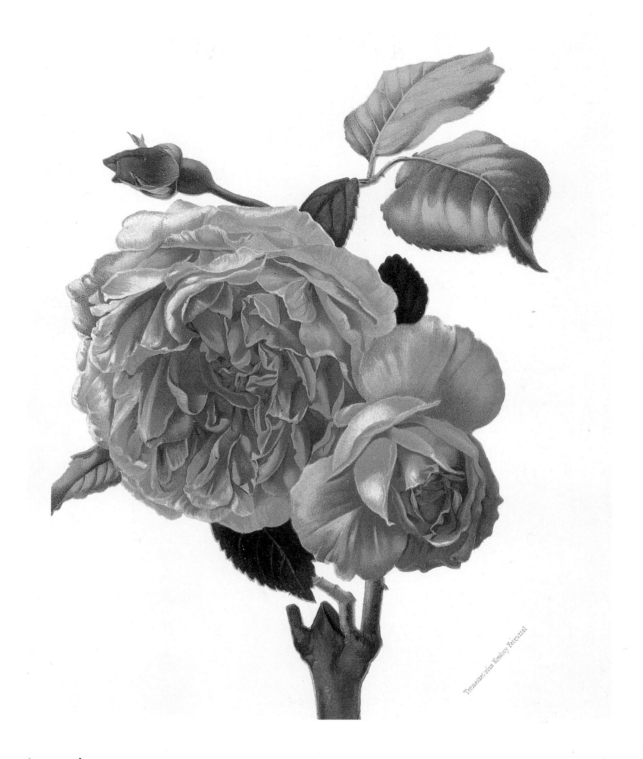

'ADAM'

'Adam' (above & opposite) is one of the earliest Tea roses, introduced in the 1830s by a gardener at Rheims whose surname was Adam. It is safe to assume that 'Hume's Blush Tea-Scented' was one parent. The identity of the other might be a Bourbon, which could account for the many short-quilled petals in the heart of its large flowers, as shown in the illustration taken from Komlosy's Rosen-Album (above). The fawn-pink colour could also be expected from such a match. The plant proved a fairly short grower and subject to mildew, but it was responsive to care in its cultivation, and sufficiently vigorous and frost-hardy to have survived to the present day. It possesses the delicate 'green tea' aroma that distinguishes many of its class.

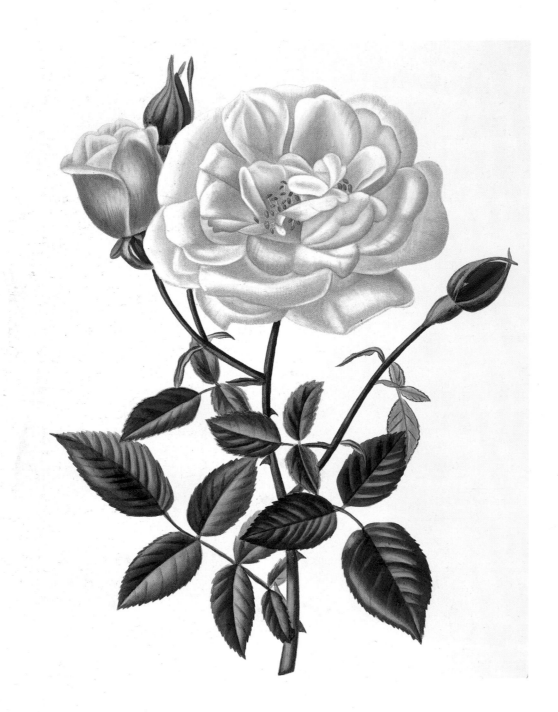

'SAFRANO'

In 1839 'Safrano' (above) brought a new colour to roses, saffron yellow with rosy shadings on the outer petals, and an elegance and perfection of form in the bud stage that has never been bettered. It makes an excellent garden rose in a warm climate or in a glasshouse, and soon became a favourite choice for buttonholes in France and England to the lasting benefit of Riviera florists.

'SOMBREUIL'

Named after a heroine whose wits saved her father and herself during France's Reign of Terror in the 1790s, this rose (opposite) is considered one of the most beautiful Teas, bearing blush-tinted white buds that open wide to show many petals. Dark leathery foliage sets them off beautifully, and the plant shows more vigour and hardiness than most Teas, capable of reaching up to 10 feet (3m) as a climber.

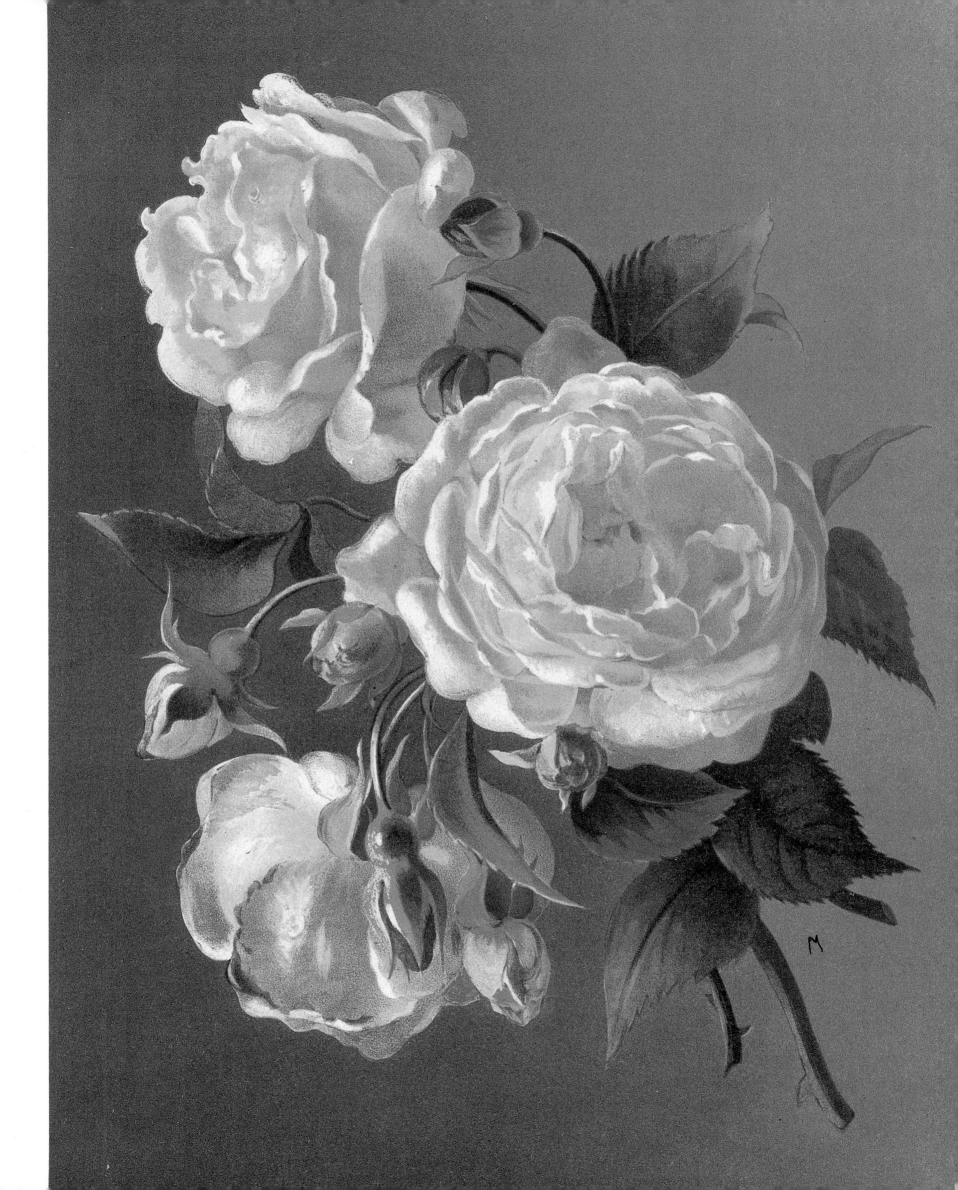

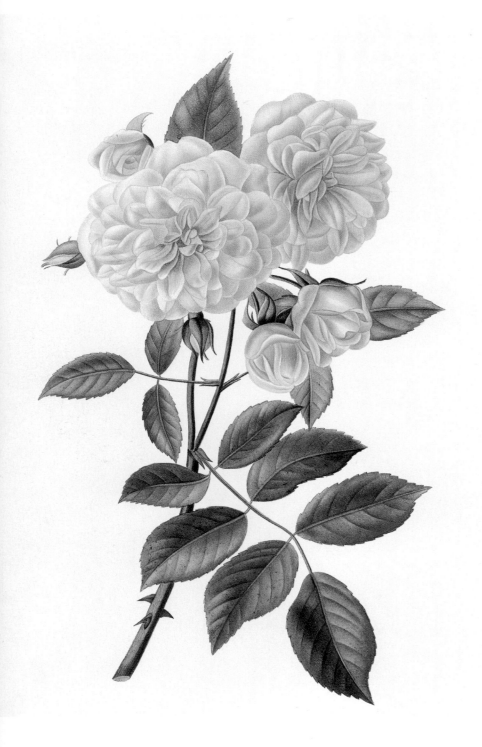

'LE PACTOLE'

This variety (left), raised by Miellez from the climber 'Lamarque' and a yellow Tea rose, was treasured for its shapely buds and the silky petal texture of its large cupped flowers. The name alludes to a river in Turkey fabled for the gold found there in early times. It was introduced before 1841, and is still in commerce.

'VICOMTESSE DE CAZES'

In 1846 this variety (opposite) became the first in a long line sent out by Henri Pradel of Montauban. It was classified as a Tea-Scented rose and has long been extinct, but contemporaries speak of its good yellow colour and the freedom with which it produced its medium sized blooms. Because it was tender it was only useful out of doors in sites protected from frost, or otherwise grown in a pot where it could readily be transferred. William Prior made a list of this and other roses available in 1874, concluding despairingly that 'golden yellow roses are scarce commodities.'

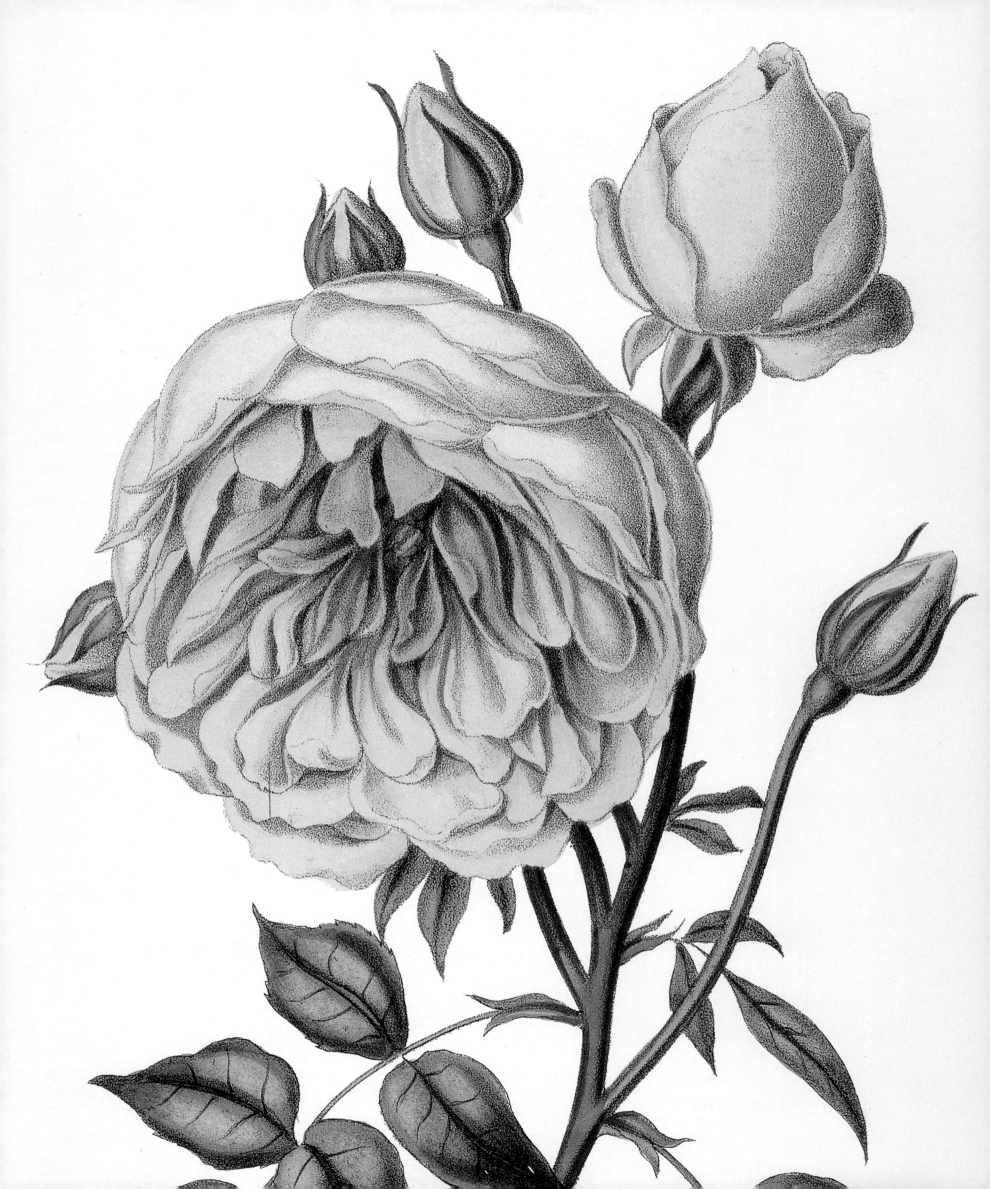

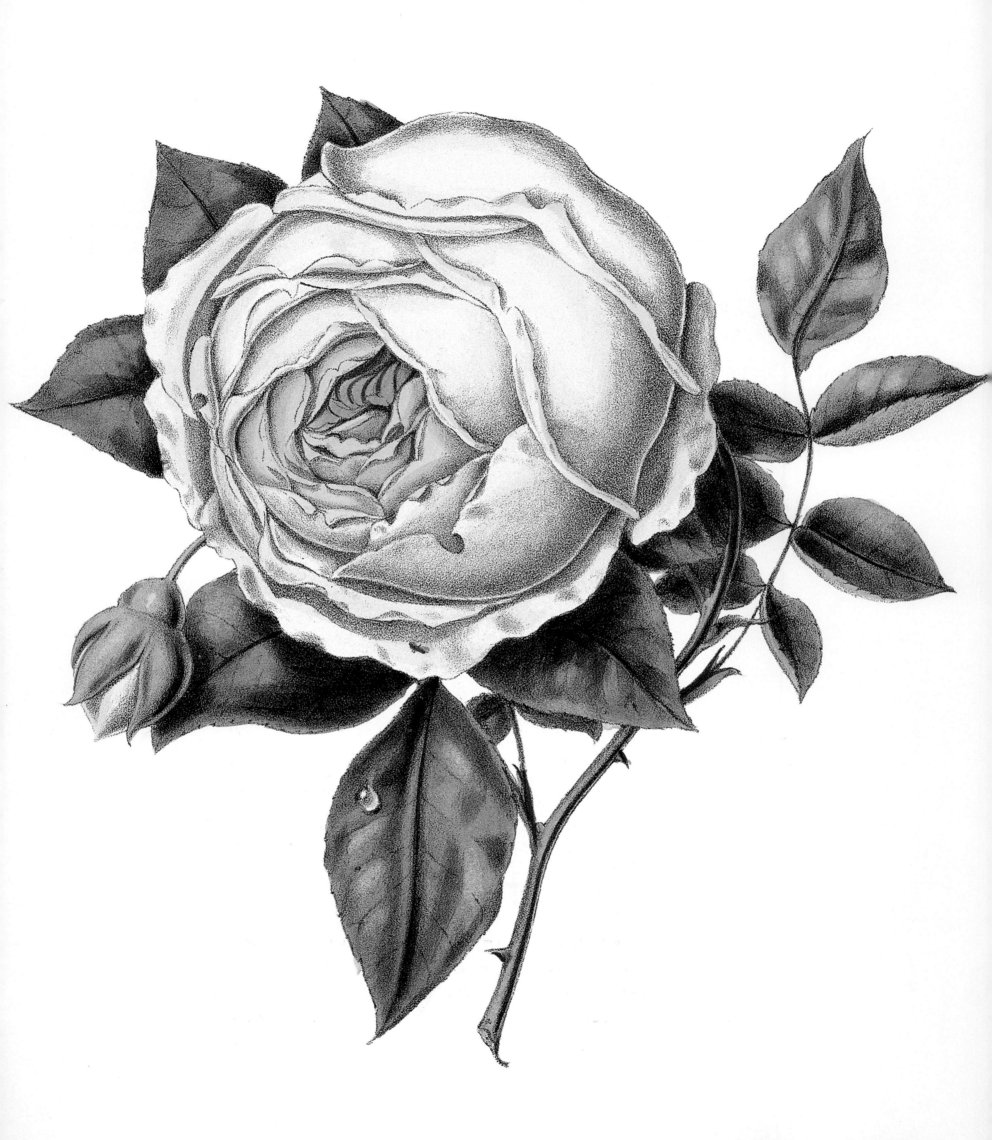

'MADAME LAMBARD'

*This Tea rose (above) was introduced in 1877 and still flourishes in the modern world, thanks to its
success in warmer climates. It does particularly well in South Africa, Bermuda and parts of the United
States. Although it is among the hardiest Teas and will survive in cooler climates, the flowers are easily
marked by rain and lose much of their rich colouring. François Lacharme of Lyon is said to have
raised this from 'Mme. de Tartas', a pink Tea and an important ancestor of modern roses.*

'MOIRÉ'

*Bearing the name of the raiser, a gardener from Angers, this early Tea (opposite) with its 'parrot's beak'
prickles was acclaimed a 'jolie variété' by the local horticulturists when introduced in 1839. It was
admired for the way the petal colours graduate from sulphur yellow at the base to pale rose at the tips.*

'LADY HILLINGDON'

The fragrant and beautiful Tea rose 'Lady Hillingdon' (above) was raised by Joseph Lowe and George Shawyer of Uxbridge near London, and deservedly received a Gold Medal from the National Rose Society on its debut in 1910. Its long slender buds and light apricot flowers against a background of purplish green foliage are usually seen today in the climbing form, which followed in 1917.

'PRINCESSE ADELAÏDE'

Described in Belle Roses as 'one of the thousand and one children of Luxembourg who have for their father M. Hardy', this rose (opposite) was exhibited in the Orangery of the Luxembourg Gardens in 1844, at once acclaimed, given a gold medal and named for the sister of King Louis-Philippe.

'PERLE DES JARDINS'

'A rose of shocking bad manners' observed the Reverend Andrew Foster-Melliar of 'Perle des Jardins' (left), but he was judging it in Britain where dampness or cool winds cause the wide petals to stick together in the bud stage so that the flowers cannot open. In warm countries it thrives, particularly in the climbing form where the bowing stems present its clear yellow flowers conveniently to view. The bush came out in 1874 from Antoine Levet of Lyon, and is regarded as a Tea rose, whereas the climbing sport, introduced by John Henderson in the United States in 1890, is classified a Noisette. Such roses can unofficially be termed 'Tea-Noisettes'.

'MARECHAL NIEL'

The pointed buds on nodding stems are a familiar sight in India, where this vigorous climbing Noisette (opposite) is a favourite choice, its pure golden yellow tone unaffected by the heat. Because it is tender its needs are difficult to accommodate in cool climates, and a magnificent greenhouse plant at Askham Bryan near York had to go when it reached 55 feet (17m) in length. Introduced in 1864, it was raised by Henri Pradel who found the demand so great that customers were required to buy twelve other roses as well. Pradel planned to name it for the wife of Adolphe Niel (1802–1869), a hero at Sebastopol, until he discovered Niel was a bachelor.

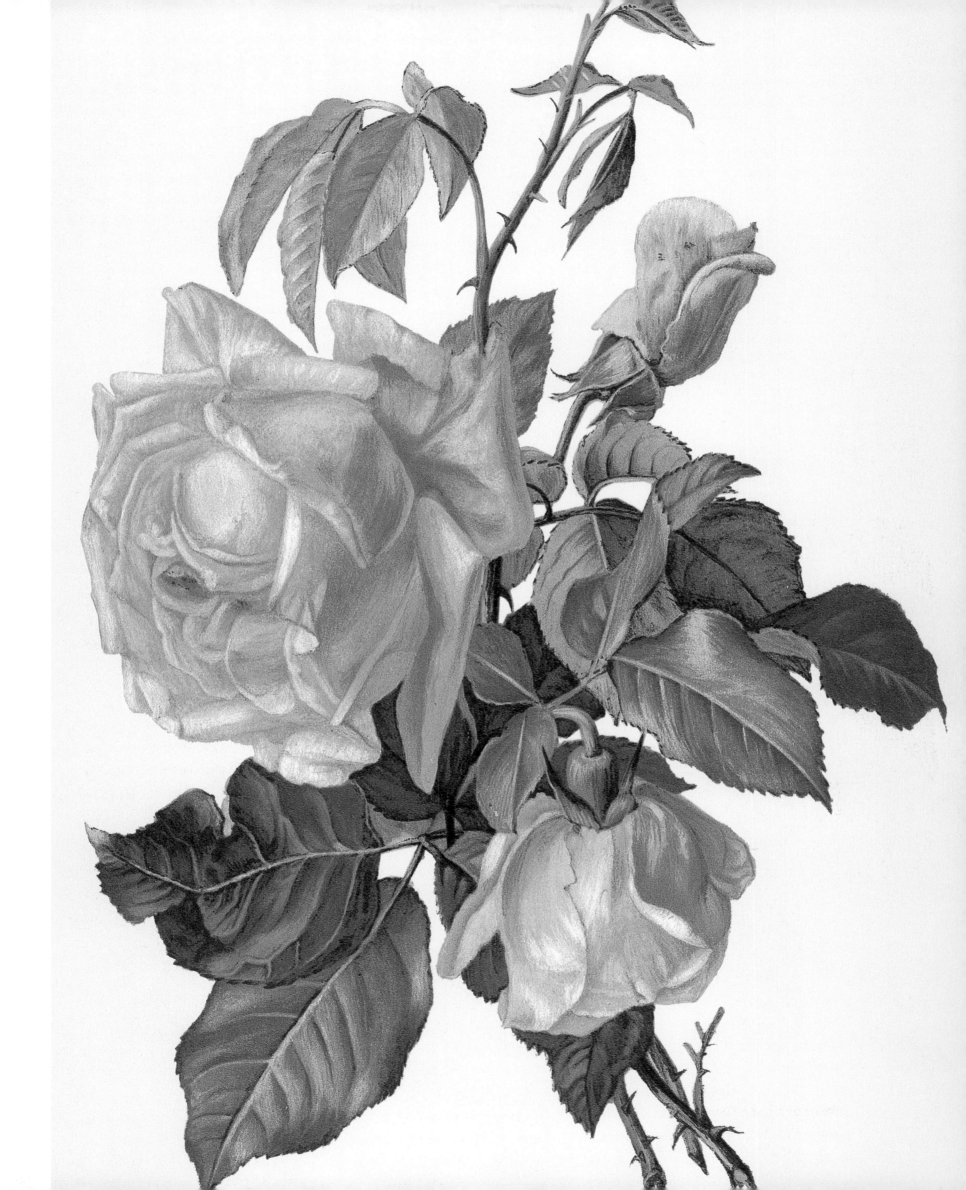

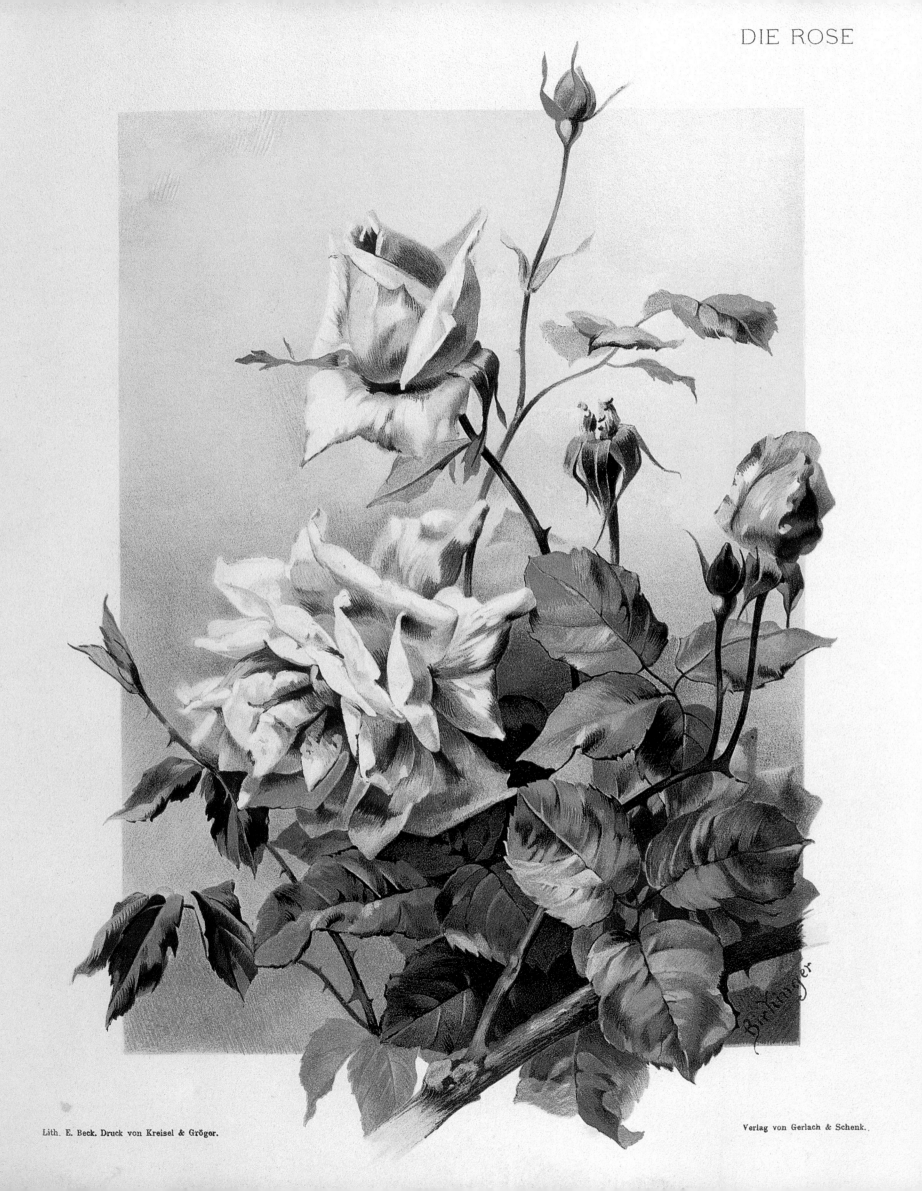

Lith. E. Beck. Druck von Kreisel & Gröger.

Verlag von Gerlach & Schenk.

DIE ROSE

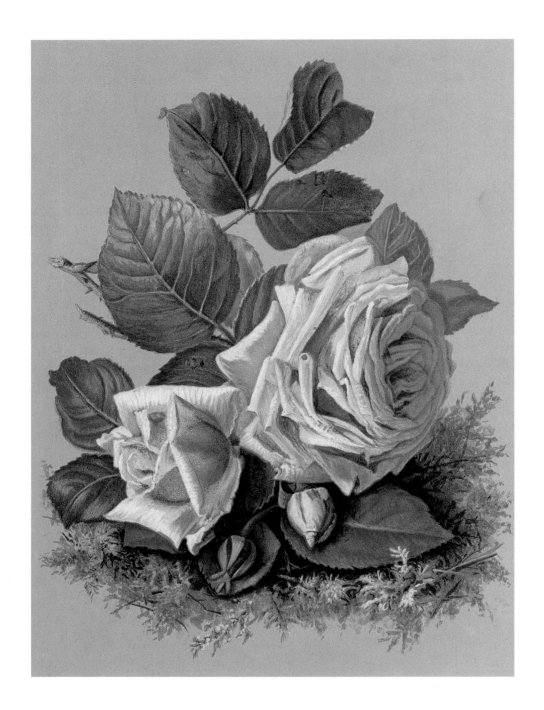

'LA FRANCE'

This rose (above & opposite) is often hailed as the first Hybrid Tea, the rose that harnesses the grace of the Teas and the strength of the Hybrid Perpetuals. There is no doubt of the impact made by 'La France' on its first appraisal in 1867, when it was selected to bear the nation's name. The raiser, Jean-Baptiste Guillot of Lyon, brought his best blooms to the ensuing Paris Universal Exhibition in expectation of further honours, but was disappointed, for his flowers were past their glory when the judges arrived two days late! Guillot, who also created the first Polyantha, surely ranks as the nineteenth century's most successful raiser.

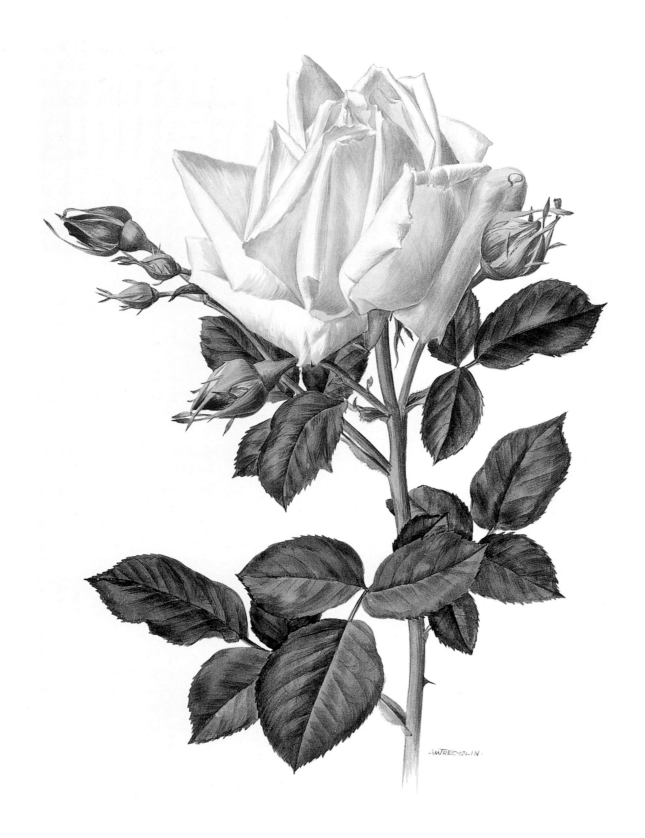

'FRAU KARL DRUSCHKI'

This vigorous Hybrid Perpetual (above & opposite) finds favour all over the world, for it has no drawbacks save the occasional failure to open in very wet weather, and lack of scent. Anne-Marie Trechslin's portrayal (above) shows it at the 'perfect' stage in all its freshness, and it maintains its attractiveness in the open flower. It was raised by Peter Lambert of Trier and named for the wife of the president of Verein Deutscher Rosenfreunde *('True German Friends of the Rose'). A superb climbing form came from T. A. Lawrenson of Newcastle-on-Tyne, England in 1906.*

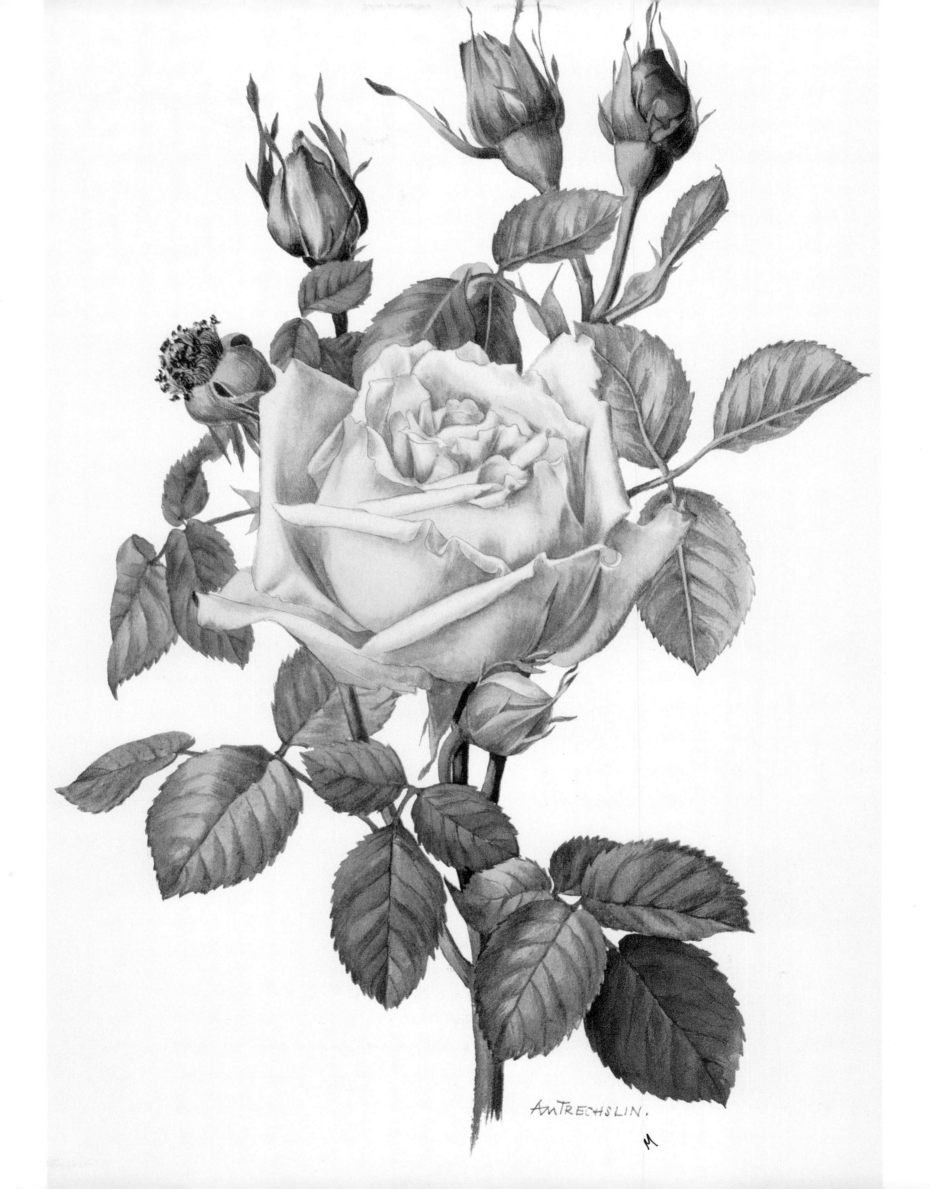

AmTrechslin.

'OPHELIA'

Although William Paul's nursery is credited with introducing this Hybrid Tea (right) as a seedling of 'Antoine Rivoire' in 1912, the firm believed it might have come as a mislabelled item with other plants ordered from France. It quickly became popular and has remained a favourite rose, admired for the elegant form of the buds, sweet scent of the open flowers and tolerance of bad weather and varied climates. It has fostered numerous sports, of which 'Madame Butterfly' and 'Lady Sylvia' are the best known, and features many times in the family trees of modern roses.

'SOCRATES'

The name of this scented Tea rose (opposite), raised in Angers by Robert and Moreau and introduced in 1858, may come from the story of Socrates' reaction when the poet Aristophanes lampooned him in the theatre. Aristophanes asked him to overlook the insult and enjoy the humour. Socrates' reply was to thrust a prickly rose into the poet's hand and tell him not to mind the barbs but enjoy the fragrance.

AnnP.ECHALIN.

JOURNAL DES ROSES (Août 1910)

M.Brun

'RAYON D'OR'

Pernet-Ducher raised 'Rayon d'Or' (left) from two of his
own hybrids, a pink and yellow Hybrid Tea called 'Mme.
Mélanie Soupert', and 'Soleil d'Or', his flame masterpiece of
1900. The new rose, the purest and brightest yellow bush
variety in existence, was exhibited in London in its year of
introduction, prompting another raiser, the Reverend Joseph
Pemberton, to declare that 'the year 1910 will be known
hereafter as the year of 'Rayon d'Or'.

'MME E HERRIOT'

The amazing colour of this Hybrid Tea (opposite) showed
that Pernet-Ducher's capacity to create beautiful roses did not
end with 'Soleil d'Or' and 'Rayon d'Or'. The vivid hues of
'Mme E Herriot' made it very popular, and it was no
surprise when it won a substantial cash prize offered by
London's Daily Mail for the best new rose. A condition of
the prize was that the rose would be called 'Daily Mail' after
the newspaper, but Pernet-Ducher had already named it for
the wife of the mayor of Lyon. A compromise was reached
that it should bear both names in tandem, but this was
unworkable in practice, giving the outcome, in the words of
Jack Harkness, as 'game, set and match to Pernet-Ducher'.

L. Schmidt-Michel.

ROSE.

"HOOSIER BEAUTY."

HODDESDON. MARCH 1931.

Laurence Perugini

'COMTESSE VANDAL'

*Raised by M. Leenders of Tegelen in Holland and
introduced in 1932, this Hybrid Tea (right) has the
excellent form of its grandparent 'Ophelia' but a larger
flower. It was a popular garden rose and is still
available from a few specialist nurseries. A climbing
form was introduced in 1936 from Jackson and
Perkins in the United States.*

'HOOSIER BEAUTY'

*This Hybrid Tea (opposite) originated from F. Dorner
& Son of Lafayette in the United States and was
raised from two popular reds, 'Richmond' x 'Château
de Clos Vougeot'. It was considered 'splendid for
cutting' and that was indeed its true worth, because
the long stems, which looked overlong and unsightly in
a rose bed, were exactly right for the florists' shops.
Moreover, when grown under glass, the blooms reached
a degree of flawless perfection and purity of colour
unmatched in outdoor conditions.*

'ENA HARKNESS'

This Hybrid Tea (above) began life in the Surrey glasshouse of Albert Norman, and he chose to name it after Ena Harkness when her husband Bill declined that honour on the grounds that if a rose was to bear the family name it should be hers. It was introduced in 1946 and was raised from 'Crimson Glory' and 'Southport', inheriting fragrance from the first, unfading scarlet crimson tones from the second, and a tendency for the flowers to nod from both. In 1954 a climbing sport was introduced, enabling the flowers to be appreciated above eye level.

'CHRISTOPHER STONE'

In 1936 Harry Wheatcroft of Nottingham introduced this brilliant crimson fragrant Hybrid Tea (opposite) on a wave of publicity, in tandem with a fine yellow called 'Phyllis Gold'. The flowers of 'Christopher Stone' are pretty at every stage, the short centre petals giving the blooms a pleasingly informal touch as they open out, and its short branching habit make it a very useful bedding rose. It was named for a major radio celebrity in the days before television. The raiser, Herbert Robinson, was a modest nurseryman from Leicestershire.

'LOUIS VAN HOUTTE'

Although not prolific, this 1869 Hybrid Perpetual was capable of 'a fine well-built bloom when you get it good.' A seedling of 'Général Jacqueminot', it was raised by Lacharme of Lyon and named for a famous Belgian horticulturist who lived from 1810 to 1876 and published a mammoth work of reference called Flore des Serres et Jardins de l'Europe.

'JOSEPHINE BRUCE'

The buds of this Hybrid Tea rose (opposite) look black, and they open as deep a crimson as can be imagined, with a beautiful velvety sheen on the petals when they catch the light. Introduced by the firm of Bees of Chester in 1949, who used 'Crimson Glory' as the seed parent, this variety was immediately in great demand. Its poor habit of growth and sparse foliage are drawbacks but it is still widely grown for its rare colour and the beauty of its flowers.

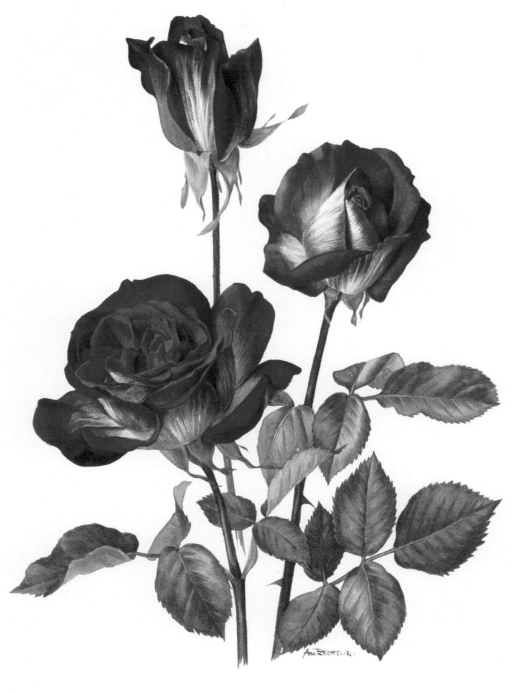

'ROSE GAUJARD'

'Rose Gaujard' (above & opposite) is the offspring of 'Peace' and 'Opera', the latter being light red with large, well-formed flowers. The raiser, Jean Gaujard of Lyon, thought so highly of his new Hybrid Tea that he gave it the family name. It is a distinctive rose, with high-centred flowers that are plum-red on the inside of the broad petals and blush-white on the reverse. Introduced in 1957, it remains a popular rose after nearly fifty years in commerce, thanks to its vigour, continuity of flower and dark shiny foliage.

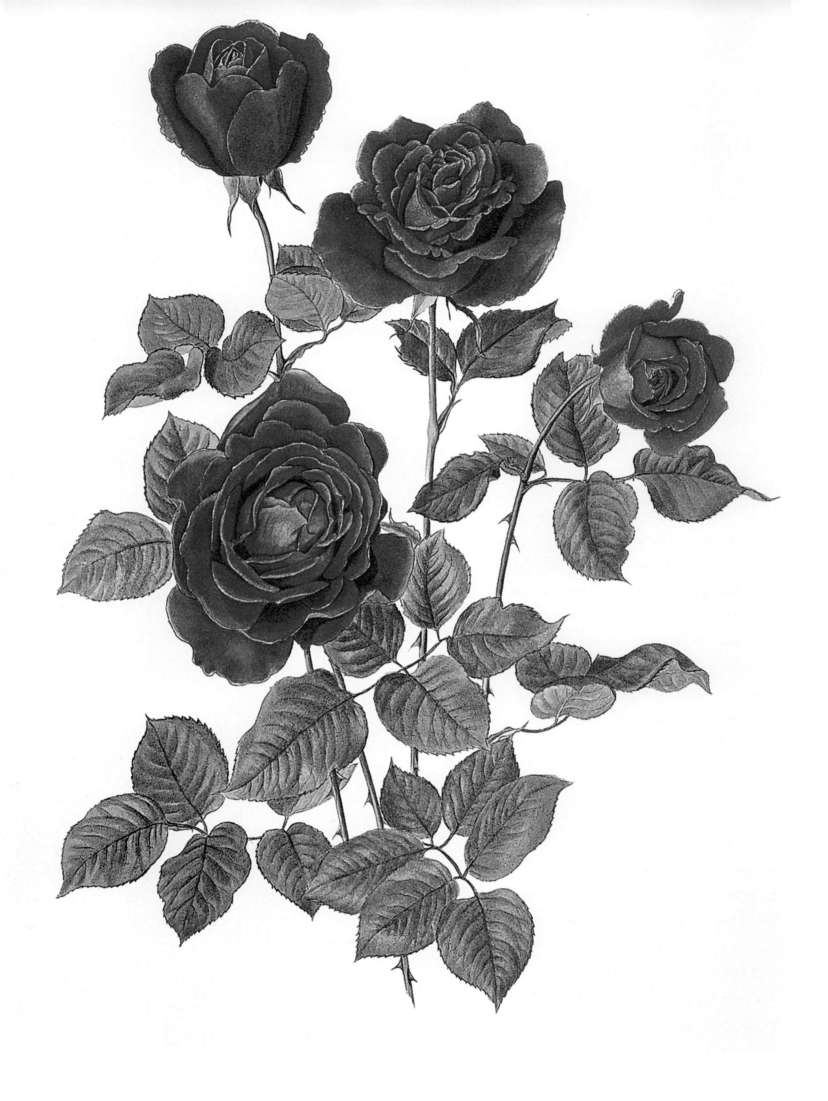

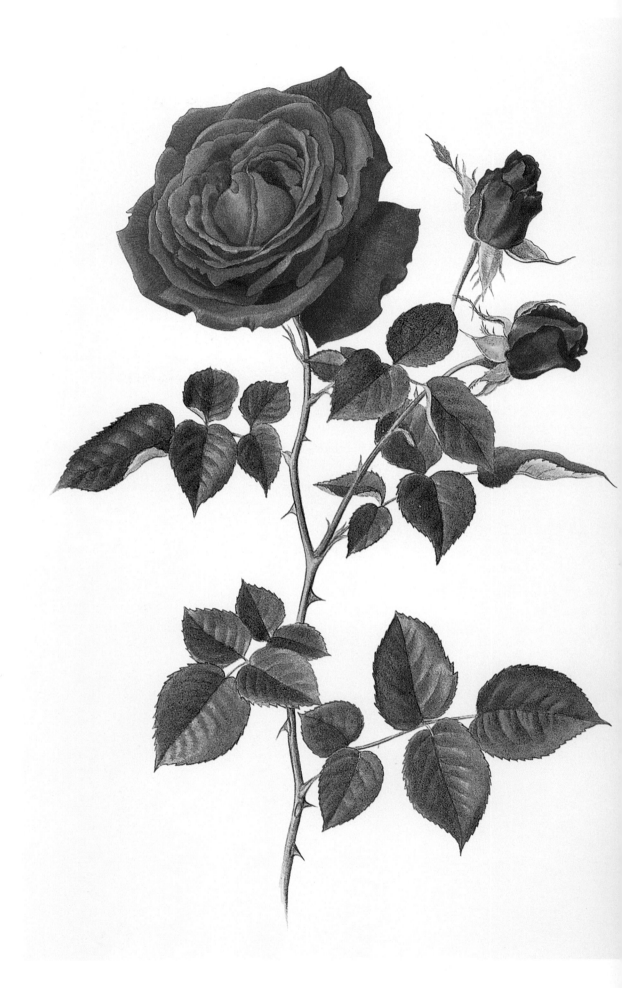

'SUPER STAR'

The pure vermillion tone of this Hybrid Tea (right)
came by way of 'Independence', bred by Wilhelm
Kordes of Germany and introduced in 1951. Despite
the indifferent quality of its flowers, 'Independence' was
used by Mathias Tantau in the creation of 'Super
Star', whose noble flower form owes much to 'Peace'.
'Super Star' was launched in 1960 and its unique
colour was soon appearing in gardens everywhere,
though not always under that name. In the United
States the American growers Star Roses objected to the
use of 'Star' as an infringement of their trade mark,
and the name was changed to 'Tropicana'.

'PINK PEACE'

The name leads one to expect something better, but
this 1959 Hybrid Tea (opposite) somehow lacks refine-
ment and charm. The colour is a hard tone of pink and
difficult to use in any planting scheme, it has foliage
that is dark, leathery and dull, and though it produces
an abundance of sweetly scented flowers of good size
throughout the season on robust plants, the ensemble
evokes no sense of harmony or restfulness.

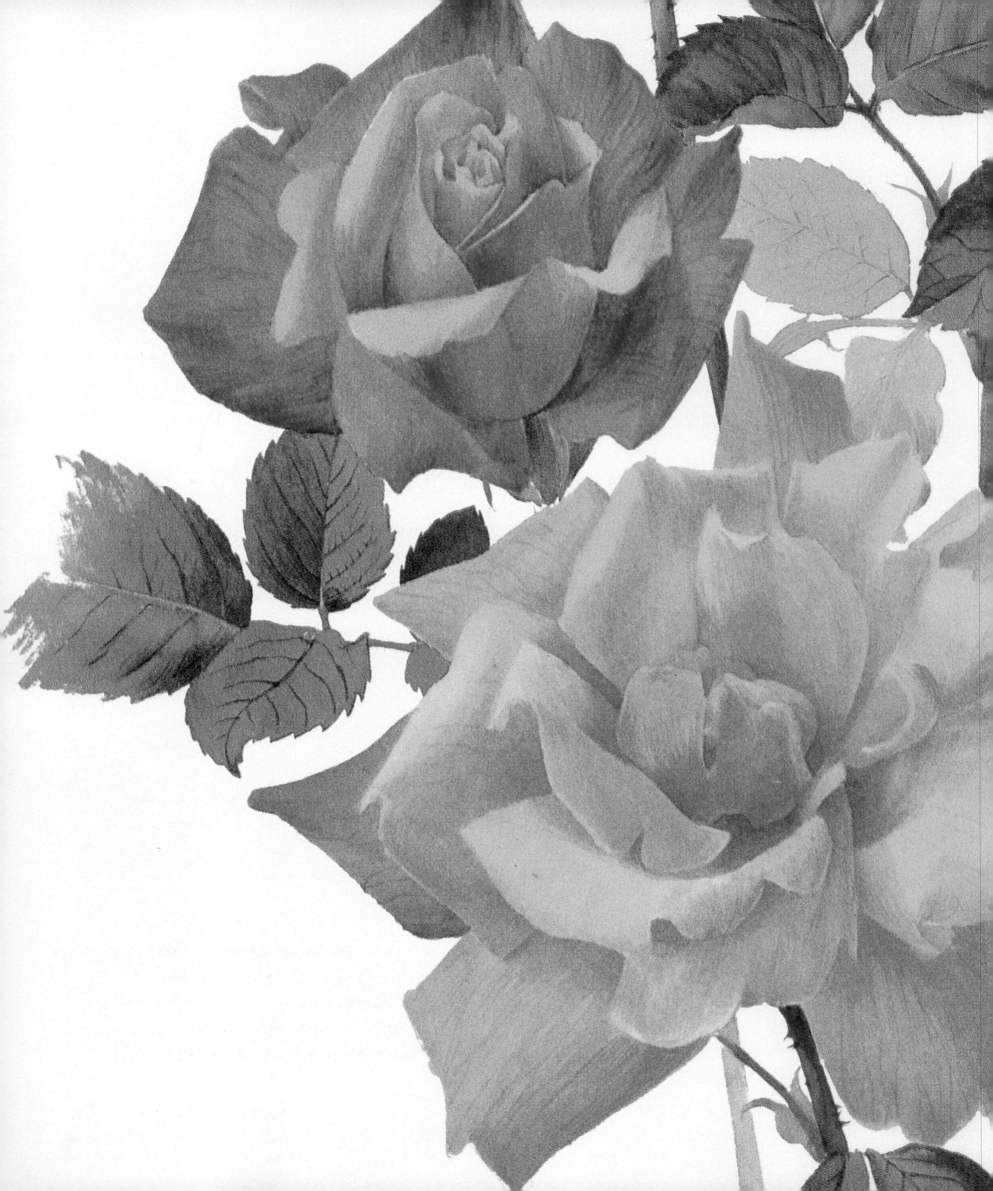

'STERLING SILVER'

In warm climates, or when the rose is cultivated in a glasshouse, the lilac mauve shades of this Hybrid Tea (above) provide a bluish effect, but when it is exposed to cool conditions the petals become an unappealing grey. In the right conditions it can provide a succession of neatly formed flowers on slim firm stems, which are excellent for cutting, as they open slowly and last well. The plant was bred with 'Peace' as the pollen parent, but lacks its vigour and is liable to die back. It was raised by Gladys Fisher of Jackson & Perkins nursery in the United States.

'SUTTERS GOLD'

Treasured for its sweet fragrance and elegant buds, this Hybrid Tea (opposite) came from Herbert Swim of Armstrong Nurseries, California in 1950. Its thin stems, bowing under the weight of medium-sized blooms, give it a frail appearance, but it proves hardy in the garden. The name commemorates the finding of gold on the estate of John Sutter (1803–1880) in California, though it did not benefit him because squatters, cattle thieves and miners soon flocked in and deprived him of his livelihood.

AMTRECHSLIN·

L. Schmidt-Michel

'GRUSS AN AACHEN'

This rose (left) is now classified as a Floribunda, a class that did not exist in 1909 when it was introduced as a Hybrid Tea. Its pale orange buds with red flushes open into scented creamy-blush blooms of rounded form, with their centre petals prettily enfolded – dark foliage sets them off well. The plants are short and compact in growth, and maintain good continuity of flower. The raiser was Philipp Geduldig of Aachen; Kordes of Germany introduced a climbing form in 1937.

'ALLGOLD'

'Few roses have stood the test of time so consistently and so deservedly, for the brilliant, unfading clear deep yellow has yet to be improved.' So wrote the raiser, Edward Le Grice, twenty years after the introduction of his Floribunda 'Allgold' (opposite) in 1956. He was a modest man and he gave a fair appraisal of his rose, for although there are varieties now with fuller flowers and better foliage, the rich yellow petals he achieved have never been improved on.

Allgold

'QUEEN ELIZABETH'

Named in 1952 at the outset of the Queen's long reign, this rose (right) has shown stamina worthy of comparison, for its neatly cupped flowers of cyclamen pink on long upright stems are a familiar sight everywhere roses are grown. It was introduced in 1954 and raised by Walter Lammerts of California. In the United States it has always been known as a Grandiflora because of its flower size and extra vigour, but elsewhere it is accepted as a cluster-flowered Floribunda.

'CIRCUS'

The flowers of 'Circus' (opposite) open yellow, then become tinged with pink and finally carmine red before the petals fall, contriving to look fresh and pretty at each stage. This remarkable ability to change colour ischaracteristic of China roses such as 'Mutabilis', and found muted expression in 'Pinocchio', the pollen parent of the flamboyant 'Circus'. It was a bonus factor for the lucky breeder, Herbert Swim of Armstrong's Nursery in the United States, who introduced this Floribunda in 1956.

'COMPASSION'

The fragrant flowers of this large-flowered climber (above) are rosy-salmon with a hint of apricot.
The name was chosen on behalf of a charity for the disabled. In France it is known as Belle de
Londres. It was raised by Jack Harkness of Hitchin in England and introduced in 1973.

'COCKTAIL'

There may only be five petals in each modestly sized bloom, but the impact made when this climber
(opposite) is in full flower is astonishing. This is true particularly in warmer climates where the leaves
are almost invisible behind a screen of scarlet roses with golden centres.

'ALBERIC BARBIER'

Anne-Marie Trechslin's picture (left) captures the contrasting forms of this rose, with its small yellowish buds opening into neat young flowers and finally into wide-opening blooms shaped like powder puffs and arrayed with scores of dainty narrow petals. The Barbier brothers of Orléans introduced this splendid rambler in 1900. It has R. luciae, *a form of* R. wichurana, *in its parentage.*

'DEBUTANTE' & 'DOROTHY PERKINS'

This plate (opposite) from Journal des Roses *for June 1908 shows two of the earliest and most successful ramblers raised by pollinating the creeping* R. wichurana *species with a Hybrid Perpetual. Both roses are vigorous and hardy and produce masses of bloom on slender trailing stems, usually after midsummer. Of the two, the pale 'Débutante' has more scent and a better health record, and is less well known than it deserves to be. It came from Michael Walsh of Wood's Hole, Massachusetts, and there is a fine planting of it at Mottisfont in Hampshire, England. The darker pink 'Dorothy Perkins' is one of the best known roses, and was named after the two-year-old grand-daughter of Charles Perkins, a principal of the Jackson & Perkins Nursery in Newark, USA.*

Debutante (Mich.)
Walsh. 1901

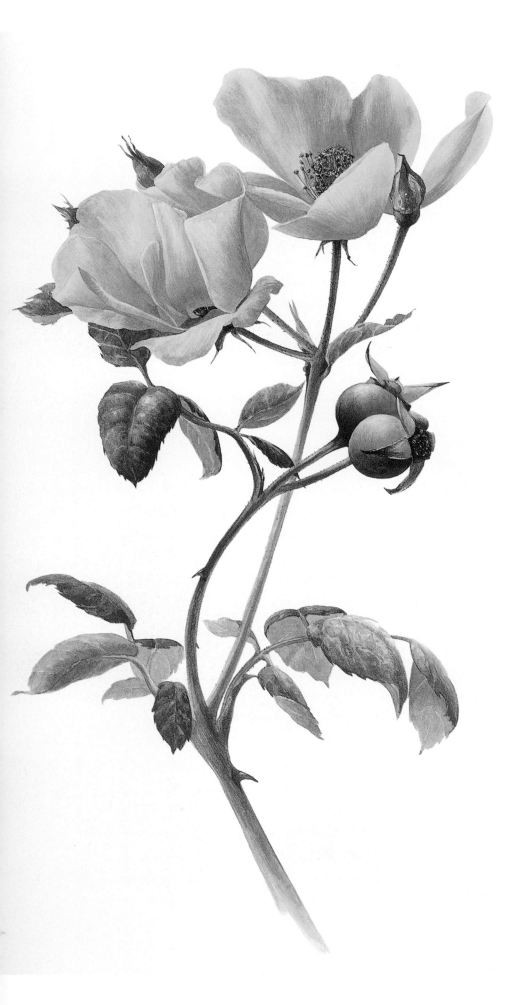

'GOLDEN WINGS'

This vigorous shrub rose (left) has a distinctive character with Foetida and Pimpinellifolia strains in the parentage. There is a happy contrast between the daintiness of its simple, saucer-like yellow blooms with their pleasing fragrance and the prickly twiggy nature of the robust plants. Flowering continues over a long period and this makes it a useful rose for shrub borders. The raiser, Roy Shepherd of Ohio in the United States, was author of History of the Rose, *and must have derived special pleasure from his contribution to that history when he introduced his rose in 1956.*

'JANET'S PRIDE'

Although classified as a Sweet Briar, the foliage of this rose (opposite) has little of the apple-like sweetness of the wild form. It grows into a tall, well-foliaged shrub and produces its pink and white flowers freely in midsummer. Most of the Sweet Briars were raised in the 1890s by Lord Penzance. This one was an English foundling, but there are different accounts of its origin. One version says it was gleaned from a hedge in Cheshire, but the National Rose Society's 1924 Annual states that Mr. Whitwell of Darlington found it in his garden and named it after his wife.

'BLANC DOUBLE DE COUBERT'

The sweetly scented blooms of this rose (above) appear over a long period from early summer to autumn. It was raised by Charles Cochet-Cochet who named it in reference to his village of Coubert in France. He indicated that it was a chance seedling from a 'Rugosa Alba' hip.

'TRIER'

This interesting rose (opposite) was raised by Peter Lambert from a Multiflora rambler which had a yellow Noisette in its ancestry. He named it 'Trier' after his home city. The Reverend Joseph Pemberton noted its distinctive character and used it in the period 1910–1930 to develop the series of delightful free-flowering shrubs known as Hybrid Musks.

'ROSERAIE DE L'HAY'

The sumptuous deep purple-red flowers of this vigorous rose (above) have an intense, almost overwhelming fragrance, which has been likened to 'a rich concentration of cloves and honey'. The variety grew from a seed, probably of R. rugosa rubra, *and was introduced by Jules Gravereaux in 1902 bearing the name of the extensive rosarium created at l'Haÿ, a few miles from Paris.*

'PINK GROOTENDORST'

The daintily fringed flowers of this variety (opposite) are unmistakable, and they can be seen for much of the year. Like many hybrids of Rugosa origin, 'Pink Grootendorst' has inherited repeat-flowering genes, though not in this instance those for fragrance. Introduced in 1923, is a sport of 'F. J. Grootendorst' which was raised from R. rugosa rubra *and a Polyantha rose.*

Constance Spry

Evelyn Campbell.

'CONSTANCE SPRY'

A familiar image of this rose (left) shows it climbing along an old wall in the Hampshire, England garden of Mottisfont, framing a garden seat and making a spectacular display of flower. It was raised by David Austin of Albrighton, England, introduced in 1961 and named in memory of a celebrated artist in flower arrangement.

ROSA **X** JACKSONII

Jackson Dawson, of the Arnold Arboretum in Massachusetts, explored the untapped potential of species roses for breeding. He raised a seedling using two species with good foliage, R. rugosa and R. wichurana, and sent it to Kew in 1897. The resulting rose (opposite) bears bright crimson flowers on low arching plants, with foliage of Wichurana *rather than* Rugosa *character. Unfortunately it was sterile. Some years later a natural cross between the same two species was discovered by James Bowditch in his garden in Connecticut. This rose, known as 'Max Graf', became the first widely used ground-cover rose, and though it rarely sets seed it did so for Wilhelm Kordes who in 1952 raised from it R. kordesii. That rose became the forerunner of a race of hardy climbers.*

20

List of Illustrations

2 'Gardening lady's gauntlet', illustration by Loudon.

3 Detail from *Rosa chinensis* var. *semperflorens*, 'Slater's Crimson China' from *Hort. Schoenbrunensis*, Vol III, p.281, illustration by Nicolas von Jacquin.

4 'Maheka' from *Les Roses* (1817), Vol III, p.78, by Pierre-Joseph Redouté.

7 *Rosa brunonii*, 'La Mortola', illustration by Graham Stuart Thomas.

PREFACE & INTRODUCTION

10 Parkson's Roses, illustration by John Parkinson.

12 'Sorting Roses for Perfume' from Illustrated London News, 4th April 1891.

13 'The Perfume Maker', illustration by Rudolph Ernst.

14 'The Conduit, Ashridge' from *Fragments* by Humphry Repton.

16–17 'The Rosary, Ashridge' from *Fragments* by Humphry Repton.

19 'A Collection of Roses' from the frontispiece to *A Collection of Roses in Nature* (1796–99), by Mary Lawrence.

20 'Madonna of the Rose Bower', illustration by Martin Schongauer.

22 'Lover with Rose' from *Medieval Gardens* (1924) by Sir Frank Crisp.

23 'Garden from Romance of the Rose' from *Medieval Gardens* (1924) by Sir Frank Crisp.

26 'Choosing the Red and White Roses from the Temple Garden', illustration by Henry A. Payne, 1910.

ROSES OF NATURE

30 *Rosa agrestis*, from *The Genus Rosa* (1914), Vol IV, pl 26, by Alfred Parsons.

32–33 *Rosa glauca*, from *Les Roses* (1817), Vol 1, pl 31, by Pierre-Joseph Redouté.

35 *Rosa palustris*, Swamp Rose from *Les Roses* (1817), Vol 1, pl 95, by Pierre-Joseph Redouté.

36 *Rosa candolleana elegans*, Rose

Decandolle from *Les Roses* (1817), Vol II, pl 45, by Pierre-Joseph Redouté.

39 'Ayrshire Splendens', from *Roses et Rosiers* (1872), illustration by Maubert.

40–41 *Rosa palustris*, Swamp Rose from *The Genus Rosa* (1914), Vol II, pl 68 by Alfred Parsons.

42–43 *Rosa corymbifera alba*, from *Die Rosen* (1802–20), pl 27, illustration by Carl Roessig.

44 *Rosa davidii*, Father David's Rose, from *Botanical Magazine* 8679 (1916).

47 *Rosa ecae*, from *Botanical Magazine* 7666.

48 *Rosa elegantula* 'Persetosa', Threepenny Bit Rose from *Botanical Magazine* 8877 (1938), illustration by G. M. Baggs.

51 *Rosa fedtschenkoana*, from *The Genus Rosa* (1914), Vol II, pl 10, by Alfred Parsons.

52 *Rosa gallica pumila*, Rosier d'Amour from *Les Roses* (1817), Vol II, pl 63, by Pierre-Joseph Redouté.

55 *Rosa gigantea*, from *The Genus Rosa* (1914), pl 30, by Alfred Parsons.

56 *Rosa moyesii*, from *The Garden* (1916).

59 *Rosa* x *hardii*, from *The Genus Rosa* (1914), Vol I, pl 7, by Alfred Parsons.

61 *Rosa rugosa*, Japanese Rose from *A Collection of Roses from Nature* (1796–99), pl 42, by Mary Lawrance.

62 *Rosa setigera*, Prairie Rose from *The Genus Rosa* (1914), Vol I, pl 21, by Alfred Parsons.

65 *Rosa stellata*, Gooseberry Rose from *The Genus Rosa* (1914), Vol III, pl 22, by Alfred Parsons.

66 *Rosa* x *reversa*, an original drawing by Edwin D. Smith, (c.1820).

68 *Rosa pimpinellifolia*, Burnet Rose from *A Collection of Roses from Nature* (1796–99), pl 48, by Mary Lawrance.

69 *Rosa wichurana*, Memorial Rose from *The Genus Rosa* (1914), Vol I, pl 19, by Alfred Parsons.

70 *Rosa acicularis*, Alpine Rose from

Rosarum monographia (1820), pl 8, illustration by John Lindley.

71 *Rosa acicularis* var. *nipponensis* from *The Genus Rosa* (1914), Vol II pl 9, by Alfred Parsons.

72 *Rosa arvensis*, Field Rose from *English Botany* (1864), Vol 3, pl 476, illustration by James Sowerby.

73 *Rosa arvensis*, Field Rose from *Roses* (1804), pl 14, by Henry Andrews.

74 *Rosa banksiae normalis*, Mu-Hsiang from *Old Garden Roses* (1975), pl 26, by Anne-Marie Trechslin.

75 *Rosa banksiae alba-plena*, Double White from John Reeves' original drawings, (1812–31), Vol II, pl 33, anonymous Chinese illustrator.

76 *Rosa bracteata*, Macartney Rose from *Botanical Magazine* 1377 (1811), p.68, illustration by Sydenham Edwards.

77 *Rosa bracteata*, Macartney Rose from *Les Roses* (1817), Vol I, pl 35, by Pierre-Joseph Redouté.

78 *Rosa sepium* from *Arbres et Arbustes* (1819), Vol VII, by Henri Duhamel du Monceau, illustration by Pancrace Bessa.

79 *Rosaceae*, an original drawing by Dorothy Martin, (c.1840).

80 *Rosa clinophylla* from *Botanical Register* 739 (1823), illustration by M. Hart.

81 *Rosa clinophylla* from *Les Roses* (1817), Vol I, pl 43, by Pierre-Joseph Redouté.

82 *Rosa persica*, Barberry Rose from *Arbres et Arbustes* (1819), Vol VII, by Henri Duhamel du Monceau, illustration by Pancrace Bessa.

83 *Rosa persica*, Barberry Rose from *Les Roses* (1817), Vol 1, pl 26, by Pierre-Joseph Redouté.

84 *Rosa foetida bicolor* from *Roses et Rosiers* (1872), illustration by Maubert.

85 *Rosa eglanteria* from *Roses* (1805), pl 109, by Henry Andrews.

86–87 *Rosa foetida bicolor* from *The Genus Rosa* (1914), Vol II, pl 9,

by Alfred Parsons.

88 *Rosa foetida* var. *punicea* from *Die Rosen* (1802-20), illustration by Carl Roessig.

89 *Rosa foetida bicolor* from *Roses* (1881), 8th ed., by William Paul, illustration by Walter Hood Fitch.

90 *Rosa foetida* from *A Collection of Roses from Nature* (1796–99), pl 12, illustration by Mary Lawrance.

91 *Rosa foetida* from *The Genus Rosa* (1914), illustration by Alfred Parsons.

92 *Rosa hugonis* from *The Genus Rosa* (1914), pl 279, by Alfred Parsons.

93 *Rosa hugonis* from *Roses* (1962), pl 4, by Eric Bois, illustration by Anne-Marie Trechslin.

94 *Rosa* x *involuta* from an original drawing by John Lindley, (1820).

95 *Rosa* x *involuta*, from an original drawing by Edwin D. Smith, (1809).

96 *Rosa laevigata* from John Reeves' original drawings, (1812–31), Vol II, pl 39, anonymous Chinese illustrator.

97 *Rosa laevigata* from *Botanical Register* 1922 (1837), illustration by Sarah Drake.

98 *Rosa multiflora* from *The Genus Rosa* (1914), Vol I, pl 6, by Alfred Parsons.

99 *Rosa nitida* from *The Genus Rosa* (1914), Vol I, pl 215, by Alfred Parsons.

100 *Rosa pendulina* from *Hort. Schoen. Fl. Austr.*, Vol III, pl 279, illustration by Nicolas von Jacquin.

101 *Rosa pendulina* from *A Collection of Roses from Nature* (1796–99), pl 9, by Mary Lawrance.

102 *Rosa pimpinellifolia* var. *altaica* from *The Genus Rosa* (1914), Vol III, pl 15, by Alfred Parsons.

103 *Rosa pimpinellifolia* (above left) from *Die Rose* (1799), pl 9, illustration by Carl Roessig, *Rosa pimpinellifolia* (above right) an original drawing by John Lindley, (1820).

104 *Rosa rugosa* from *Botanical Register* (1819), illustration by John Lindley.

105 *Rosa rugosa* from *Flora japonica* (1835), Vol I, pl 28, illustration by Philipp von Siebold.
106 *Rosa rugosa alba* from *The Garden* (1876), Vol IX, p.452, illustration by H. Hyde.
107 *Rosa rugosa*, from *A Collection of Roses from Nature* (1796–99), pl 45, by Mary Lawrance.
108 *Rosa sempervirens* from *Roses* (1805), pl 89, by Henry Andrews.
109 *Rosa sempervirens* from *A Collection of Roses from Nature* (1796–99), pl 45, by Mary Lawrance.
110 *Rosa sericea pteracantha* from *Old Garden Roses* (1975), pl 34, by Anne-Marie Trechslin.
111 *Rosa sericea pteracantha* from *Botanical Magazine* 8218 (1908), illustration by John Fitch.
112 *Rosa virginiana* from *The Genus Rosa* (1914), Vol II, pl 197, by Alfred Parsons.
113 *Rosa virginiana* from *Les Roses* (1817), Vol I, pl 45, by Pierre-Joseph Redouté.

ROSES OF HISTORY
116 Great Maiden's Blush from *Roses* (1805), pl 16, by Henry Andrews.
119 *Rosa x damascena bifera*, Autumn Damask from *Die Rosen* (1802–20), pl 42, illustration by Carl Roessig.
121 *Rosa x damascena trigintipetala*, 'Kazanlik' from *Old Garden Roses* (1975), pl 12, by Anne-Marie Trechslin.
122 Perpetual White Moss from *The Rose Garden* (1888), 9th ed., pl 10, by William Paul.
125 *Rosa gallica officinalis*, Apothecary's Rose from *Arbres et Arbustes* (1819), Vol VII, pl 8, by Henri Duhamel du Monceau, illustration by Pancrace Bessa.
126 *Rosa x* 'Alba Semiplena', Double White from *Arbres et Arbustes* (1819), Vol VII, pl 9, by Henri Duhamel du Monceau, illustration by Pancrace Bessa.

129 *Rosa x richardii*, Holy Rose, from *The Genus Rosa* (1914), Vol II, pl 337, by Alfred Parsons.
130 Portland Rose from *Les Roses* (1817), Vol I, pl 104, by Pierre-Joseph Redouté.
133 *Rosa x centifolia*, 'Petite de Hollande', 'Petit Junon de Hollande' from *A Collection of Roses from Nature* (1796–99), pl 55, by Mary Lawrance.
134 *Rosa foetida persiana*, Persian Yellow from *Belle Roses* (1845–1854), pl 336, illustration by Annica Bricogne.
137 Chinese Garden Rose from John Reeves' original drawings, (1812–31), Vol I, pl 22, anon. Chinese illustrator.
138 *Rosa chinensis* var. *semperflorens*, Slater's Crimson China' from *Botanical Magazine* 284 (1794), illustration by William Curtis.
141 'Lawranciana Pompons' from *Belle Roses* (1846), pl 14, illustration by Annica Bricogne.
142 *Rosa chinensis* 'Mutablis', Tipo Ideale from *The Genus Rosa* (1914), Vol I, pl 85, by Alfred Parsons.
145 *Rosa x odorata*, 'Hume's Blush Tea-Scented' from *Les Roses* (1817), Vol I, pl 61, by Pierre-Joseph Redouté.
146 'Turner's Crimson Rambler' from *Journal des Roses* (Sept. 1893), p.136, illustration by P. Hauber.
149 *Rosa multiflora* 'Carnea', Lotus Rose from *Arbres et Arbustes* (1819), Vol VII, pl 17, by Henri Duhamel du Monceau, illustration by Pancrace Bessa.
151 *Rosa banksiae lutescens* from *Botanical Register* 1105 (1827).
152 Fortune's Double Yellow from *The Genus Rosa* (1914), Vol I, pl 36, by Alfred Parsons.
155 *Rosa roxburghii*, Chestnut Rose from John Reeves' original drawings, (1812–31), pl 4, anon. Chinese illustrator.
156 'Celsiana' from *Les Roses* (1817),

Vol II, pl 53, by Pierre-Joseph Redouté.
157 *Rosa x damascena* var. *versicolor*, York & Lancaster from *A Collection of Roses from Nature* (1796–99), pl 10, by Mary Lawrance.
158 'Rubrotincta' from *The Genus Rosa* (1914), pl 125, by Alfred Parsons.
159 *Holoserica Duplex* from *Die Rose* (1802), pl 16, illustrated by Carl Roessig.
160 *Rosa gallica* 'Versicolor', Rosa Mundi from *A Collection of Roses from Nature* (1796–99), pl 13, by Mary Lawrance.
161 *Rosa gallica* 'Versicolor', Rosa Mundi from *Roses* (1805), pl 46, by Henry Andrews.
162 'De van Eeden' from *Les Roses* (1817), Vol II, pl 18, by Pierre-Joseph Redouté.
163 'Stapeliae Flora' from *Les Roses* (1817), Vol III, pl 26, by Pierre-Joseph Redouté.
164–165 'Double Velvet' from *A Collection of Roses from Nature* (1796–99), pl 2, by Mary Lawrance.
166–167 *Rosa x centifolia*, 'Tuscany' from *Roses* (1805), pl 43, by Henry Andrews.
168 Giant Rose from *A Collection of Roses from Nature* (1796–99), pl 49, by Mary Lawrance.
169 'Maheka' from *Les Roses* (1817), Vol III, pl 153, by Pierre-Joseph Redouté.
170 'Cardinal de Richelieu' from *Old Garden Roses* (1975), pl 5, by Anne-Marie Trechslin.
171 *Rosa x francofurtana*, 'Turbinata' from *Les Roses* (1817), Vol I, pl 127, by Pierre-Joseph Redouté.
172 *Rosa x alba*, Single White Rose from *A Collection of Roses from Nature* (1796–99), pl 37, by Mary Lawrance.
173 *Rosa x* 'Alba Maxima', White Rose of York from *Arbres et Arbustes* (1819), Vol VII, p.16, fig. 1, by Henri Duhamel du Monceau, illustration by Pancrace Bessa.
174–175 *Rosa x* 'Alba Maxima', White

Rose of York from *Die Rose* (1802), pl 15, illustration by Carl Roessig.
176 'Great Maiden's Blush' from *Les Roses* (1817), Vol I, pl 36, by Pierre-Joseph Redouté.
177 'Small Maiden's Blush' from *Die Rose* (1802), pl 23, illustration by Carl Roessig.
178 *Rosa moschata*, Musk Rose from *Les Roses* (1817), Vol I, p.33, by Pierre-Joseph Redouté.
179 *Rosa moschata*, Musk Rose from *Roses* (1805), pl 93, by Henry Andrews.
180 *Rosa x centifolia*, Cabbage Rose from *Les Roses* (1817), p.189, by Pierre-Joseph Redouté.
181 *Rosa x centifolia*, Cabbage Rose from *Les Roses* (1873), pl 15, by Jamain & Forney, illustration by F. Grobon.
182 *Rosa x centifolia muscosa*, Common Moss, from *Fiori, Frutti & Agrumi*, illustration by Giovanni Geri.
183 *Rosa x centifolia muscosa*, Common Moss from *Roses* (1962), pl 3, by Eric Bois, illustration by Anne-Marie Trechslin.
184 *Rosa x centifolia muscosa*, Single Moss, illustration by Sydenham Edwards.
185 *Rosa x centifolia muscosa*, Common Moss from *A Collection of Roses from Nature* (1796–99), pl.14, by Mary Lawrance.
186 *Rosa x centifolia muscosa alba*, Double White Moss from *Botanical Register* 102 (1816), illustration by Sydenham Edwards.
187 *Rosa x centifolia cristata*, Crested Moss from *Botanical Magazine* 3475 (1836), illustration by Miss Adams.
188 *Rosa x centifolia muscosa alba*, 'White Bath' from *Les Roses* (1817), Vol I, pl 87, by Pierre-Joseph Redouté.
189 'Crimson Globe' from William Paul's catalogue, 1890.
190 *Rosa x centifolia* var. *pomponia*, 'Rose de Meaux' from *Les Roses* (1817), Vol I, pl 65, by Pierre-Joseph Redouté.

191 *Rosa* x *centifolia parvifolia*, 'Lesser de Meaux' from *A Collection of Roses from Nature* (1796–99), pl 50, by Mary Lawrance.

192–3 *Rosa* x *centifolia* var. *pomponia*, 'Rose de Meaux' from *The Genus Rosa* (1914), Vol III, pl 119, by Alfred Parsons.

194 *Rosa hemisphaerica*, Yellow Provence Rose from *A Collection of Roses from Nature* (1796–99), pl 77, by Mary Lawrance.

195 *Rosa hemisphaerica*, Yellow Provence Rose from *Les Roses* (1817), Vol I, pl 29, by Pierre-Joseph Redouté.

196 *Rosea lutea* var. *hoggii*, 'Harisonii' from *The British Flower Garden* (1838), Vol I, pl 410, illustration by J.T Hart.

197 'Marbled Scots' from *A Collection of Roses from Nature* (1796–99), pl 78, by Mary Lawrance.

198 'Stanwell Perpetual' from *Old Garden Roses* (1975), pl 37, by Anne- Marie Trechslin.

199 'Stanwell Perpetual' from *The Genus Rosa* (1914), Vol III, pl 3, by Alfred Parsons.

200 *Rosa chinensis* var. *semperflorens*, 'Slater's Crimson China' from *Botanical Magazine 284* (1794), illustration by William Curtis.

201 *Rosa chinensis* var. *semperflorens*, 'Slater's Crimson China' from *Die Rose* (1802–20), pl 12, illustration by Carl Roessig.

202–3 *Rosa chinensis* var. *semperflorens*, 'Slater's Crimson China' from *The Genus Rosa* (1914), Vol I, pl 89, by Alfred Parsons.

204 *Rosa chinensis* var. *semperflorens*, 'Slater's Crimson China' from *Roses* (1805), pl 72, by Henry Andrews.

205 *Rosa chinensis* var. *semperflorens*, 'Slater's Crimson China', from *Hort. Schoenbrunensis* (1798), Vol III, p.281, illustration by Nicolas von Jacquin.

206 Old Blush from *Arbres et Arbustes* (1819), Vol VII, pl 18, by Henri Duhamel du Monceau, illustration by Pancrace Bessa.

207 Old Blush from *The Genus Rosa* (1914), Vol I, pl 26, by Alfred Parsons.

208 Old Blush from *Die Rosen* (1802–20), illustration by Carl Roessig.

209 Old Blush from *Les Roses* (1817), Vol I, pl 51, illustration by Pierre-Joseph Redouté.

210–211 Bengal Centfeuilles from *Les Roses* (1817), Vol I, pl 49, by Pierre-Joseph Redouté.

212 *Rosa viridiflora*, Green Rose from *Roses et Rosiers* (1872), pl 19, illustration by Annica Bricogne.

213 *Rosa viridiflora*, Green Rose from *Flore des Serres* (1856), pl 1136.

214 *Rosa multiflora platyphylla*, 'Seven Sisters' from *Botanical Register* 1372 (1830), Vol 16, illustration by M. Hart.

215 *Rosa multiflora platyphylla*, 'Seven Sisters' from *Les Roses* (1817), Vol II, pl 69, by Pierre-Joseph Redouté.

216–217 *Rosa Banksiae lutea*, Banksian Yellow from John Reeves' original drawings, (1812–31), Vol I, pl 33, illustration by Wang Heang Kow.

218 *Rosa* x *fortuniana*, Banksian Epineux from *Roses et Rosiers* (1872), pl 21, illustration by Annica Bricogne.

219 *Rosa* x *fortuniana*, Banksian Epineux from *The Genus Rosa* (1914), Vol I, pl 36, by Alfred Parsons.

220 Fortune's Double Yellow from *Botanical Magazine* 4679 (1852), illustration by Walter Hood Fitch.

221 Fortune's Double Yellow from *Rosengarten* (1866) by H. Nestel, illustration by Anna Peters.

222 *Rosa roxburghii*, Chestnut Rose from *Botanical Magazine* 3490 (1836), illustration by Miss Adams.

223 *Rosa roxburghii*, Chestnut Rose from *The Genus Rosa* (1914), Vol II, pl 135, by Alfred Parsons.

ROSES BY DESIGN

226 *Rosa* x *anemonoides*, Anemone Rose from *The Genus Rosa* (1914), Vol I, pl 34, by Alfred Parsons.

229 'Archduke Charles' from *The Beauties of the Rose* (1850), pl 11, illustration by Henry Curtis.

230 *Rosa* x *noisettiana*, 'Blush Noisette' from *Les Roses* (1817), Vol II, pl 77, by Pierre-Joseph Redouté.

233 'Bourbon Queen' from *Rosen Album* (1868–75), illustration by Franz Komlosy.

234 'Félicité-Perpétue' from *Rosenzeitung* (1890), p.80, illustration by L. Schmidt-Michel.

237 'Gloire des Rosomanes' from *Belle Roses* (1845–54), pl 12, illustration by Annica Bricogne.

238 'Soleil d'Or' from *Journal des Roses* (1900), p.87.

241 'Cécile Brunner & Perle d'Or' from *Old Garden Roses* (1975), pl 6, by Anne-Marie Trechslin.

242 'Frensham' from *Roses* (1962), pl 18, by Eric Bois, illustration by Anne-Marie Trechslin.

245 'New Dawn' from *Roses* (1962), pl 26, by Eric Bois, illustration by Anne-Marie Trechslin.

247 'Etoilé' from *Les Roses* (1817), Vol III, pl 41, by Pierre-Joseph Redouté.

248–249 *Rosa* x *centifolia* 'Purpurea' from *Roses* (1805), pl 35, by Henry Andrews.

250 'Calocarpa' from *The Genus Rosa* (1914), Vol II, pl 189, by Alfred Parsons.

251 'Général Fabvier' from *Belle Roses* (1845–54), pl 21, illustration by Annica Bricogne.

252 'Cramoisi Supérieur' from *The Beauties of the Rose* (1850), Vol II, pl 11, illustration by Henry Curtis.

253 'Cramoisi Supérieur' from *Journal des Roses* (Aug. 1883), p.119.

254 'Ternauxiana à Fleurs Rouges' from *Les Roses* (1817), Vol III, pl 103, by Pierre-Joseph Redouté.

255 'Desprez à Fleur Jaune' from *Belle Roses* (1845–54), pl 35, illustration by Annica Bricogne.

256 'Lamarque' from *Journal des Roses* (July 1905), p.110.

257 'Lamarque' from *Belle Roses* (1845–54), pl 30, illustration by Annica Bricogne.

258 'Aimée Vibert' from *Belle Roses* (1845–54), pl 26, illustration by Annica Bricogne.

259 'Aimée Vibert' from *Rosen Album* (1868–75), pl 86, illustration by Franz Komlosy.

260 'Hermosa' from *Belle Roses* (1845–54), pl 38, illustration by Annica Bricogne.

261 'Louise Odier' from *Belle Roses* (1845–54), pl 40, illustration by Annica Bricogne.

262 'Madame Isaac Pereire' from *Le Livre d'Or des Roses* (1904), pl. 44.

263 'Madame Isaac Pereire' from *Journal des Roses* (1893), p.52, illustration by L. Descamps-Sabouret.

264–5 'Variegata de Bologna' from *Old Garden Roses* (1975), pl 38, by Anne-Marie Trechslin.

266 'Zéphirine Drouhin' from *Old Garden Roses* (1975), pl 40, by Anne-Marie Trechslin.

267 'Diamond Jubilee' from *Glory of the Rose* (1965), pl 6, illustration by Lotte Gunthart.

268–9 'Lauré Davoust' from *Belle Roses* (1845–54), pl 20, illustration by Annica Bricogne.

270 'Mme de Sancy de Parabère' from *Journal des Roses* (Aug. 1885), p.124.

271 'Rose du Roi' from *Belle Roses* (1845–54), pl 39, illustration

by Annica Bricogne.

272 'Madame Hardy' from *Old Garden Roses* (1975), pl 18, illustration by Anne-Marie Trechslin.

273 'Marquise Boccella' from *Belle Roses* (1845–54), pl 8, illustration by Annica Bricogne.

274 'Baronne Prévost' from *Journal des Roses* (Oct. 1879), pl 152.

275 'Jules Margottin' from *Belle Roses* (1845–54), pl 44, illustration by Annica Bricogne.

276 'Duchess of Bedford' from William Paul's catalogue, (1890).

277 'Duchess de Morny' from William Paul's catalogue, (1890).

278 'Adam' from *Rosen Album* (1868–75), pl 86, illustration by Franz Komlosy

279 'Adam' from *Belle Roses* (1845–54), pl 26, illustration by Annica Bricogne.

280 'Safrano' from *Belle Roses* (1845–54), pl 19, illustration by Annica Bricogne.

281 'Sombreuil' from *Rosengarten* (1867), pl 9, by H. Nestel, illustration by Anna Peters.

282 'Le Pactole' from *Belle Roses* (1845–54), pl 42, illustration by Annica Bricogne.

283 'Vicomtesse de Cazes' from *Beauties of the Rose* (1850), Vol I, p.25, illustration by Henry Curtis.

284 'Elisa Sauvage' from *Beauties of the Rose* (1850), pl 9, illustration by Henry Curtis.

285 'La Boule d'Or' from *Rosengarten* (1866), pl 7, by H. Nestel, illustration by Anna Peters.

286 'Moiré' from *Belle Roses* (1845–54), pl 31, illustration by Annica Bricogne.

287 'Madame Lambard' from The Rose Garden (1888), 9th edition, pl 19, by William Paul, illustration by Walter Hood Fitch.

288 'Princesse Adélaide' from *Belle Roses*

(1845–54), pl 7, illustration by Annica Bricogne.

289 'Lady Hillingdon' from *Old Garden Roses* (1975), pl 13, by Anne-Marie Trechslin.

290 'Perle des Jardins' from *The Rose Garden* (1888), 9th ed., pl 20, by William Paul, illustration by Walter Hood Fitch.

291 'Maréchal Niel' from *Die Rose* (1880), p.144, illustration by Th. Nietner.

292 'La France' from *Die Rose* (1891), pl 3, illustration by Alfred Birkinger.

293 'La France' from *Die Rose* (1880), p.96, illustration by Th. Nietner.

294 'Frau Karl Drushki' from *Old Garden Roses* (1975), pl 9, by Anne-Marie Trechslin.

295 'Frau Karl Drushki' from *Roses* (1962), pl 18, by Eric Bois, illustration by Anne-Marie Trechslin.

296 'Socrates' from *Rosen Album*, pl 57, illustration by Franz Komlosy.

297 'Ophelia' from *Old Garden Roses* (1975), pl 22, by Anne-Marie Trechslin.

298 'Rayon d'Or' from *Journal des Roses* (Aug. 1910), p.124, illustration by M. Brun.

299 'Mme. E. Herriot' from *Rosenzeitung* (1917), pl 1, illustration by L. Schmidt-Michel.

300 'Hoosier Beauty' from an original drawing by Lawrence Perugini, 1931.

301 'Comtesse Vandal' from *Glory of the Rose* (1965), pl 16, illustration by Lotte Gunthart.

302 'Christopher Stone' from *Glory of the Rose* (1965), pl 28, illustration by Lotte Gunthart.

303 'Ena Harkness' from *The Rose Today* (c.1970), pl 14, illustration by Johanna Prins.

304 'Josephine Bruce' from *Glory of the Rose* (1965), pl 11, illustration by Lotte Gunthart.

305 'Louis van Houtte' from *The Rose*

*Garden (*1888), 9th edition, pl 14 by William Paul, illustration by Walter Hood Fitch

306 'Rose Gaujard' from *Glory of the Rose* (1965), pl 36, illustration by Lotte Gunthart.

307 'Rose Gaujard' from *Roses* (1962), pl 146, by Eric Bois, illustration by Anne-Marie Trechslin.

308 'Pink Peace' from *Glory of the Rose* (1965), pl 25, illustration by Lotte Gunthart.

309 'Super Star' from *Roses* (1962), pl 54, by Eric Bois, illustration by Anne-Marie Trechslin.

310 'Sutter's Gold' from *Roses* (1962), pl 19, by Eric Bois, illustration by Anne-Marie Trechslin.

311 'Sterling Silver' from *Glory of the Rose* (1965), pl 9, illustration by Lotte Gunthart.

312 'Gruss an Aachen' from *Rosenzeitung* (1912), p.1, illustration by L. Schmidt-Michel.

313 'Allgold' from *The Rose Today* (c.1970), p.1, illustration by Johanna Prins.

314 'Circus' from *Glory of the Rose* (1965), pl 8, illustration by Lotte Gunthart.

315 'Queen Elizabeth' from *Glory of the Rose* (1965), pl 29, illustration by Lotte Gunthart.

316 'Compassion' from *Royal Roses of London* (1992), pl 41, illustration by Coral Guest.

317 'Cocktail' from *Roses* (1962), pl 92, by Eric Bois, illustration by Anne-Marie Trechslin.

318 'Albéric Barbier' from *Old Garden Roses* (1975), pl 1, by Anne-Marie Trechslin.

319 'Débutante & Dorothy Perkins' from *Journal des Roses* (Jun. 1908), pl 93, illustration by L. Schmidt-Michel.

320 'Golden Wings' from *Royal Roses of London* (1992), pl 21, illustration by Coral Guest.

321 'Janet's Pride' from *The Genus Rosa* (1914), Vol IV, pl 24, by Alfred Parsons.

322 'Trier' from *Rosenzeitung* (1907), p.49, illustration by L. Schmidt-Michel.

323 'Blanc Double de Coubert' from *Old Garden Roses* (1975), pl 3, by Anne-Marie Trechslin.

324 'Roseraie de l'Haÿ' from *Royal Roses of London* (1992), pl 37, illustration by Coral Guest.

325 'Pink Grootendorst' from *Roses* (1962), pl 22, by Eric Bois, illustration by Anne-Marie Trechslin.

326 'Constance Spry' from an original drawing by Evelyn Campbell, (c.1970).

327 *Rosa x jacksonii* from *The Genus Rosa* (1914), Vol I, pl 20, illustration by Alfred Parsons.

ACKNOWLEDGMENTS

336 'Gardens with Fences' from *Medieval Gardens* by Sir Frank Crisp.

Index

Page numbers in italics refer to illus-
trations. Captions are indexed as text.

Abbotts Ann, Hampshire 21
Alcuin 16
Allen, E.F. 43
Ambrose, Saint 24
American Rose Annual 261
Andrews, Henry 72, 74, 140, 160,
165, 248
Aristophanes 297
Arnold Arboretum, Boston 50
Ashridge, Hertfordshire *14*, 15, 16,
16-17
attar 13, 118–20
Austin & McAslan 196
Austin, David 246, 326
Avesta 12

Banerjee, Shri B.K. 49
Banks, Sir Joseph 38, 74, 148
Beales, Peter 43
Beauties of the Rose 228
Bees of Chester 305
Bekler, Jelena de 57
Belles Roses 140, 289
Benedict, Saint 15
Bennett, Henry 239
Bérenger, Raymond, IV, Count of
Provence 25
Bermuda Rose Society 45
Besler, Basilius 173
Bible 12, 109
Bideford 12
Bizot 266
Boerner, Eugene 243, 266
Bonnet, M. 270
Book of the Rose 147
Borromeo, Prince Giberto 143
Borromeo, Prince Vitalino IX 13
Botanical Magazine 200, 201, 220
Botanical Register 81, 96
Botticelli, Sandro 21
Boulenger, Georges 62
Boursault, Jean-François 235–6
Bowdich, James 326
Bowles, E.A. 50-3
Bréon, Jean-Nicolas 232
Bronzino, Angelo 139
Brougham, Lord 227
Brown, Robert 46, 135
Bruant, François-René 251
Brunner, Ulrich 240
Buist, Robert 269
Byron, Lord 24

Candolle, Augustin-Pyramus de 37

Carla Fineschi Botanical Rose
Garden, Cavriglia 235
Cartier, Dr 210
Cels, Jacques-Martin 157
Champneys, John 231
Charlemagne 16–18
Charles, Archduke of Austria 228
Chin-Nun, Emperor 135
China 135–54
Cleopatra 15
Cochet nursery 274
Cochet-Cochet, Charles 323
Coles, Sarah 21
*Collection of Roses from Nature (Various
Kinds of Roses Cultivated in England)*
18, 60, 140
Collett, Sir Henry 54
Colmar 21
Conard-Pyle nursery 93, 240
Confucius 136
Coquereau, M. 252
Corrévon, Henri 140, 143
Couturier 252
Cowper, William 24
Crépin, 50, 64
Crisp, Sir Frank 22
Cromwell, Thomas 128
Curtis, Henry 228
Curtis, William 200, 285

Daily Mail 298
David, Père Armand 45, 49–50
Dawson, Jackson 326
Delavay, Jean-Marie 63
Desportes, 127
Desprez, Jean 235, 255, 272, 274
Dorner, F., & Son 301
Dot, Pedro 57
DuPont, André 131, 132, 227-8
Dubreuil, Francis 240
Ducher, Jean-Claude 240
Duhamel, 207
Durand, Jacques 232

Ecoffay, M. 270
Edmund, Earl of Lancaster 25–7
Edward I 25
Edward IV 27
Edward VII 261
Eleanor of Provence 25
England, rose of 25–7
Ephesus 11
Ernst, Rudolph 13
Evans, Thomas 148

Fa Tee nursery 143–4
Fagan, Gwen 266

Farrer, Reginald 50
Fatima 22
Feast, Samuel and John 62
Fedtschenko, Alexei, Olga and Boris 53
Felicitas, Saint 21
Fisher, Gladys 311
Flora Ovvero Cultura di Fiori 139
Forrest, George 58
Fortune, Robert 150, 153, 218
fossils 31, 33, 117
Foster-Melliar, Rev. Andrew 147, 290
Franchet, Père 67

Garden Book 127
Gardeners' Chronicle 48
Gaujard, Jean 307
Geduldig, Philipp 312
Gee, Mary 148
genus 31–3
Genus Rosa 40, 67, 98, 153
Gerarde, John 11, 49, 91, 117, 124,
128, 165, 173
germination 33
Giovanni de Paolo 21
Giraldi, Father 93
gods and goddesses 11, 12, 15, 18, 21
Gondwanaland 33
grafting 228
Gravereaux, Jules 324
Greville, Hon. Charles 215
Guadeloupe 22
Guillot, Jean-Baptiste 228, 239, 293
Guillot nursery 240

habitats 33–7
Hakluyt, Richard 118
Hanbury, Sir Thomas 6
Hanmer, Sir Thomas 127, 139
Hardy, Alexandre 228, 232, 289
Hardy, Julien-Alexandre 59
Harison, Rev. George F. 196
Harkness, Bill 243, 303
Harkness, Jack 34, 46, 62, 298, 316
Hawara, Egypt 128
Heliogabulus, Emperor 15
Henderson, John 290
Henry, Augustine 48
Henry III 25
Henry VI 27
Henry VII 27
Herball 117, 124, 128, 165, 173
Herculaneum 123–4
Heritage of Roses 227
Herodotus 118
Herrmann, Johann 38
Hildesheim Cathedral 18
hips 34–7, 46

History of the Rose 320
Hooker, Sir Joseph 49
Howrah Botanic Garden, Calcutta 210
Hsieh Lung-yiu 136
Hulthermia persica see Rosa persica
Hume, Sir Abraham 144
hybridising 227

Illustrated London News 13

Jackson and Perkins 301
Jacquemin, Mme 123
Jacques, Antoine 227, 232, 235
Jahangir, Emperor 24
James II 175
Jamin, M. 270
Japan 144–8
Jefferson, Thomas 45
Jenner, Robert 147
Josephine, Empress 64, 131, 132, 162,
170, 228
Journal des Roses 318

Kennedy, John 228
Kerr, William 74, 148, 150
Kew Gardens, London 46, 50
Kingsley, Rose 150
Kisai of Mervi 31
Knossos, Crete 11
Koelreuter, Joseph 227
Komlosy, 279
Kordes, Wilhelm 243, 309, 312, 326

Lacharme, François 287
Laffay, Jean 228, 251, 269, 274
Lambert, Peter 240, 294, 323
Lammerts, Walter 315
Lancastrian royal house 25, *26*, 27
Latin names 31
Laurenson, T.A. 294
Laurentia 33
Lawrance, Mary 18, 60, 140, 157,
165, 168, 191
Le Grice, Edward 46, 243, 312
Le Rouge, 144
l'Ecluse, Charles de 124, 131, 132, 170
Lee, James 135
Lee and Kennedy 53, 60
Leenders, M. 301
Lelieur, Comte 270
Lens, Louis 64
Levet, Antoine 290
Linaker, Dr 118
Lindley, John 31, 46, 70, 103, 154
Linnaeus 34, 38, 168
literature, roses in 11–12, 22–4
Livingstone, John 143–4

Lo-yang 136
Lochner, Stefan 22
Lodi and Bonfiglioli 265
Louis the Pious 18
Louis XIII 124, 170
Louis XIV 123, 127
Louis XVIII 270
Louis-Philippe, King 235
Lourdes 22
Lowe, Joseph 289
Luini, Bernardino 22

Macartney, Lord 45
Madonna of the Rose Bower 20, 21
'Maiden's crown' 21
Malcolm, William 135
La Malmaison 228
Mansuino, Quinto 57
Manual of Roses 231
Manyoshu 144
Marcheseau 261
Margottin, Jacques-Julien 140, 261,
274, 285
Mark Antony 15
Megginch Castle, Scotland 45
Meilland, François 240
Meyer, F. N. 63
Miellez, 282
mildew 53, 54
Miller, Philip 38, 88, 165
Milton, John 24
Minden Rose 25
Monardes, Nicholas 118
monasteries 15–18
Moore, Thomas 208
Mortimer, Anne 27
Moyes, Rev. J. 58
Mulchinock, William 15
Mulligan, Brian 58

Napoleon Bonaparte 228
nationhood, symbol of 25
Nees, Dr 170
Nero 15
Nestel, 220, 285
Neumann, Joseph 232
Nightingale and the Rose 22
Noisette, Louis 148, 215, 231, 232
Noisette, Philippe 231–2
Norman, Albert 243, 303

Odier, James 261
Ogisu, Mikinori 48
Omar Khayyam 24
Onodera, Toru 244
Ootacamund Botanical Gardens,
India 31

Osbeck, Peter 140, 208

paintings, roses in 20, 21–2
Paradise Lost 24
Paradisus terrestris 10, 11
Parkinson, John 11, 49, 64, 67, 157, 159
Parkman, 236
Parks, John 144, 150, 216
Parmentier, Louis 170, 228
Parsons, Alfred 40, 98, 140, 153, 207
Paul, George 235
Paul, William 76, 140, 188, 227, 228, 239, 277, 297
Pemberton, Rev. Joseph 43, 298, 323
Penzance, Lord 50, 320
perfume making *12, 13, 13*
Périchon, Edouard 32
Perkins, Charles 318
Pernet-Ducher, Joseph 135, 239–40, 298
Perpetua, Saint 21
Peters, Anna 285
Phillips, Roger 128, 154
Pizzi, Helena 143
Plant Hunter 54
Plantae Wilsoniae 50
Pliny the Elder 18, 109, 123–4, 136, 173
Pompeii 124
Postans, R.B. 277
Poulsen, Svend 243
Pradel, Henri 282, 290
Price, William 282
prickles 34, 117
Prince, W.R. 231
propagation 136, 228

Quest for the Rose 128

Radegund, Queen 15
Rambaux, Philippe 240
Raymond, Olivier 132
Redouté, Pierre Joseph 34, 40, 81, 132, 143, 162, 177, 208, 210, 215, 228, 232
Reeves, John 96, 136, 144, 153, 154, 216
Rehder, Alfred 37
religion 11–12, 15, 18, *20*, 21–2
Repton, Humphry 15, 16
Richard, Duke of York 27
Richelieu, Cardinal de 170
Rivory, Aimée Dubucq de 168
Rix, Martyn 128, 154
Robert, Nicholas 127
Robert and Moreau 297

Robinson, Herbert 303
Roessig, 103, 208
Romance of the Rose 22, *22*, 23
rootstocks 46
Rosa:
 acicularis 31, 33, 38, 70, *70*
 var. *nipponensis* 70, *71*
 'Adam' *278, 279, 279*
 'Adélaïde d'Orléans' 235
 agrestis 30, 78
 'Aimée Vibert' 258, *258, 259*
 'Alba' *172*, 173
 x *alba*:
 'Alba Maxima' 173
 maxima 127–8, 173, *173, 174–5*, 175
 'Semiplena' *126*, 127, 173
 '*alba* Regalis' *see* R. 'Great/Small Maiden's Blush'
 Albas 18, 49, 127–8
 'Albéric Barbier' 67, 318, *318*
 'Allgold' 312, *313*
 'Aloha' 244
 Alpine Rose *see* R. *pendulina*
 'American Pillar' 62
 anemoniflora 153
 x *anemonoides* 226, *227*
 'Animating' 231
 'Antoine Ducher' 239
 'Antoine Rivoire' 297
 'Apothecary's Rose' *see* R. *gallica officinalis*
 Apple Rose *see* R. *villosa*
 'Archduke Charles' 228, *229*, 231
 'Arctic Rose' *see* R. *acicularis*
 arkansana 38–40
 arvensis 38, 40, 43, 63, *72, 73*, 244
 Austrian Briar *see* R. *foetida*
 Austrian Copper *see* R. *foetida bicolor*
 Austrian Yellow *see* R. *foetida*
 Autumn Damask 118, *119*, 123, 135, 139, 236
 'Ayrshire Splendens' *see* R. *splendens*
 'Baby Love' 45
 'Ballerina' 246
 banksiae 43–5, 148–50
 alba-plena 45, 74, 74–5, 148–50, 218
 lutea 150, 216, 216–17
 lutescens 150, *151*
 normalis 43–5, 74, 74, 150
 Banksian *see* R. *banksiae*
 Banksian Yellow *see* R. *banksiae lutea*
 Banksianae 38, 43, 49
 Barberry Rose *see* R. *persica*
 'Baronne Prévost' 274, *274*
 'Beauty of Glazenwood'

see R. Fortune's Double Yellow
Belfield *see*
R. *chinensis* 'Semperflorens'
Bella Donna *see* R. 'Great Maiden's Blush'
'Belle Couronnée' *see* R. 'Celsiana'
Bengal Centfeuilles 210, *210–11*
'Benitos' *see* R. 'Cécile Brunner'
'Bermuda Kathleen' 143
'Blanc Double de Coubert' 323, *323*
'Blue Rose' *see* R. 'Indica Purpurea'
'Blush Noisette' *230*, 231, 232, 255, 256
'Blush Rambler' 147
'Bourbon Queen' 232, *233*
Bourbons 57, 140, 228, 232–5, 236
Boursault 235–6, 270
bracteata 45, 49, 64, 76, *76*, 77
Bracteatae 38
Bramble Leaved Rose *see* R. *setigera*
Bramble-flowered China *see* R. *multiflora*
brownii see R. *brunonii*
Brown's Musk *see* R. *brunonii*
brunonii 45–6
'La Mortola' *6, 7, 8–9*
Burnet *see* R. *pimpinellifolia*
Burr Rose *see* R. *roxburghii*
Cabbage Rose *see* R. x *centifolia*
californica 46
 nana 46
 plena 46
'Calocarpa' *250*, 251
Camelia Rose *see* R. *laevigata*
'Canary Bird' 154
Candolleana Elegans 36
canina 18, 40, 46, 49, 78, *79*
Caninae 38, 46, 49, 50, 64, 127
'Cardinal de Richelieu' 170, *170*
'Cardinal Hume' 46
carolina 38, 48
Carolinae 38, 48, 60, 64
carolinensis see R. *virginiana*
'Cécile Brunner' 240, *241*
'Celsiana' *156*, 157
x *centifolia* 11, 13, 118, 131, *180*, 181, *181*
 cristata 187, *187*
 muscosa 131, *182*, 183, *183, 184*, 185, *185*
 alba 186, 187, 188, *188*
 parvifolia 191, *191*
 'Petite de Hollande' ('Petit Junon de Hollande') 131
 var. *pomponia 190*, 191, 192, *192–3*
 'Purpurea' 248, *248–9*

'Spong' 131
'Tuscany' 165, *166–7*
'*centifolia Varietates subnigrae*' 165, *166–7*
Centifolias 132
'Champney's Pink Cluster' 231–2, 258
'Charles Desprez' 235
'Charles Lefebvre' 277
'Château de Clos Vougeot' 301
Cherokee Rose *see* R. *laevigata*
Cherry Rose *see* R. 'Turner's Crimson Rambler'
'Cheshunt Hybrid' 239
Chestnut Rose *see* R. *roxburghii*
'Chi Long Han Zhu' 140
Chickasaw Rose *see* R. *bracteata*
Chinas 57, 135–54, *137*, 228, 236, 246
chinensis 136
 'Minima' 140–3
 'Mutabilis' *142*, 143
 'Semperflorens' *138*, 139–40, 200, *200*, 201, *201*, 202, *202–3*, 204, 205, *205*, 207
 var. *spontanea* 48–9, 57, 139, 144
 'Viridiflora' 140
Chinensis section 38, 48, 54
Chinquapan Rose *see* R. *roxburghii*
'Christopher Stone' *302*, 303
'Cider Cup' 243
cinnamomea 49
Cinnamomeae 38, 46, 49, 50, 53, 58, 59, 60, 63, 67
Cinnamon Rose *see* R. *cinnamomea*
'Circus' *314*, 315
Clifton Moss *see* R. 'White Bath'
climbers 148–50, 244–6
'Climbing Cécile Brunner' 246
'Climbing Pompon de Paris' 143, 246
clinophylla 34, 49, 59, *80*, 81, *81*
'Cocktail' *316*, 317
Common Blush China *see* R. Old Blush
Common Briar *see* R. *canina*
Common Moss Rose *see* R. x *centifolia muscosa*
'Compassion' 244, 316, *316*
'Comtesse Vandal' 301, *301*
'Conditorum' 11, 124
'Constance Spry' *326*, 327
'Cooper's Burmese' 96
corymbifera 49, 127
 alba 42–3
'Cramoisi Supérieur' 231, 252, *252*, *253*

Crested Moss *see* R. x *centifolia cristata*
Crimson China Rose *see* R. *chinensis* 'Semperflorens'
'Crimson Globe' 188, *189*
'Crimson Glory' 303, 305
'Crimson Rambler' 240
'Cruenta' 231
'Cuisse de Nymphe Emue' *see* R. 'Great/Small Maiden's Blush'
cymosa 49
'Dainty Maid' 243
x *damascena*:
 bifera 118, *119*, 123
 trigintipetala 118, 120, *121*
 var. *versicolor* 157, *157*
Damask 50, 118–23, 132
davidii 44, 49–50, 58
 elongata 45
'De Van Eeden' 162, *162*
'Débutante' 318, *319*
'Desprez à Fleur Jaune' 255, *255*
'Diamond Jubilee' 266, *266–7*, 305, *305*
Dog Rose *see* R. *canina*
'Dorothy Perkins' 67, 318, *319*
Double Velvet' *164–5*, 165
Double White Moss *see* R. 'Shailer's White Moss'
'Dr W. Van Fleet' 244
Drop Hip Rose *see* R. *pendulina*
'Dublin Bay' 244
'Duchess of Bedford' *276*, 277
'Duchess of Portland' 132
'Duchesse de Morny' 277, *277*
'Dusky Maiden' 243
ecae 47, 50
eglanteria 50, 78, *79*, 85, *85*
Eglantine *see* R. *eglanteria*
Elderflower Rose *see* R. *cymosa*
elegantula 'Persetosa' *48*, 50–3
'Elisa Sauvage' *284*, 285
'Else Poulsen' 243
'Emile Courtier' 261
'Emmie Gray' 205
'Ena Harkness' 303, 303
Engineer's Rose *see* R. 'Turner's Crimson Rambler'
'Etoilé' 246, *247*
Eurosa 37–8
Ever-blowing Rose
 see R. *chinensis* 'Semperflorens'
Evergreen Chine 135
Evergreen Rose *see* R. *sempervirens*
farreri persetosa see R. *elegantula* 'Persetosa'

'Fashion' 243
Father David's Rose *see R. davidii*
fedtschenkoana 51, 53, 120, 123
'Félicité-Perpétue' 21, 132, *234, 235*
Field Rose *see R. arvensis*
'F.J. Grootendorst' 324
Floribundas 57, 140
foetida 53, 54, 57, *90,* 91, *91,* 135, 196
 bicolor 53–4, *84,* 85, *86–7*
 var. *hoggii* 196, *196*
 'Persiana' *(persiana) 134,* 135, 239
 var. *punicea* 88, *88, 89*
Fortune's Double Yellow 150–3, *152,* 220, *220, 221*
x *fortuniana* 150
 Banksian Epineux 218, *218, 219*
Four Seasons
 see R. x damascena bifera
x *francofurtana* 11, 170, *171*
'Frau Karl Druschki' 294, *294, 295*
'French Rose' *see R. gallica*
'Frensham' 242, 243
'Frühlingsgold' 62
gallica 18, 54, 63, 120, 123, 123–7, 128, 132, 168
 officinalis 20, 21, 25, 54, 124, *125,* 127, 160
 pumila 11, *52,* 53
 'Versicolor' 127, 157, 160, *160,* 161
Gallicanae 38, 54
'Général Fabvier' 251, *251*
'Général Jacqueminot' 236
gentiliana 34
Giant Rose 168, *168*
gigantea 54–7, *55,* 136, 140, 144, 207
'Gigantesque' 261
'Gioia' *see R. 'Peace'*
glauca 32–3
'Gloire des Polyanthas' 240
'Gloire des Rosomanes' 236, *237*
'Gloria Dei' *see R. 'Peace'*
'Gloria Mundi' 243
'Gold of Ophir' *see R.* Fortune's Double Yellow
'Goldbusch' 50
'Golden Cherry' *see R. laevigata*
'Golden Rose of China' *see R. hugonis*
'Golden Wings' 62, 320, *320*
'Goldfinch' 147
'Goldilocks' 243
Gooseberry Rose *see R. stellata*
'Graham Thomas' 246

Grandiflora 246
'Great Maiden's Blush' *116,* 117
Green Rose *see R. chinensis* 'Viridiflora'
Ground Cover 244
'Grouse' 244
'Gruss an Aachen' 312, *312*
Hama-nashi *see R. rugosa*
Hama-nasu *see R. rugosa*
x *hardii 59,* 62
'Harisonii' ('Harison's Yellow') 196, *196*
Hedgehog Rose *see R. rugosa*
helenae 57
hemisphaerica 11, 18, *19,* 57, 132, 194, *194, 195*
 var. *rapinii* 57, 132, 194
henryi 34
'Hermosa' *260,* 261
Hesperrhodos 37, 58, 64
'Holoserica Duplex' 159, *159*
Holy Rose *see R. x richardii*
'Hoosier Beauty' *300,* 301
'*Hudsoniana Salicifolia*' 34
hugonis 58, *92,* 93, *93*
Hulthemosa 37
'Hume's Blush Tea-Scented' 144, *145,* 228, 231, 279
Hungarian Rose *see R.* 'Conditorum'
Hybrid Perpetuals 235, 236–9
Hybrid Polyanthas *see R.* Floribundas
Hybrid Teas 57, 140, 235, 239, 240, 244
'Iceberg' 243
'Incarnata' *see R.* 'Great/Small Maiden's Blush'
'Incense Rose' *see R. primula*
'Independence' 309
'*Indica* Linneana' 246
'Indica Major' 231
'Indica Purpurea' 231
indica stelligera see R. 'Etoilé'
'International Herald Tribune' 46
involucrata see R. clinophylla
x *involuta 94,* 95, 95
x *jacksonnii* 326, *327*
'Jacqueline du Pré' 246
'Janet's Pride' 320, *321*
Japanese Rose *see R. rugosa*
'Jaune Desprez' *see R.* 'Desprez à Fleur Jaune'
'Jin Ying Tzu' *see R. laevigata*
'Josephine Bruce' *304,* 305
'Jules Margottin' 274, *275*
'Kazanlik' 11, *121*

'Kiska Rose' *see R. rugosa*
kokanica 57
kordesii 326
'La Belle Sultane' *see R.* 'Maheka'
La Bengale *see R.* 'Slater's Crimson China'
'La Boule d'Or' 285, *285*
'La France' 239, 244, *292,* 293, *293*
La Royale *see R.* 'Great/Small Maiden's Blush'
La Séduisante *see R.* 'Great/Small Maiden's Blush'
'La Villageoise' 160
'Lady Banks Rose' *see R. banksiae alba-plena*
'Lady Hillingdon' 289, *289*
'Lady Mary Fitzwilliam' 239
'Lady Sylvia' 297
laevigata 57–8, 96, *96, 97,* 150, 153, 218, 227
Laevigatae 38, 57
'Lamarque' 256, *256, 257,* 282
'Lauré Davoust' *268–9,* 269
Lawrancianas 140, *141,* 143
'Le Pactole' 282, *282*
'Léonie Lamesch' 240
'Lesser de Meaux' 191, *191*
'Little Rambler' 246
longicuspis 58
Lotus Rose *see R. multiflora* 'Carnea'
'Louise Odier' 261, *261*
luciae 67, 318
lucida see R. virginiana
lutea see R. foetida
'Ma Pâquerette' 240
Macartney Rose *see R. bracteata*
macrophylla 58
'Madame A. Meilland' *see R.* 'Peace'
'Madame Butterfly' 297
'Madame Caroline Testout' 239
'Madame de Sancy de Parabère' 236, 270, *270*
'Madame de Tartas' 240, 287
'Madame Desprez' 235
'Madame E. Herriot' *298,* 299
'Madame Hardy' 272, *272*
'Madame Isaac Pereire' 262, *262, 263*
'Madame Lambard' 287, *287*
'Madame Mélanie Soupert' 298
'Maheka' 168, *169*
Mai Kwai 154
'Mai Xiao' 136
'Maigold' 62
majalis see R. cinnamomea
'Manning's Blush' 50
'Marbled Scots' 196, *197*

Mardan Rose *see R. laevigata*
'Maréchal Niel' 266, 290, *291,* 305
'Marquise Boccella' ('Marquesa di Bocella') 272, *273*
'Masquerade' 243
'Max Graf' 326
Memorial Rose *see R. wichurana*
'Mermaid' 76
Miniatures 140, 243, 246
minutifolia 34, 37, 58
Miss Lawrance's Rose 140–3
'Moiré' *286,* 287
Monthly Rose
 see R. chinensis var. *semperflorens;*
 R. x damascena bifera;
 R. Old Blush
'Morning Jewel' 244
moschata 43, 46, 120, 123, 128, *178,* 179, *179,* 231, 235
 nepalensis 46
moyesii 56, 58
 'Geranium' 57
 'Sealing Wax' 57
'Mu-Hsiang'
 see R. banksiae normalis
mulliganii 58–9
multibracteata 59
multiflora 59–60, 98, *98,* 144, 147, 240, 244, 323
 cathayensis 148
 multiflora 148
 platyphylla 147–8, 214, 215, *215*
 'Carnea' 148, *149,* 235
Musk Rose *see R. moschata*
'Mutabilis' 315
Myrrh-scented Rose *see R. splendens*
'Narrow Leaved Sweet Briar' *see R. sepium*
Nastarana 128
'Nevada' 57, 246
'New Dawn' 244, *245*
'Nipheos' 244
nitida 60, 98, *99*
'Noisette à Fleurs Blanches' 140, *141*
Noisettes 57, 128, 140, 228, 231–2, 236, 240, 323
x *noisettiana 230,* 231
'Nozomi' 244
nutkana 64
Oakington Ruby 140, 243
x *odorata* 144, *145*
Old Blush 140, *206,* 207, *207,* 208, *208, 209,* 212, 228, 231, 235, 236
Old Crimson China

see R. chinensis var. *semperflorens*
Old Pink Moss Rose *see R. x centifolia muscosa*
omeiensis pteracantha see R. sericea pteracantha
'Opera' 307
'Ophelia' 297, *297,* 301
Oranda Ibara 147
'Orléans Rose' 240–3
'Pallida' *see R.* Old Blush
palustris 34, *35,* 40–1, 60
'Parks' Yellow Tea-Scented' 144, 228, 255
Parsons' Pink China *see R.* Old Blush
Patio 243
'Paul Crampel' 243
'Peace' 88, 240, 307, 309, 311
pendulina 60, 67, *100,* 101, *101,* 236, 270
'Perle des Jardins' 290, *290*
'Perle d'Or' 240, *241*
Pernetianas 135, 239, 240
Perpetual White Moss *122,* 123
Perpetuals 198
Persian Yellow *see R. foetida* 'Persiana'
persica 37, 60–2, 82, *82, 83*
phoenicia 128
'Phyllis Gold' 303
pimpinellifolia 18, 37, 62, 67, *68,* 78, *79,* 95, 103, *103,* 135
 var. *altaica 102,* 103
Pimpinellifoliae 38, 50, 53, 57, 62
'Pink Grootendorst' 324, *325*
'Pink Mystery' 53
'Pink Peace' *308,* 309
'Pinocchio' 243, 315
Platyrhodon 37, 153, 154
Poly Pompons *see R.* Polyanthas
Polyanthas 60, 240–3, 293, 324
pomifera see R. villosa
'Pompon de Bourgoyne' *see R. x centifolia parvifolia*
Portland Crimson Monthly 131
Portland Rose *130,* 131
'Portlandica' 131
Portlands 131–2, 236
Potato Rose *see R. rugosa*
Prairie Rose *see R. setigera*
Prickly Rose *see R. acicularis*
primula 62–3
'Princesse Adélaïde' *288,* 289
'Princesse Louise' 235
Provence Rose *see R. x centifolia*
'Purezza' 150
Quatre Saisons

see *R. x damascena bifera*
Quatre Saisons Blanc Mousseux
 122, 123
'Queen Elizabeth' 222, 236, 246,
 315, *315*
Ramanas Rose *see R. rugosa*
ramblers 244
'Ramona' 96
'Raubritter' 246
'Rayon d'Or' 240, 298, *298*
'Reine des Iles Bourbon'
 see R. 'Bourbon Queen'
x *reversa* 66
x *richardii* 128
'Richmond' 301
'Robert le Diable' 131
'Rödhätte' 243
Rosa Mundi
 see R. gallica 'Versicolor'
Rose of Austria
 see R. gallica pumila
Rose Capucine
 see R. foetida bicolor
Rose of Castile
 see R. x damascena bifera
Rose de Meaux *16–17, 190,* 191,
 192, *192–3*
Rose de Pompon
 see R. x centifolia parvifolia
Rose des Peintres *see R. x centifolia*
'Rose du Roi' 270, *271*
'Rose Edouard' 232–5
Rose Gaujard *306,* 307, *307*
'Rose of May' *see R. cinnamomea*
Rose Muscade *see R. moschata*
Rose of Praeneste *see R. gallica*
Rose of Provins *see R. gallica*
'Roseraie de l'Haÿ' 324, *324*
Rosier d'Amour
 see R. gallica pumila
'Rosier de l'Ile de France' 235
Rosier de Portland 132, 270
'Rouletii' 140, 243
roxburghii 31, 33, 37, 153, 154, *155,*
 222, *222, 223*
 normalis 37, *222*
rubiginosa see R. eglanteria
rubrifolia see R. glauca
'Rubrotincta' *158,* 159
rugosa 31, 33, *61,* 63, 104, *104,*
 105, 107, *107,* 147, 251, 326
 alba 106, *106,* 323
 rubra 63, 324
 'Scabrosa' 63
'Rutland' 244
'Sacramento Rose'
 see R. stellata mirifica

'Safrano' 280, *280*
Saint John's Rose *see R. richardii*
salictorum 34
sancta see R. richardii
'Scots Rose' *see R. pimpinellifolia*
'Semperflorens Rose'
 see R. chinensis var. *semperflorens*
sempervirens 63, *108,* 109, *109,* 235,
 236, 244, 258
sepium 78, *78*
sericea 58
 pteracantha 63, 110, *110, 111*
setigera 62, 63–4, 244
'Seven Sisters' 147–8, *214,* 215, *215*
'Shailer's White Moss'
 (Double White Moss) *186,* 187,
 188
sherardii 95
'Shi Tse Mei'
 see R. 'Turner's Crimson Rambler'
Shrub 246
'Silver Moon' 96
simpicifolia see R. persica
'Simplex' *204,* 205
Simplicifoliae 37, 60
sinowilsonii 34
'Slater's Crimson China' *138,* 139,
 200, *200,* 201, *201,* 202, *202–3,*
 204, 205, *205,* 210, 228, 236,
 246, 251, 252
'Small Maiden's Blush' *176,* 177,
 177
'Socrates' *296,* 297
'Soleil d'Or' *238,* 239, 240, 298
'Sombreuil' 280, *281*
soulieana 58, 64
'Southport' 303
'Souvenir de la Princesse de
 Lamballe' *see R.* Bourbon Queen'
spinosissima see R. pimpinellifolia
splendens 39
'Stanwell Perpetual' 135, 198, *199*
'Stapeliae Flora' 162, *163*
stellata 37, 64, *65*
 mirifica 37, 64
'Sterling Silver' 311, *311*
suffulta see R. arkansana
sulphurea see R. hemisphaerica
'Super Star' 222, 309, *309*
'Surrey' 244
'Sutters Gold' 244–6, *310–11,* 311
Swamp Rose *see R. palustris*
Sweet Briar *see R. eglanteria*
Synstylae 38, 40, 45, 57, 58, 59, 63,
 64, 67, 72
Tea-Noisettes 140, 290
Teas 57, 228, 231, 236, 239, 244

'Teri Ha-No-Ibara'
 see R. wichurana
'Ternauxiana à Fleurs Rouges'
 254, 255
'The Fried Egg' *see R. bracteata*
'Thé Maréchal' *see R.* 'Lamarque'
'The Queen Alexandra Rose' 88
Threepenny Bit Rose
 see R. elegantula 'Persetosa'
Tiny-leaf Rose *see R. minutifolia*
Tipo Ideale *see R. chinensis*
 'Mutabilis'; *R.* Unique Blanche
Titbit Rose *see R.* 'Conditorum'
'Tom Brown'46
'Tom Thumb' 150
Tous les Mois 123, 139, 232
Trailing Rose *see R. arvensis*
'Trier' *322,* 323
'Tropicana' *see R.* 'Super Star'
'Turbinata' *see R. x francofurtana*
'Turner's Crimson Rambler'
 146, 147
Unique Blanche 143
'Variegata di Bologna' *264–5,* 265
'Veilchenblau' 147
'Vicomtesse de Cazes' 282, *283*
'Victor Emmanuel' 265
villosa 64
Virginia Rose *see R. virginiana*
virginiana 38, 64–7, *112,* 113, *113*
viridiflora Green Rose 212, *212, 213*
'White Bath' 188, *188*
White Rose of York
 see R. x 'Alba Maxima'
wichurana 67, 69, *69,* 147, 244,
 318, 326
'William III' 135
'William's Double Yellow' 135, 196
willmottiae 67
'Willmott's Crimson' 140
Winged Thorn Rose
 see R. sericea pteracantha
'Wintonensis' 57
woodsii 34
xanthina 57, 153–4
 spontanea 154
Yellow Provence Rose
 see R. hemisphaerica
'Yellow Rose of Asia' *see R. foetida*
York & Lancaster
'Zéphirine Drouhin' 266, 266
Rosaceae 31
Rose Manual 269
rose oil 118
Rosen, Die 43, 208
Rosenalbum 279
Rosengarten 285

Roses, Les 157, 228
Roses Anciennes 43
Roses Anciennes de France 154
rosewater 13, 118
Rousseau 261
Roussel, 236
Rousselet, 236
Roxburgh, William 153
Royal Exotic Nursery 93
Royal Horticultural Society 11
Royal National Rose Society 43

St Gall, Switzerland 16
Samos, Hera's Temple 117
Sappho 11–12, 109
Sargon I 117
Savatier, Dr 67
Scallan, Father Hugo 93
Schmidt, J. C. 227
Schongauer, Martin 21, 22
Séguier, Dominic 192
sepals 46
Shailer, Henry 187
Shakespeare, William, Midsummer
 Night's Dream 40–3
Shawyer, George 289
Shepherd, Roy 320
Silk Road 136
site requirements 34
Slater, Gilbert 139, 201
Smith, Robert 147
Socrates 297
Somerset Rose Nurseries, New
 Brunswick 244
Souchet, M. 270
Soulié, Père Jean 64
Sowerby, James 72
species 33–47
Spenser, Edmund 24
sports 127, 244
Stapelia 162
subgenera 37–8
suckers 46
Sumerians 118
Sutter, John 311
Swim, Herbert 311, 315

Tagore, Rabindranath 24
Tantau, Mathias 309
Tchertoff, Barbara 235
Teika, Fujiwara 147
tetanus 25
Theatrum Bonicum 67
Thomas, Graham 43, 45, 179, 227
Thomson, Richard 139
thorns 34

Thory, Claude Antoine 34, 37, 157,
 162, 170, 228, 246
Thunberg, Carl Peter 59, 63, 106, 147
Trattinick, Leopold 153
Trechslin, Anne-Marie 294, 318
Tudor Rose 27
Turner, Charles 147

understocks 46, 49, 218, 228
United States of America, rose of 27

valour, symbol of 25
Van Fleet, Dr W. 62, 96, 244
Van Houtte, 170
Van Hulthem, 82
Veitch, James 93
Verdier, Eugène 277
Vibert, Jean-Pierre 37, 236, 252, 258
Victoria, Queen 147
Viraraghavan, Shri M.S. 49, 81
Virgin Mary 20, 21–2

Wallisch, Nathaniel 46
Walsh, Michael 318
Wang Heang Kow 216
Wangenheim, Louise von 43
Ward, Frank Kingdom 54
Ware, 106
Warner, Chris 246
West, roses in 117
Wheatcroft, Harry 303
white roses 21
Whitwell, Mr 320
Wichura, Dr Max 67, 69
William III 135
Willmott, Ellen 67, 153
Willock, Sir Henry 132–5, 239
Wilson, Ernest H. 50, 57, 58, 150
Wilton Diptych 21–2
Wood, Charles 198
Wu Di, Emperor 136

'Yellow Rose of Texas' 15
yellow roses 132–5
York, dukes of 26, 27

Zoroastrianism 12, 24

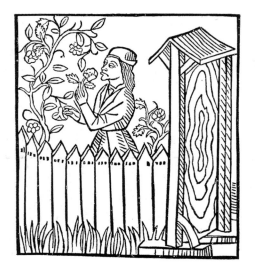 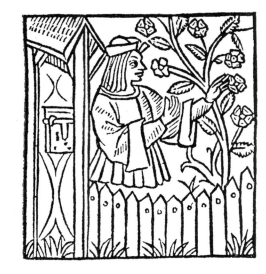

Acknowledgments

Writing this book incurred the pleasurable necessity of visiting the Lindley Library of the Royal Horticultural Society and handling many rare volumes in the search for illustrations. My thanks for their whole-hearted cooperation and enthusiasm for the project are due to Librarian/Archivist Dr. Brent Elliott, Picture Librarian Jennifer Vine, and her volunteer assistant Barbara Harrison.

At each stage of the book's production I have been grateful for guidance, advice and constructive suggestions from the publishers Co & Bear, especially from David Shannon, Pritty Ramjee, Ruth Deary and Alex Black.

In presenting afresh the story of how roses of nature have evolved into our roses of today many sources have been consulted. I owe a special debt to the scholarly and inspirational works of Graham Stuart Thomas, and am especially honoured that he has agreed to contribute the foreword. Among sources useful for throwing new light on the origins of older roses, recent outputs from Brent C. Dickerson, Roger Phillips, Martyn Rix and Francois Joyaux, the DNA research of Maurice Jay and publications of the Royal National Rose Society and its Historic Roses Group have been particularly helpful. Sarah Coles has kindly permitted me to quote a passage from *The Rose in European Art*.

Finally my thanks are due to my wife Margaret, not only for skilful proof reading but also for suffering with patience a tide of books and paper around the house, and to my daughters Anne and Rosemary, reassuring sources of advice in moments of computer aberration.

Peter Harkness

ALL IMAGES SOURCED FROM THE LINDLEY LIBRARY EXCEPT:
page *26* 'Choosing the red and white roses in the Temple Garden' by Henry A. Payne, (1910). Location: Houses of Parliament, Westminster/Bridgemann Art Library; pages *74, 93, 110, 121, 170, 183, 198, 241, 242, 245, 264–5, 266, 272, 289, 294, 295, 297, 307, 309, 310, 317, 318, 323, 325* © Anne Marie Trechslin; pages *316, 320, 324* from Royal Roses of London (1992) © Four Seasons for Victoria's Secret, illustrations by Coral Guest.
The publishers have attempted to contact the copyright owners of the images in this book. The publisher apologises if inadvertently permission has not been obtained.